Scandinavian Glass 1930-2000
Smoke & Ice

Lorenzo Vigier & Leslie Piña
Text — Visuals

Schiffer Publishing Ltd
4880 Lower Valley Road, Atglen, PA 19310 USA

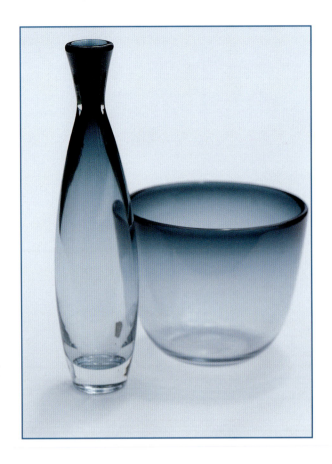

Library of Congress Cataloging-in-Publication Data
Piña, Leslie A., 1947-
 Scandinavian glass, 1930-2000: smoke & ice/by leslie Piña & Lorenzo Vigier
 p. cm.
 ISBN 0-7643-1653-2
 1. Glassware—Scandinavia—Collectors and collecting—Catalogs. 2. Glassware—Scandinavia—History—20th century—Catalogs. 3. Art glass—Scandinavia—Collectors and collecting—Catalogs. 4. Art glass—Scandinavia—History—20th century—Catalogs. I. Title: Smoke & ice. II. Vigier, Lorenzo. III. Title.
 NK5157.A1 P55 2003
 748'.0948'075—dc21
 2002011476

Copyright © 2002 by Leslie Piña & Lorenzo Vigier

All rights reserved. No part of this work may be reproduced or used in any form or by any means—graphic, electronic, or mechanical, including photocopying or information storage and retrieval systems—without written permission from the copyright holder.
 "Schiffer," "Schiffer Publishing Ltd. & Design," and the "Design of pen and ink well" are registered trademarks of Schiffer Publishing Ltd.

Designed by Leslie Piña
Layout by John P. Cheek
Type set in Korinna BT
ISBN: 0-7643-1653-2
Printed in China
1 2 3 4

Published by Schiffer Publishing Ltd.
4880 Lower Valley Road
Atglen, PA 19310
Phone: (610) 593-1777; Fax: (610) 593-2002
E-mail: Schifferbk@aol.com
Please visit our web site catalog at www.schifferbooks.com
We are always looking for people to write books on new and related subjects. If you have an idea for a book please contact us at the above address.

This book may be purchased from the publisher.
Include $3.95 for shipping.
Please try your bookstore first.
You may write for a free catalog.

In Europe, Schiffer books are distributed by
Bushwood Books
6 Marksbury Ave.
Kew Gardens
Surrey TW9 4JF England
Phone: 44 (0) 20 8392-8585; Fax: 44 (0) 20 8392-9876
E-mail: Bushwd@aol.com
Free postage in the U.K., Europe; air mail at cost.

Contents

Dedication and Acknowledgments .. 4
Introduction .. 5
Chapter 1. Simple Form .. 7
Chapter 2. Geometric Form .. 23
Chapter 3. Sculptural Form .. 30
Chapter 4. Texture and Bubbles .. 50
Chapter 5. Pattern .. 58
Chapter 6. Molded Form 66
Chapter 7. Cut Glass 83
Chapter 8. Engraved Glass 98
Chapter 9. Figural Glass 117
Chapter 10. Tableware 131
Chapter 11. Companies 171
Chapter 12. Designers 180
Chapter 13. Labels 189
Chapter 14. Signatures 197
Appendix 205
Selected Bibliography 219
Index 222

Dedication

Para mis padres, Nancy y Lorenzo

Acknowledgments

We would like to thank the following individuals, companies, and institutions for their support and generous help with the completion of this book. Without you, this project would not have been possible.

Carol Jo Williams
Ramón Piña
Rita Vigier
Paivi Jantunen at iittala
Kosta Boda
Ulf Rosen at Lindshammar
Mats Jonasson Maleras
Ake Ernstsson at Sea Glasbruk
Tiina Willman
Eva-Pia Worland
Anne Palkonen
Michael Ellison
Ed Goshe
Gordon Harrell
Ruth Hemminger
The Rakow Library at The Corning Museum of Glass
Ursuline College Library
Cleveland Museum of Art library
Retro Gallery

Introduction

Twentieth-century Scandinavian glass has been admired and collected for as long as the numerous factories of Denmark, Finland, Norway, and Sweden have produced it. Most has been design-driven and a good deal of this wildly varied product would fall into the category known as art glass. Not necessarily utilitarian, the "art" precedes any other reason for being. Yet Scandinavian design has demonstrated a strong focus on "form and function" even in primarily decorative pieces. Designers of other interior furnishings and arts have used the medium of glass to express variations of form and function as well as other modern innovative ideas. Often signed, numbered, and cataloged by large companies such as Orrefors, Kosta, Iittala, and Holmegaard, these highly desirable works of art command high prices and interest from the collecting world.

If either form or function upstages the other, modern Scandinavian design is best known for its usefulness. From furniture to kitchen utensils, objects have been designed with the user in mind. Size, proportion, texture, color, comfort, simplicity, and durability are features that have contributed to the widespread acceptance of what is loosely called "Scandinavian modern." But it is the function, the usefulness, that stands out. Glassware for the table has been created by the same designers responsible for the vases and other purely decorative items. The result has been well-designed functional tableware as well as some surprisingly useful art. The same concepts of usefulness and beauty have gone into the making of both categories of glass objects — art glass and utilitarian ware.

Since both types or functions of glassware have been designed by the same designers and produced by the same factories, we have chosen to include both in the same volume. But in order to have a representative sample, we also realized that two volumes would be necessary. After much debate, we decided to divide the material according to color. For another major type of glass, such as Italian, this would not have worked. But Scandinavian glass has a surprisingly neat division by color. Much of the early twentieth-

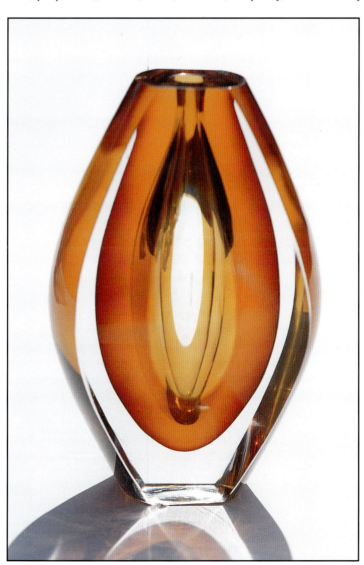

Kosta "Ventana" vase designed by Mona Morales-Schildt in 1963.

Kosta Boda unique vase designed by Ulrica Hydman-Vallien in 1999.

Photo courtesy of Kosta Boda

Nuutajarvi Notsjo bowls designed by Heikki Orvola in 1970.

Photo by Timo Kauppila courtesy of iittala

century product of large companies like Orrefors and Kosta, for example, was colorless. The form and cut or engraved decoration superseded any need for color. The post-World War II era brought color into the home in every way possible. Designers added vibrant color palettes into lines of glassware, while the same companies continued to produce colorless crystal. By the 1960s and 1970s, most cut and engraved decoration had been replaced by pure color and form. More economical mold-blown and molding methods began to replace off-hand or mouth-blown glass. Fanciful, even bizarre shapes and vivid hues by companies such as Aseda, Riihimaki, and Holmegaard are typical of this period.

This volume, entitled *Smoke & Ice*, is about modern Scandinavian glass that depends solely on form and minimal decoration for its success. The separate volume, entitled *Fire & Sea*, includes examples of glass by many of the same designers and companies — but in colors. Since designers and makers looked to nature for inspiration, the titles reflect it. Whether your taste leans toward the crisp and icy or the liquid and fiery, the decades of Scandinavian design leadership can provide a banquet for all.

A word about pricing

As with any book with a price guide, this should be looked at with some caution. Prices range and prices vary; only a specific seller and buyer can make a price. A book can only suggest a range based on a sample of specific sellers and buyers. We have used a variety of sources to arrive at the numbers in this guide: auction catalogs, on-line auctions, shows, shops, flea markets, web sites, companies, and individuals. Some items are relatively rare, and fewer transactions have occurred. Others are fairly common, so it was much easier to identify a reasonable price range. Regional differences, seasonal changes, and other factors can create prices outside of the suggested range. Condition is extremely important. Unlike furniture, which should show some wear and signs of use, glass cannot. Chips, cracks, fogginess (sick glass) or other damage will cause a piece of glass to loose much, perhaps all, of its monetary value. Rim chips can often be repaired (ground) without causing devaluation, providing the piece does not become noticeably shorter. About the only acceptable sign of wear would be surface scratches on the bottom where a vase or a bowl sits on a hard surface. These minute scratches are "good" signs of age, and they cannot be imitated.

So the prices suggested in this volume are approximate and should be used as a rough guide. Transactions outside the range are to be expected. Neither the authors nor the publisher can be responsible for any outcomes from using the price guide, but we hope that the information offered will be helpful to your collecting, education, and enjoyment. Please accept our apologies for omitting accents from Scandinavian names.

Chapter 1
Simple Form

Johansfors vases designed by Bengt Orup around the late 1950s or early 1960s.

Flattened teardrop vessels with stylized thin necks, with a light amber underlay, cased in clear glass; h. 12 in. (30.48 cm), h. 16-1/2 in. (41.91 cm), h. 22 in. (55.88 cm); signed J.FORS ORUP. *Sweden.* $225-$450 each, depending on size.

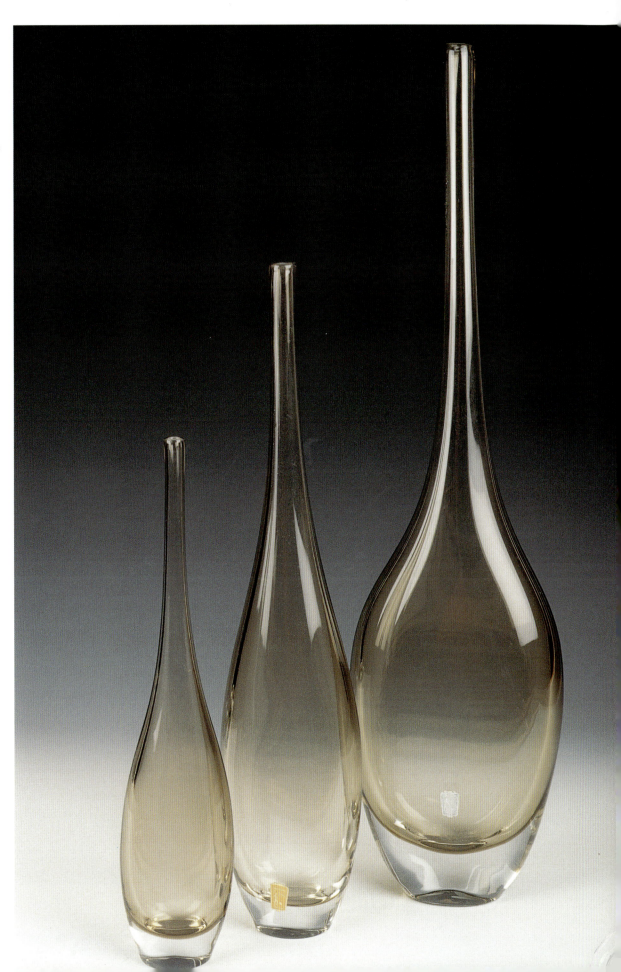

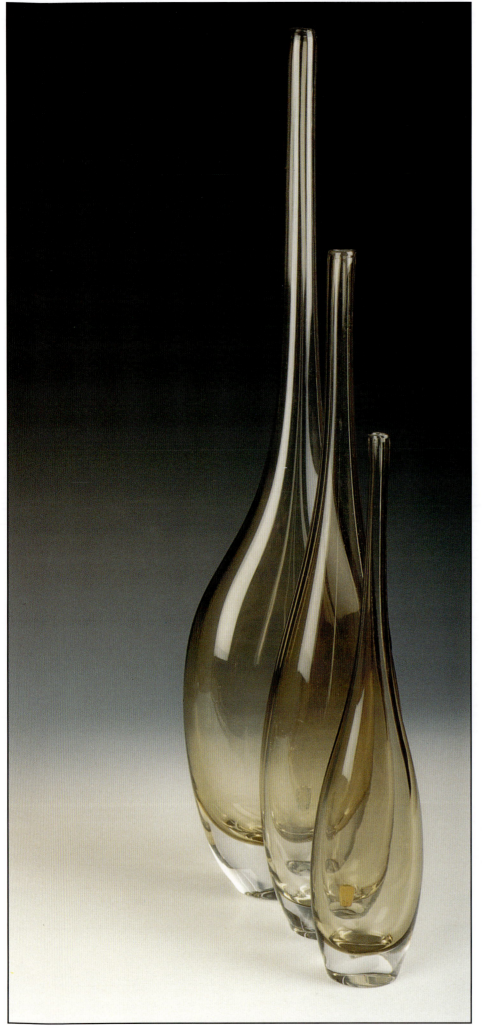

Johansfors vases photographed to accentuate simplicity of form and scale.

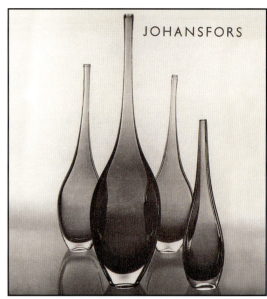

Advertisement from *Kontur* magazine in 1964, featuring Johansfors vases designed by Bengt Orup.

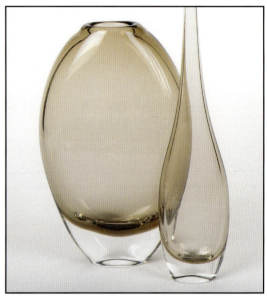

Johansfors vase designed by Bengt Orup around the late 1950s or early 1960s, photographed with thin neck vase.

Flattened bulbous form with a light amber underlay, cased in clear glass; h. 9-1/2 in. (24.13 cm); signed J.FORS ORUP. *Sweden.* $250-300

Advertisement from *Form* magazine in 1954, featuring Johansfors vases designed by Bengt Orup.

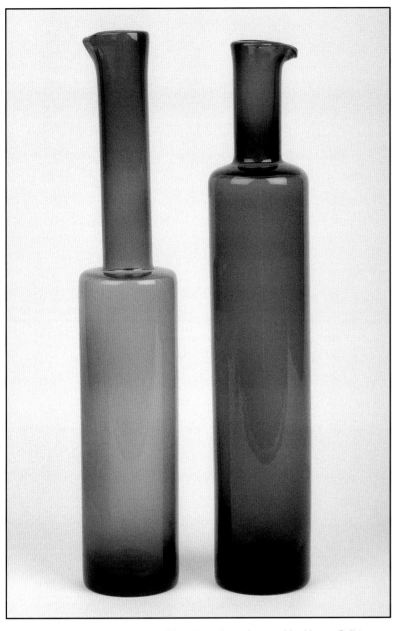

Riihimaen Lasi "Koristepullo" bottle pitchers designed by Nanny Still in 1959.

Cylindrical forms with reduced necks and spouts in transparent charcoal gray glass; h. 12-3/4 in. (32.38 cm), h. 12-1/2 in. (31.75 cm); signed RIIHIMAEN LASI OY NANNY STILL. *Finland.* $225-250 each

This design was produced in a variety of different colors and forms from 1959 to 1968. As shown, the main design variant consisted of different combinations of body and neck lengths.

Gullaskruf bottle vases designed by Arthur Percy in 1952.

Globular forms with elongated necks in transparent charcoal gray glass; h. 4-3/4 in. (12.06 cm), h. 4-3/4 in. (12.06 cm); both retain the original yellow and gold foil paper label: GULLASKRUF SWEDEN. Small, $25-35; large, $125-150.

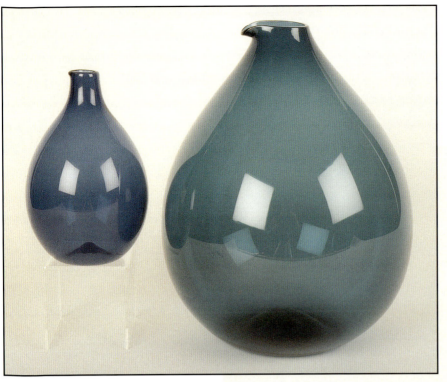

Bottle pitchers.

iittala i-401 "bird bottle" pitcher from the i-collection, designed by Timo Sarpaneva in 1956; globular form with cylindrical neck, spout and indented bottom, in transparent charcoal blue glass; h. 6-1/2 in. (16.51 cm); signed TS. *Finland.* $225-250

Gullaskruf bottle pitcher attributed to Arthur Percy; globular form with spout and indented bottom in transparent charcoal blue glass; h. 11 in. (27.91 cm). *Sweden.* $250-300

Gullaskruf bottle vases designed by Arthur Percy in 1952.

Globular forms with elongated necks in transparent charcoal gray and charcoal blue glass; h. 4-3/4 in. (12.06 cm.), h. 5-1/4 in. (13.34 cm.), h. 19-1/2 in. (49.53 cm.); the smallest retains the original yellow and gold foil paper label: GULLASKRUF SWEDEN. $25-35 small, $125-150 large.

Bottom:
Johansfors bowls designed by Bengt Orup around 1958.

Vessels with graded charcoal blue transparent glass underlays, cased in clear glass; d. 8-3/4 in. (22.23 cm), d. 8 in. (20.32 cm); signed J.FORS ORUP; signed ORUP JOHANSFORS SWEDEN. $175-250 depending on size.

These bowls were part of the Corning Glass Museum Special Exhibition of International Contemporary glass in 1959. This was likely one of the most important modern glass exhibitions in the United States during the mid-20th century. Objects were selected because they showed "evidence of superior ability in the art of glass making and decorating," a direct reflection of the designer's creativity and mastery of design. This exhibition captured and created a permanent record of what Modernism in glass was, as it was occurring.

Right:
Johansfors vases designed by Bengt Orup around 1958.

Tapered cylindrical forms with cinched necks and flared rims, with graded charcoal blue glass underlays, cased in clear glass; h. 11-3/4 in. (29.84 cm), h. 8-3/4 in. (22.23 cm); both signed J.FORS ORUP; larger retains original yellow and gold foil paper label: JOHANSFORS SWEDEN. $275-400 each

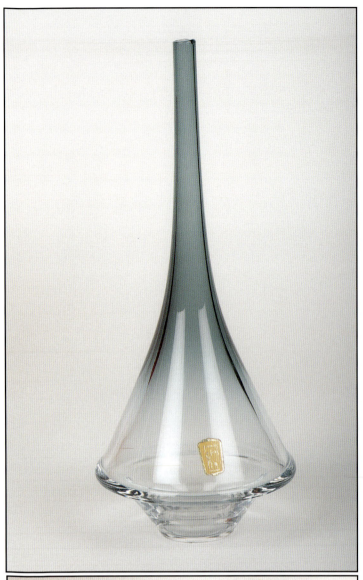

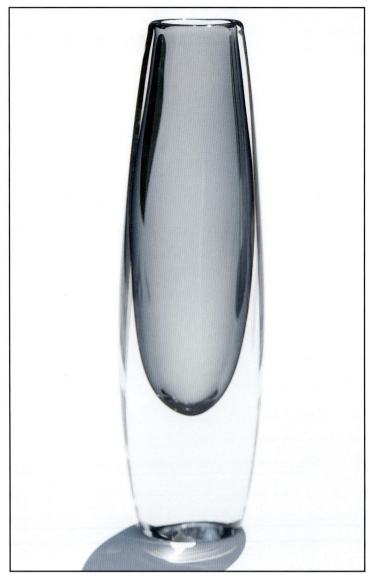

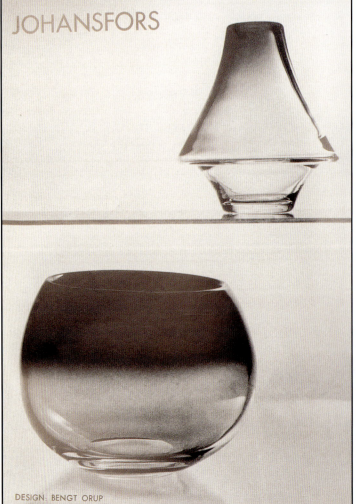

Top left:
Johansfors vase designed by Bengt Orup around 1958.

Tapered conical form with an exaggerated and thin neck, with a graded transparent charcoal gray glass underlay, cased in clear glass; h. 10-1/2 in. (26.67 cm); signed J.FORS ORUP; retains yellow and gold foil paper label: JOHANSFORS SWEDEN. $300-350

Left:
Advertisement from *Kontur* magazine in 1964 depicting Johansfors pieces designed by Bengt Orup.

Top right:
Strombergshyttan vase attributed to Gunnar Nylund, designed around 1957.

Flattened and slightly bulbous cylindrical form with charcoal gray glass underlay heavily cased in clear glass; h. 7-1/4 in. (18.41 cm); signed STROMBERG B936. *Sweden*. $125-150

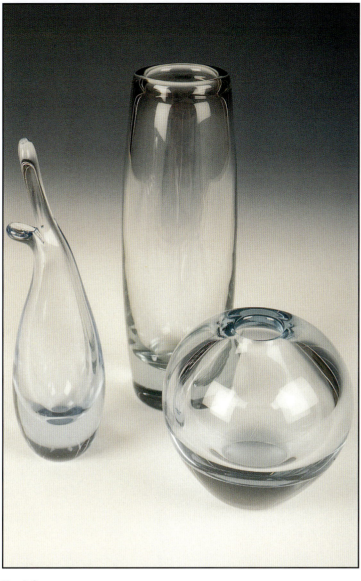

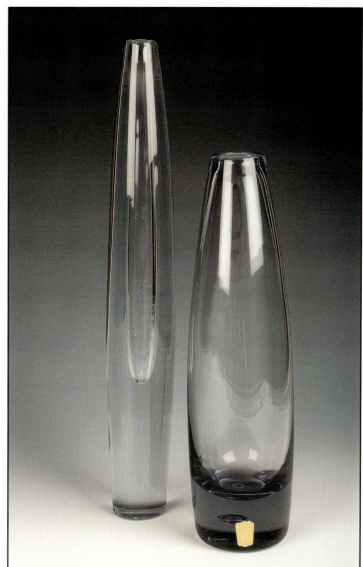

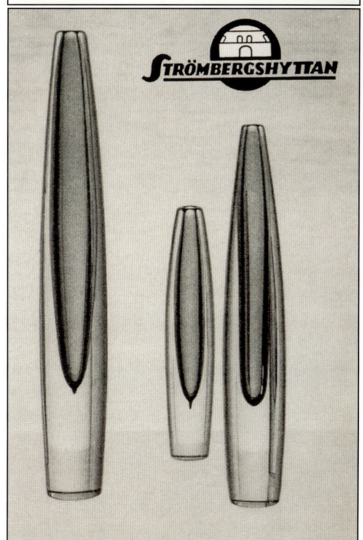

Top left:
Holmegaard vases designed by Per Lutken in transparent turquoise blue glass. (*Denmark*)

"Beak" or "Duckling" vase with asymmetrical double pulled lip, designed in 1950; h. 6-1/2 in. (16.51 cm); signed HOLMEGAARD PL 15272. $100-125

Vase with slightly bulbous cylindrical form, designed around 1957; h. 7-1/4 in. (19.05 cm); unsigned. $125-150

"Rondo" vase with bulbous form and reduced opening, designed around 1956; h. 3-1/2 in. (8.13 cm); signed HOLMEGAARD 19PL59. $75-100

Top right:
Vases.

Strombergshyttan vase attributed by Gunnar Nylund, designed around 1958; elongated and tapered cylindrical form in transparent glass with a heavy base; h. 13-3/4 in. (34.92 cm). *Sweden*. $150-175

Johansfors vase attributed to Bengt Orup; tapered cylindrical form in transparent gray or "smoke" glass; h. 10-3/4 in. (27.30cm); retains yellow and gold foil paper label: JOHANSFORS SWEDEN. $100-125

Right:
Advertisement from *Form* magazine in 1958 depicting Strombergshyttan vases. These vases were produced with color underlay cased in clear glass, in clear glass only, or with deeply cut rings around the solid base.

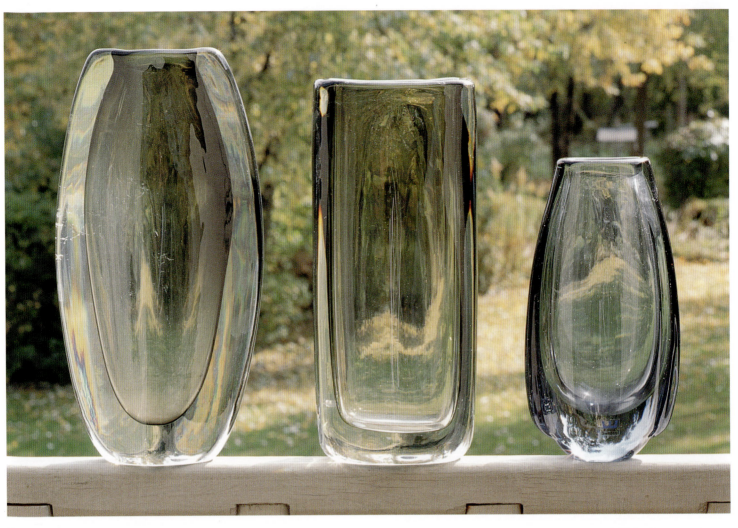

Vases.

Orrefors vase by Nils Landberg designed between 1955-1960; ovoid form in transparent glass, flattened on four sides; h. 10 in. (25.40 cm); signed ORREFORS NU 3668/7. *Sweden.* $175-250

Orrefors vase designed by Nils Landberg between 1955-1960; cylindrical form in transparent glass, flattened on two sides; h. 9-1/2 in. (24.13 cm); signed ORREFORS NU 3595/2. *Sweden.* $175-250

Kosta vase; ovoid form in transparent turquoise blue glass; h. 7-3/4 in. (19.68 cm); retains original cellophane label: KOSTA SWEDEN. $125-175

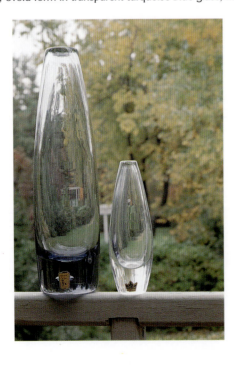

Vases.

Johansfors vase attributed to Bengt Orup; tapered cylindrical form in transparent gray or "smoke" glass; h. 10-3/4 in. (27.30 cm); retains original yellow and gold foil paper label: JOHANSFORS SWEDEN. $100-150

Kosta vase designed by Vicke Lindstrand around the late 1950s; tapered cylindrical form in clear glass; h. 6 in. (15.24 cm); signed LH ???4, retains original Kosta "crown" paper label: KOSTA SWEDEN. $100-150

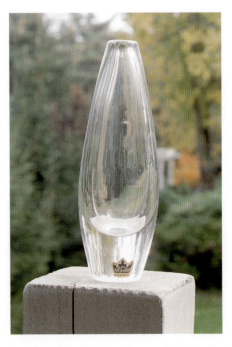

Kosta vase designed by Vicke Lindstrand around the late 1950s.

Tapered cylindrical form in clear glass; h. 6 in. (15.24 cm); signed LH ???4; retains original Kosta "crown" paper label: KOSTA SWEDEN. $100-150

Sea Glasbruk "Eva" Vases designed by Inge Samuelsson in 1963.
Tapered cylindrical forms in clear glass. *Sweden*. $50-100 each
Photo courtesy of Sea Glasbruk

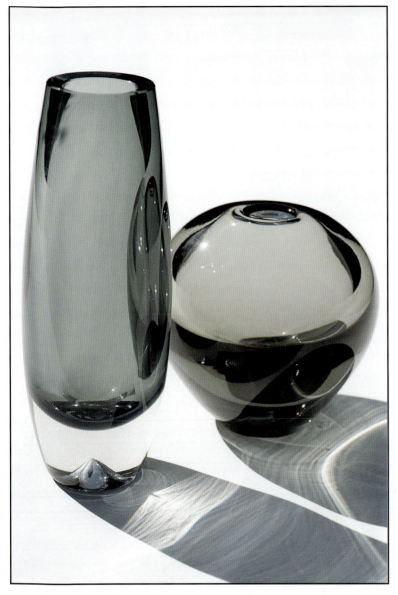

Vases.

iittala vase from the "Lappi" series designed by Erkki Vesanto in 1958 and produced from 1963 to 1968. Slightly bulbous cylindrical form with transparent charcoal gray glass underlay cased in clear glass, with polished rim and clear, heavy, indented bottom; h. 7-3/4 in. (19.68 cm); signed ERKKI VESANTO 3654. *Finland.* $150-175

Holmegaard "Rondo" vase designed by Per Lukten around 1956. Bulbous form with reduced opening in transparent charcoal gray glass; h. 5 in. (12.70 cm); signed HOLMEGAARD 19PL59. *Denmark.* $100-125

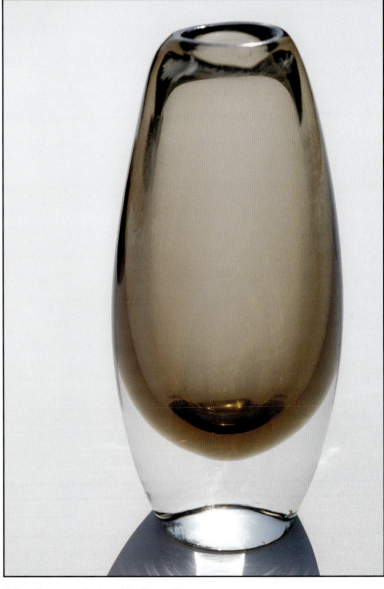

Johansfors vase designed by Bengt Orup.

Slightly bulbous cylindrical form with transparent charcoal gray glass underlay, cased in clear glass; h. 6-1/2 in. (16.51 cm); signed J.FORS ORUP. *Sweden.* $125-150

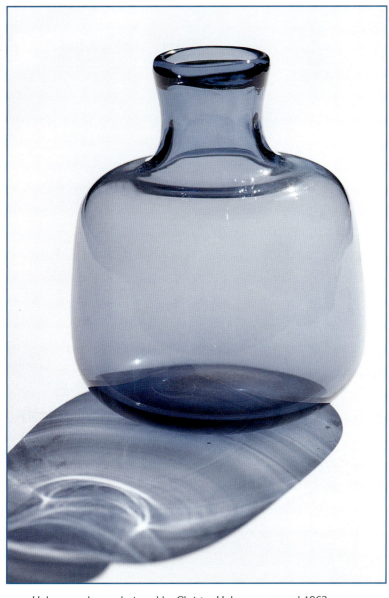

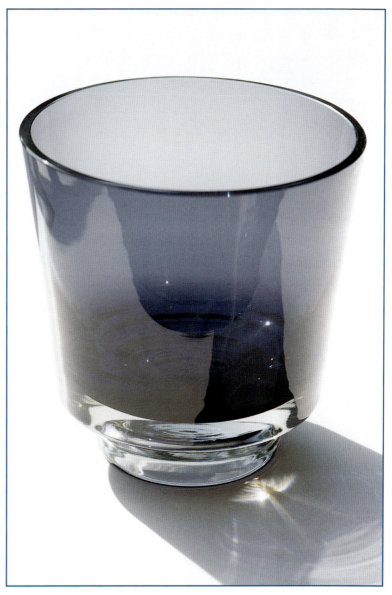

Holmegaard vase designed by Christer Holmgren around 1963.

Slightly bulbous and wide cylindrical form with reduced neck in transparent charcoal blue glass; h. 6 in. (15.24 cm); signed HOLMEGAARD C 17795. *Denmark.* $150-175

Nuutajarvi Notsjo bowl designed by Kaj Franck.

Vessel of slightly flared cylindrical form with transparent gray or "smoke" underlay cased in clear glass, with reduced cylindrical base in clear glass; d. 7 in. (17.78 cm); signed KF NUUTAJARVI NOTSJO-67. *Finland.* $250-300

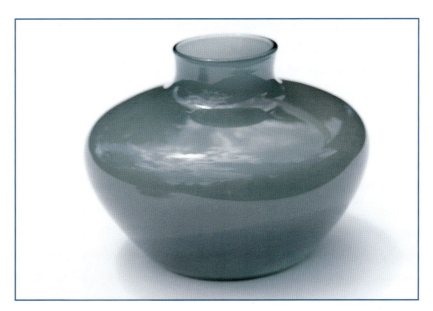

Hadeland vase designed by Willy Johansson.

Bulbous form with cylindrical neck in opaque gray glass; h. 6.5 in. (16.51 cm); signed HADELAND 2101.W.J. *Norway.* $175-225

17

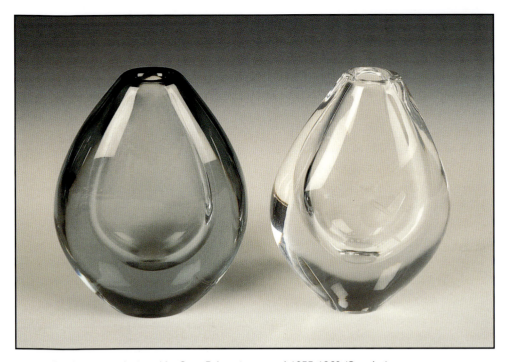

Orrefors vases designed by Sven Palmqvist around 1955-1960 (*Sweden*)

Flattened tear-shaped vessel in transparent smoky gray with thick bottom and small mouth; signed ORREFORS PU 3632; h. 4 1/2 in. (11.43 cm). $75-125

Crystal vessel in the same shape and size, copper wheel engraved with bird on a twig; signed OFP 3685/111.1215. $75-125

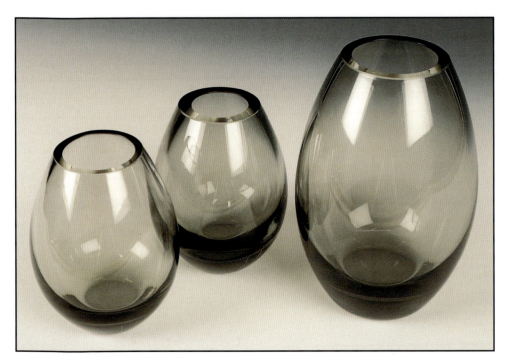

Holmegaard "Hellas" vases designed by Per Lutken, around 1957. (*Denmark*).

Bulbous form in transparent charcoal gray or "smoke" with polished rim; h. 4-1/2 in. (11.43 cm); signed HOLMEGAARD PL; h. 4-1/2 in. (11.43 cm); signed HOLMEGAARD PL 15382; h. 6-1/2 in. (16.51 cm); signed HOLMEGAARD PL 160051. $75-125 each, depending on size.

iittala vase from the "Lappi" series designed by Erkki Vesanto in 1958 and produced from 1963 to 1968.

Cylindrical form widening below midpoint, then tapering to the mouth, with transparent charcoal gray underlay cased in clear glass with polished rim and clear, heavy, indented bottom; h. 8 in. (20.32 cm); signed ERKKI VESANTO 3656. *Finland*. $150-175

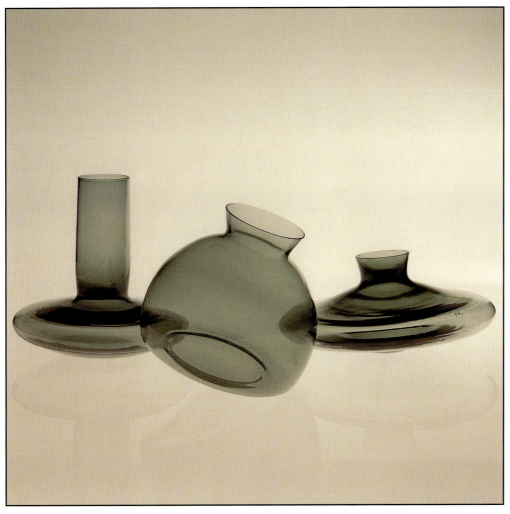

Lindshammar "Alpha, Beta, Gamma" vases designed by Matz Borgstrom in the early 1990s.

Bulbous forms of complementary variations, in charcoal gray transparent glass. *Sweden.* $75-100 each.

Photo courtesy of Lindshammar

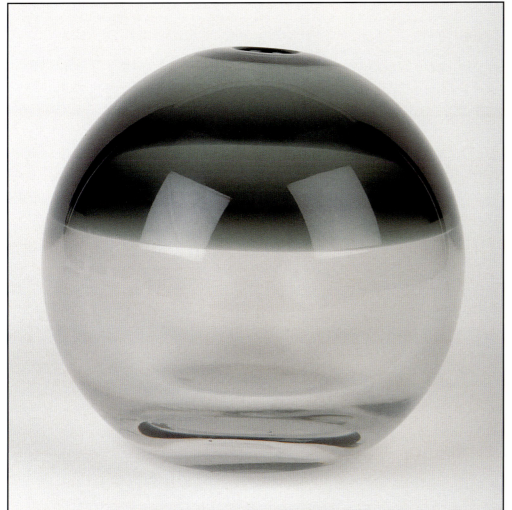

iittala vase designed by Timo Sarpaneva in 1957, design number 3595.

Globular form with reduced opening, upper half in transparent charcoal gray glass and lower half in transparent pale gray glass; h. 5-3/4 in. (14.61 cm); signed TIMO SARPANEVA iittala 57. *Finland.* $600-800

This particular vase was produced in three different sizes in the same color combination. It is part of a series of similar forms (globular, ovoid, "pill-like" cylinders) in dual-color combinations, some different from the one shown. The series span in production numbers from 3594 to 3599.

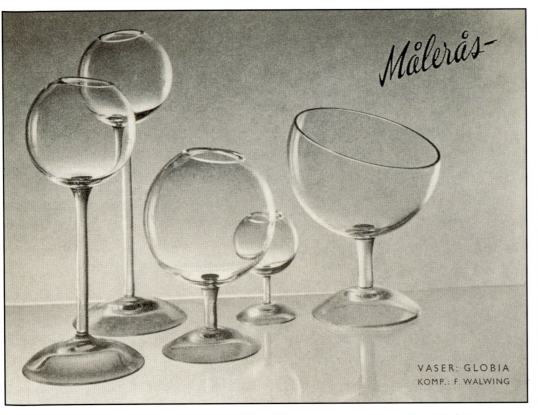

Advertisement from *Form* magazine in 1954, featuring Maleras "Globia" vases designed by Folke Walwing.

Hovmantorp vase.

Slightly tapered cylindrical form in transparent gray or "smoke" glass; h. 11 in. (27.94 cm); retains original yellow and gold paper label: HOVMANTORP - VAN DOW SWEDEN. $75-125

Holmegaard vase designed by Per Lutken around 1951.

Biomorphic form in transparent blue glass; h. 11 in. (27.94 cm); signed HOLMEGAARD 19PL60 KH (Kastrup Holmegaard). *Denmark*. $250-300

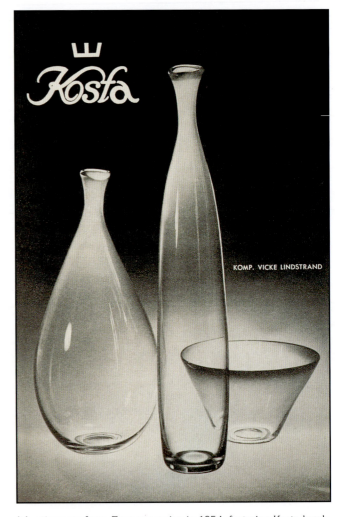

Advertisement from *Form* magazine in 1954, featuring Kosta bowls and vases designed by Vicke Lindstrand.

Kosta vase.

Cylindrical form with a cut and polished rim and base, and an opaque white, web-like underlay, cased in clear glass; h. 5-1/4 in. (13.34 cm); signed KOSTA 06089. *Sweden*. $125-175

Lindshammar vase from the "Matz" series designed by Matz Borgstrom in the early 1990s.

Freestanding bulbous form with separate disk-like base in transparent glass. *Sweden*. $75-125

Photo courtesy of Lindshammar

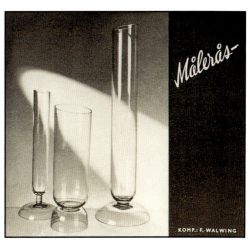

Advertisement from *Form* magazine in 1957, featuring Maleras vases designed by Folke Walwing.

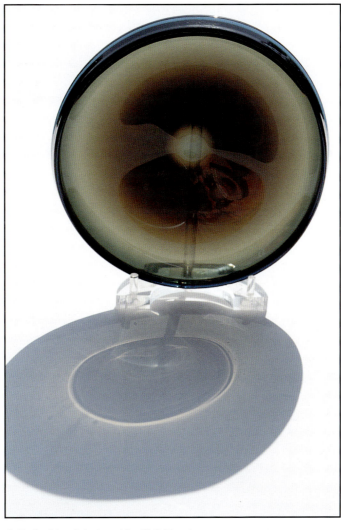

Gullaskruf bowl designed by Kjell Blomberg.

Vessel in graded opaque earth tones with hues of browns, blues, and yellows; d. 8-1/2 in. (21.59 cm); signed BLOMBERG GULLASKRUF 1963. *Sweden*. $125-150

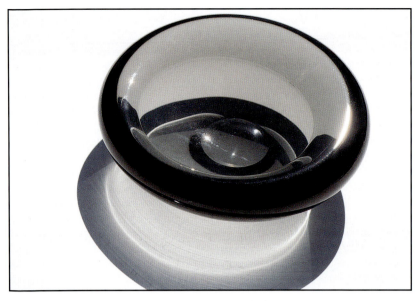

Holmegaard bowl designed by Per Lutken around 1956.

Vessel with slightly sloping form and asymmetrical rim in charcoal gray transparent glass; d. 7-1/2 in. (19.05 cm); signed HOLMEGAARD 19PL62. *Denmark.* $100-150

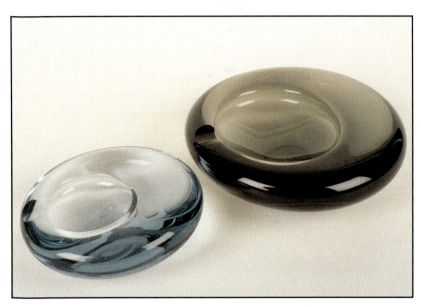

Holmegaard ashtrays designed by Per Lutken around 1956.

Slightly sloped form with asymmetrical rim and cigarette rest in charcoal gray and light blue transparent glass; d. 5-1/4 in. (13.34 cm), 7-1/2 in. (19.05 cm); signed HOLMEGAARD 19PL57, HOLMEGAARD 19PL62. *Denmark.* $75-125 depending on size.

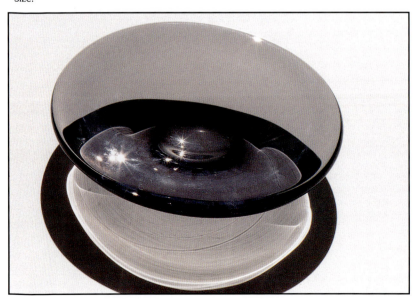

Afors bowl designed by Ernest Gordon in the late 1950s or early 1960s.

Thick walled vessel in charcoal gray transparent glass; d. 10 in. (25.40 cm); signed AFORS G.H.374 ERNEST GORDON. *Sweden.* $125-175

Holmegaard bowl designed by Per Lutken in 1960.

Vessel in light gray transparent glass with a pronounced raised center, resembling the yolk of a fried egg; d. 5-1/2 in. (13.97 cm); signed HOLMEGAARD PL 170586. *Denmark.* $75-125

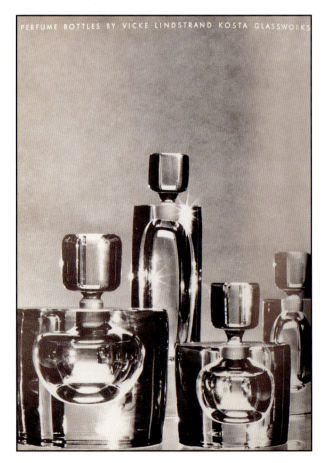

Advertisement from *Kontur* magazine in 1964, featuring Kosta perfume bottles designed by Vicke Lindstrand.

Chapter 2
Geometric Forms

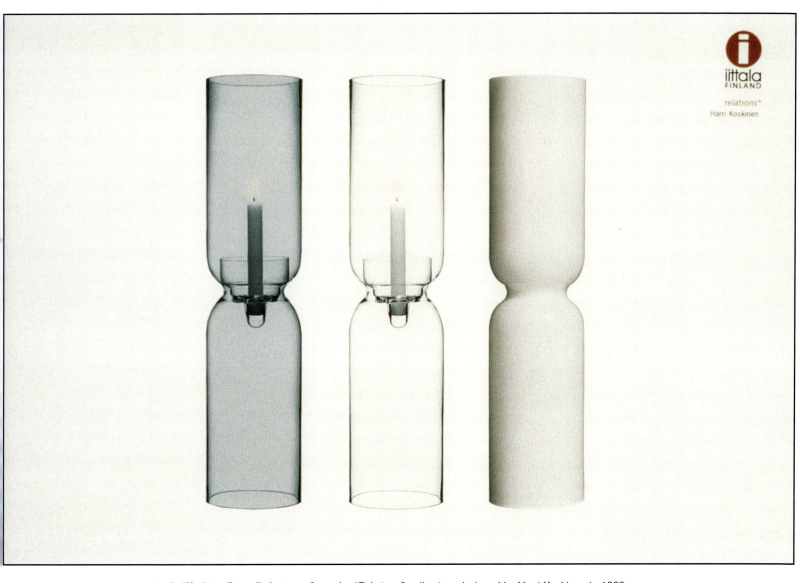

iittala "Koskinen" candle lanterns from the "Relations" collection, designed by Harri Koskinen in 1999.

Open cylindrical forms with cinched waist and interior candle holders, in opal, clear and gray glass. These pieces are still in production; h. 23 in. (58.42 cm). *Finland.* $175-200 each

Photo courtesy of iittala

Holmegaard vases.

Slightly flared cylindrical forms in opaque white cased in clear glass; h. 5-1/4 in. (13.34 cm), h. 9 in. (22.86 cm), 6-3/4 in. (17.14 cm); first retains Holmegaard paper label: HOLMEGAARD OF COPENHAGEN BY APPOINTMENT TO THE ROYAL DANISH COURT MADE IN DENMARK 369. $75-150 depending on size.

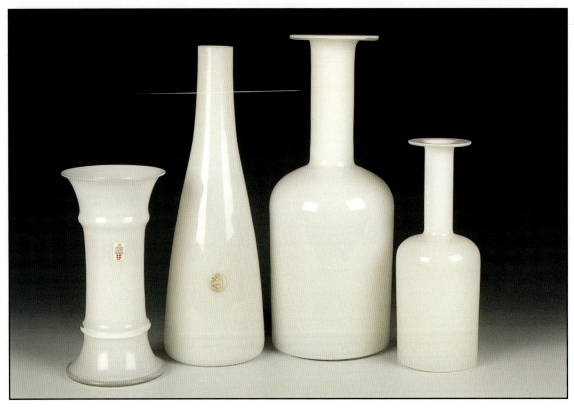

Vases. (*Denmark*)

Holmegaard vase; Slightly flared cylindrical form in opaque white glass, cased in clear glass; h. 9 in. (22.86 cm); retains Holmegaard paper label. $125-175

Kastrup vase designed by Jacob Bang in the late 1950s; tapered bottle form vessel in opaque white glass; h. 14 in. (35.56 cm); retains gold paper label: KASTRUP GLAS. $150-175

Holmegaard gulvases from the "Pallet" series designed by Michael Bang around 1968; bottle form vases with narrow cylindrical necks and disk-like rims in opaque white glass, cased in clear glass; h. 14-1/2 in. (36.83 cm), 10 in. (25.40 cm). $225-300 depending on size.

Holmegaard's gulvase design is likely one of the most recognizable forms of Scandinavian glass. The form was first designed by Otto Brauer in 1962, however, the pieces were produced in colored transparent glass. In 1968, Michael Bang reproduced the same form in white opaque glass, cased with strongly colored "overlays." This experiment resulted in the "Pallet" series, to which these cased gulvases belong.

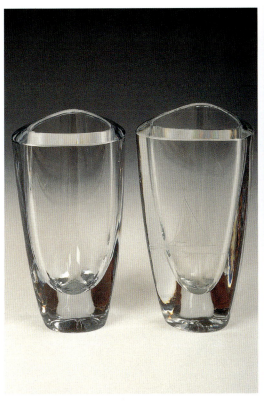

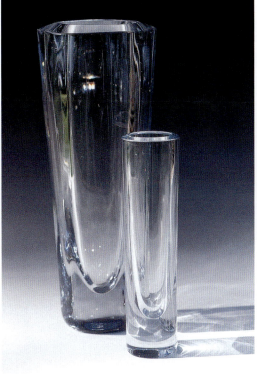

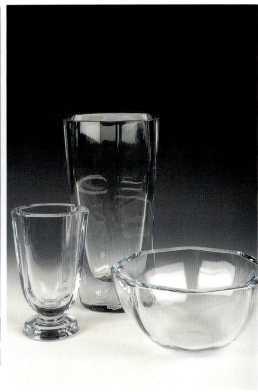

Strombergshyttan vases attributed to Asta Stromberg designed in the late 1950s.

Slightly flared triangular forms with cut and polished beveled rims in light blue transparent glass; h. 6 in. (15.24 cm); signed STROMBERG B808. *Sweden*. $100-125 each

Strombergshyttan vases. (*Sweden*)

Slightly flared hexagonal form with cut and polished beveled rim in light blue transparent glass; h. 12-1/2 in. (31.75 cm); signed STROMBERG B1568. $250-300

Vase attributed to Asta Stromberg and designed around 1963; cylindrical form with cut and polished beveled rim in light blue transparent glass; h. 8-1/2 in. (21.59 cm); signed STROMBERGSHYTTAN B1032. $150-175

Strombergshyttan vases and bowl. (*Sweden*)

Footed vase designed by Gerda Stromberg around 1947, with cut and polished beveled rim in light blue transparent glass; h. 7 in. (17.78 cm); signed STROMBERG B426. $125-150

Vase attributed to Asta Stromberg and designed around 1959; slightly flared form, flattened and squared, in light blue transparent glass; h. 11-1/4 in. (28.57 cm); signed STROMBERG B928. $250-300

Scalloped bowl in light blue transparent glass attributed to Asta Stromberg and designed around 1955; d. 8 in. (20.32 cm); signed STROMBERGSHYTTAN T470. $175-200

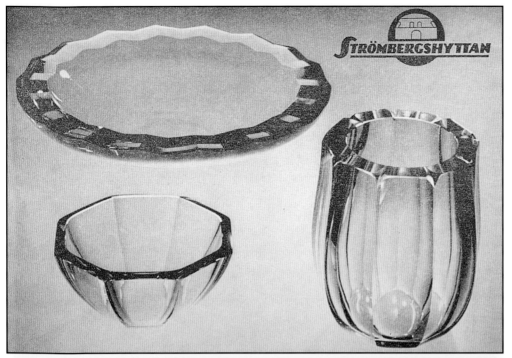

Advertisement from *Form* magazine in 1953, featuring Strombergshyttan bowls and vase.

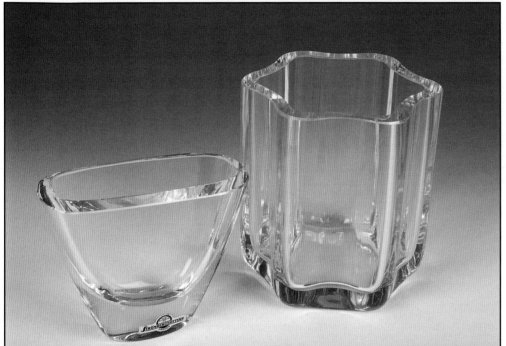

Strombergshyttan vases. *(Sweden)*

Scalloped cylindrical form in light blue transparent glass; h. 6-1/2 in. (16.51 cm); signed STROMBERGSHYTTAN with an illegible number. $125-150

Vase attributed to Asta Stromberg, designed around 1958; flared form, flattened on two sides, in light blue transparent glass; h. 4 in. (10.16 cm); retains foil label-STROMBERGSHYTTAN SWEDEN; signed STROMBERGSHYTTAN B917. $100-125

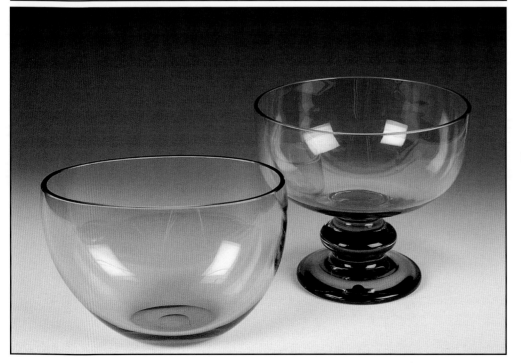

Bowls. *(Sweden)*

Kosta vase designed by Vicke Lindstrand in 1959; ovoid vessel in transparent charcoal gray glass; d. 8 in. (20.32 cm); signed Kosta LH1611. $150-175

Strombergshyttan bowl attributed to Asta Stromberg and designed around 1957; vessel in transparent gray glass with formed foot; d. 8 in. (20.32 cm); retains foil label: STROMBERGSHYTTAN SWEDEN; signed STROMBERGSHYTTAN T306. $150-175

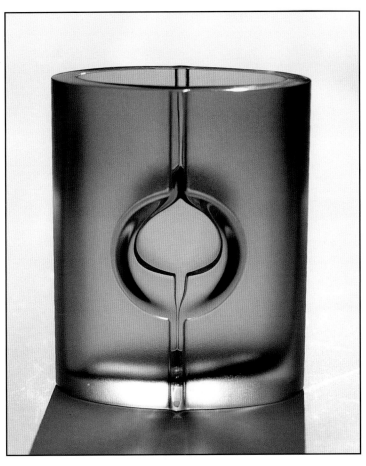

iittala vase designed by Tapio Wirkkala around 1959.

Molded, oval pillow form with a transparent charcoal gray glass underlay, cased in clear glass, the surface sandblasted, and then decorated with polished circular and linear geometric detail; h. 7 in. (17.78 cm); signed TAPIO WIRKKALA 3304. *Finland.* $500-550

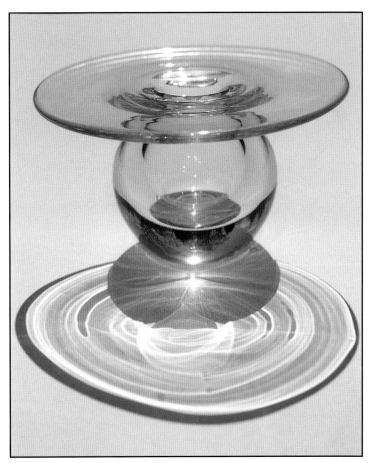

Riihimaen Lasi "Saturnus" vase designed by Nanny Still in 1961, produced from 1961 to 1968.

Bulbous form with a dramatically exaggerated and flattened rim in clear glass; h. 2-1/4 in. (5.71 cm); signed NANNY STILL RIIHIMAEN LASI OY. *Finland.* $150-200

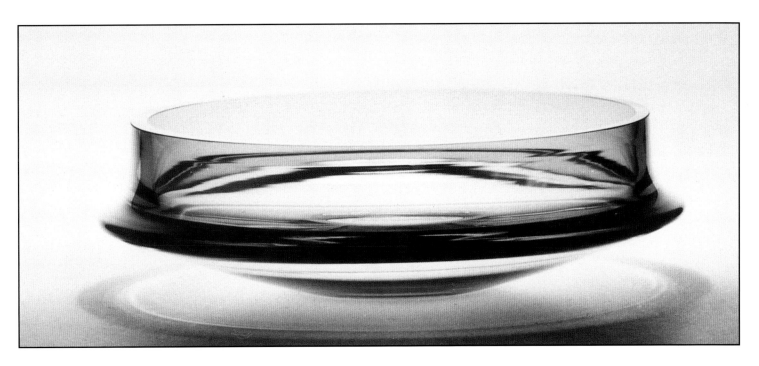

iittala bowl designed by Tapio Wirkkala in 1959, design number 3591.

Shallow vessel with rounded bottom, flared to midpoint with cylindrical walls, with a transparent gray underlay cased in clear glass; d. 10.75 in. (27 cm). *Finland.* $500-550

Photo by Ounamo courtesy of iittala

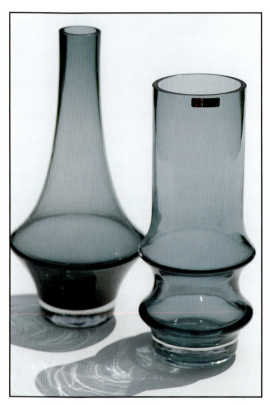
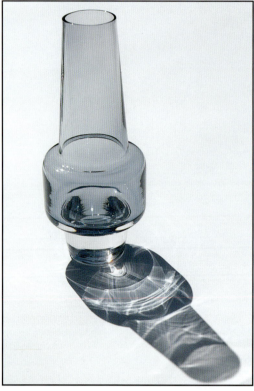
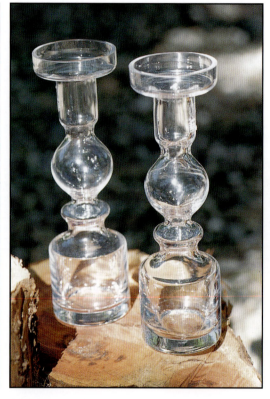

Riihimaen Lasi vases. (*Finland*)

Vase attributed to Tamara Aladin, likely a 1970s design; stylized bottle form flared below midpoint, with tapered neck, and a charcoal gray underlay, cased in clear glass; h. 11 in. (27.97 cm). $150-200

Vase designed by Tamara Aladin in the early 1970s; cylindrical form with two "gurgles," with a charcoal gray underlay, cased in clear glass; h. 10 in. (25.40 cm); retains silver and black label: FINNCRISTALL MADE IN FINLAND. $150-200

The "Finncristall" label is often found in Riihimaen Lasi pieces produced during the 1970s. This label was used in pieces intended for the export and tourist market.

Sea Glasbruk vase, probably designed during the early 1960s.

Cylindrical form with a protruding ring below midpoint and tapered neck, with a light purple gray underlay cased in clear glass; h. 5 in. (12.70 cm). *Sweden*. $50-75

Riihimaen Lasi "Pompadour" vases designed by Nanny Still in 1968.

Complex forms in clear glass, closely resembling turned wood banisters; h. 8-3/4 in. (22.23 cm); retains clear plastic and white paw label: RIIHIMAEN LASI MADE IN FINLAND. $150-200 each

This design was also produced with a turned upper rim.

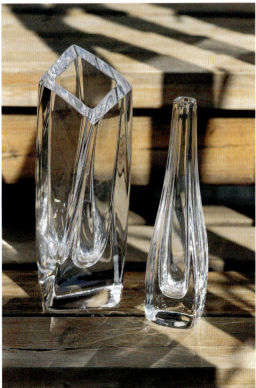
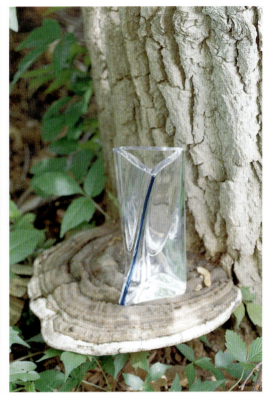

Holmegaard vase designed by Michael Bang during the 1970s.

Bulbous form in clear glass with randomized holes throughout for flower arrangement; h. 5-1/2 in. (13.97 cm); signed HOLMEGAARD MB. *Denmark.* $125-150

Vases. (*Sweden*)

Kosta Boda Vase from the "Sails" series, designed by Goran Warff in 1989; twisted square form in clear glass with angular cut and polished rim; h. 9 in. (22.86 cm); signed KOSTA BODA 48923 G WARFF. $175-200

Orrefors vase; tapered square form in clear glass, rising to slender neck; h. 8 in. (20.32 cm); signed ORREFORS. $75-100

Kosta Boda vase from the "Contra" series designed by Goran Warff in 1988.

Twisted triangular form in clear glass with angular cut and polished top, accentuated with a cobalt blue line along one of the rims; h. 8 in. (20.32 cm); signed KOSTA BODA 48860 G WARFF. *Sweden.* $175-200

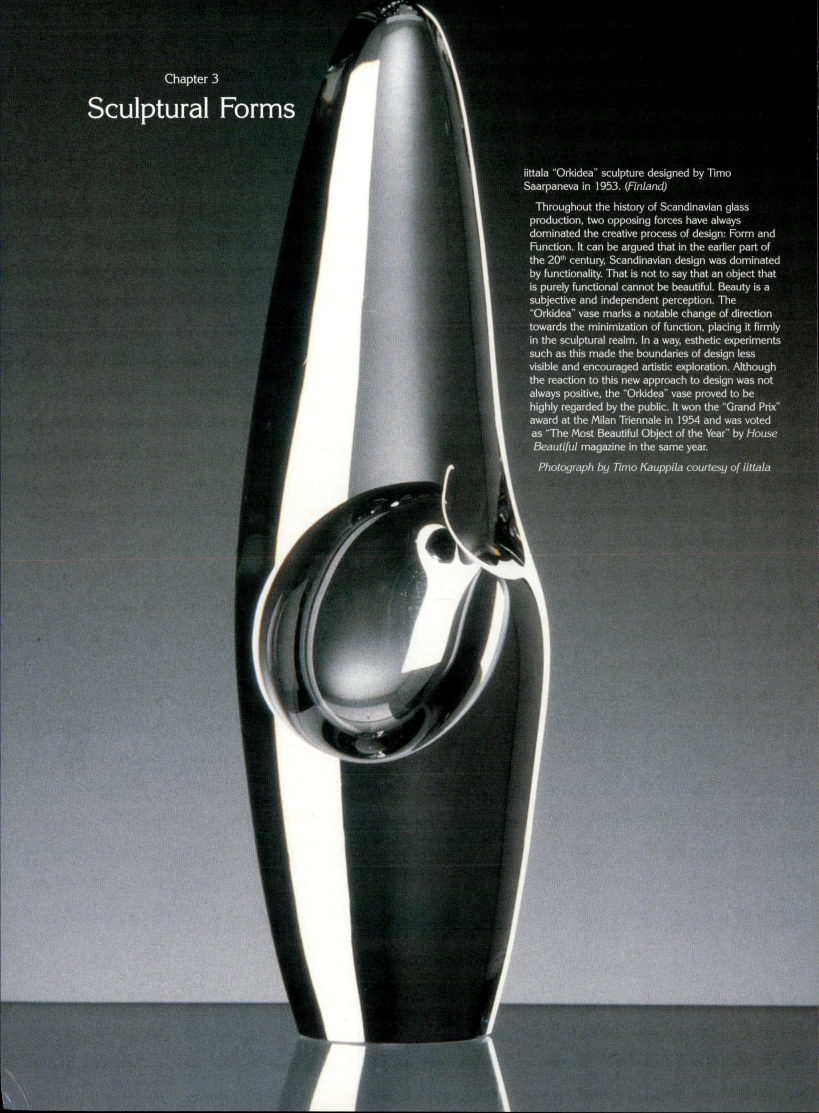

Chapter 3
Sculptural Forms

iittala "Orkidea" sculpture designed by Timo Saarpaneva in 1953. (*Finland*)

Throughout the history of Scandinavian glass production, two opposing forces have always dominated the creative process of design: Form and Function. It can be argued that in the earlier part of the 20th century, Scandinavian design was dominated by functionality. That is not to say that an object that is purely functional cannot be beautiful. Beauty is a subjective and independent perception. The "Orkidea" vase marks a notable change of direction towards the minimization of function, placing it firmly in the sculptural realm. In a way, esthetic experiments such as this made the boundaries of design less visible and encouraged artistic exploration. Although the reaction to this new approach to design was not always positive, the "Orkidea" vase proved to be highly regarded by the public. It won the "Grand Prix" award at the Milan Triennale in 1954 and was voted as "The Most Beautiful Object of the Year" by *House Beautiful* magazine in the same year.

Photograph by Timo Kauppila courtesy of iittala

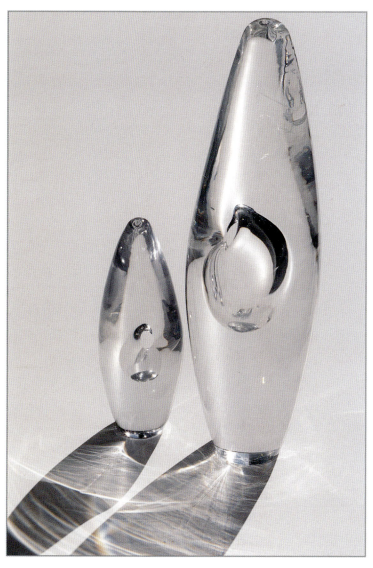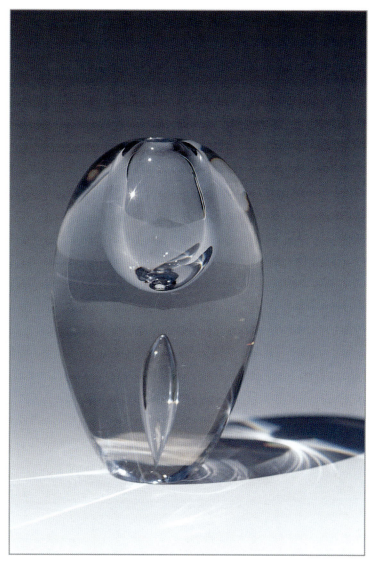

iittala "Orkidea" sculptures in different sizes.

Organic forms with an internal bubble and reduced opening in clear glass; h. 6 in. (15.24 cm), 9-3/4 in. (24.77 cm); both signed TIMO SARPANEVA 3568. $500-800 depending on size.

iittala vase designed by Timo Sarpaneva around 1954, production number 3575.

Bulbous form with a reduced opening and an elongated trapped air bubble in the base, in clear glass; h. 5-1/4 in. (13.34 cm); signed TIMO SARPANEVA iittala 56; retains foil label: KARHULA. *Finland*. $350-400

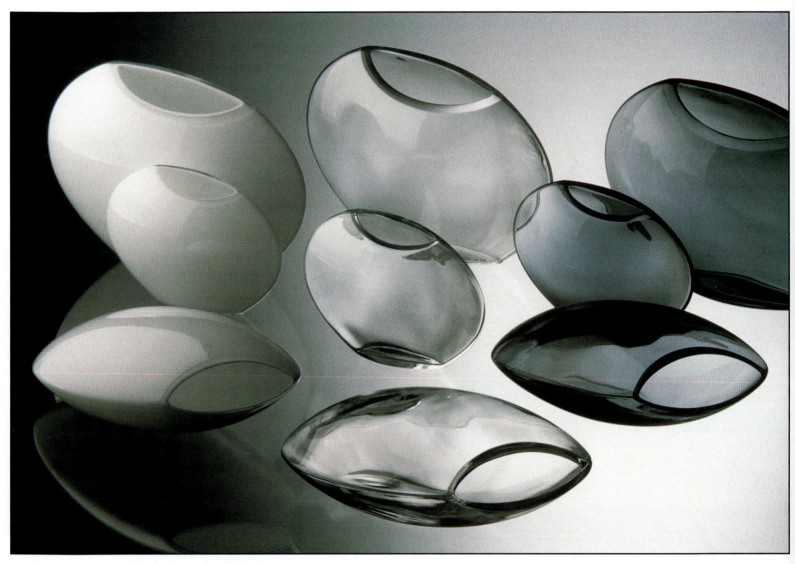

Group of "Aava" vases showing different designs, sizes, and colors.

Shell forms are the inspiration for Markku Salo's "Aava" series. The vase lying flat is one of the three design variations produced, measuring 10-3/4 in. (27.30 cm) in length. $125-150

Photo by Timo Kauppila courtesy of iittala

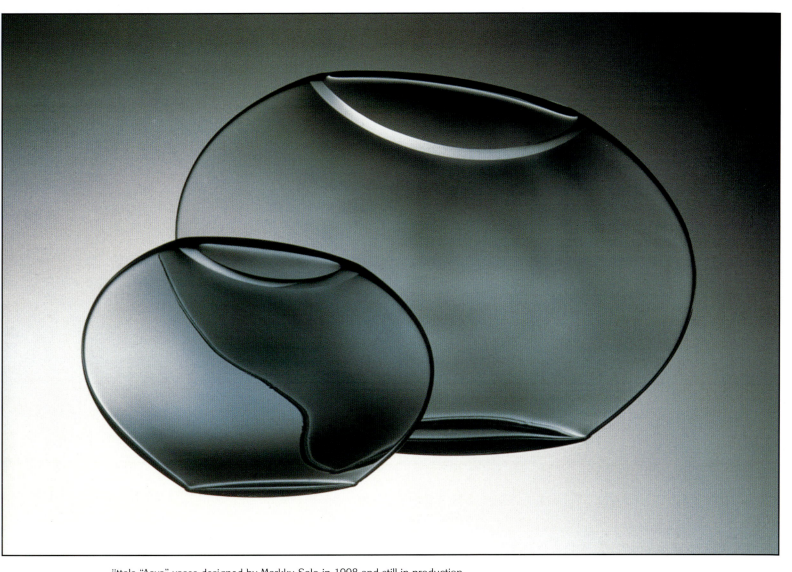

iittala "Aava" vases designed by Markku Salo in 1998 and still in production.

Ovoid forms, flattened on two sides with angular cut asymmetrical openings, in white, clear and gray glass; h. 4-3/4 in. (12.06 cm), h. 7-1/4 in. (18.41 cm). *Finland.* $100-150 depending on size.

Photo by Timo Kauppila courtesy of iittala

Holmegaard bowls designed by Per Lutken in 1952. *(Denmark)*

"Fionia" bowl; flared tri-lobed form with slung thin walls terminating in thick rims, in charcoal gray transparent glass; d. 8-1/2 in. (21.59 cm); signed HOLMEGAARD 19PL55. $150-175

"Selandia" bowl; flared and circular form with undulating thin walls terminating in thicker rims, with a protuberance in the center, in transparent charcoal gray glass; d. 14-1/2 in. (36.83 cm); signed HOLMEGAARD PL 13781. $225-250

Close-up of "Fionia" bowls in two size variations; 8-1/2 in. (21.59 cm) and 11 in. (27.94 cm). $200-225 for the larger.

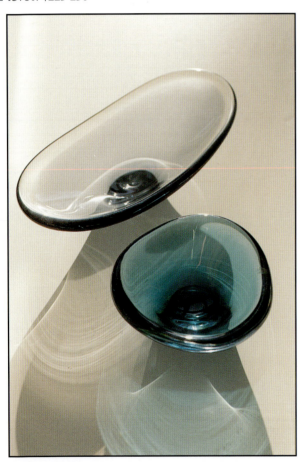

Bowls. *(Sweden)*

RYD bowl; elongated boat form with a light gray, clear glass underlay cased in clear glass; l. 10-1/2 in. (26.67 cm). *Sweden.* $75-100

Orrefors bowl designed by Sven Palmqvist between 1945 and 1954; triangular and asymmetrical flared form with a turquoise blue underlay cased in clear glass; d. 5-1/2 in. (13.97 cm); signed ORREFORS PU 3092/13. *Sweden.* $150-175

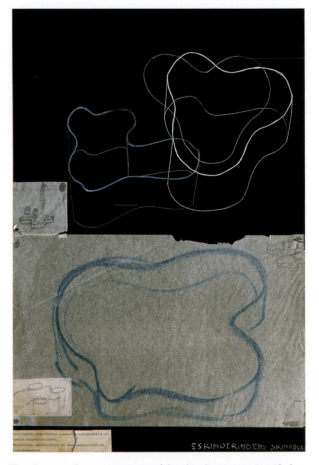

The photograph represents one of the sketches in a series titled "Eskimo Woman's Leather Breeches," with which Alvar Aalto won the competition at the Karhula-iittala Glassworks in 1936. The purpose of this competition was to find exceptional designs suitable for the Paris World's Fair of 1937. His completed series, from shallow bowls to tall vases, was exhibited at the World's Fair and created great interest throughout Europe. Production began in 1937 at Karhula and one of the first purchasers of the vase was the Savoy restaurant in Helsinki, for which Aalto was the architect. This led to the most popular vase in the collection being named "Savoy," although the name was changed in 1970 to "Aalto" in honor of the designer. Production of the "Aalto" series was moved to iittala in 1949, where it is still produced.

Photo by Lasse Koivunen courtesy of iittala

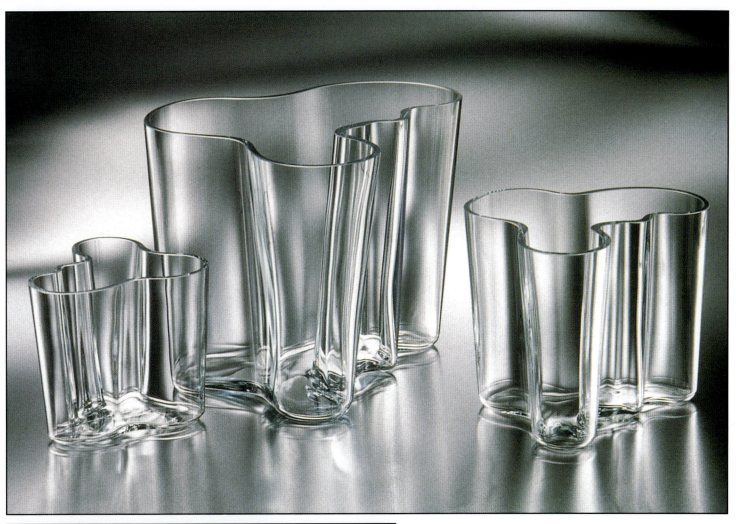

"Aalto" vases in clear glass and different sizes; h. 3-3/4 in. (9.53 cm), h. 6-1/4 in. (15.88 cm), h. 4-3/4 in. (12.06 cm). $50-150 depending on size

Photo by Timo Kauppila courtesy of iittala

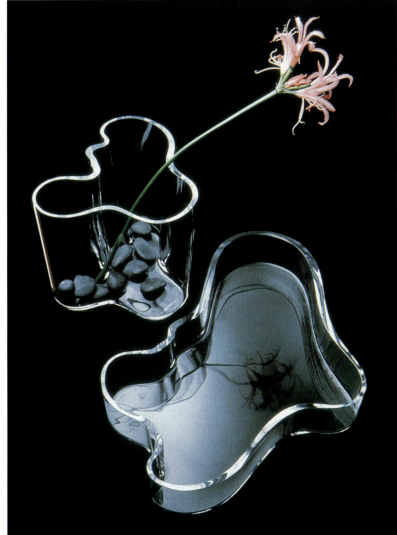

iittala "Aalto" vase and tray designed by Alvar Aalto in 1936.

Biomorphic forms with free-flowing and undulating walls in clear glass; h. 6-1/4 in. (15.88 cm), l. 15 in. (38.10 cm); Finland. Vase, $125-150; tray, $300-325.

Photo courtesy of iittala

Although the "Aalto" series is currently in production at iittala, production throughout the years has been intermittent. Different colors were produced at different times also. Earlier pieces and limited production colors should command higher prices. These are the production periods and colors.

Karhula- 1937-1949: clear and opal (opaque white glass, cased in clear glass);

iittala- 1949, 1954-1955, 1962-1973: clear and opal;

iittala- 1954-1955; green;

iittala- current production; clear, clear (1937), opal, blue, red, gray. The red pieces are limited editions. The red "Aalto" vase with the same dimensions as shown in the picture is priced at $1000-1200.

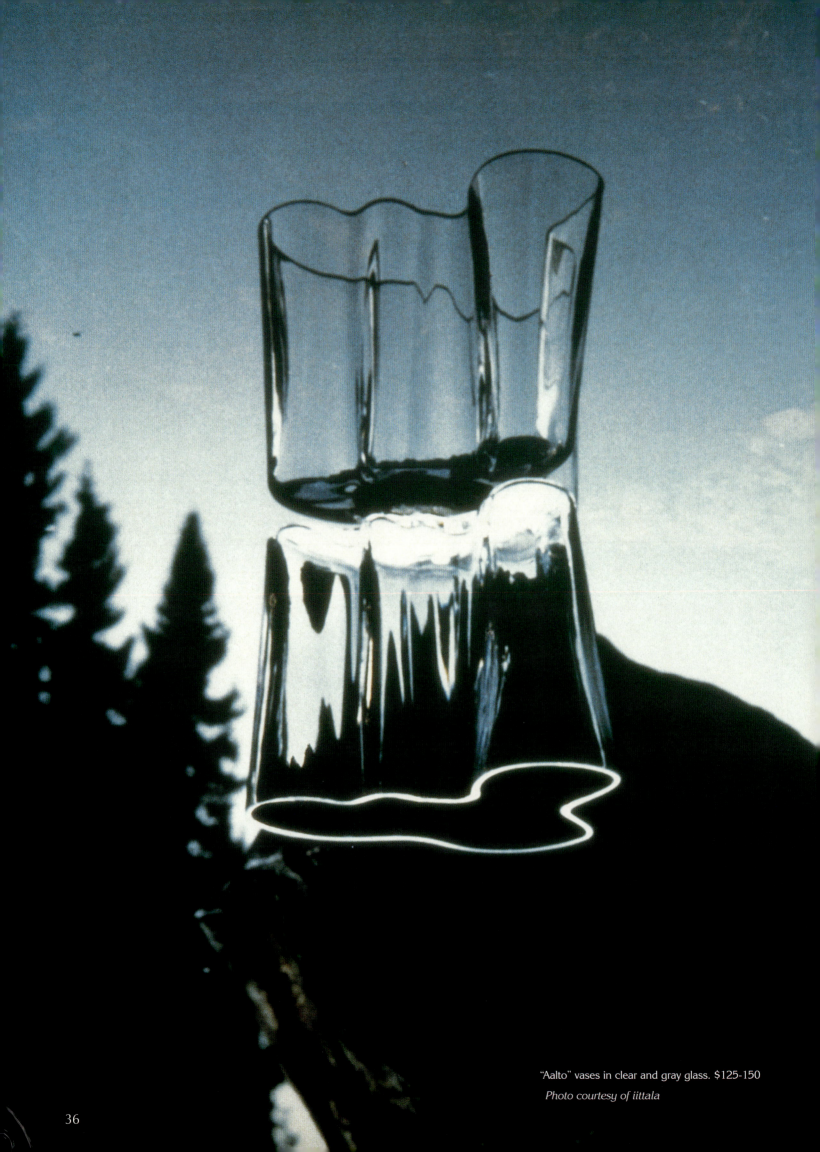

"Aalto" vases in clear and gray glass. $125-150

Photo courtesy of iittala

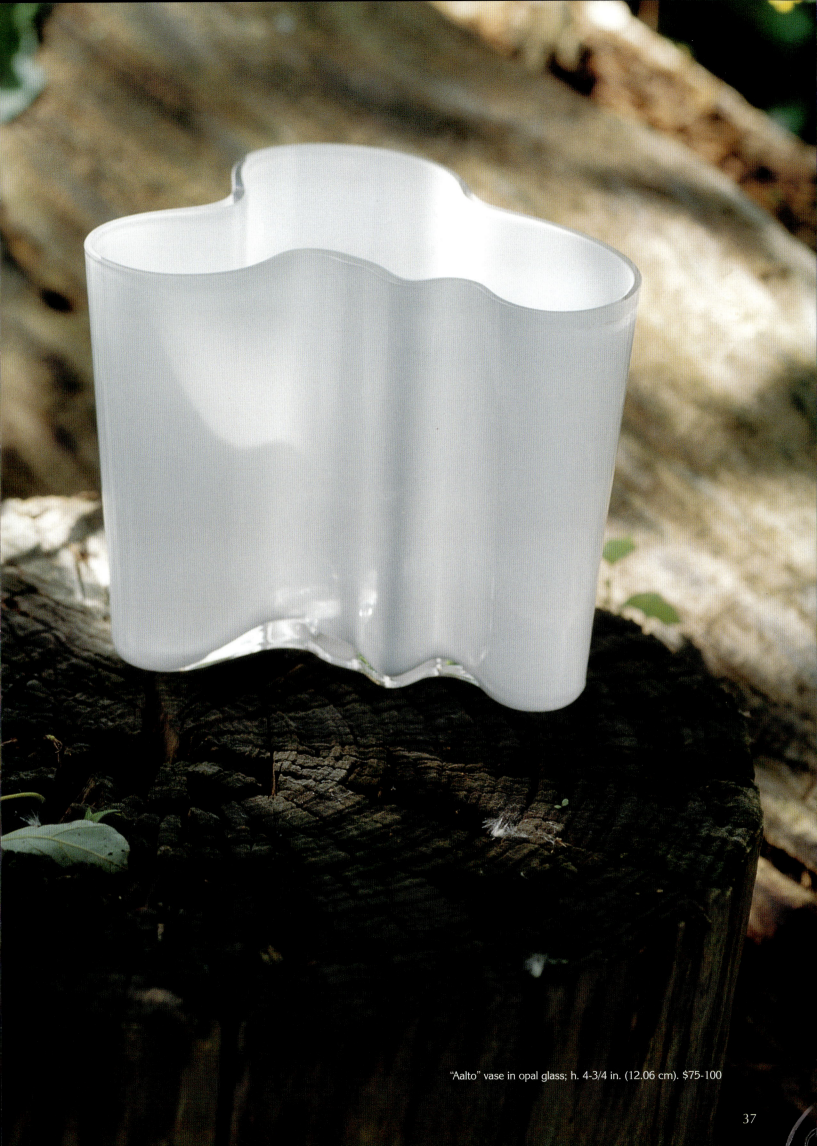

"Aalto" vase in opal glass; h. 4-3/4 in. (12.06 cm). $75-100

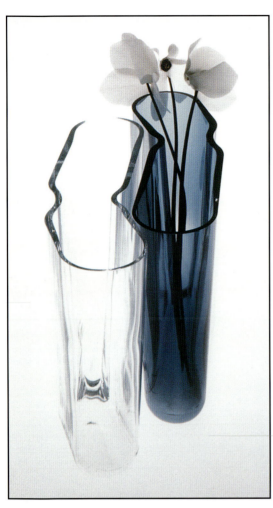

iittala "Muotka" vases designed by Harri Koskinen in 2000.

Narrow pillow forms, slightly angular and divided into two compartments in clear and smoke blue glass; h. 6-1/4 in. (15.88 cm). *Finland.* $150-200

Photo by Timo Junttila courtesy of iittala

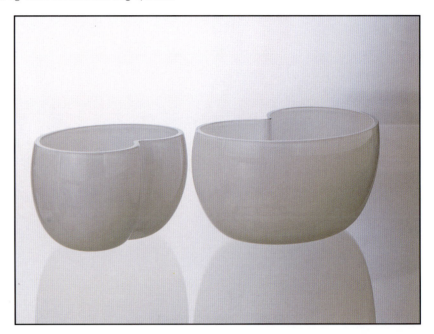

Mats Jonasson Maleras "Bello" bowls designed by Erika Hoglund.

Biomorphic forms comprised of two lobes in white opaque glass, cased in clear glass; d. 8 in. (20.32 cm), d. 7 in. (17.78 cm). *Sweden.* $150-200 depending on size.

Photo courtesy of Mats Jonasson Maleras

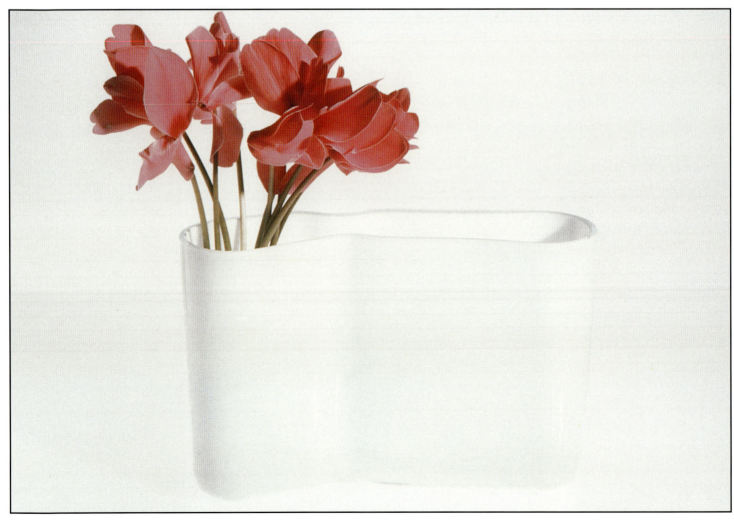

Detail of "Muotka" vase in cased opaque white glass, another production color.

Photo by Timo Junttila courtesy of iittala

Vases.

Kosta Boda "Aqua" vase designed by Anna Ehrner in 1986; pillow form comprised of four lobes with diagonal optic, in clear glass; h. 8 in. (20.32 cm); retains paper label: KOSTA BODA HANDMADE. *Sweden.* $125-150

Sea Glasbruk "Pauline" vase designed by Rune Strand; 7 in. (17.78 cm) signed SEA/25. *Sweden.* $100-125

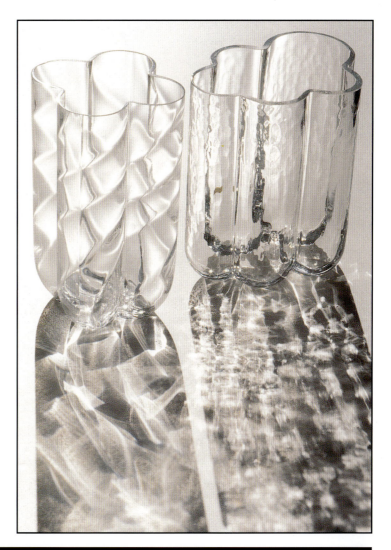

Sea Glasbruk vases from the "Pauline" series designed by Rune Strand.

Multi-lobed forms with slightly textured walls in clear glass; h. 10-3/4 in. - 6-1/4 in. (27.00 cm - 16.00 cm). *Sweden.* $75-150 depending on size.

The "Pauline" series was designed in 1983, and pieces were added later in 1994.

Photo courtesy of Sea Glasbruk

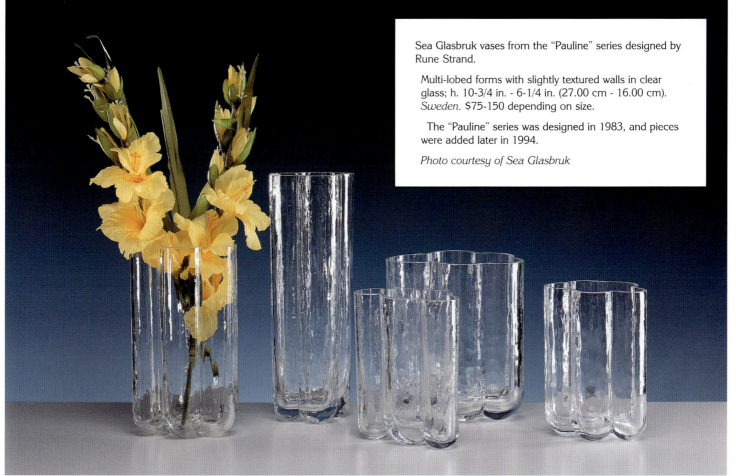

iittala "Ylosnousemus" vase designed by Gunnel Nyman in 1947.

Twisted cylindrical form in clear glass with external ridges creating an optical effect. *Finland.* $600-800

Photo courtesy of iittala

Mats Jonasson Maleras "Two-in-one" vase designed by Klas-Goran Tinback.

Complex form in clear glass, with curved walls and pinched in the center, creating 2 internal pockets; h. 10.24 in. (26 cm). *Sweden.* $250-350

Photo courtesy of Mats Jonasson Maleras

Afors bowl.

Shallow, multi-lobed form in clear glass; d. 6-1/4 in. (15.88 cm); signed AFORS BOSSE KR? *Sweden.* $75-125

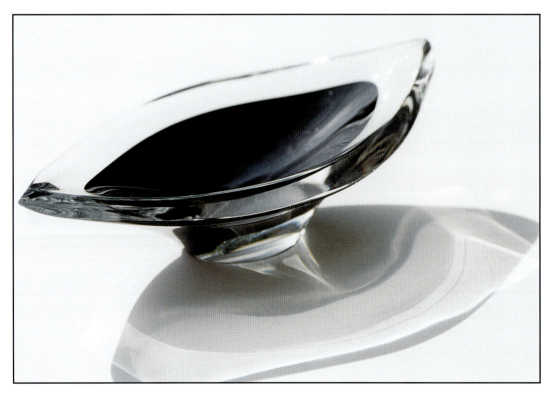

Kosta bowl designed by Vicke Lindstrand in 1958.

Flared form with a centered, opaque black glass underlay, cased in clear glass, with the rim cut and polished in a beveled fashion; 10-3/4 in. (27.30 cm); signed KOSTA LS 619. *Sweden.* $275-325

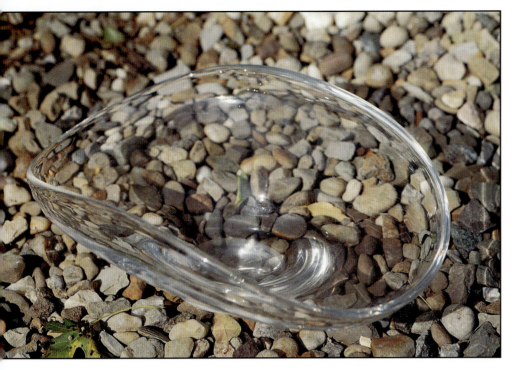

Top:

Johansfors bowl designed by Bengt Orup around 1958. (*Sweden*)

Flared elliptical form in clear glass with the rim slightly bent to the inside on two sides; d. 11-1/2 in. (29.21 cm); signed J.FORS ORUP. *Sweden.* $175-225

Center:

Johansfors bowls designed by Bengt Orup around 1958.

Same form as in the previous picture, in different sizes and with different marks; d. 11-1/2 in. (29.21 cm), d. 9 in. (22.86 cm); signed J.FORS ORUP; signed JOHANSFORS ORUP. $175-225, $125-175

Bottom:

Vases and bowl designed by Vicke Lindstrand. (*Sweden*)

Cylindrical form flattened on two sides with asymmetrical rim, with a copper wheel engraved squirrel, in clear glass; h. 4-1/2 in. (11.43 cm); signed KOSTA LINDSTRAND 41376?. $125-150

Vase designed in 1958, catalog and production number LH 1400; hourglass form with flared bowl and narrow waist, in clear glass; h. 7-3/4 in. (19.68 cm); signed KOSTA 51689? LINDSTRAND. $350-425

"Fish" bowl designed in 1958; organic form in clear glass with controlled bubbles, resembling a fish; l. 6 3/8 in. (16.19 cm); signed KOSTA LH 1342. $125-175

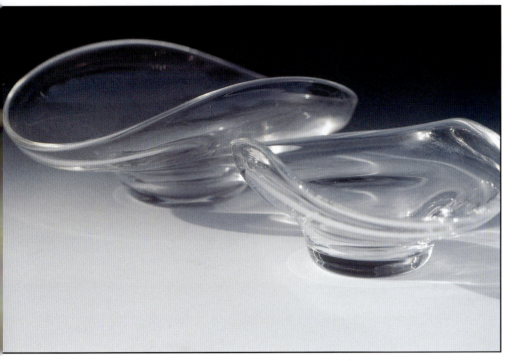

These three pieces present interesting information for the collector in terms of the signatures and markings. Vicke Lindstrand was the artistic director at Kosta from 1950 to 1972. Although the design numbers for Lindstrand pieces usually correspond to two letters and 3 or 4 digits (i.e. LH 1342), some pieces, as in the case of the hourglass vase, are marked with 5 digits and the complete last name. These pieces likely correspond to later years of production, probably the 1970s, even after 1972. It was around this time when the design numbering system at Kosta changed. Lindstrand's designs were so enduring and popular that they were continued to be produced at Kosta and at Kosta Boda, for many years after they were designed, and past Lindstrand's tenure with the company. The 5 digit numbering system is still used by Kosta Boda today.

Johansfors vase designed by Bengt Orup.

Hourglass form in clear glass with a single teardrop bubble trapped in a thick-walled base; h. 13-1/4 in. (34.92 cm); signed JOHANSFORS ORUP. *Sweden*. $275-325

Courtesy of Gordon Harrell

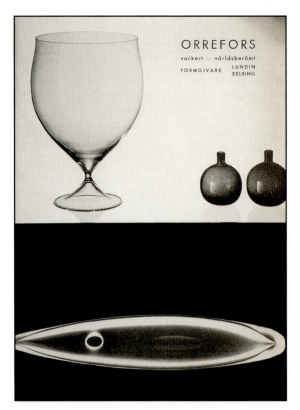

Advertisement from *Form* magazine in 1958, featuring Orrefors vases designed by Ingeborg Lundin.

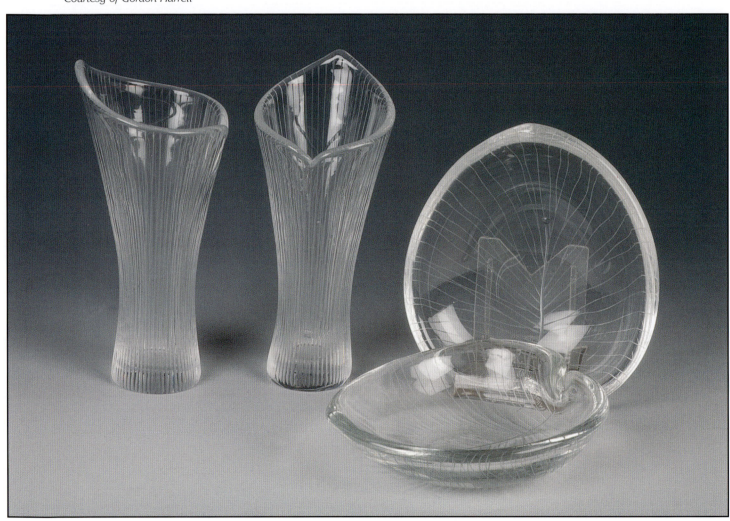

Vases and leaf bowls designed by Tapio Wirkkala in the late 1940s or early 1950s. *(Finland)*

Flared form in clear glass with asymmetrical rims with cut vertical groves; h. 4 3/8 in. (11.10 cm); signed TAPIO WIRKKALA iittala 55. $350-400 each

Broad leaf-form bowls in clear glass with cut lines resembling veins; l. 3-1/2 in. (8.89 cm); signed T. WIRKKALA iittala. $200-250 each

iittala vase designed by Tapio Wirkkala in the late 1940s or early 1950s, design number 3523.

Flared form in clear glass with wraparound vertical cut grooves of different depths along the outside surface; h. 6 (15.24 cm); signed TAPIO WIRKKALA iittala 55. *Finland.* $3000-5000

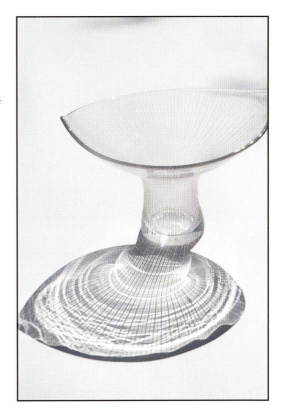

Bottom:
iittala "Kantarelli" vases designed by Tapio Wirkkala in 1946.

Organic forms in clear glass resembling mushrooms, with flared and asymmetrical rims, and a series of cut vertical groves of different depths on the outside surface. *Finland.* $3000-5000 each

Wirkkala's Kantarelli vase has become one of the most recognizable and memorable forms of Scandinavian glass and likely of modern glass design as well. This form was inspired by a mushroom, but by design, the cap seamlessly joins into the stem to become a vase. Throughout his career, Wirkkala was fascinated by forms found in nature. He was also a great observer of how natural materials are transformed by nature's forces. Wirkkala's ability to observe nature, and skillfully abstract from it, is present in many of his designs. The Kantarelli vase exemplifies this notion perfectly.

The Kantarelli vase was exhibited at the Milan Triennale of 1951, for which Wirkkala served as the exhibition architect for the Finnish section. Wirkkala received the Grand Prix award three times at this Triennale: for the design of the Finnish exhibition; for a sculpture named Pyorremyrsky (Hurricane) made of laminated and carved birchwood; and for his glass designs created at iittala, including the Kantarelli vase. The Triennale proved to be a great success for Wirkkala and for Finnish design as well.

Initially, only two series of 50 Kantarelli vases were produced at iittala. The vases from the original series command very extraordinary prices, because they are so difficult to find and so important. The initial series were marked with the series production number, for example, the fifteenth piece in the series would be marked "TAPIO WIRKKALA iittala 15/50".

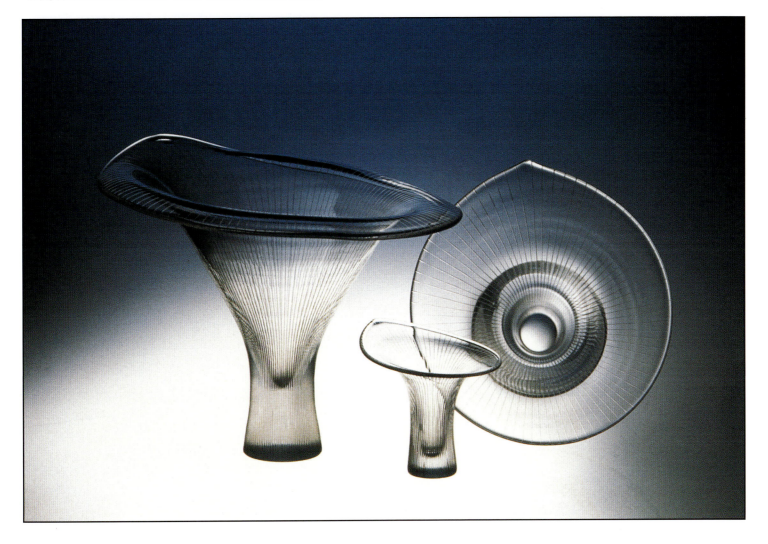

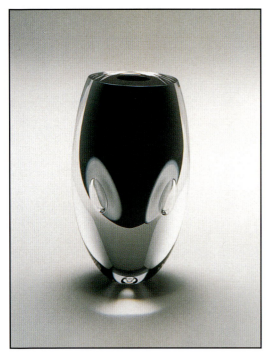

iittala sculpture from the "Claritas" series designed by Timo Sarpaneva in 1983.

Ovoid form with a black and opaque with glass underlay and bubbles, cased in clear glass, the top open, with a thick and polished rim. *Finland.* $500-600 *Photo courtesy of iittala*

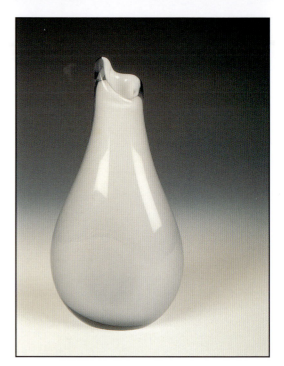

Johansfors vase from the "Thunder" suite designed by Bengt Orup in the late 1950s.

Teardrop form with pulled asymmetrical rim and opaque gray underlay, cased in clear glass; h. 7-1/4 in. (18.41 cm); acid etched stamped JOHANSFORS ORUP SWEDEN. $175-225

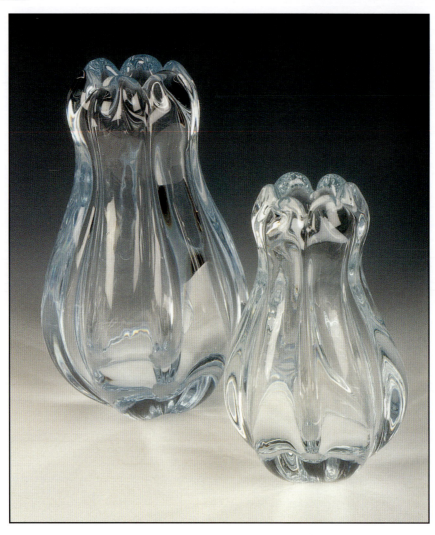

Orrefors "Stella Polaris" vases designed by Vicke Lindstrand in 1939.

Bulbous form with wide external ribs in light transparent blue glass; h. 8 in. (20.32 cm), h. 5-1/2 in. (13.97 cm); BOTH signed ORREFORS LU225/2. *Sweden.* $250-500 depending on size.

Most of the vases and bowls found in the "Stella Polaris" series were also produced in the "Platina" series. While the "Stella Polaris" form is characterized by a light blue and brilliant color, described as "aquamarine" in the Orrefors catalogs, the "Platina" series is characterized by a complete surface treatment comprised of random shallow cuttings.

Orrefors bowl designed by Sven Palmqvist.

Ribbed cylindrical form in clear glass; h. 3-1/4 in. (8.26 cm); signed OF P (illegible numbers). *Sweden.* $75-100

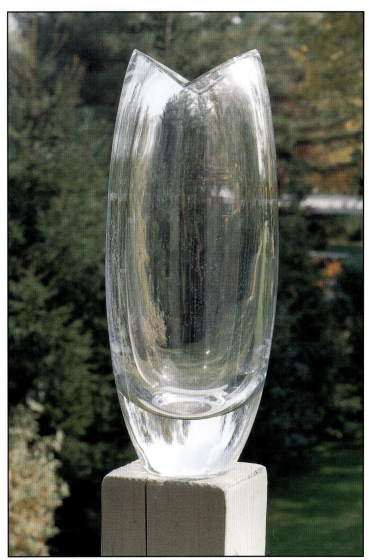

Kosta Boda "Tulip" vase designed by Bengt Edenfalk in 1986.

Ovoid form resembling a tulip blossom in clear glass with perpendicular cut opening; h. 10-1/2 in. (26.67 cm); signed KOSTA BODA 48629 B. EDENFALK. *Sweden.* $125-$175

Sea Glasbruk vases from the "Blomknyte" series designed by Rune Strand originally in 1978, pieces added later in 1991 and 1992.

Different forms resembling cinched bags in clear glass; h. 8-1/2 in. to 3-3/4 in. (21 cm to 13.5 cm). *Sweden.* $35-$85 depending on size.

Photo courtesy of Sea Glasbruk

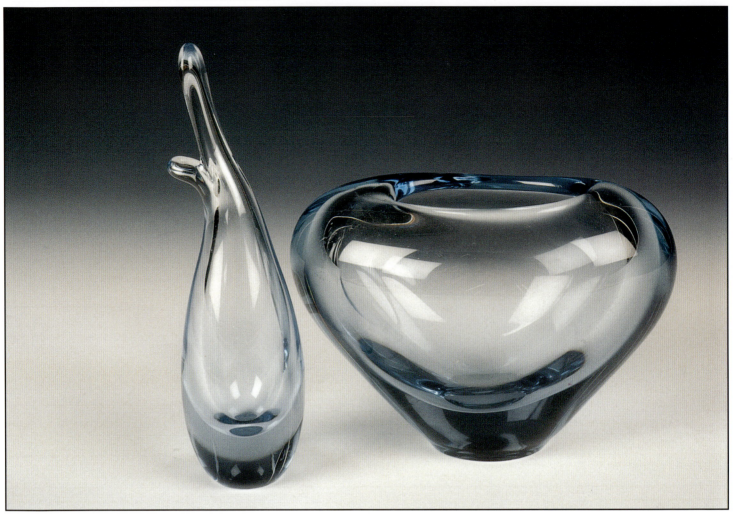

Holmegaard vases in transparent blue glass designed by Per Lutken. *(Denmark)*

"Beak" or "Duckling" vase with asymmetrical double pulled lip, designed in 1950; h. 6-1/2 in. (16.51 cm); signed HOLMEGAARD PL 15272. $125-$175

"Minuet" vase of flattened and flared ovoid form, designed in 1956; h. 4 in. (10.16 cm); signed HOLMEGAARD 19PL56. $100-$150

Afors vases designed by Ernest Gordon in the 1950s.

Cylindrical forms with reduced bases in clear glass, the top slightly tapered with cut, undulating openings, in charcoal gray and blue transparent glass; h. 9 in. (22.36 cm), h. 6-1/4 in. (15.88 cm); signed AFORS GH 554 E. GORDON; signed AFORS GH 555 E. GORDON. *Sweden.* $125-$200 depending on size.

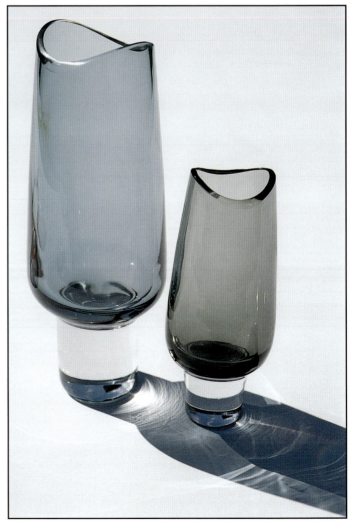

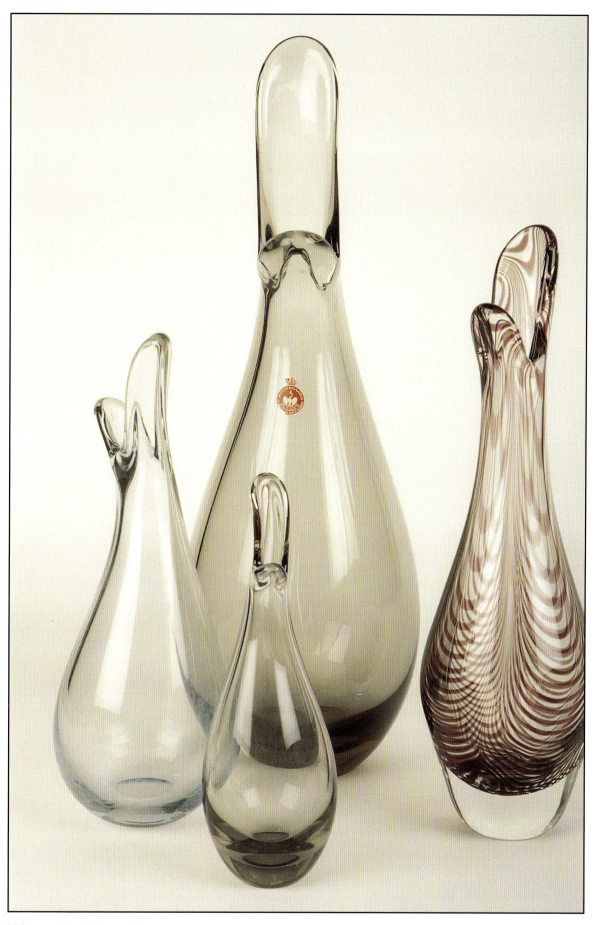

Holmegaard and Kastrup "Beak" or "Duckling" vases in a range of different sizes, colors, and techniques. Height ranging from 7-1/2 in. (19.05 cm) to 16 in. (40.64 cm). *Denmark*. $125-$350 depending on size.

Although the "Beak" vases, internally decorated with spiraling lines, are often attributed to Per Lutken, it should be noted that these vases were manufactured by Kastrup prior to the merger with Holmegaard in 1965. Per Lutken had no creative input in the designs produced at Kastrup, as the two companies were operated as independent, competing glass factories until the merger. However, some of Per Lutken's designs were manufactured at Kastrup, in particular to produce them in certain colors that were developed at that factory. Also, it has been the case that Kastrup has produced designs which were based on Per Lutken's creations. The gulvase designed by Otto Brauer at Kastrup, was based on one of Per Lutken's designs.

Strombergshyttan vases designed by Gunnar Nylund around 1955.

Flattened and slightly bulbous cylindrical forms with asymmetrical rims, with off-center and graded smoky green glass underlays, heavily cased in clear glass; h.11-3/4 in. (29.84 cm), h. 11-1/2 in. (29.21 cm), h. 10 in. (25.40 cm); all signed STROMBERG B845. *Sweden.* $350-425

These vases exemplify Gunnar Nylund's design contribution to the wares produced at Strombergshyttan in the post-war period. His designs are characterized by organic forms with free-flowing lines and non-traditional proportions. Although some of his designs were produced completely in transparent glass or crystal, the use of heavily colored underlays is also characteristic of his work.

Strombergshyttan vases photographed to accentuate the fluid design.

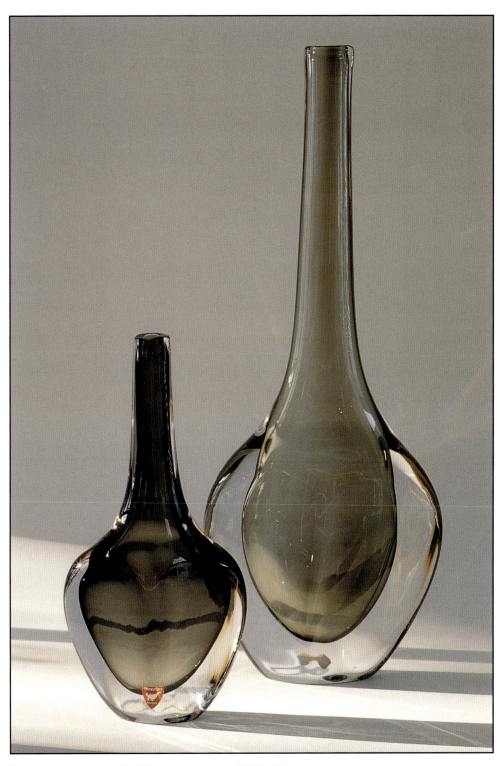

Orrefors vases designed by Nils Landberg around 1954-56.

Teardrop forms with elongated necks, the body flattened on four sides, with charcoal gray underlays, cased in clear glass; h. 13-3/4 in. (35 cm), h. 7-1/2 in. (19.05 cm); both signed ORREFORS NU 3538/1, the smaller retains the paper label: ORREFORS SWEDEN . $225-$600 depending on size.

Chapter 4
Texture and Bubbles

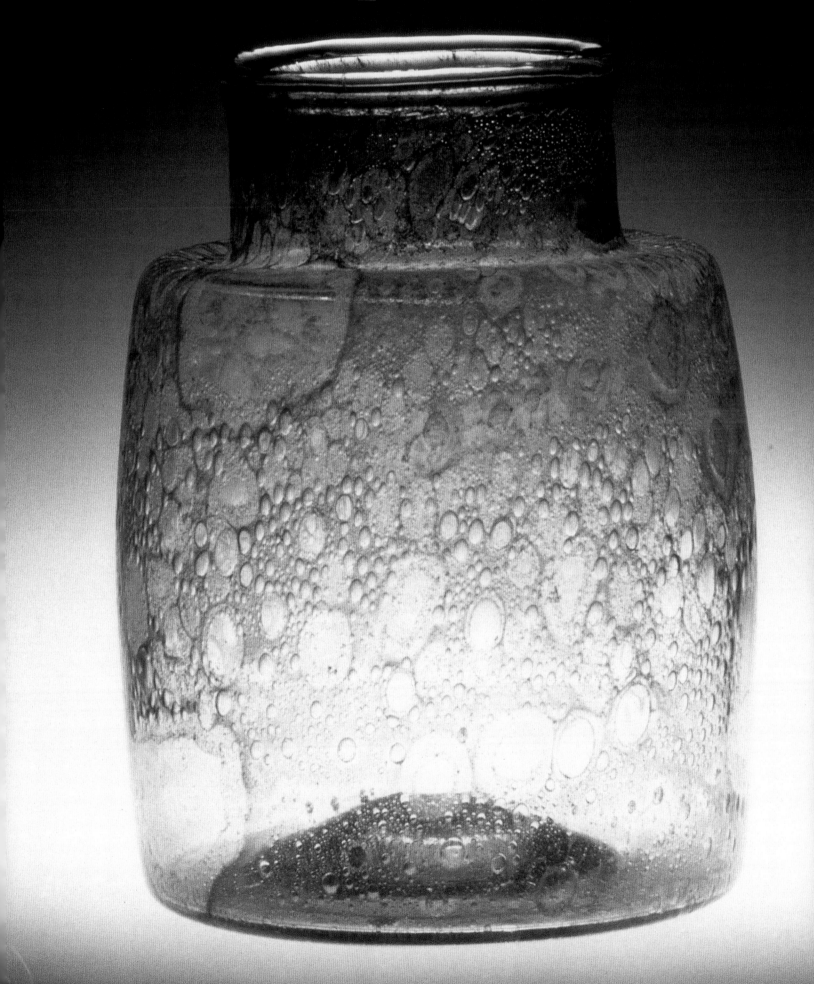

Opposing Page:
Nuutajarvi Notsjo vase designed by Kaj Frank.

Cylindrical form with reduced neck, in transparent light gray glass with bubbles. *Finland.* $800-1000

Photo by Timo Kauppila courtesy of iittala

Nuutajarvi Notsjo bowl designed by Kaj Frank.

Slightly flared and highly textured form with bubbles, in clear glass, the asymmetrical rim composed of a series of applied circular blobs. *Finland.* $1200-$1500

Photo by Gero Mylius courtesy of iittala

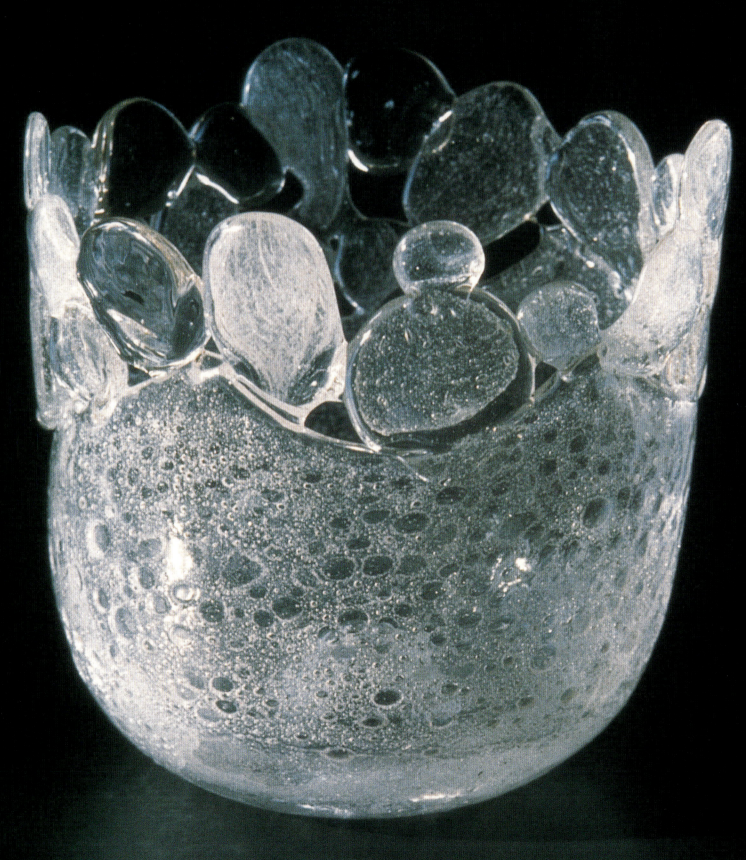

Johansfors vase designed by Bengt Orup around 1967.

Bulbous form with flared rim in clear glass, internally decorated with metallic particles and trapped air bubbles; h. 8-1/4 in. (20.95 cm); signed JOHANSFORS ORUP. *Sweden*. $800-1000

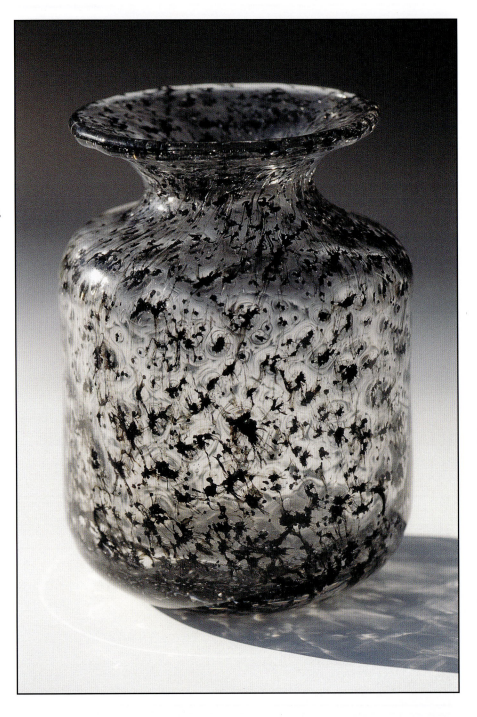

Kosta bowl in the "Brava" technique designed by Ann and Goran Warff in the late 1960s.

Flared form with heavy rim, the surface textured, in clear glass; d. 7-1/2 in. (19.05 cm); signed KOSTA BRAVA. *Sweden*. $100-150

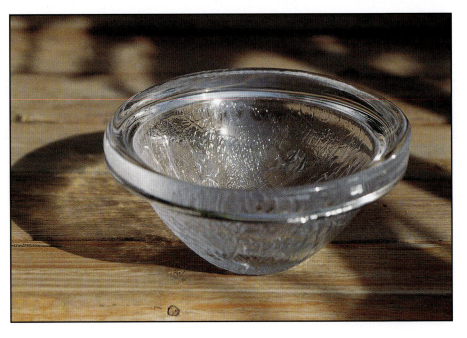

Nuutajarvi Notsjo vase.

Cylindrical form with extended and curved rim, internally decorated with light amber particles and bubbles, cased in clear glass; h. 5 in. (12.70 cm); retains blue and silver foil label: NUUTAJARVI 1793 MADE IN FINLAND. $75-125

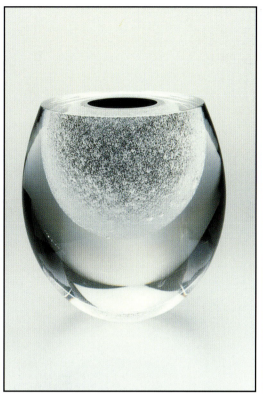

iittala sculpture from the "Claritas" series designed by Timo Sarpaneva in 1983.

Ovoid form with an internal layer of tightly packed bubbles, cased in clear glass, the top open with a thick and polished rim. *Finland.* $500-600

Photo courtesy of iittala

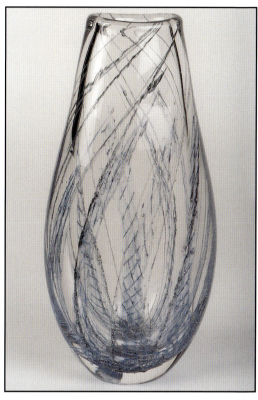

Konst Glashyttan Urshult vase.

Ovoid form in clear glass, internally decorated with swirling pattern of metallic netting and bubbles; h. 9 in. (22.86 cm) signed SJOGROS G STRINGREN; retains gold and black plastic foil label: KONST GLASHYTTAN URSHULT and blue and white paper label: MADE IN SWEDEN. $150-250

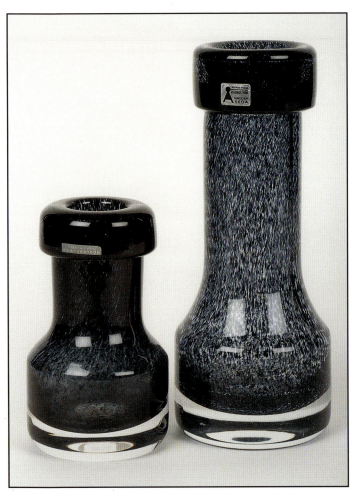

Aseda vases designed by Bo Borgstrom in the late 1950s or early 1960s.

Cylindrical forms reduced at the waist, with turned and pressed upper rim, internally decorated with dark gray particles and bubbles, cased in clear glass; h. 6 in. (15.24 cm), h. 9-1/2 in. (24.13 cm); both retain labels, the smaller vase of earlier production: SVENSK FORM BO BORGSTROM, SVENSK FORM BO BORGSTROM SWEDEN ASEDA. $150-250 each

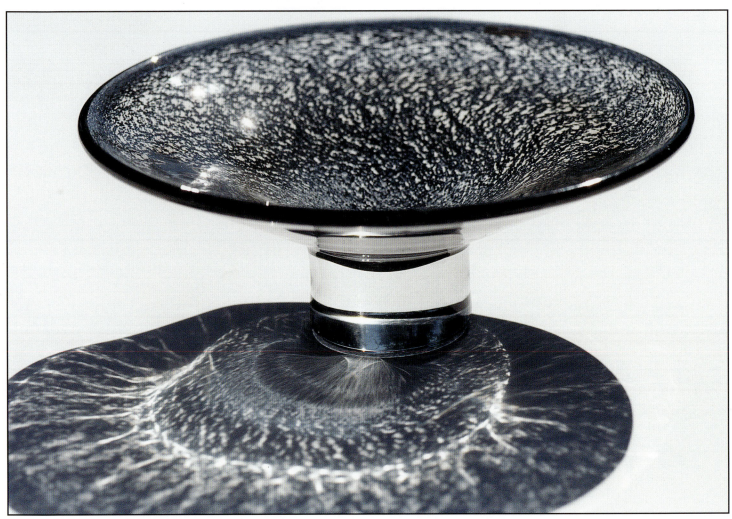

Aseda bowl designed by Bo Borgstrom in the late 1950s or early 1960s.

Flared form with a cylindrical foot, internally decorated with dark gray particles and bubbles, cased in clear glass; d. 11-1/4 in. (28.57 cm); retains original paper label: SVENK FORM BO BORGSTROM. *Sweden.* $175-225

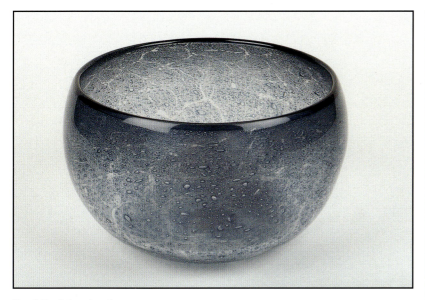

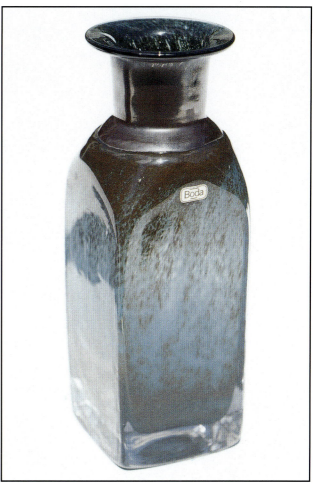

Randsfjordglass bowl.

Ovoid form, internally colored with charcoal blue particles and filled with random sized bubbles throughout; d. 9 in. (22.86 cm); retains original paper label: RANDSFJORDGLASS MADE IN NORWAY HANDBLOWN. $100-150

Boda-Afors vase designed by Bertil Vallien in the late 1960s.

Square form tapering to a flared cylindrical neck, with a light charcoal blue underlay and dark blue particles, cased in clear glass; h. 8-3/4 in. (22.23 cm); retains original paper label: HANDMADE BODA SWEDEN; signed BODA.AFORS B.VALLIEN. $200-250

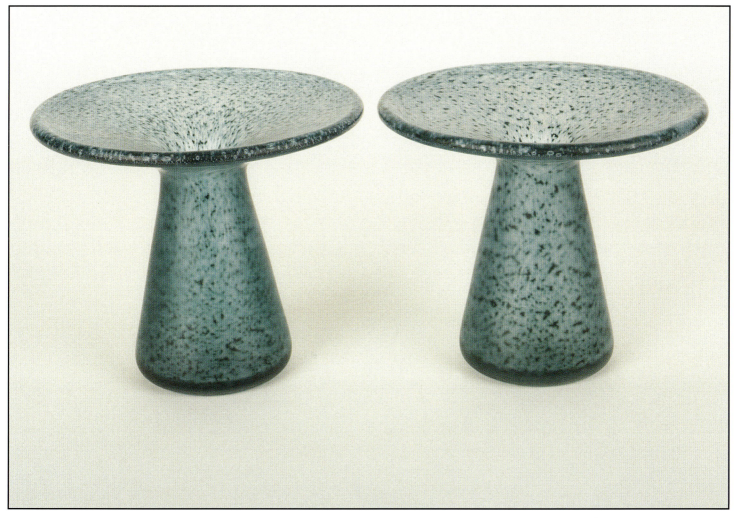

Hadeland vases designed by Willy Johansson around the mid-1950s.

Conical forms with flared and exaggerated rims, internally decorated with dark blue particles, the exterior acid treated; h. 5 in. (12.70 cm); both retain the original paper label: HADELAND PASCO NORWAY, both signed HADELAND 2117 W. J. $150-200 each

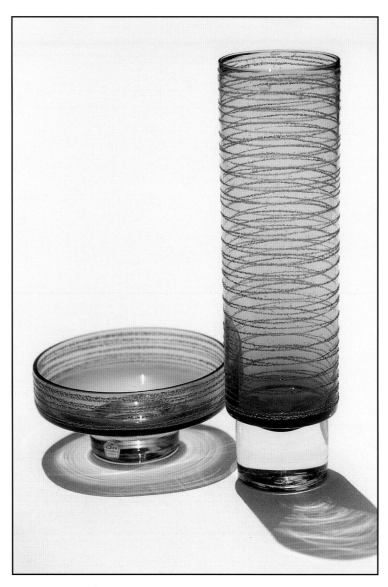

Sea Glasbruk bowl and vase, likely designed by Rune Strand.

Cylindrical forms with a light gray underlay and reduced bases cased in clear glass, the exterior decorated with small glass particle rings. Bowl, d. 5-1/2 in. (13.97 cm); retains original paper label (earlier production): SEA GLASBRUK KOSTA SWEDEN. Vase, h. 11 in. (27.94 cm); retains original plastic label (later production): SEA GLASBRUK AB KOSTA SWEDEN. Bowl, $35-65; vase, $50-75.

Nuutajarvi Notsjo vase attributed to Kaj Frank, 1950s production.

Cylindrical form in clear glass with a heavy polished rim, internally decorated with a gauze-like layer of scales and minute controlled bubbles; h. 5-1/4 in. (13.34 cm); signed NUUTAJARVI NOTSJO. *Finland.* $500-600

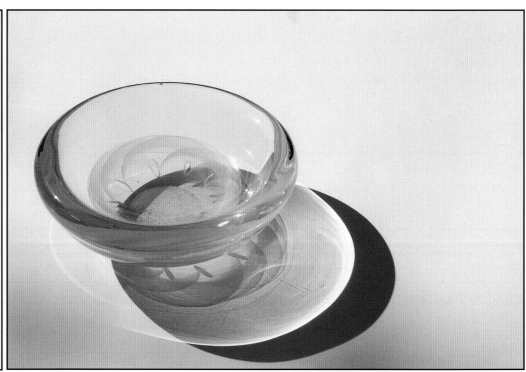

Nuutajarvi Notsjo bowl designed by Olavi Nurminen in the early 1950s and produced through the 1950s.

Flared form in clear glass internally decorated with a gauze-like layer of semi-circles, creating a flower-like effect, overlaid by circle of elliptical controlled bubbles; d. 6 in. (15.24 cm); signed NUUTAJARVI NOTSJO-59. *Finland.* $200-250

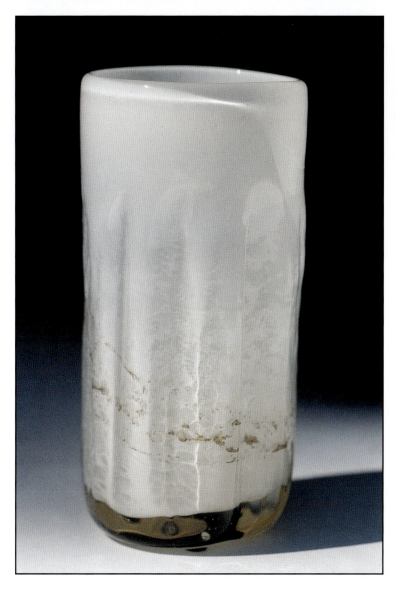
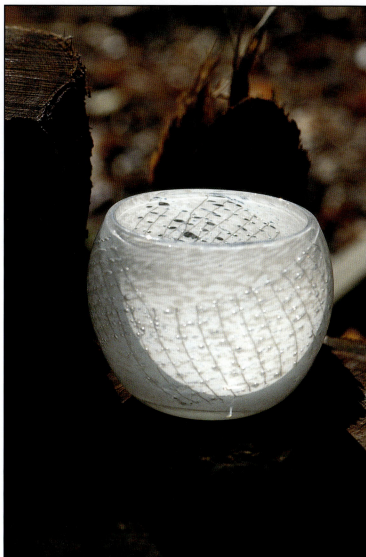
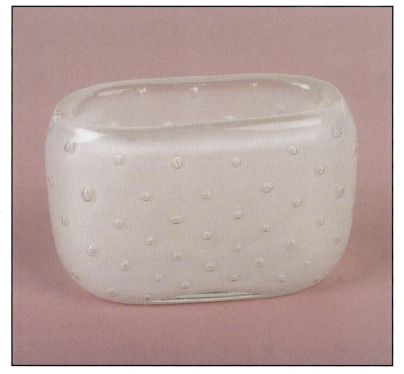

Top left:
Plus Glasshytte vase designed by Benny Motzfeldt, likely in the 1970s.

Externally ribbed cylindrical form with an opaque white underlay and random patches of opaque amber particles and fibers; h. 8-1/4 in. (20.95 cm); acid etched signature: PLUS BM NORWAY. $275-350

Top right:
Plus Glasshytte bowl designed by Benny Motzfeldt, likely in the 1970s.

Bulbous form with opaque white underlay cased in clear glass, internally decorated with glass fiber inclusions which have created a web-like pattern of netted strings and bubbles after the blowing process; d. 5 in. (12.70 cm); acid etched signature: PLUS BM NORWAY. $150-200

Hadeland vase designed by Hermann Bongard and produced in 1955.

Rectangular flattened form in opaque white glass with regularly spaced controlled bubbles; h. 2-3/4 in. (6.99 cm); signed HADELAND 55 HB. *Norway.* $125-175

Pattern

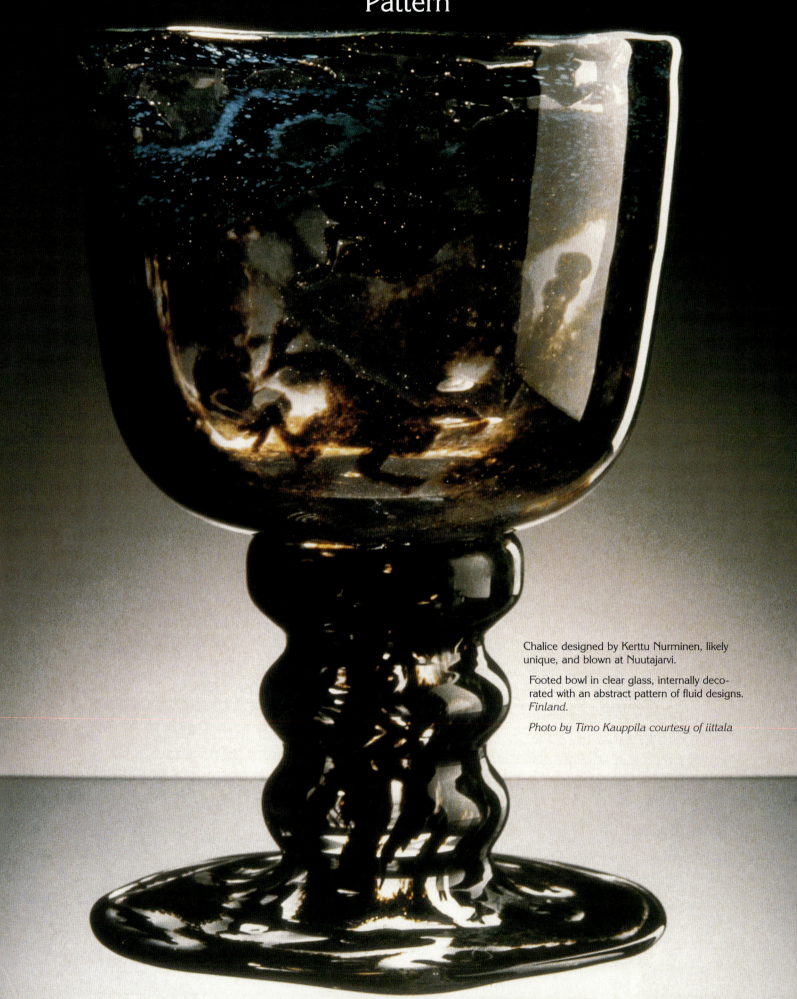

Chalice designed by Kerttu Nurminen, likely unique, and blown at Nuutajarvi.

Footed bowl in clear glass, internally decorated with an abstract pattern of fluid designs. *Finland.*

Photo by Timo Kauppila courtesy of iittala

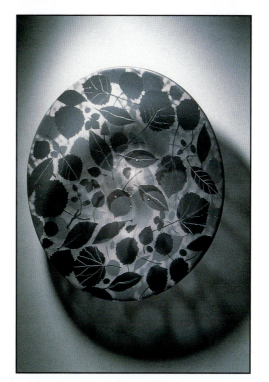

Bowl designed by Kerttu Nurminen, likely unique, and blown at Nuutajarvi.

Flared form in clear glass, internally decorated with a pattern of mixed leaves. *Finland.*

Photo by Timo Kauppila courtesy of iittala

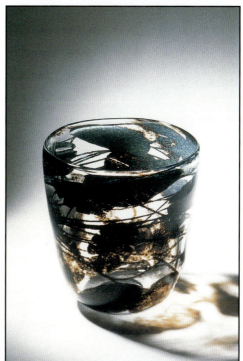

Bowl designed by Kerttu Nurminen, likely unique, and blown at Nuutajarvi.

Slightly flared bowl in clear glass, internally decorated with abstract pattern of stringed and fluid designs. *Finland.*

Photo by Timo Kauppila courtesy of iittala

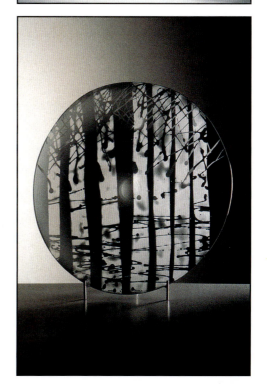

Plate designed by Kerttu Nurminen, likely unique, and blown at Nuutajarvi.

Flat form in clear glass, internally decorated with a pattern resembling tree trunks in a dense forest. *Finland.*

Photo by Timo Kauppila courtesy of iittala

Nuutajarvi Pro Arte pieces from the "Palazzo" series, designed by Kerttu Nurminen in 1998.

Decanters, glass, and plate, in clear glass, internally decorated with colored filigree spirals. *Finland.* $250-600 each

Photo by Timo Kauppila courtesy of iittala

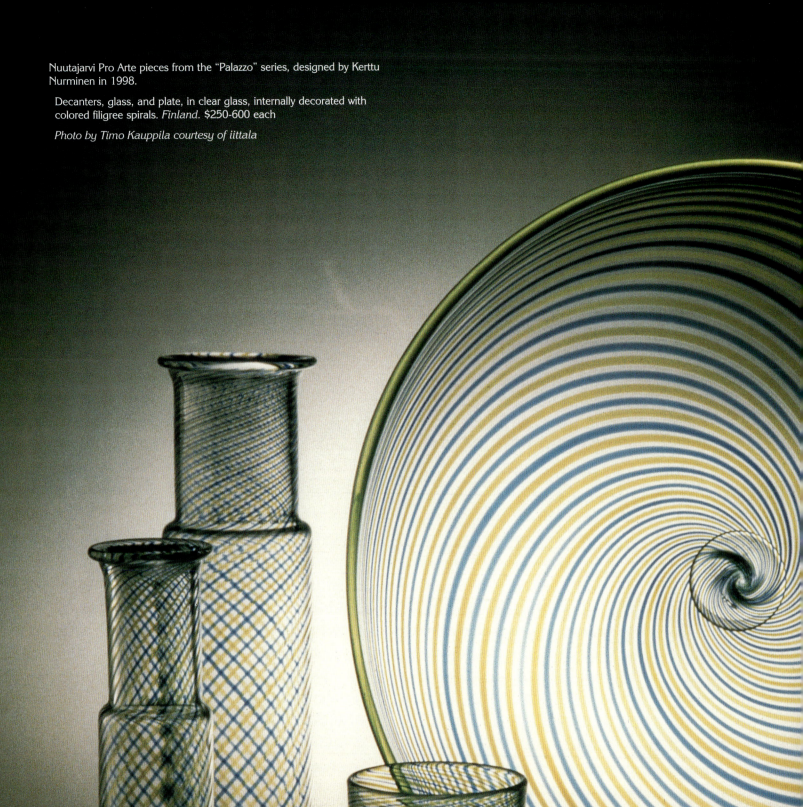

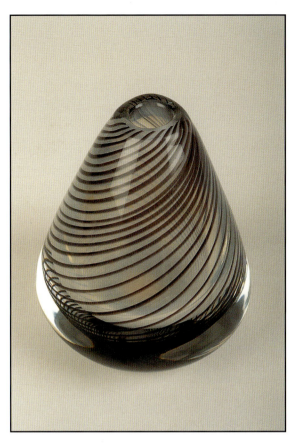

Hadeland vase designed by Willy Johansson and produced in 1955.

Teardrop form in clear glass internally decorated with dark amethyst filigree spirals; h. 5 in. (12.70 cm); signed HADELAND 55 WJ. *Norway.* $150-200

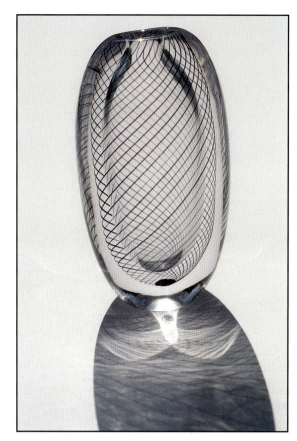

Kosta vase designed by Vicke Lindstrand in 1958.

Bulbous form in clear glass, internally decorated with dark amethyst filigree spirals, described in the catalog as "black threads"; h. 5-3/4 in. (14.61 cm); signed Kosta LH. *Sweden.* $600-800

Courtesy of Gordon Harrell

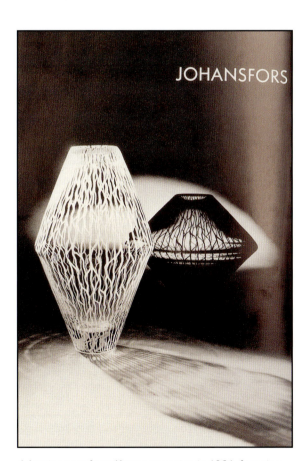

Advertisement from *Kontur* magazine in 1964, featuring Johansfors vases likely designed by Bengt Orup.

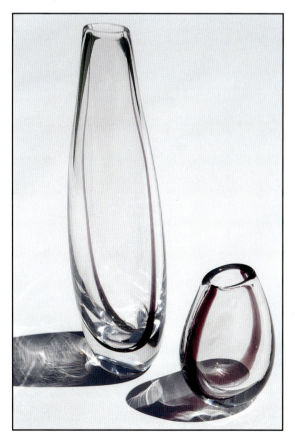

Kosta "Kontur" vases designed by Vicke Lindstrand between 1950 and 1954.

Teardrop forms in clear glass, internally decorated with a dark amethyst thread delineating their contours or silhouettes; h. 11 in. (27.94 cm), 4 in. (10.16 cm); large signed KOSTA LH 1240, small is unsigned. *Sweden.* Small, $75-150, Large, $350-400.

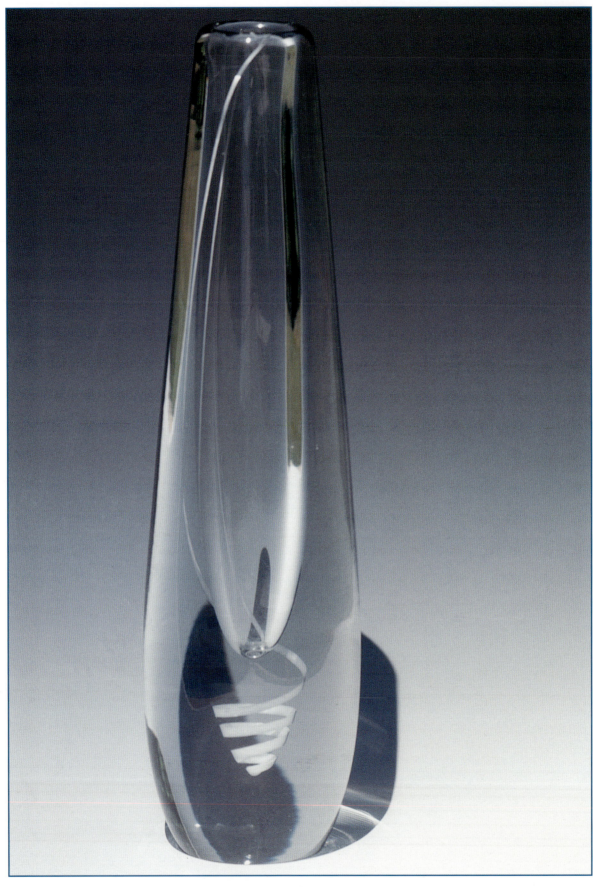

Nuutajarvi Notsjo "Sepentiini" vase designed by Gunnel Nyman in 1947.

Teardrop form in clear glass internally decorated with a single opaque white spiral; h. 16-1/2 in. (41.91 cm); signed G. NYMAN NUUTAJARVI NOTSJO 55. *Finland.* $4500-5500

 In many ways, Gunnel Nyman's work is an affirmation of the power of the designing process. During her short time as a designer, she managed to create some of the most revered and influential glass pieces ever produced in the Scandinavian countries. The "Serpentiini" vase, marked by its complete economy of design, is certainly one of them. With this design and others such as "String of Pearls," Gunnel Nyman demonstrated that the use of simple materials and minimal decoration does not necessarily lead to the creation of a utilitarian object. Beauty can be complex, but in its purest form, it can also be simple.

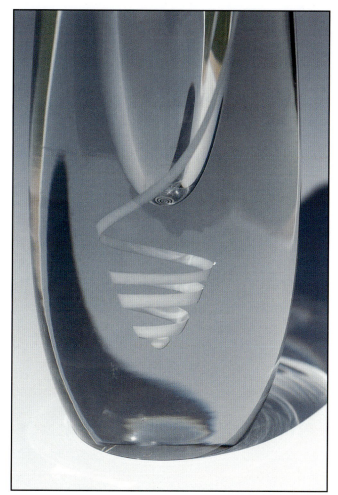

Detail of the "Serpentiini" spiral.

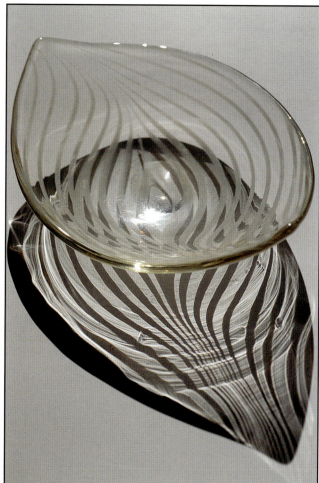

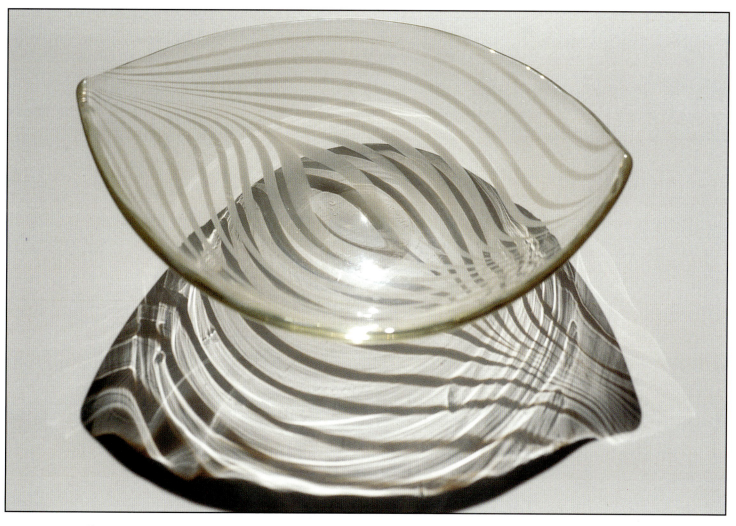

Kumela bowl designed by Maija Karlsson.

Leaf-like form in clear glass, internally decorated with a pattern of curvy, opaque white ribbons; d. 8-1/2 in. (21.59 cm); signed OY KUMELA MAIJA KARLSSON. *Finland.* $150-250

Boda "Rainbow" vase designed by Bertil Vallien in 1983.

Pillow form in clear glass, with surface-fired strands in various colors; h. 9-1/4 in. (23.50 cm); signed BODA B. VALLIEN 48328. *Sweden.* $250-300

Boda "Rainbow" vases designed by Bertil Vallien in 1982-1983.

Vessels with surface-fired opaque white enamel, decorated with colored enamel strands; 8-1/2 in. (21.59 cm.), h. 6 in. (15.24 cm.); both signed BODA B. VALLIEN. SWEDEN. $200-300 each

Bergdala bowl.

Flared form in opaque white glass with a blotchy abstract pattern in black glass; d. 4 in. (12.70cm); signed BABY 84, retains label B BERGDALA SWEDEN. $75-125

Holmegaard vase.

Bottle form with flared rim in opaque white glass, with an abstract pattern in purple, black, and blues; h. 6-3/4 in. (17.14 cm); retains label: HOLMEGAARD GLASS OF COPENHAGEN BY APPOINTMENT TO THE ROYAL DANISH COURT MADE IN DENMARK 369. $150-250

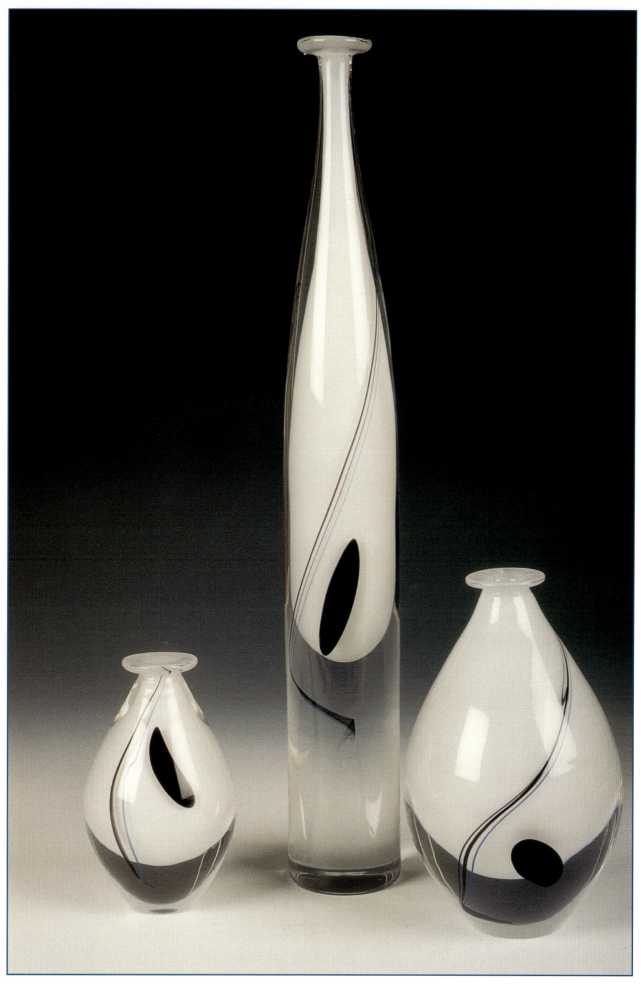

Kosta vases designed by Klas-Goran Tinback in 1982.

Stylized bottle forms with an opaque white underlay heavily cased in clear glass, internally decorated with colored spirals and black patches; h. 4 in. (10.16 cm0, h. 15 in. (38.10 cm), h. 6 in. (15.24 cm); signed KOSTA 48252 TINBACK, signed KOSTA 48257 TINBACK, signed KOSTA 48254 TINBACK. *Sweden.* $200-600 each

Chapter 6
Molded Forms

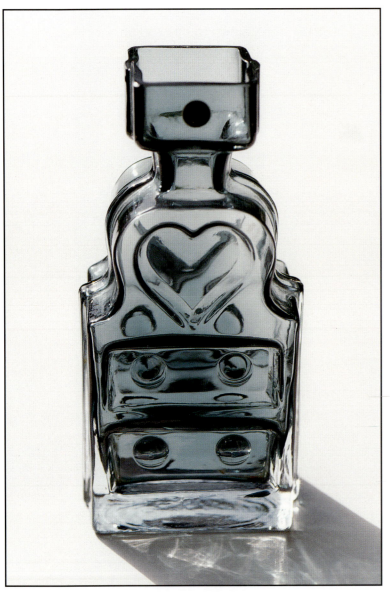

Riihimaen Lasi "Pironki" vase designed by Helena Tynell in 1974.

Complex form resembling a chest of drawers with a heart, with a transparent gray underlay cased in clear glass; h. 8-1/2 in. (21.59 cm); retains original gold and black lion label: RIIHIMAEN LASI MADE IN FINLAND. $150-200

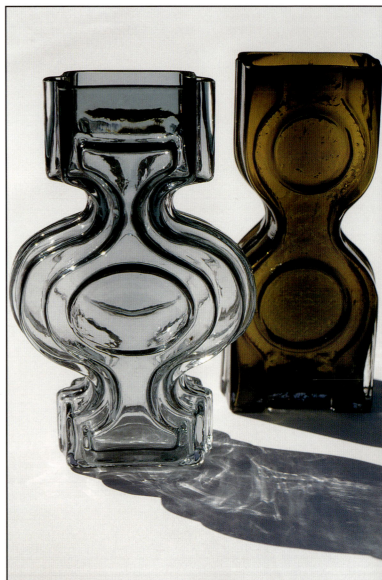

Riihimaen Lasi vases designed by Helena Tynell. *(Finland)*

"Emma" vase designed in 1976; abstract anthropomorphic form resembling a female figure, with a transparent gray underlay cased in clear glass; h. 6-1/2 in. (16.51 cm). $150-200

"Kaapikello" vase designed in 1967 and produced through 1969; hourglass form with two circles and a partly textured surface, with a transparent olive green glass underlay cased in clear glass; h. 8-1/4 in. (20.95 cm). $150-200

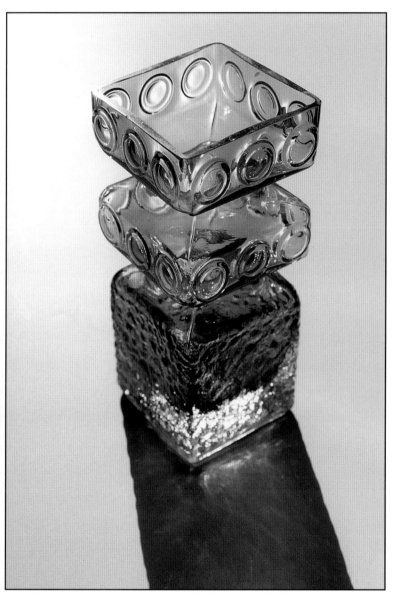

Riihimaen Lasi "Kehra" vase designed by Tamara Aladin around the early 1970s, first seen in the marketing and export catalog of 1972.

Complex square form segmented into three parts, the top two with circles all around and the bottom with a textured effect, with a transparent charcoal gray underlay, cased in clear glass, the underside with graduated squares; h. 8 in. (20.32 cm). *Finland.* $150-200

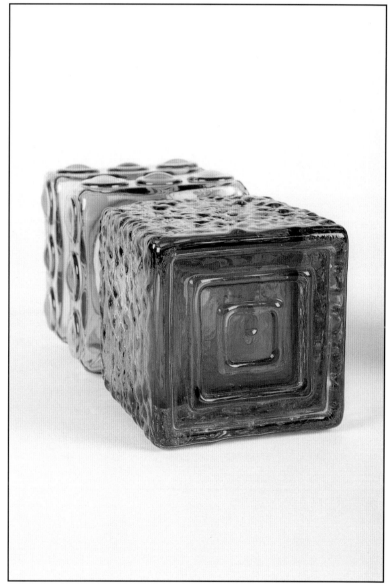

Underside detail of the Riihimaen Lasi "Kehra" vase designed by Tamara Aladin.

The graduated squares found on the bottom of this piece are a typical characteristic of Riihimaen Lasi production during the late 1960s and 1970s. Some vases with cylindrical bases also have a series of concentric circles on the underside. This detail serves as an important identifying characteristic of Riihimaen Lasi production for the collector. Although not all Riihimaen Lasi vases have this detail on the underside, most that do were always labeled and rarely signed.

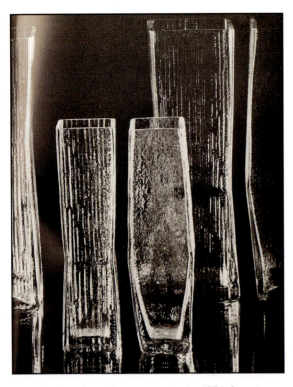

Advertisement from *Kontur* magazine in 1964, featuring Lindshammar vases designed by Christer Sjogren.

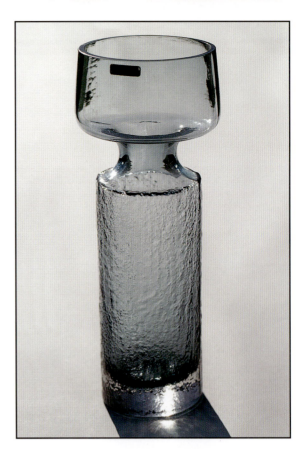

Riihimaen Lasi "Safari" vase designed by Tamara Aladin around the early 1970s, first seen in the marketing and export catalog of 1972.

Cylindrical form with cinched neck and slightly wider cupped top, textured surface below the neck, with transparent charcoal gray underlay, cased in clear glass; retains original Riihimaen Lasi plastic gold and black export label: FINNCRISTALL MADE IN FINLAND. $150-200

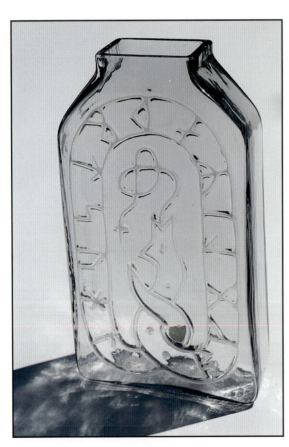

Flygsfors vase designed by Wiktor Berndt in 1960.

Flattened rectangular form with a reduced neck in transparent light gray glass, with a relief of an abstract and modernistic curled serpent ready to strike. The surface of the relief has been ground. This is a characteristic technique used by Berndt in his molded relief designs during his tenure at Flygsfors; h. 10 in. (25.40 cm); retains original red and gold paper label: FLYGSFORS MADE IN SWEDEN; signed FLYGSFORS-60 BERNDT. $350-400

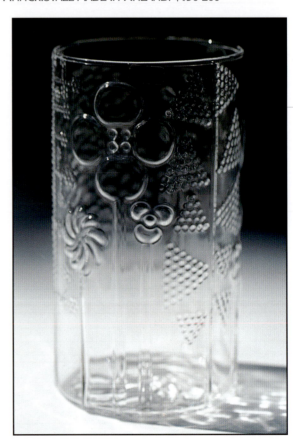

Nuutajarvi Notsjo "Flora" vase designed by Oiva Toikka in 1966.

Cylindrical form in clear glass with a relief of different abstract stemmed flowers and leaves; h. 8-1/4 in. (20.95 cm); retains original plastic label with blue fish: NUUTAJARVI 1793 WARTSILA FINLAND. $175-225

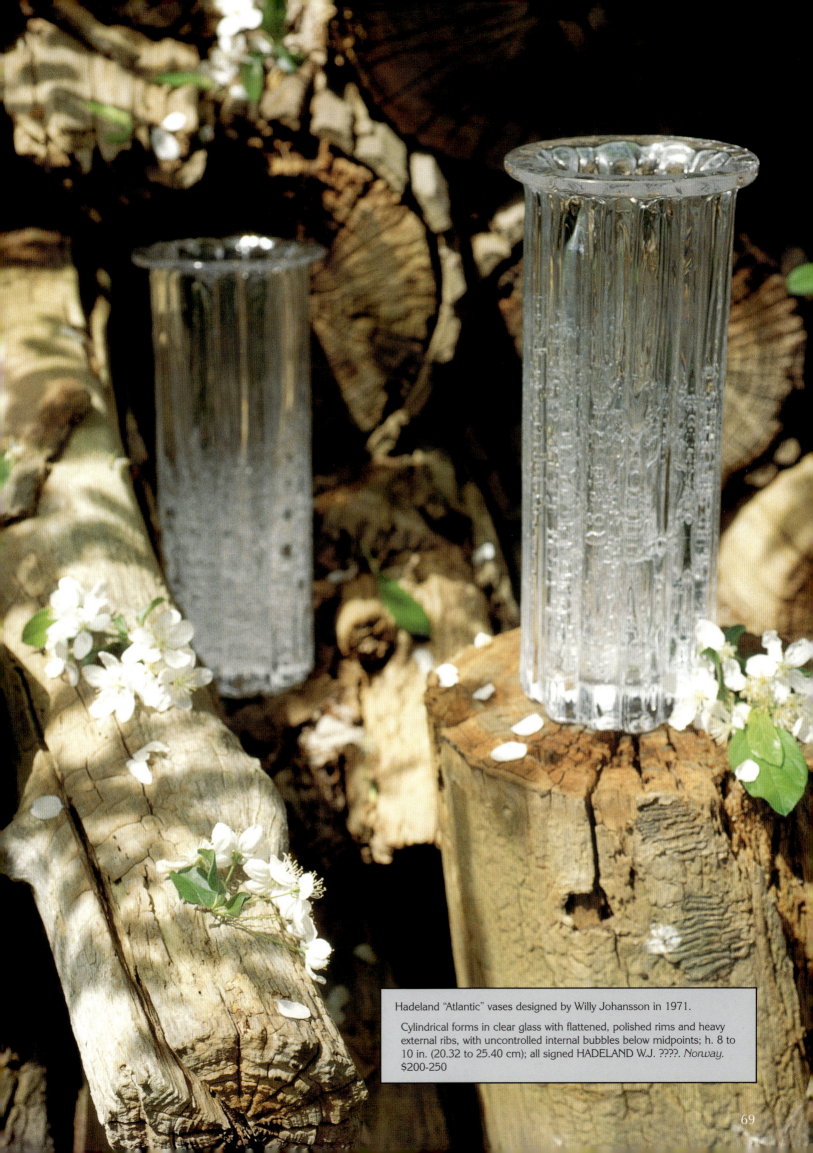

Hadeland "Atlantic" vases designed by Willy Johansson in 1971.

Cylindrical forms in clear glass with flattened, polished rims and heavy external ribs, with uncontrolled internal bubbles below midpoints; h. 8 to 10 in. (20.32 to 25.40 cm); all signed HADELAND W.J. ????. *Norway*. $200-250

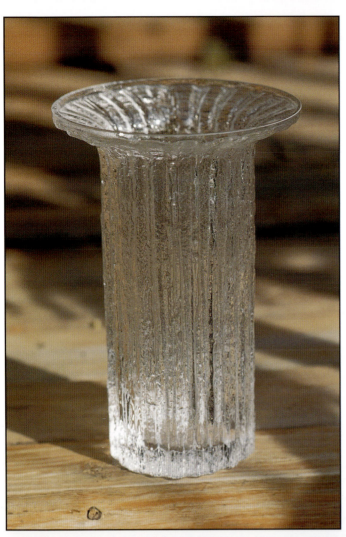

iittala vase designed by Timo Sarpaneva around the late 1960s or early 1970s, appearing in the iittala catalog of 1972, production number 2756, manufactured in three different heights.

Highly textured cylindrical form in clear glass with flared rim and external ribs; h. 7-1/2 in. (19.05 cm); signed TS. *Finland.* $500-600

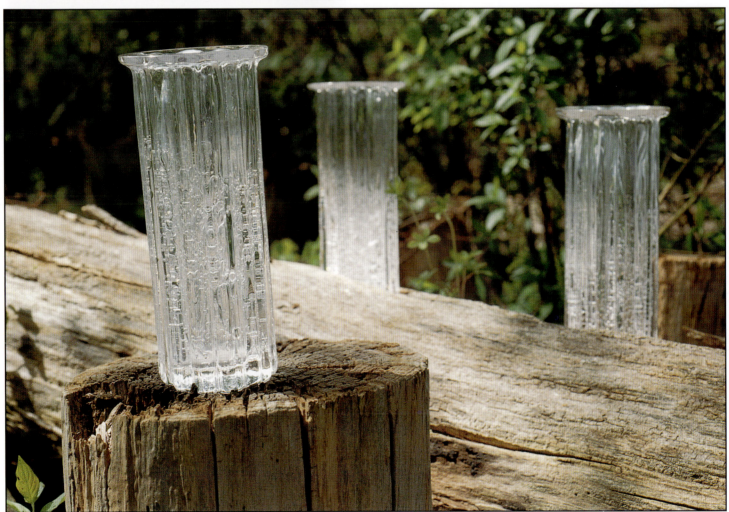

Grouping of "Atlantic" vases designed by Willy Johansson.

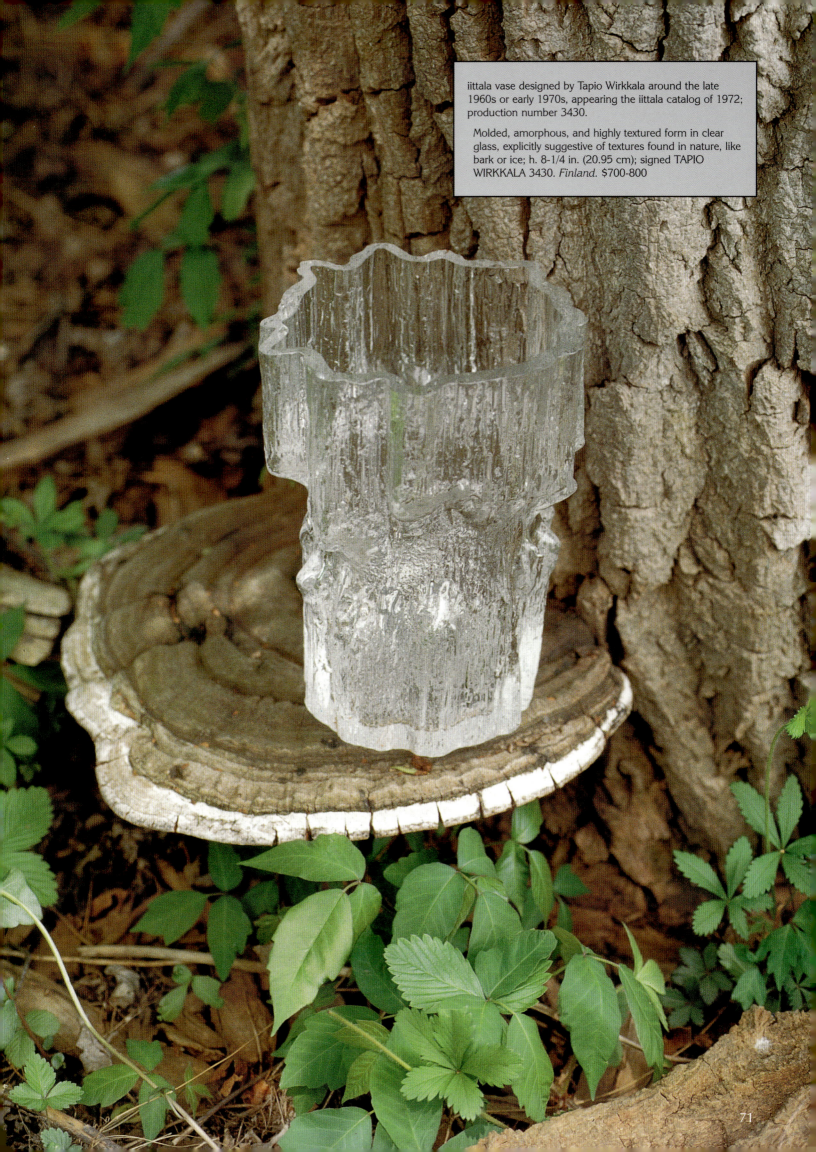

iittala vase designed by Tapio Wirkkala around the late 1960s or early 1970s, appearing the iittala catalog of 1972; production number 3430.

Molded, amorphous, and highly textured form in clear glass, explicitly suggestive of textures found in nature, like bark or ice; h. 8-1/4 in. (20.95 cm); signed TAPIO WIRKKALA 3430. *Finland.* $700-800

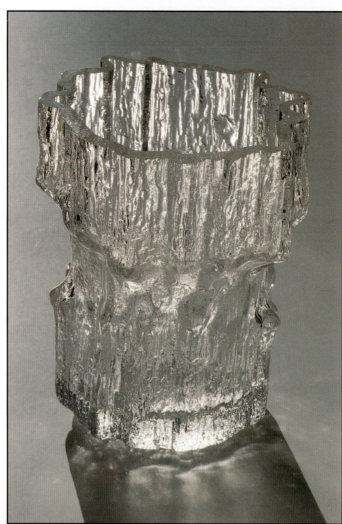

iittala vase designed by Tapio Wirkkala, production number 3430, shown in the previous photograph.

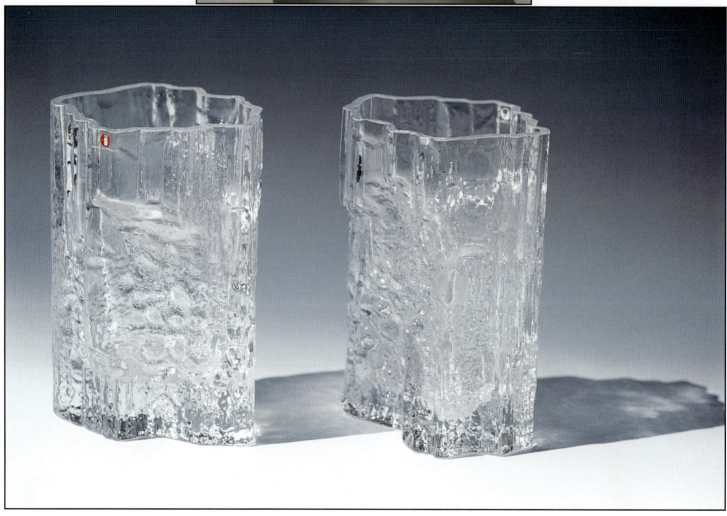

iittala "Pinus" vases designed by Tapio Wirkkala in 1972.

Mold-blown forms in clear glass with highly textured surfaces resembling chipped blocks of ice; h. 6-1/2 in. (16.51 cm); both retain plastic red dot label: i MADE IN FINLAND; both signed TW. $125-175 each

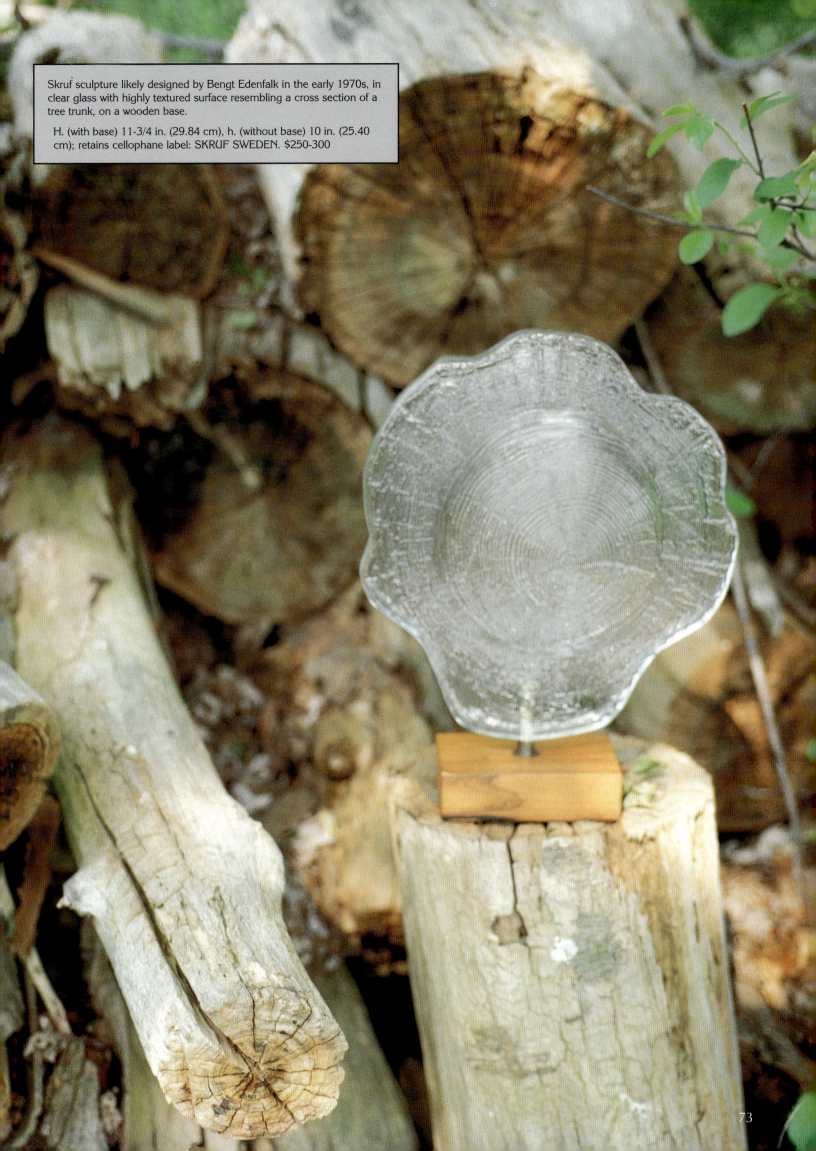

Skruf sculpture likely designed by Bengt Edenfalk in the early 1970s, in clear glass with highly textured surface resembling a cross section of a tree trunk, on a wooden base.

H. (with base) 11-3/4 in. (29.84 cm), h. (without base) 10 in. (25.40 cm); retains cellophane label: SKRUF SWEDEN. $250-300

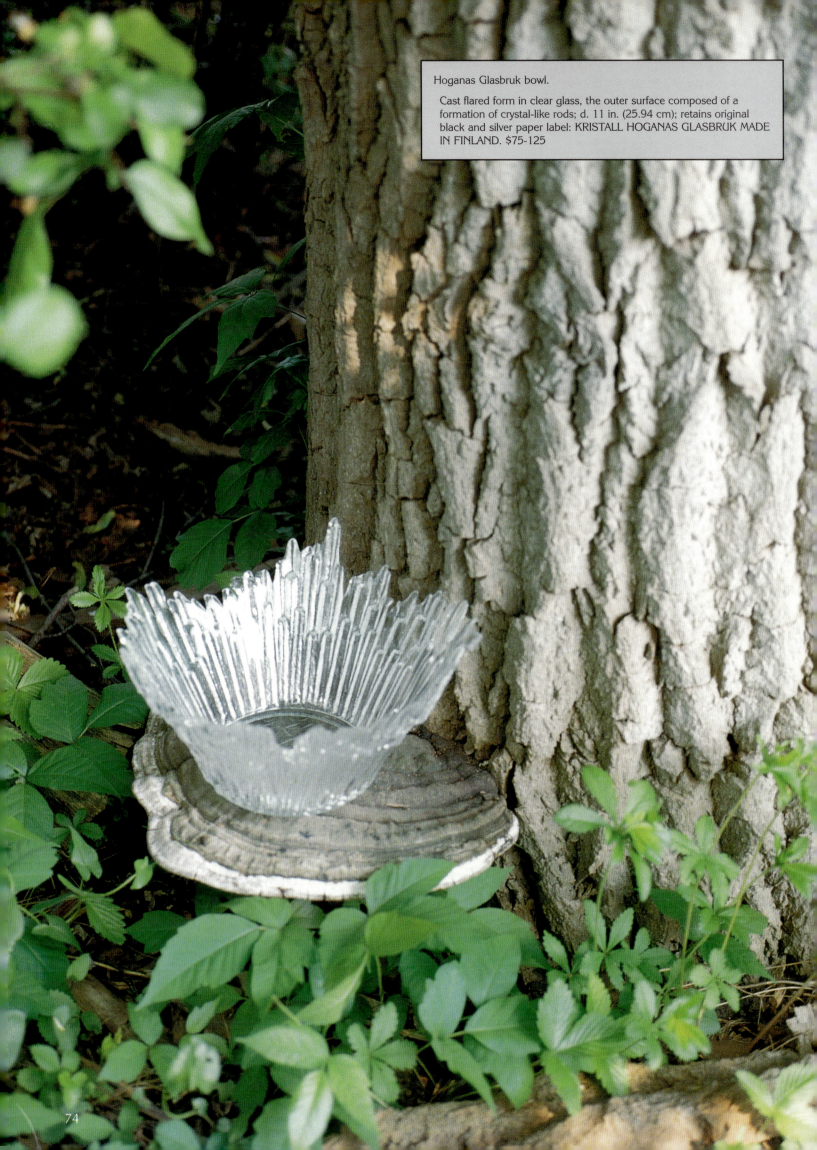

Hoganas Glasbruk bowl.

Cast flared form in clear glass, the outer surface composed of a formation of crystal-like rods; d. 11 in. (25.94 cm); retains original black and silver paper label: KRISTALL HOGANAS GLASBRUK MADE IN FINLAND. $75-125

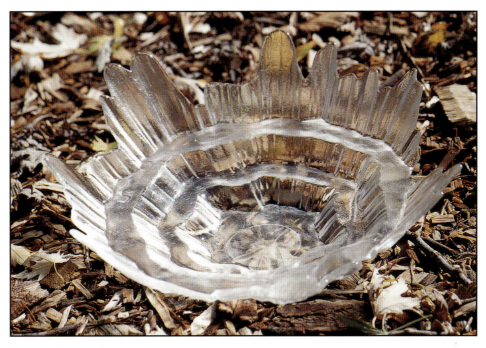

Hoganas Glasbruk bowl.

Mold-blown, stepped flared form in clear glass with a highly textured surface terminating in icicle-like edges; d. 15 in. (38.10 cm). *Finland.* $75-125

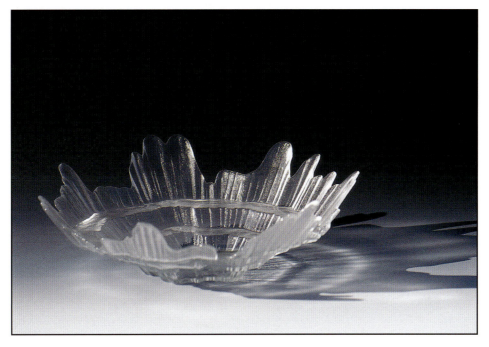

Hoganas Glasbruk bowl under indirect light, accentuating form and texture.

Pukeberg bowls.

Flared forms in clear glass with vertical lines on the undersides; d. 6-1/4 in. (15.88 cm); one retains original black and white plastic label: PUKEBERG SWEDEN. $75-125 each

Orrefors bowl.

Flared form in clear glass with a twisted and scalloped surface; h. 6-1/4 in. (15.88 cm); retains brown and white paper label: ORREFORS SWEDEN; signed ORREFORS. $100-150

Pukeberg bowl.

Flared form in clear glass with a highly textured and rather organic surface; d. 7-1/2 in. (19.05 cm); retains original black and white plastic label: PUKEBERG SWEDEN. $100-150

Kosta Bowl designed by Goran and Ann Warff, likely in the late 1960s or very early 1970s.

Flared form in clear glass with molded relief resembling nautilus shells; d. 6 in. (15.24 cm); retains original plastic label: KOSTA SWEDEN; signed KOSTA WARFF 56129. $150-200

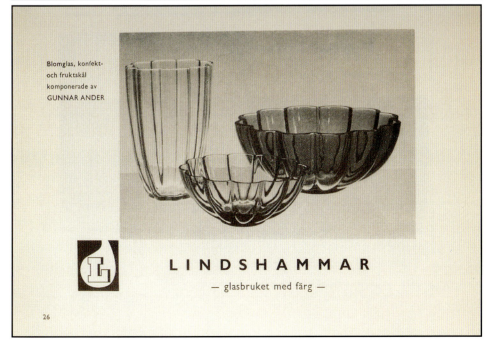

Advertisement from *Form* magazine in 1957, featuring Lindshammar vases designed by Gunnar Ander.

Kumela bowl.

Cast square form in clear glass with a highly textured and organic bottom resembling ice, the top decorated with a metal filigree band; d. 7 in. (17.78 cm); signed KUMELA OY FINLAND E. WANNRI? $125-175

Sea Glasbruk "Olympia" vases designed by Goran Anneborg in 1995.

Ribbed complex forms in clear glass with a heavy vase. *Sweden*. $75-125 each

Photo courtesy of Sea Glasbruk

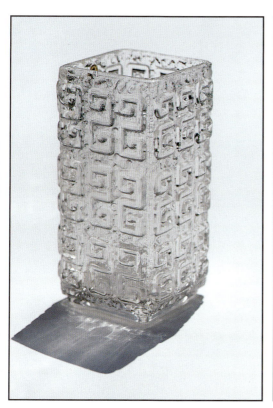 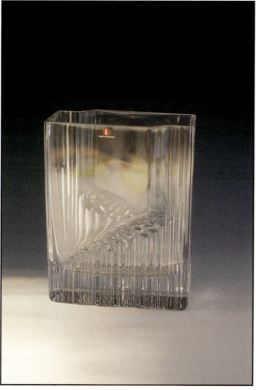

Riihimaen Lasi "Taalari" vase designed by Tamara Aladin, likely in the late 1960s, and available in the company's product catalog of 1970.

Square form in clear glass with a repeating geometric, scroll-like pattern and an overall textured surface; h. 7-3/4 in. (19.68 cm); retains black and gold foil label: RIIHIMAEN LASI MADE IN FINLAND. $125-175

iittala "Sointu" vase designed by Tapio Wirkkala in 1973.

Molded pillow form in clear glass with a linear design composed of irregular, indented grooves; h. 7 in. (17.78 cm); signed TW; retains original red and white plastic label: i MADE IN FINLAND. $150-200

Johansfors vase designed by Bengt Orup.

Squared bottle form in clear glass with applied threading around the body; h. 7-1/4 in. (18.41 cm); signed JOHANSFORS ORUP. *Sweden*. $150-200

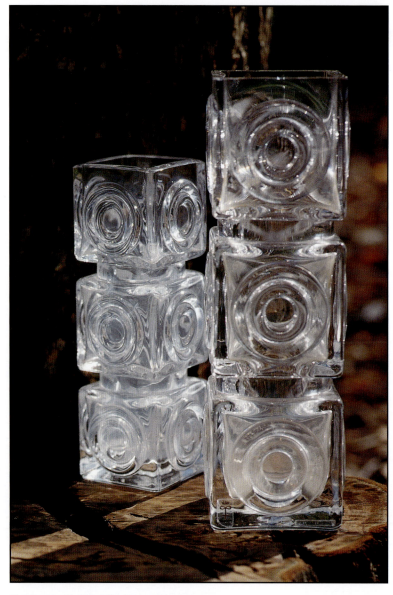

Skruf vases designed by Bengt Edenfalk.

Complex square forms in clear glass composed of three cubes, each one having concentric circle designs of four sides; h. 8 in. (20.32 cm); signed EDENFALK SKRUF EMB 2-6; h. 10-1/4 in. (26.04 cm); signed EDENFALK SKRUF EMB 2-5. The larger retains the black and gold paper label: SKRUF SWEDEN FULL CRYSTAL. $150-250 depending on size.

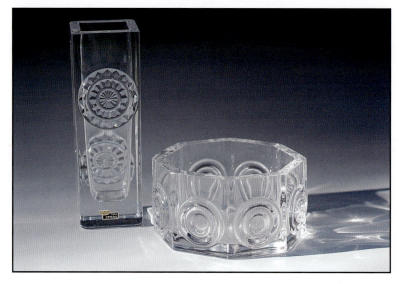

Skruf vase and bowl deigned by Bengt Edenfalk.

Square form in clear glass, two sides with molded concentric circles which are cut, resulting in a sunburst-like design; h. 7-1/4 in. (18.41 cm.); retains black, yellow and gold paper label: SKRUF SWEDEN FULL CRYSTAL; signed EDENFALK SKRUF SPECTRAL? $150-200

Octagonal form in clear glass, each side with a concentric circle relief design. $75-125

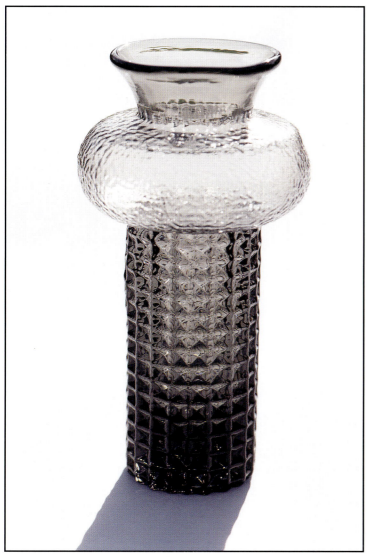

Magnor vase.

Molded cylindrical form with gurgle and flared top in transparent gray glass, with a raised diamond-like pattern below midpoint and an overall textured surface; h. 8-1/2 in. (21.59 cm); retains black and white paper label: MAGNOR GLASS NORWAY. $75-125

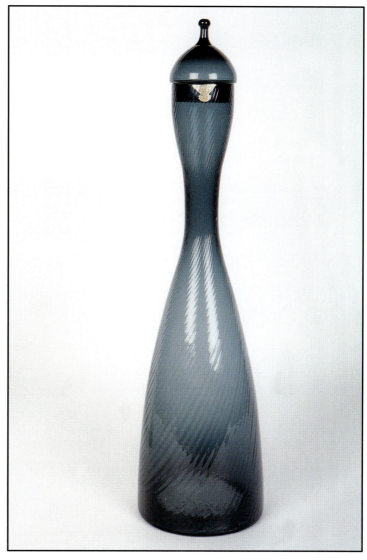

Gullaskruf decanter.

Hourglass form in transparent gray glass, the body accentuated with spiraling ribs, and a dome-like stopper; h. 19-1/4 in. (48.90 cm); retains yellow and gold paper label: GULLASKRUF SWEDEN. $350-425

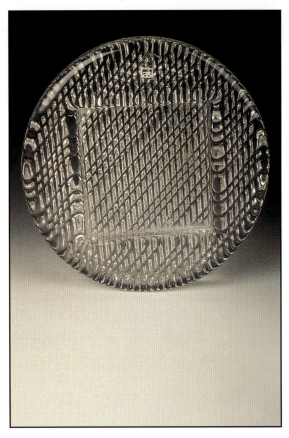

Riihimaen Lasi "Flindari" bowl, designed by Nanny Still in 1963.

Circular form in clear glass with square indentation, the underside textured with a lattice pattern; d. 8 in. (20.32 cm); retains plastic clear and white label: RIIHIMAEN LASI MADE IN FINLAND. $150-200

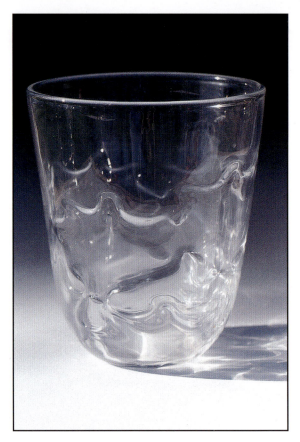

Orrefors vase designed by Edward Hald around 1935.

Slightly flared, blown form in clear glass with areas of irregular thickness that create a design resembling clouds or waves; h.10 in. (25.40 cm); signed OF HU 1462/2. $500-600

Advertisement from the early 1960s featuring Orrefors lamps designed by Carl Fagerlund.

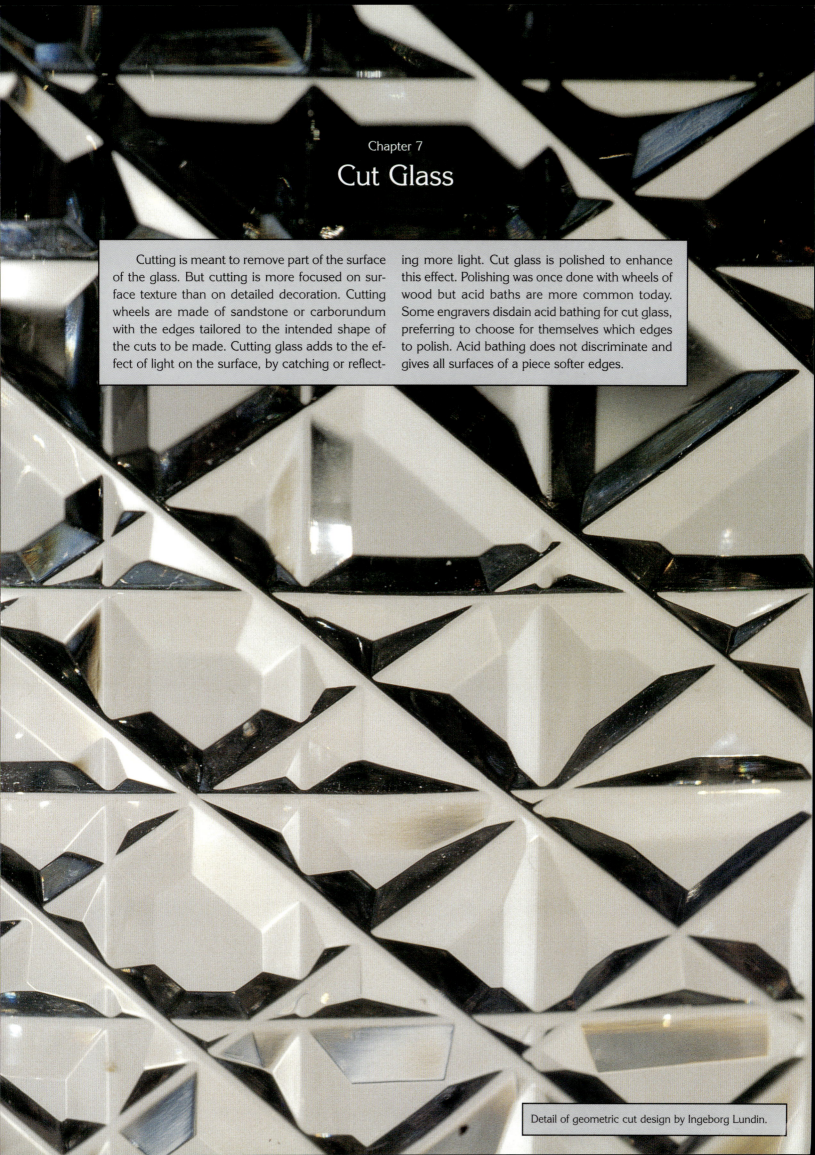

Chapter 7
Cut Glass

Cutting is meant to remove part of the surface of the glass. But cutting is more focused on surface texture than on detailed decoration. Cutting wheels are made of sandstone or carborundum with the edges tailored to the intended shape of the cuts to be made. Cutting glass adds to the effect of light on the surface, by catching or reflecting more light. Cut glass is polished to enhance this effect. Polishing was once done with wheels of wood but acid baths are more common today. Some engravers disdain acid bathing for cut glass, preferring to choose for themselves which edges to polish. Acid bathing does not discriminate and gives all surfaces of a piece softer edges.

Detail of geometric cut design by Ingeborg Lundin.

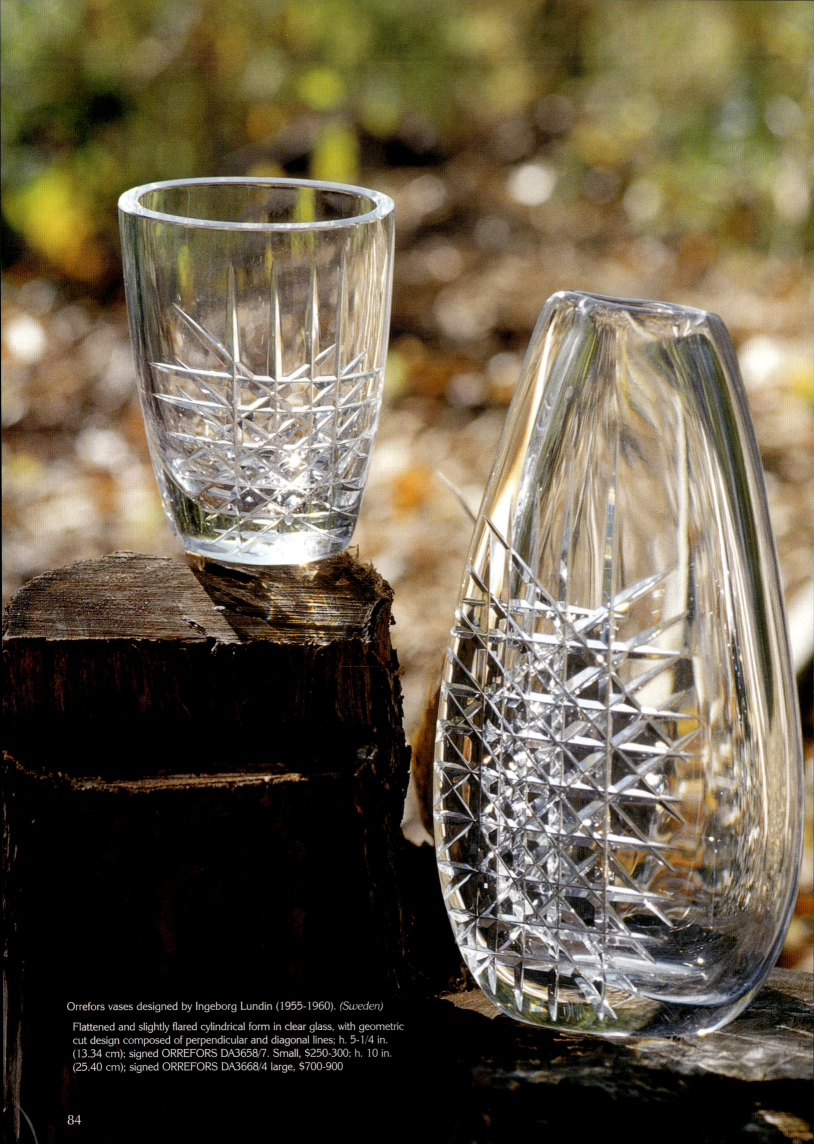

Orrefors vases designed by Ingeborg Lundin (1955-1960). *(Sweden)*

Flattened and slightly flared cylindrical form in clear glass, with geometric cut design composed of perpendicular and diagonal lines; h. 5-1/4 in. (13.34 cm); signed ORREFORS DA3658/7. Small, $250-300; h. 10 in. (25.40 cm); signed ORREFORS DA3668/4 large, $700-900

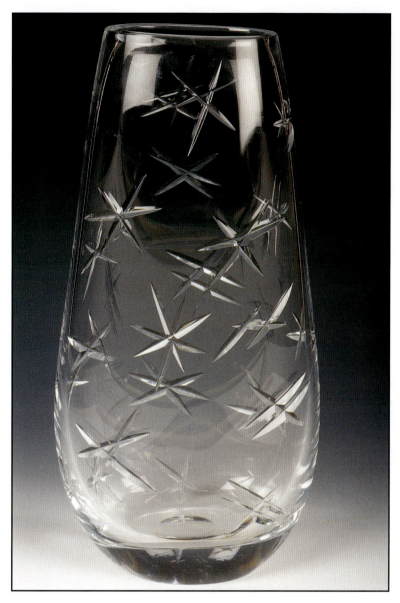

Kosta vase designed by Vicke Lindstrand around 1962.

Bulbous form in clear glass, with randomly spaced miter cuts in star designs; h. 14-1/4 in. (36.20 cm); signed KOSTA LS 692. *Sweden.* $1000-1200

Advertisement from *Form* magazine in 1954, featuring Ekenas cut vases and bowls designed by John Orwar Lake.

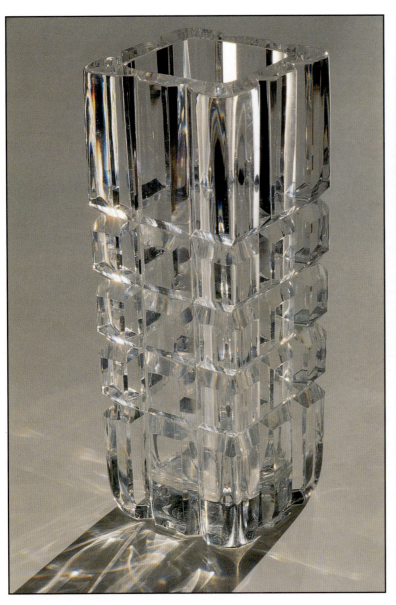

Orrefors vase designed by Sven Palmqvist.

Square form in clear glass with deeply cut horizontal and diagonal lines, which create beveled squares and rectangles: h. 8-1/4 in. (20.95 cm); signed ORREFORS P 4258221. *Sweden.* $500-700

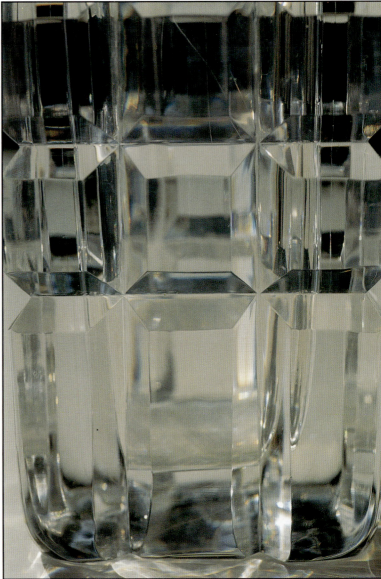

Detail of beveled, square cut design.

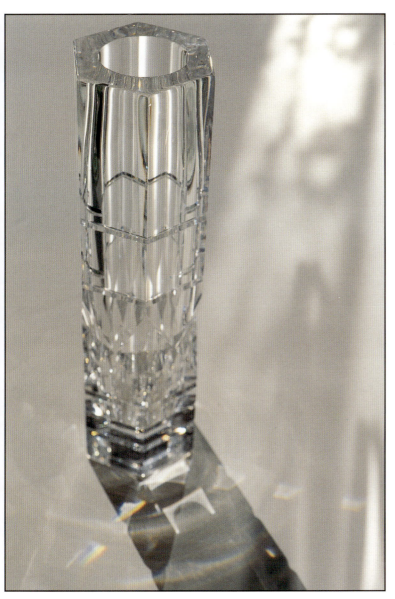

Orrefors vase.

Hexagonal form in clear glass with cut rings and faceted triangular design at midpoint; h. 8-3/4 in. (22.23 cm); signed ORREFORS 4328221. *Sweden.* $300-500

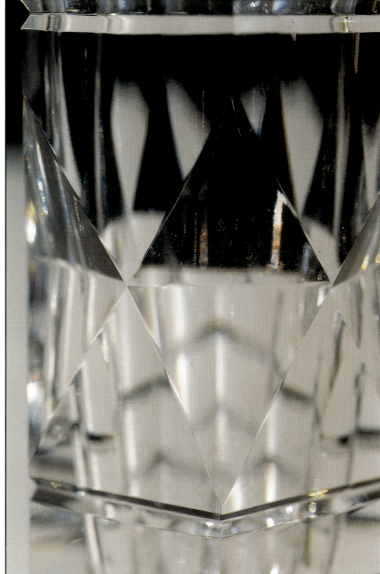

Detail of triangular faceted design.

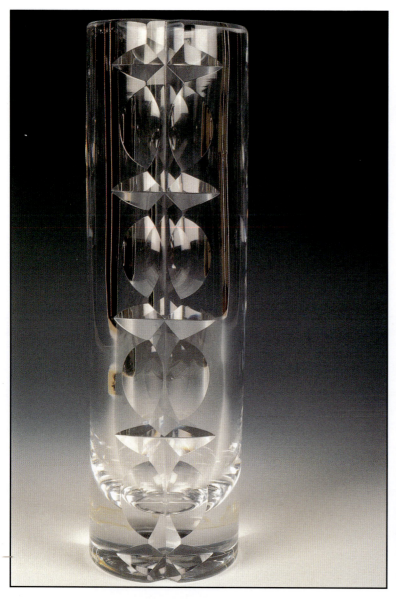

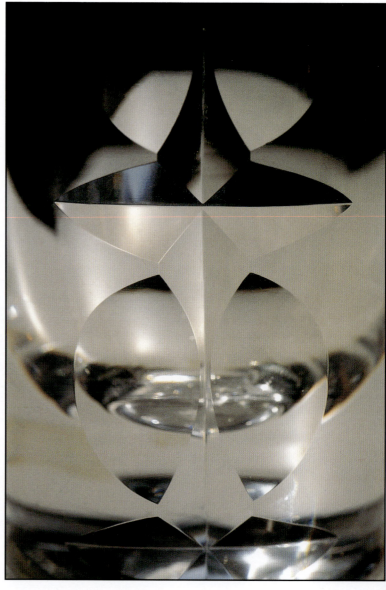

Kosta vase designed by Mona Morales-Schildt in 1962.

Cylindrical form in clear glass with heavily cut and repeating geometric design resembling stars and semi-circles; h. 11 in. (27.94 cm); signed KOSTA 45280 M. SCHILDT. *Sweden.* $1000-1200

Detail of cut geometric design.

Kosta lidded bowl designed by Mona Morales-Schildt in 1962.

Flared form in clear glass, with a heavily cut and repeating geometric design resembling stars and semi-circles, the lid with a cut circle; d. 4 in. (10.16 cm); signed KOSTA SS 5317. *Sweden.* $225-275

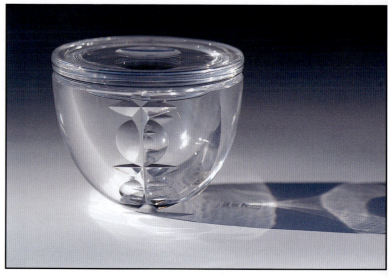

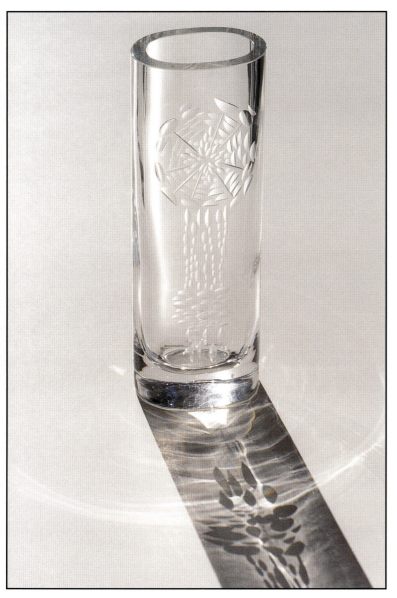

Hadeland vase.

Slightly flattened cylindrical form in clear glass with abstract, freeform cutting resembling a flower in bloom; h. 8-3/4 in. (22.23 cm); signed HADELAND. *Norway.* $250-300

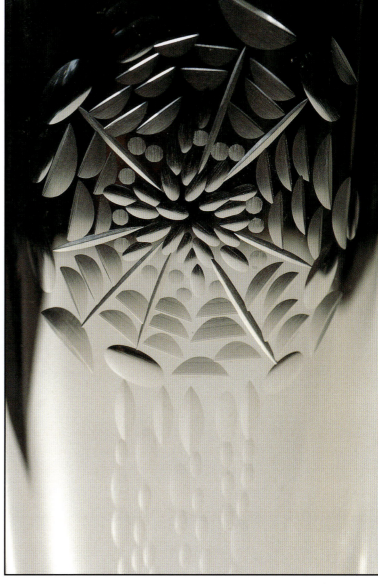

Detail of abstract flower design.

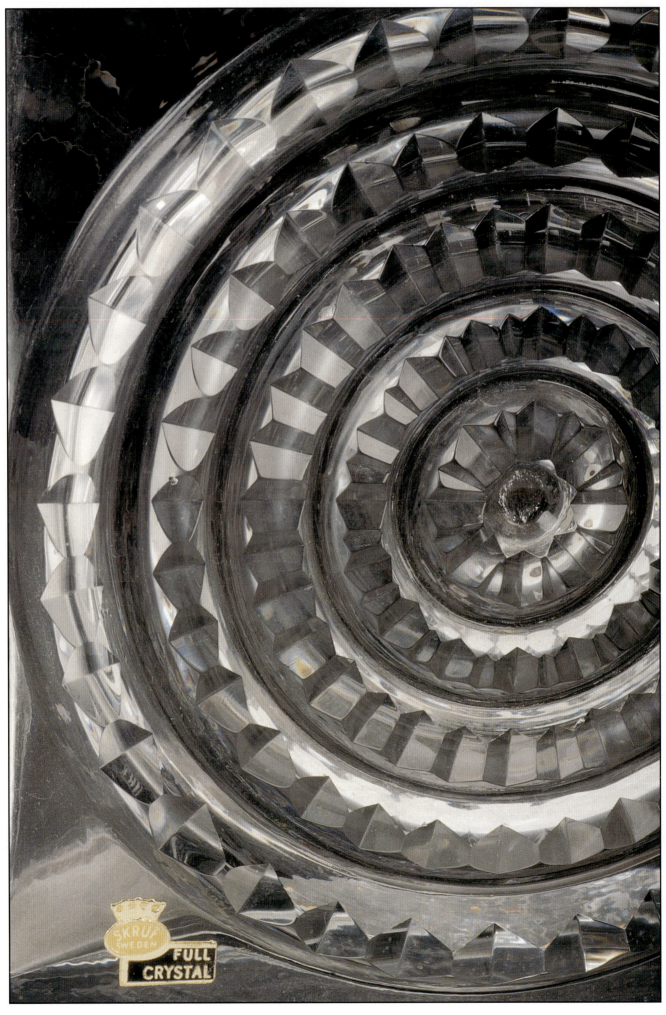

Detail of cut relief.

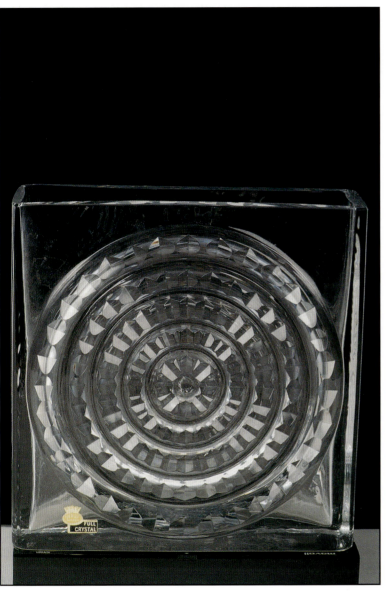
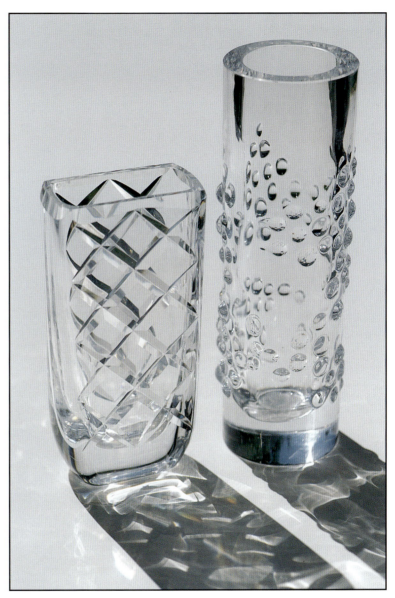

Skruf vase designed by Bengt Edenfalk.

Cube form in clear glass with a molded concentric circle design in relief with cuts along the radius, resulting in a sunburst-like design; h. 7-1/4 in. (18.41 cm); retains black and gold paper label: SKRUF SWEDEN FULL CRYSTAL. $250-300

Skruf vases. *(Sweden)*

Vase attributed to Bengt Edenfalk, of pillow form in clear glass with deep diagonal cuts on two sides, creating a lattice pattern; h. 6-1/2 in. (16.51 cm); signed SKRUF. $175-225

Vase designed by Bengt Edenfalk, of cylindrical form in clear glass, mold-blown, with a relief pattern of small bumps; h. 8-1/2 in. (21.59 cm); signed EDENFALK SKRUF. $125-175

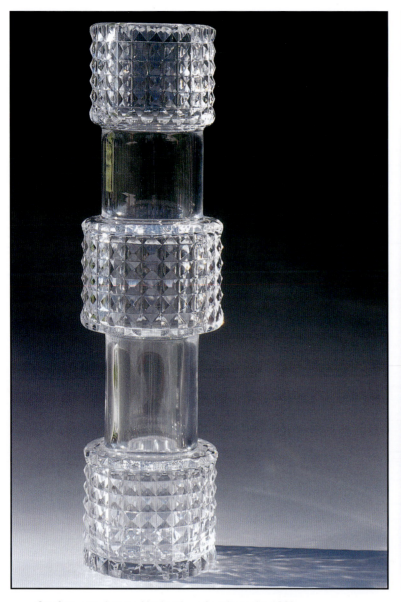
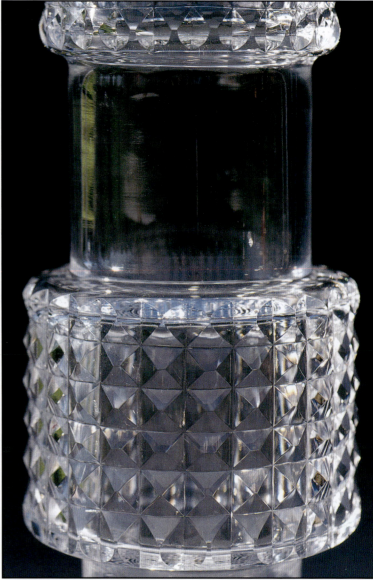

Orrefors vase designed by Ingeborg Lundin in the 1960s.

Cylindrical form in clear glass with three wider rings which are decorated with diamond-like, faceted cutting; h. 16-3/4 in. (42.55 cm); signed ORREFORS DA 3862/2 INGEBORG LUNDIN. *Sweden.* $2000-2500

Courtesy of Nancy Romero

Detail of diamond-like, faceted cutting.

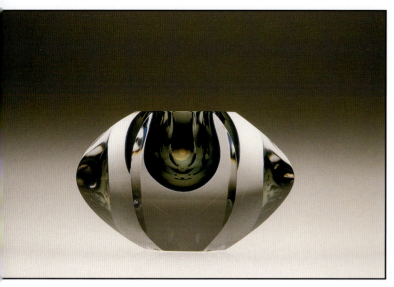
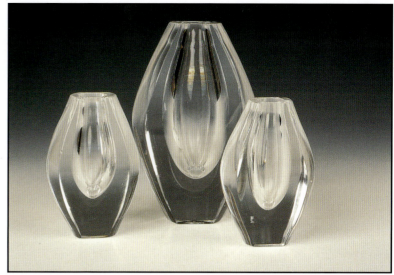

Kosta vase from the "Ventana" series designed by Mona Morales-Schildt in 1963.

Bulbous form with a transparent charcoal gray underlay, cased in clear glass with an optical mirror cut. This treatment adds a visual depth to the piece, which would not be perceived otherwise. *Sweden.* $600-700

Photo courtesy of Kosta Boda

Kosta vases designed by Mona Morales-Schildt in the 1960s.

Bulbous forms in clear glass with a complete surface, optical mirror cut on two sides. Smaller two, h. 3-1/2 in. (8.89 cm); signed KOSTA SS 5331. Larger, 5-1/4 in. (13.34 cm); signed KOSTA SS 222. *Sweden.* $200-350 each, depending on size

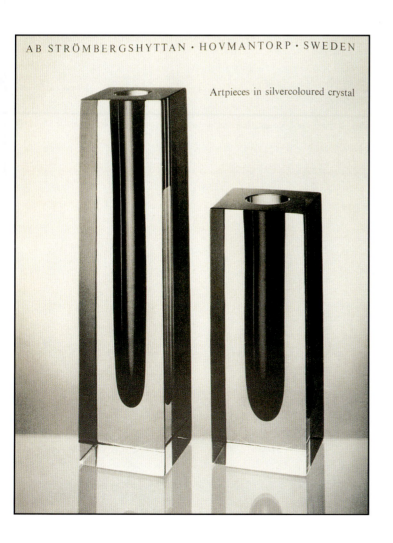

Advertisement from *Kontur* magazine in 1964 featuring Strombergshyttan vases.

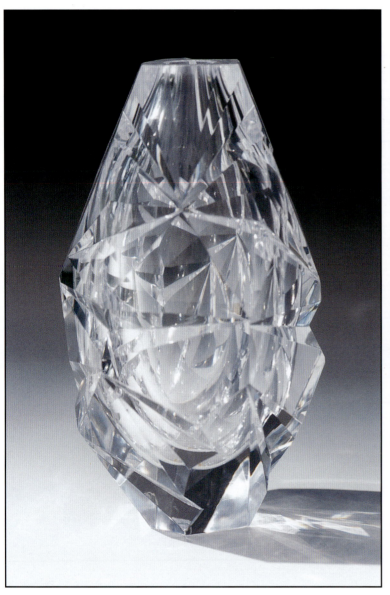 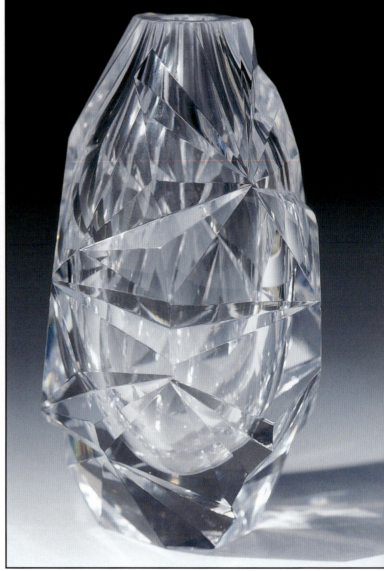

Kosta vase designed by Vicke Lindstrand in the late 1960s.

Bulbous form in clear glass with the surface extensively treated with random linear cuts and mirror cuts, all of different depths and shapes; h. 8-1/2 in. (29.59 cm); signed KOSTA LS 2770. *Sweden.* $1500-2000

Kosta vase by Vicke Lindstrand, photographed from a different angle to demonstrate the intricacy of the cut design.

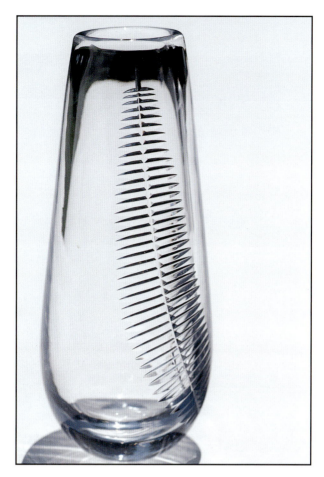

Orrefors vase designed by Sven Palmqvist between 1955 and 1960.

Teardrop form in clear glass with a deeply cut design of a single fern leaf; h. 9-1/2 in. (24.13 cm); signed ORREFORS PA 3634/2. *Sweden*. $500-600

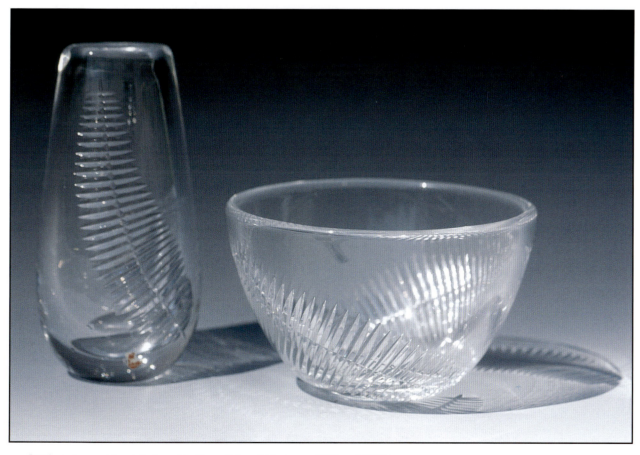

Orrefors vase and bowl designed by Sven Palmqvist between 1955 and 1960.

Teardrop form and flared bowl in clear glass, with deeply cut designs of a fern leaf; h. 7-1/4 in. (18.41 cm), d. 7 in. (17.78 cm); vase signed ORREFORS PA 3634/2, the bowl signed ORREFORS 3634/4. *Sweden*. $400-600 each

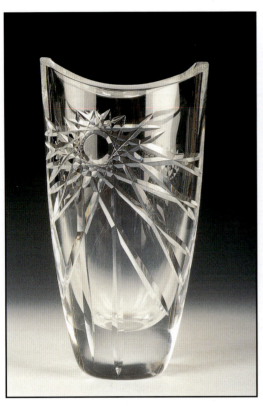
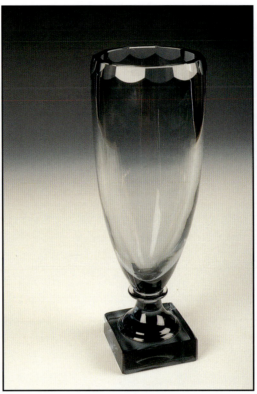

Skruf vase designed by Bengt Edenfalk.

Flat and slightly flared cylindrical form in clear glass, the top cut and beveled, and ending in two points, with an off-center, cut sunburst design on the front; h. 8-1/4 in. (20.95 cm); signed EDENFALK SKRUF ?433. *Sweden*. $500-600

Kosta vase designed by Elis Bergh in 1938.

Chalice form in transparent charcoal blue glass, with a square foot and scalloped cuts around the top rim; h. 10-1/4 in. (26.04 cm); signed KOSTA BH 1353. *Sweden*. $250-300

Kosta "Dark Magic" vase designed by Vicke Lindstrand around 1958.

Slightly bulbous cylindrical form in clear glass, decorated with an internal black spiral and a deep spiral cut along the surface; h. 13 in. (33.02 cm); signed KOSTA LS 602. *Sweden*. $600-800

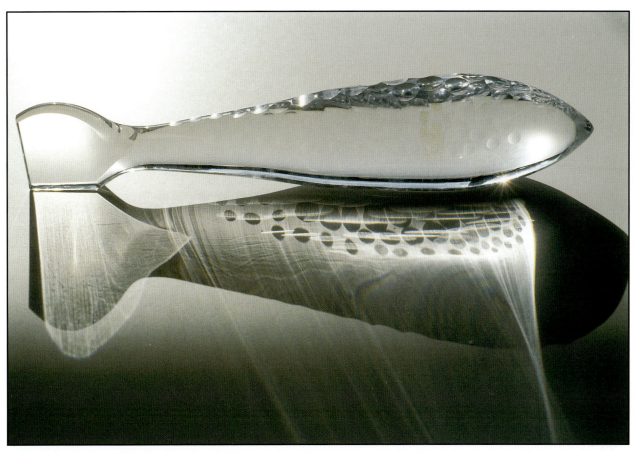

Kosta fish sculpture designed by Vicke Lindstrand.

Stylized fish in clear glass with shallow, round cuttings resembling scales throughout its top; l. 14 in. (35.56 cm); signed KOSTA 96009 VICKE LINDSTRAND. *Sweden.* $500-600

Orrefors perfume bottle, likely designed by Simon Gate.

Perfume bottle with stopper in clear glass with a series of semicircle cuts separated by miter cuts; h. 5 in. (12.70 cm); signed ORREFORS. *Sweden.* $125-175

Chapter 8
Engraved Glass

Engraving is a technique applied to many artistic mediums, but when coupled with the unique canvas of glass, engraving can further and fulfill the dream of the glass artist. The glass and the engraving upon it combine and complement each other.

Copper wheel engraving is the most common type. A copper wheel spins on a spindle with an abrasive, such as emery powder with oil. There are varying sizes of wheels utilized to achieve varying depths and textures on the surface of the glass. The unpolished section of the engraved area is called the "gray" area. Other areas are polished partially or completely, depending on the desired look, to give added texture or depth to the engraved area.

A diamond point can be used for engraving, but this method lacks the range available with changeable copper wheels. However, diamond point engraving does achieve a more textural effect, which is often desired by artists.

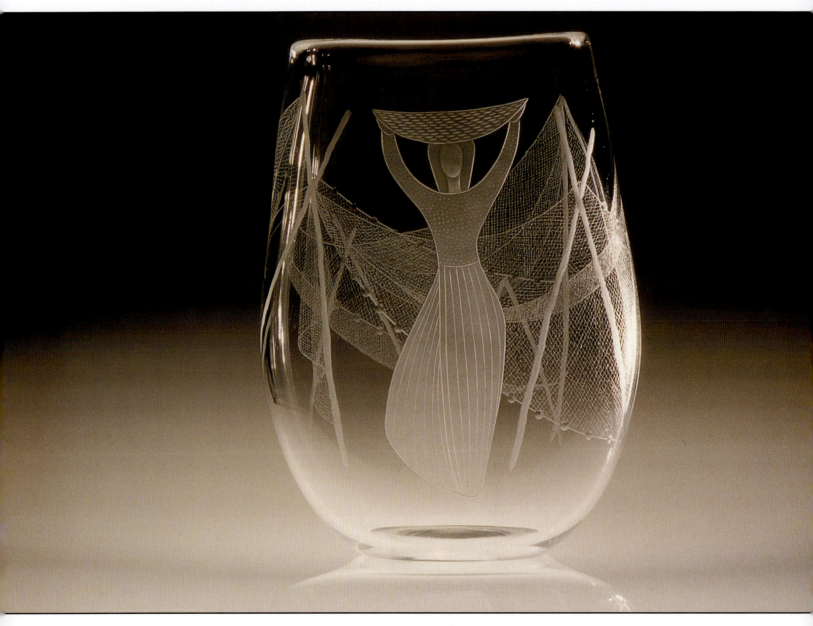

Kosta "Fishing Net" or "After the Haul" vase designed by Vicke Lindstrand in 1951.

Ovoid form in clear glass, flattened on two sides with an intricate, wraparound copper wheel engraving of fishing nets and a woman tending them. *Sweden.* $4000-5000

Photo courtesy of Kosta Boda

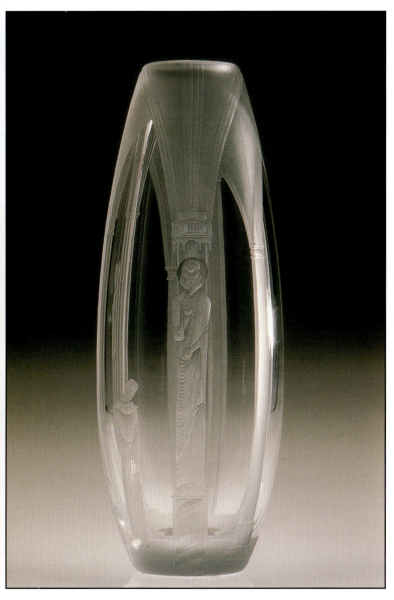

Kosta "The Cathedral" vase designed by Vicke Lindstrand in 1953.

Slightly bulbous cylindrical form in clear glass, with a wraparound copper wheel engraving of columns and arches, and iconic religious figures. *Sweden*. $4000-5000

Photo courtesy of Kosta Boda

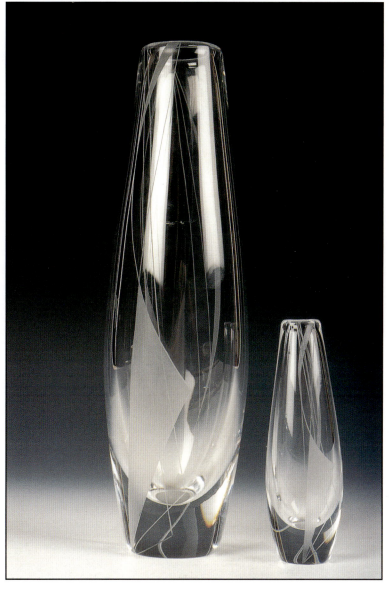

Orrefors vases designed by Sven Palmqvist between late 1955 and 1960.

Slightly bulbous cylindrical forms in clear glass, flattened on two sides, with an abstract curvilinear copper wheel engraving on both sides. Larger, h. 11 in. (27.94 cm); signed OF P3664. C9. Smaller, h. 5-1/4 in. (13.34 cm); signed OF.P.3664.C.6? SWEDEN. Large, $400-500; small, $125-175

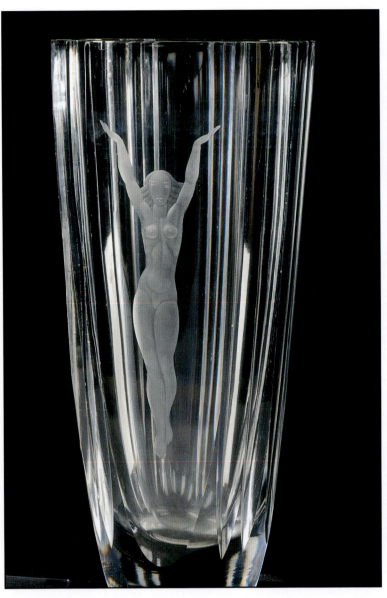

Orrefors vase designed by Vicke Lindstrand in 1936-1937.

Slightly flared and faceted cylindrical form in clear glass, with an engraving of a female nude posing with her arms extended overhead; h. 8 1/5 in. (21.59 cm); signed ORREFORS L1860 A.W.1. *Sweden.* $1500-1700

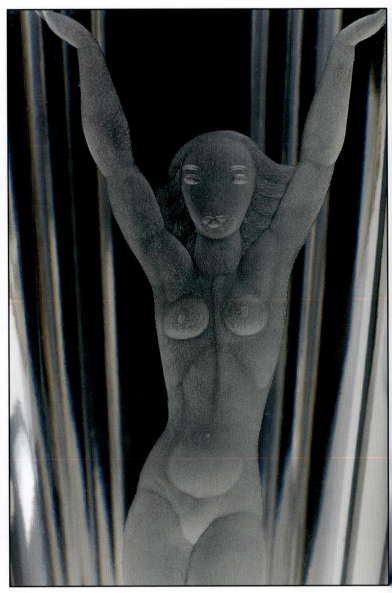

Detail of female nude engraving.

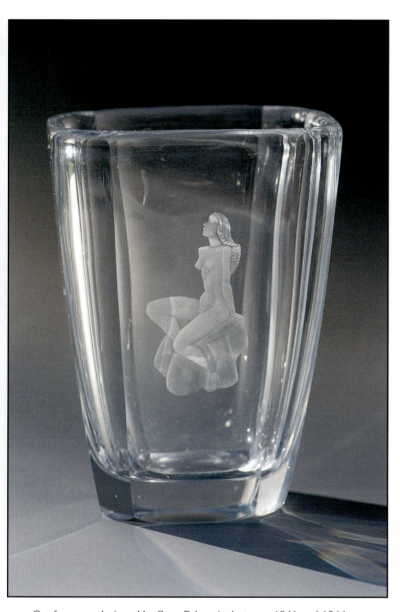

Orrefors vase designed by Sven Palmqvist between 1941 and 1944.

Faceted pillow form in clear glass with an engraving of a female nude sitting on a rock; signed ORREFORS PALMQVIST 2833.536.572. *Sweden.* $500-600

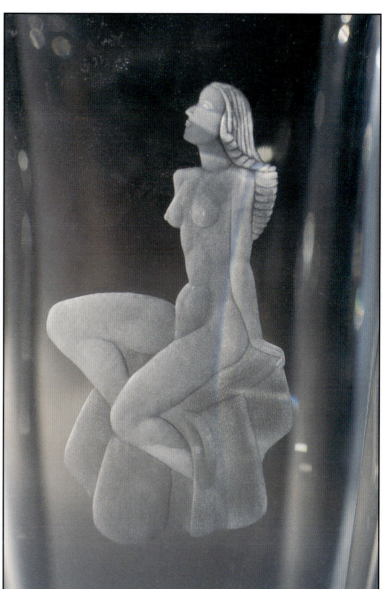

Detail of female nude engraving.

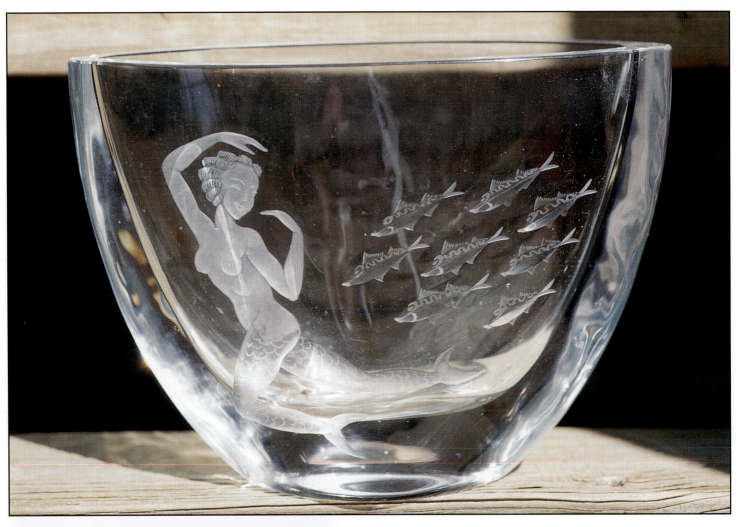

Kjellander vase.

Flared oval form in clear glass, with a copper wheel engraving of a playful nude mermaid swimming with a school of fish; h. 5-1/2 in. (13.97 cm); signed KJELLANDER 556-1619. *Sweden.* $500-600

Although not much information is available about the Kjellander company, we do know that the Kjellander family had been in the business of glass engraving since the 18th century. The legendary engraver at Orrefors, Gustaf Abels, learned the art from Lars Kjellander. The engravings made by the company were intricate and technically precise. They often used diamond point engraving upon copper wheel engravings to give added detail to the images

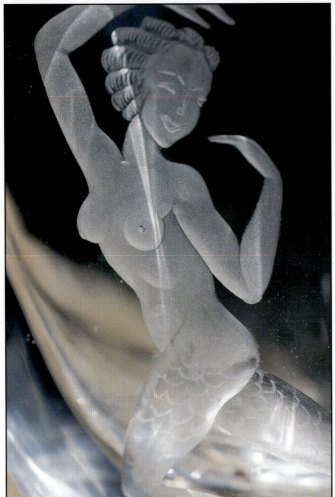

Detail of mermaid engraving.

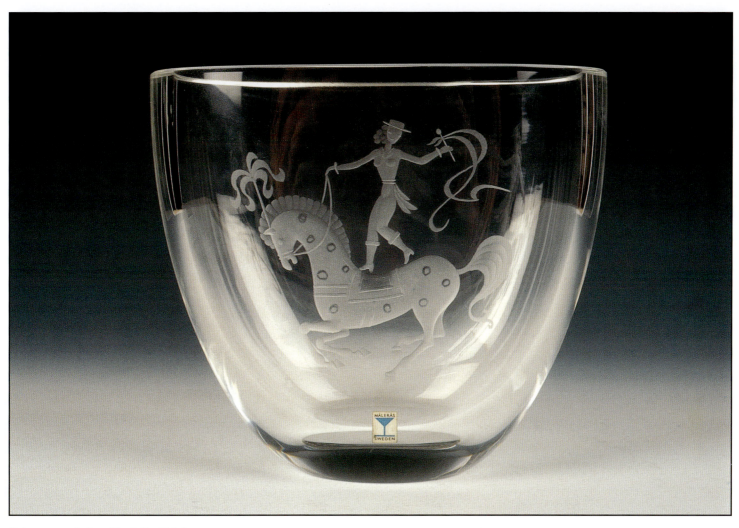

Maleras vase designed by Folke Walwing.

Flared oval form in clear glass, with a copper wheel-engraved circus scene of a woman standing, while riding a horse; h. 6 in. (15.24 cm); retains blue and white paper label: MALERAS SWEDEN; signed MALERAS FW VA SWEDEN. $350-400

Advertisement from *Kontur* magazine in 1964, featuring Orrefors cut and engraved vase, designed by Ingeborg Lundin.

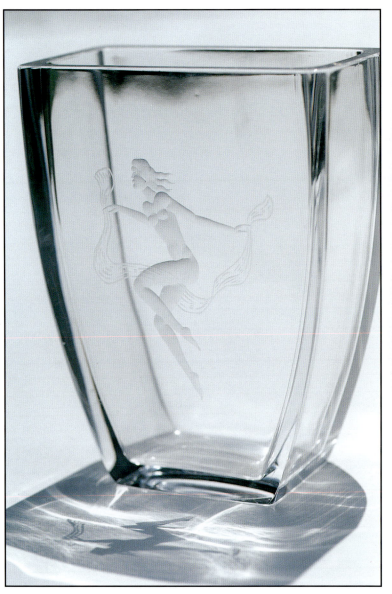

Boda vase.

Slightly flared pillow form in clear glass, with a copper wheel engraving of a female nude, effortlessly floating with a scarf; h. 6-1/2 in. (16.51 cm); signed BODA 1387/596 F.M. *Sweden*. $300-350

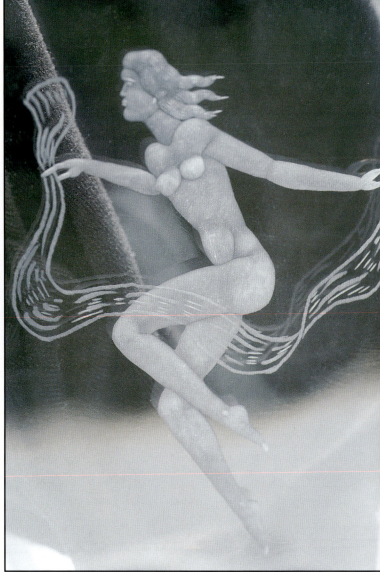

Detail of female nude engraving.

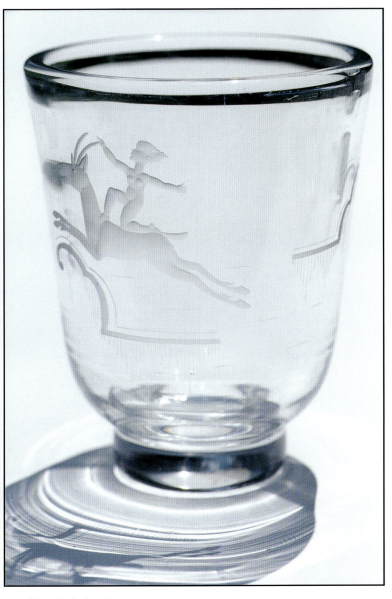

Vase, likely Swedish.

Flared cylindrical form in clear glass with applied foot, decorated with a copper wheel engraving of a female figure riding an antelope; h. 7 in. (17.78 cm); signed W.320.W. $250-300

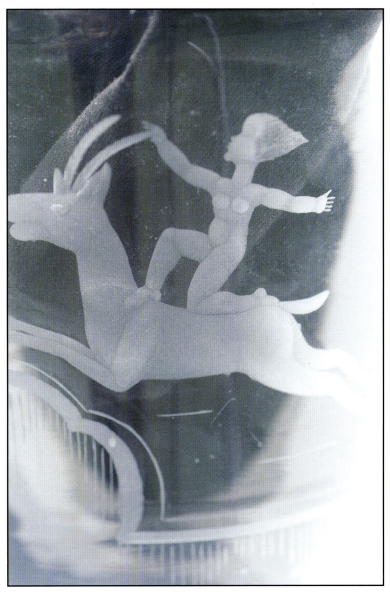

Detail of antelope and female figure engraving.

Kjellander vase.

Flattened oval form in clear glass, with a copper wheel engraved figure of a battling angel with bow and arrow, resting on a cloud; h. 6-1/4 in. (15.88 cm); signed KJELLANDER 189 1966. *Sweden.* $500-600

Boda vase.

Cylindrical form in clear glass, cut and faceted into a hexagonal form, copper wheel engraved with the figure of a madonna and child; h. 7-3/4 in. (19.68 cm); signed BODA 1585/604. *Sweden.* $300-350

Courtesy of Nancy Romero

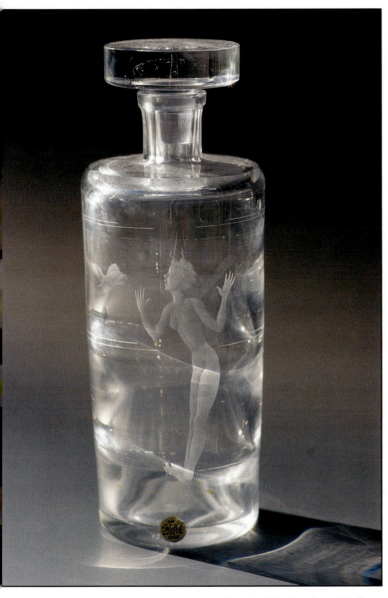 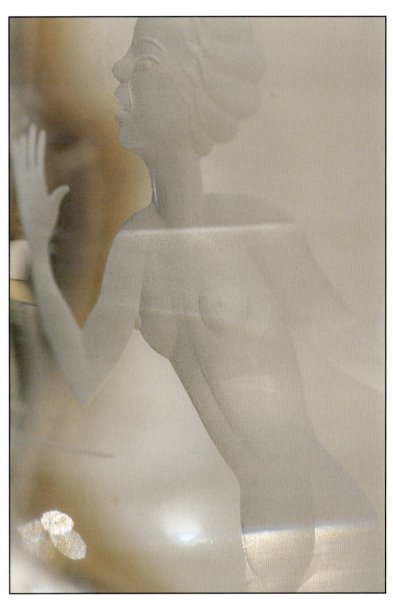

Kosta decanter with underwater scene attributed to Ellis Bergh and likely designed in the early 1940s.

Cylindrical form with internal horizontal optic and stopper in clear glass, with copper wheel engraving of female nude startled by a fish; h. 9-1/4 in. (23.50 cm); signed KOSTA with illegible production number; retains blue and gold paper label: KOSTA SWEDEN 1742. $350-400

Detail of female nude engraving.

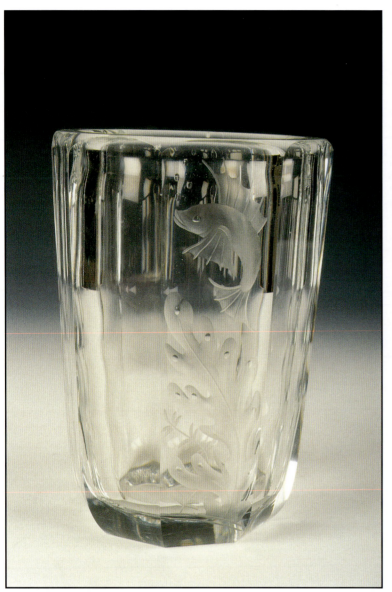

Vase, likely Swedish.

Cut and faceted cylindrical form in clear glass with internal optic, with copper wheel engraving of a fish and seaweed; h. 6 in. (15.24 cm.); signed EW.2H. $300-350

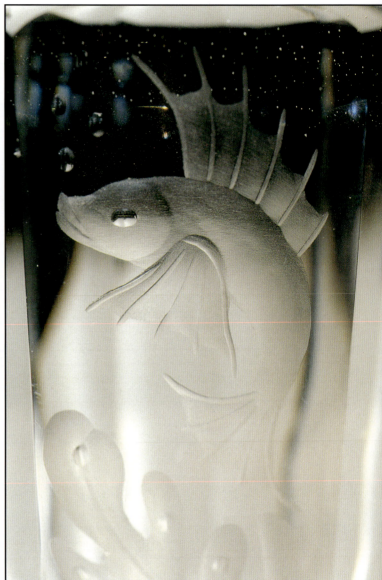

Detail of engraved fish and seaweed.

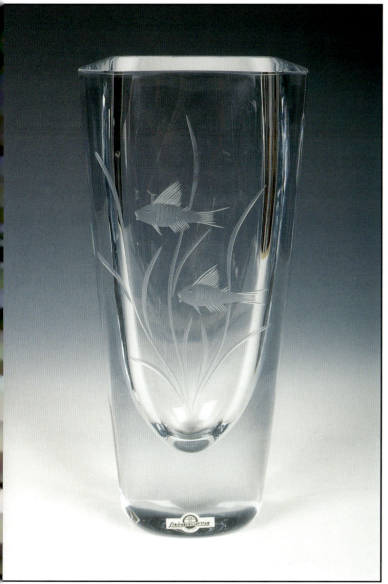

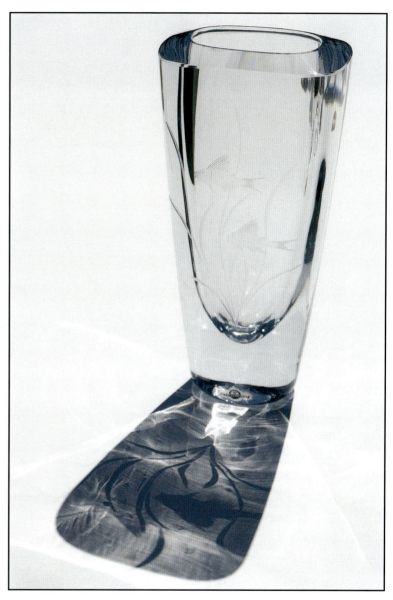

Strombergshyttan vase, likely designed by Asta Stromberg between 1954 and 1960.

Slightly flared and flattened cylindrical form in transparent blue glass, copper wheel engraved with an underwater scene of fish and seaweed; h. 8-1/2 in. (21.59 cm); signed B852 C250; retains plastic black and silver label: STROMBERGSHYTTAN SWEDEN. $350-400

Strombergshyttan vase, photographed to accentuate engraving.

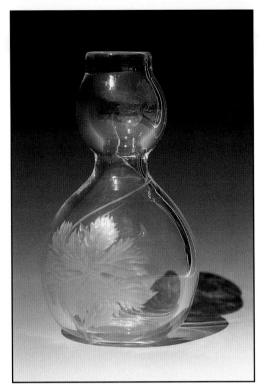

Kosta vase designed by Sigurd Persson and Lisa Bauer in the early 1970s.

Gourd-like form in clear glass, with a wraparound copper wheel engraving of leaves on a twig; h. 9 in. (22.86 cm); signed KOSTA 71/28 SIG P/ BAUER. *Sweden.* $300-350

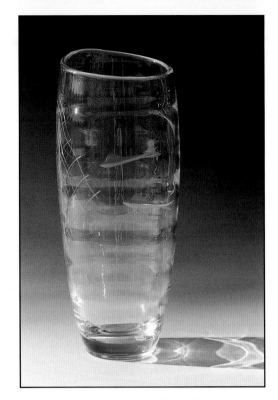

Johansfors vase designed by Bengt Orup in the mid-1950s.

Slightly bulbous cylindrical form with horizontal optic and asymmetrical rim in clear glass, with deeply cut fish and engraving of a net; h. 10-1/2 in.(26.67 cm). *Sweden.* $250-300

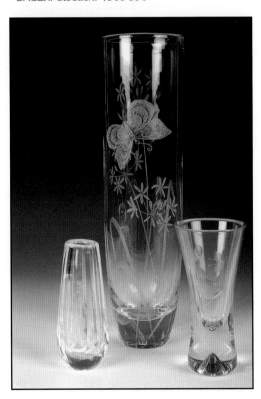

Vases.

Orrefors vase designed by Sven Palmqvist designed between 1941 and 1944; teardrop form in clear glass with mirror cuts on fours sides and a copper wheel engraving of a butterfly and flowering plants; h. 5 in. (12.70 cm); signed OF P2683/111.B?E?. *Sweden.* $150-200

Kosta vase designed by Vicke Lindstrand, likely in the late 1960s; cylindrical form in clear glass, with sandblasted design of a butterfly amidst flowering plants; h. 13-1/4 in. (33.63 cm); signed LG 5639?, retains black and gold plastic label: KOSTA SWEDEN. $250-300

iittala vase designed by Erkki Vesanto, likely designed during the late 1950s or early 1960s; flared cylindrical form in clear glass with a heavily indented base, with a copper wheel engraving of stylized butterflies in flight; h. 6 in. (15.25 cm); signed ERKKI VESANTO ??50. *Finland.* $150-200

Advertisement from *House Beautiful* magazine in 1951, featuring a vase by Strombergshyttan.

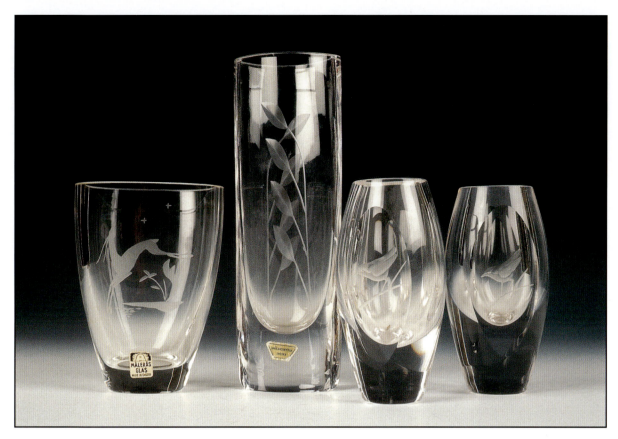

Vases.

Hovmantorp vases; bulbous forms in clear glass, with surface mirror cuts, decorated with a copper wheel engraving of birds on a twig; h. 5 in. (12.70 cm); both signed HOVMANTORP SWEDEN NO.7. $50-100 each

Smalandshyttan vase; flattened cylindrical form in clear glass with deeply cut leaves on twigs, on both sides; h. 7-3/4 in. (19.68 cm); retains blue and gold paper label: SMALANDSHYTTAN SWEDEN. $50-100

Maleras vase; oval form in clear glass with a sandblasted design of an antelope leaping over a bush, under the stars; retains black and white paper label: MALERAS MADE IN SWEDEN. $75-125

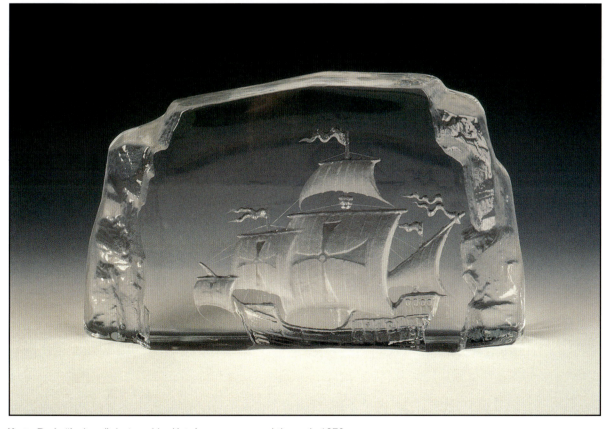

Kosta Boda "Iceberg" designed by Mat Jonasson around the early 1970s.

Mold-blown, ice-like sculpture in clear glass, with a textured relief of a galleon; l. 9-1/4 in. (23.50 cm); signed (illegible) M. JONASSON. *Sweden*. $250-300

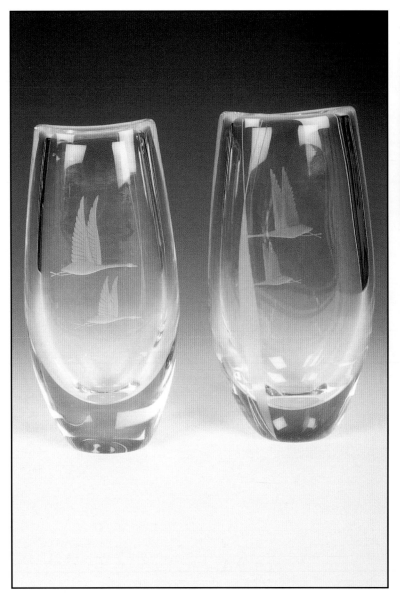 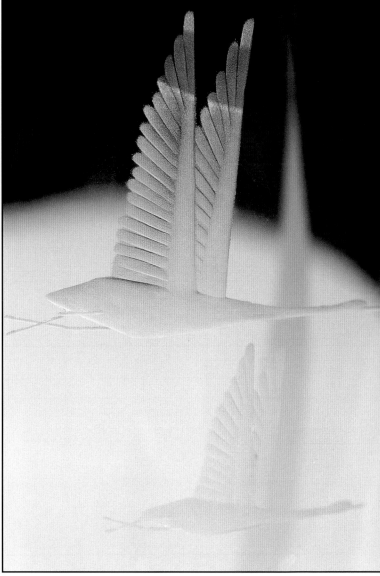

Orrefors vases designed by Sven Palmqvist between 1955 and 1960.

Slightly bulbous forms in clear glass flattened on two sides, copper wheel-engraved with flying geese on one side and a curvilinear design on the other; h. 8 in. (20.32 cm); both signed P.3724.111.D5. *Sweden*. $350-400 each

Detail of engraving of flying geese.

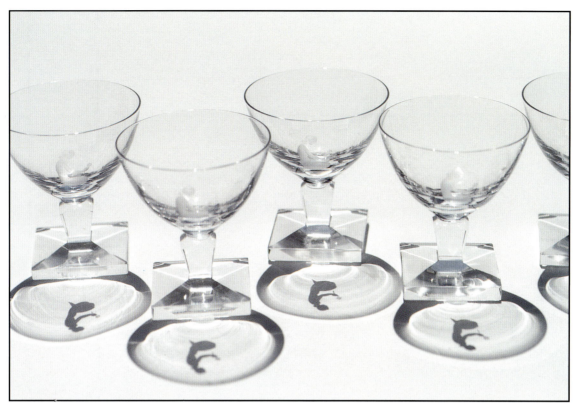

Orrefors cordials designed by Nils Landberg around 1935.

Clear glasses with squared, cut and polished feet and stems, all copper wheel engraved with kneeling female nudes gazing at a bouquet of flowers. The cordials also have sparsely engraved flowers around the bowls; all signed ORREFORS N.1420.C5.0. *Sweden.* $75-125 each

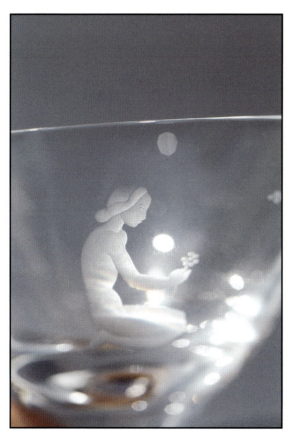

Detail of female nude engraving.

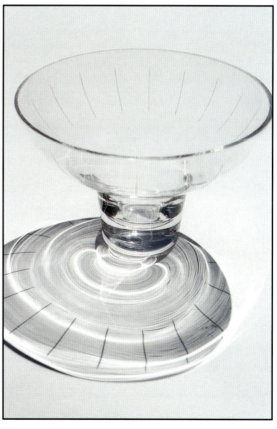

Flygsfors bowl produced in 1964.

Flared form in clear glass, with a wraparound linear engraving; signed FLYGSFORS-64. *Sweden.* $100-150

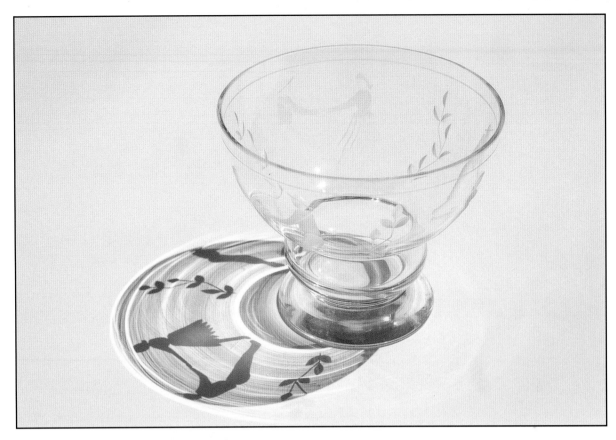

Karhula bowl, likely produced in the late 1940s.

Chalice-like form in clear glass, with provincial scene engravings of couples dancing, and cuttings of leaves; d. 5-1/2 in. (13.97 cm); signed HL KARHULA. *Finland*. $200-250

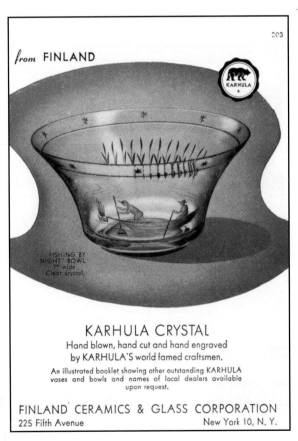

Advertisement from *House Beautiful* magazine in 1948, featuring a Karhula bowl titled "Fishing by Night."

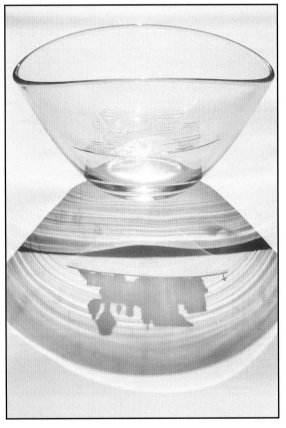

Hadeland bowl.

Oblong form in clear glass with a copper wheel engraving of a train; l.11-3/4 in.(29.84 cm); signed HADELAND J. CUMMINGS ENGRAVER. *Norway*. $175-225

Orrefors "Wish to the Moon" vase designed by Edvin Ohrstrom between 1941 and 1944.

Hexagonal pillow form with a copper wheel engraved etching of a girl looking at the stars (etched in the back side); h. 4-1/4 in. (10.79 cm); signed ORREFORS P 2769.C.9.AR. *Sweden.* $300-400

This vase has the distinction of being one of Orrefors' biggest seller of all time.

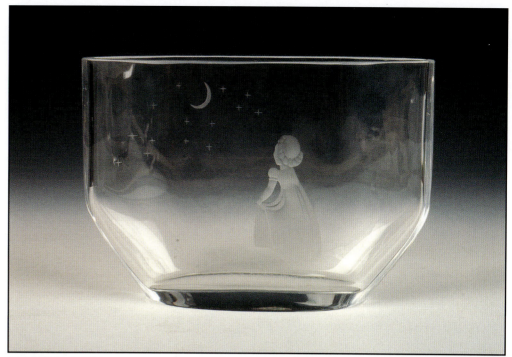

Advertisement from *Form* magazine in 1953, featuring Orrefors engraved vase and bowl, designed by Edvin Ohrstrom.

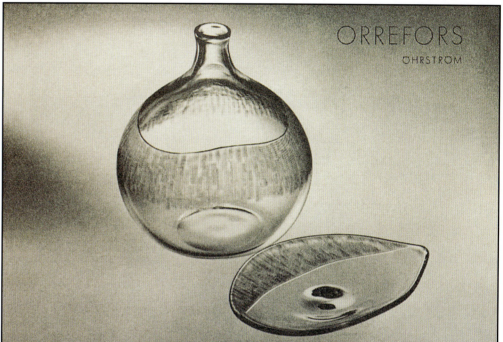

Kosta bowl designed by Ann and Goran Warff, likely in the late 1960s.

Molded and flared form in clear glass with a heavy rim, diamond point-engraved with the figure of a duck surrounded by a primitive pattern design; d. 7.5 in. (19.05 cm); signed KOSTA 55683. *Sweden.* $250-300

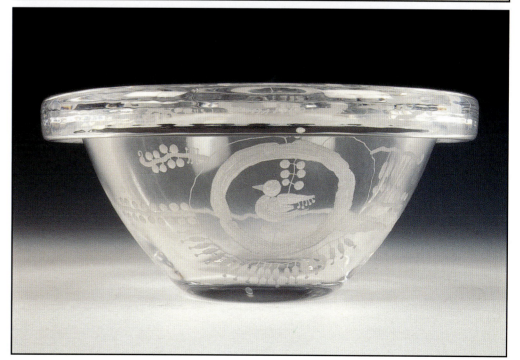

115

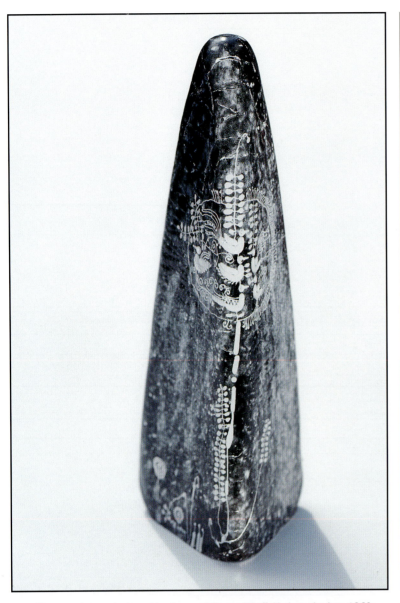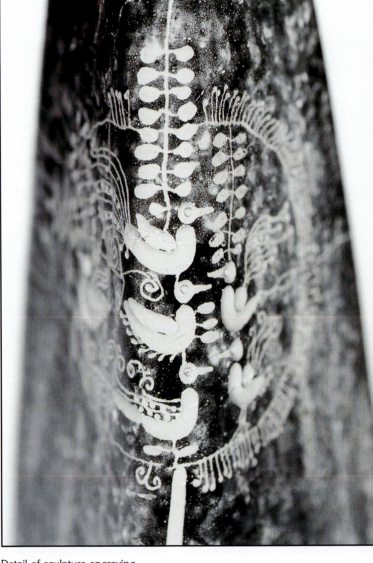

Kosta sculpture designed by Ann and Goran Warff, likely in the late 1960s.

Rock-like form in clear glass, with the surface treated to create texture and smoke-like patina, with diamond point primitive engravings resembling early pictographs found in caves; signed KOSTA WARFF (illegible numbers). *Sweden.* $1250-1500

Detail of sculpture engraving.

Chapter 9
Figural Glass

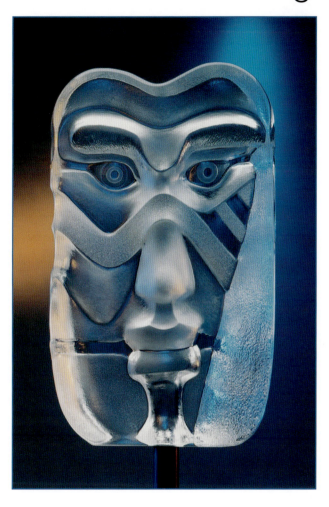

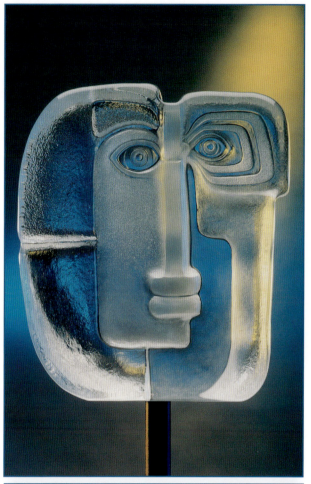

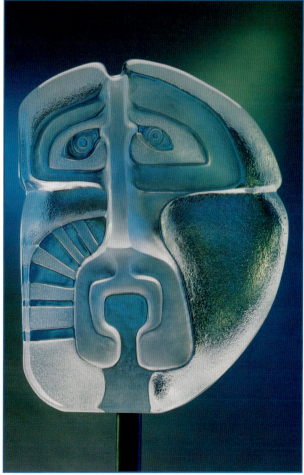

Above:
Mats Jonasson Maleras "Rawr" sculpture from the "Totem" series, designed by Mats Jonasson.

Mold-blown, clear glass sculpture with different textured effects, evocative of tribal imagery. This series is currently in production. *Sweden.* $275-325

Photo courtesy of Mats Jonasson Maleras

Top Right:
Mats Jonasson Maleras "Molok" sculpture from the "Totem" series, designed by Mats Jonasson. *Sweden.* $275-325

Photo courtesy of Mats Jonasson Maleras

Right:
Mats Jonasson Maleras "Oioi" sculpture from the "Totem" series, designed by Mats Jonasson. *Sweden.* $275-325

Photo courtesy of Mats Jonasson Maleras

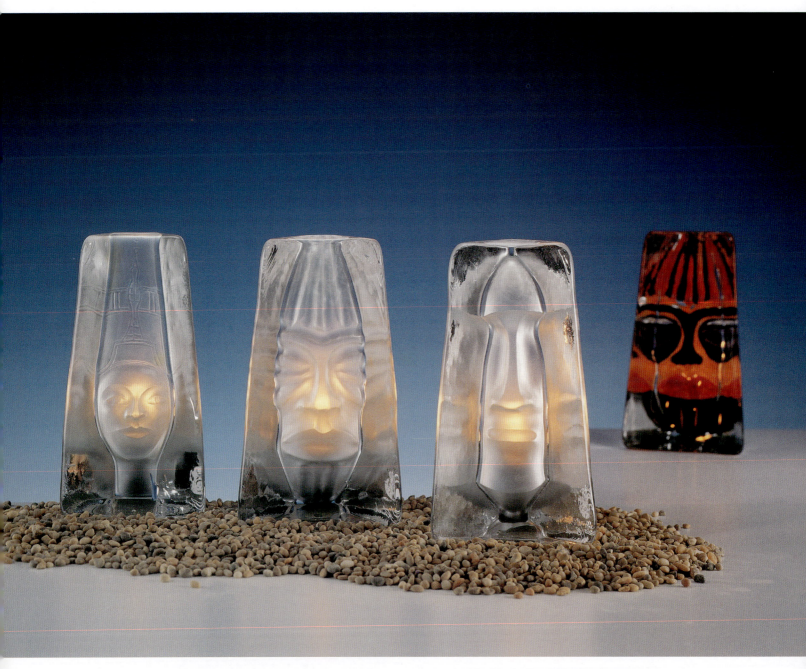

Sea Glasbruk frosted clear glass candleholders from the "Moai" series, named "Nefertite," "Mask," and "Paskon," designed by Renate Stock in 2000, and still in production. *Sweden*. $40-65 each

Photo courtesy of Sea Glasbruk

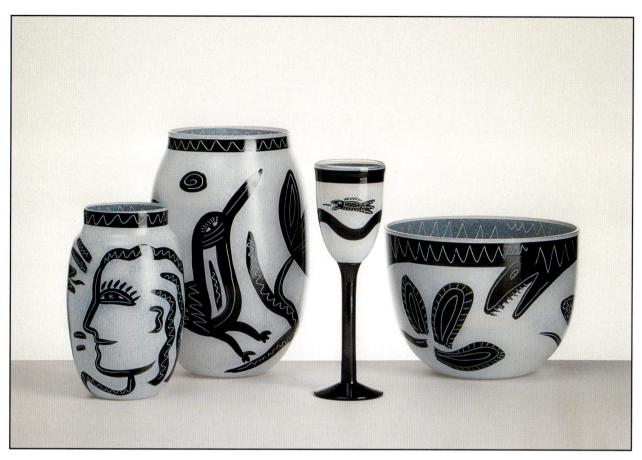

Kosta Boda vases, bowl and wine glasses from the "Caramba" series designed by Ulrica Hydman-Vallien in 1987, in opaque white glass, decorated with primitive, hand painted, enameled decorations of people, animals, and plants. This series is still in production. *Sweden.* $75-300 each

Photo courtesy of Kosta Boda

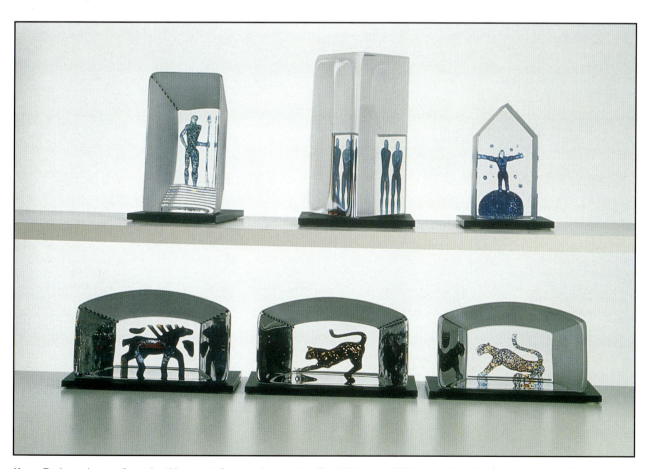

Kosta Boda sculptures from the "Viewpoints" series designed by Bertil Vallien in 1995, consisting of human and animal forms in colored glass encased by geometric forms in clear glass. This series is still in production. *Sweden.* $275-500 each

Photo courtesy of Kosta Boda

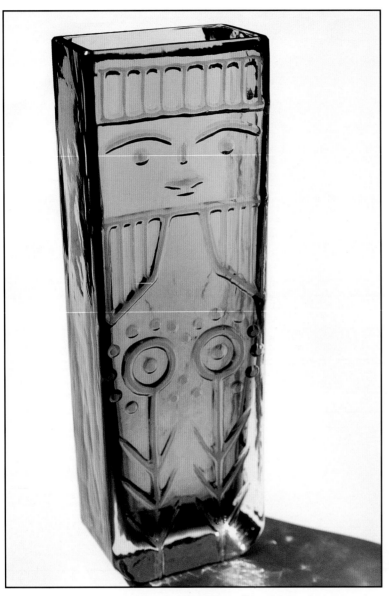 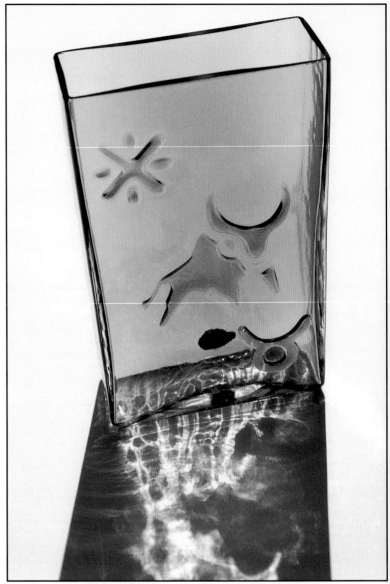

Flygsfors vase designed by Wiktor Berndt in 1960.

Molded pillow form with a transparent gray glass underlay, cased in clear glass, with a ground surface relief of a stylized female nude, her breasts skillfully disguised as blooming flowers; h. 9-3/4 in. (24.77 cm); signed FLYGSFORS-60 BERNDT. *Sweden*. $350-400

Flygsfors vase designed by Wiktor Berndt around 1960.

Molded pillow form with a transparent gray glass underlay, cased in clear glass, with a ground abstract surface relief depicting bulls under the sun; h. 7-3/4 in. (19.68 cm); signed FLYGSFORS 61 BERNDT; retains red and gold foil paper label: FLYGSFORS SWEDEN. $350-400

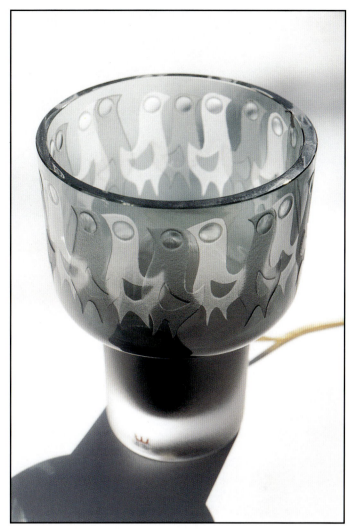

Kosta lamp designed by Ove Sandeberg, likely in the late 1960s.

Modern gray glass form, sandblasted inside and out, with engraved decoration of birds; h. 8 in.(20.32 cm); signed Kosta 10540 SANDEBERG. *Sweden*. $800-1000

Courtesy of Michael Ellison

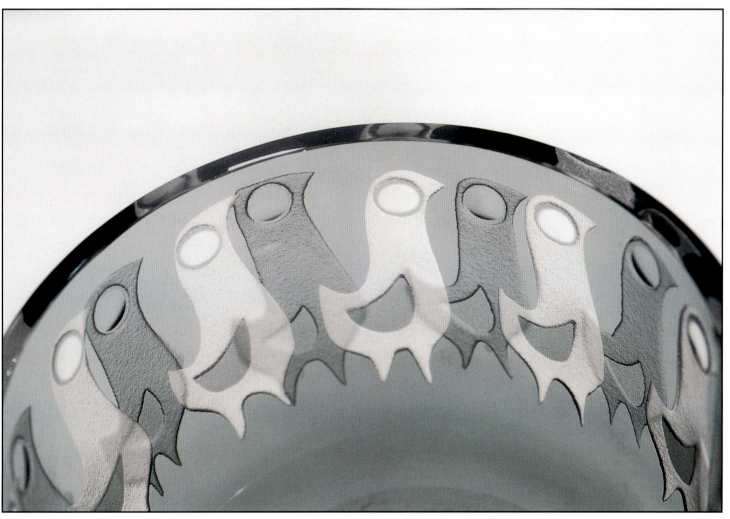

Detail of Kosta lamp.

iittala Spotted Crake bird figure designed by Oiva Toikka and produced since 2001. *Finland.* $90-125

Photo by Timo Kauppila courtesy of iittala

iittala Dotterel bird figure designed by Oiva Toikka and produced since 1996. *Finland.* $90-125

Photo by Timo Kauppila courtesy of iittala

iittala Arctic Tern "2000 millennium" bird figure designed by Oiva Toikka and still produced. *Finland.* $150-200

Photo by Timo Kauppila courtesy of iittala

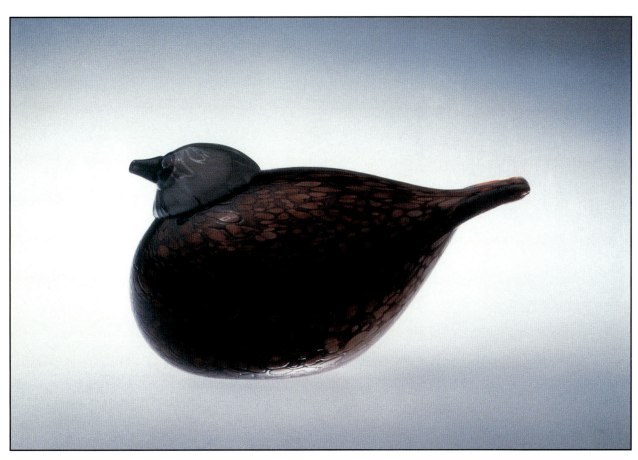

iittala Rosy Finch bird figure designed by Oiva Toikka and produced since 2001. *Finland.* $90-125

Photo by Timo Kauppila courtesy of iittala

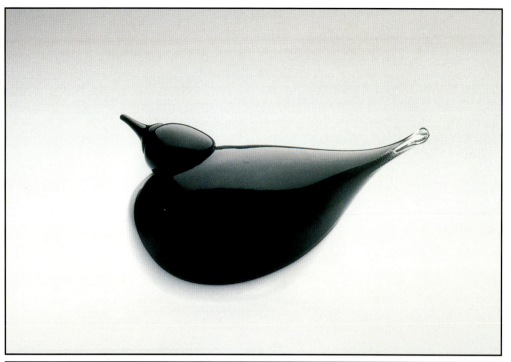

iittala Dipper bird figure designed by Oiva Toikka and produced since 1998. *Finland.* $150-200

Photo by Timo Kauppila courtesy of iittala

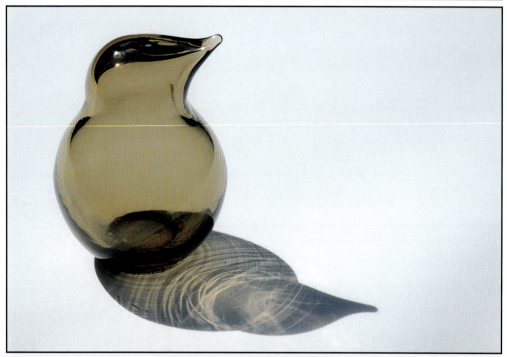

Riihimaen Lasi minimalist bird figure in amber glass designed by Sakari Pykala in the 1950s; h. 3-1/2 in. (8.89 cm); signed RIIHIMAEN LASI OY SAKARI PIKALA. *Finland.* $75-125

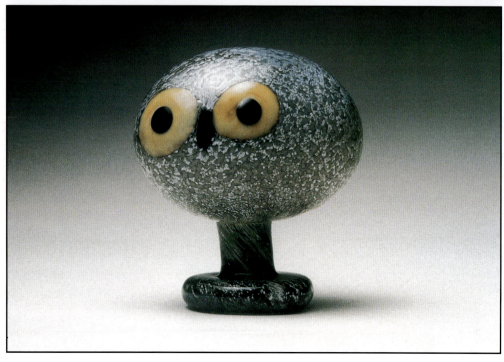

iittala owl figure designed by Oiva Toikka. *Finland.* $125-175

Photo by Timo Kauppila courtesy of iittala

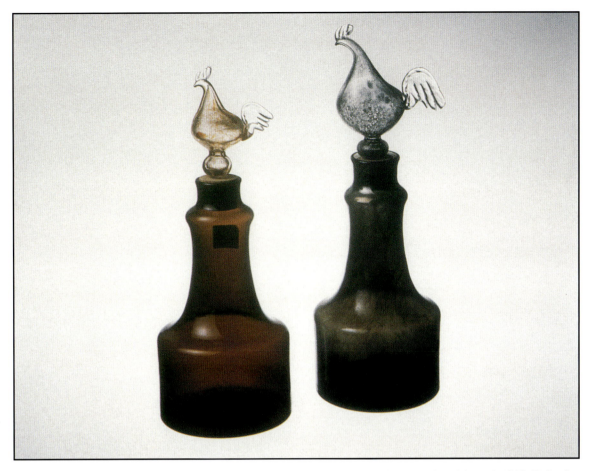

Nuutajarvi Notsjo decanters with rooster stoppers designed by Kaj Frank in 1958 and produced through 1968. *Finland.* $900-1200 each

Photo by Timo Kauppila courtesy of iittala

Penguin figurines in opaque black and white glass, cased in clear glass, possibly produced by FM Konstglas and designed by the Marcolin brothers; h. 4-1/2 in. (11.43 cm), h. 7-1/2 in. (19.05 cm); both retain white and blue paper label: MADE IN SWEDEN. $50-125 each

Kumela stylized cat and duck figurines with conical bodies in opaque glass, and clear glass heads with applied features, designed by Armado Jacobino; both signed OY KUMELA JACOBINO; one retains black and gold paper label: KUMELA RIIHIMAKI MADE IN FINLAND. $150-200 each

Bird and cat figures.

Nuutajarvi Notsjo bird with transparent green body and orange beak designed by Oiva Toikka; h. 2-1/2 in. (6.35 cm); signed OIVA TOIKKA NUUTAJARVI NOTSJO; retain silver and black paper label: ARABIA WARTSILA FINLAND. $150-200

Gullaskruf minimalist cat figure in clear glass with applied green glass eyes; h. 4-1/4 in. (11.43 cm); retains gold and yellow paper label: GULLASKRUF SWEDEN. $75-125

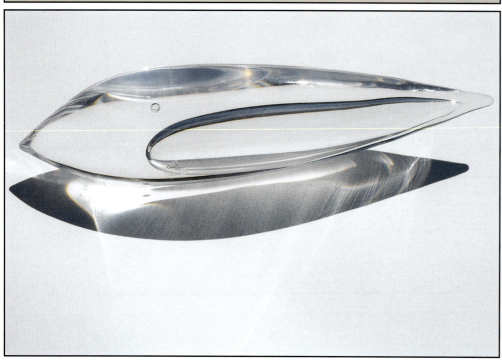

Kosta streamlined fish figure in clear glass with trapped air bubbles designed by Vicke Lindstrand around 1962; l. 8-3/4 in. (21.18 cm); signed KOSTA LH 1623. SWEDEN. $250-300

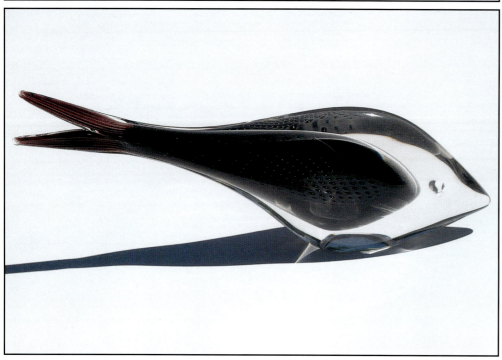

FM Konstglas fish with an opaque gauze-like, gray glass underlay and controlled bubbles, cased in clear glass designed by the Marcolin brothers; l. 11-1/2 in. (29.21 cm). *Sweden.* $175-225

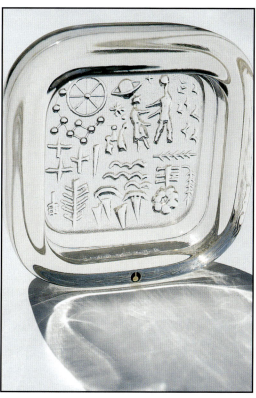
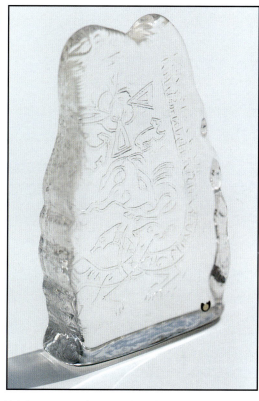

Kosta 1971 commemorative paperweight shaped as a man with a top hat and a gold painted suit; h. 6-1/4 in. (15.88 cm); signed KOSTA 1971 FAR. *Sweden*. $75-125

Pukeberg cast bowl in clear glass with an abstract relief composed of human figures, birds, planets, plants, etc.; l. 8-1/2 in. (21.59 cm); retains black and white plastic label: PUKEBERG SWEDEN. $75-125

Pukeberg cast sculpture in clear glass, resembling a block of ice, with a series of primitive, tribal-like designs of reptiles; h. 5-1/2 in. (13.97 cm); retains black and white plastic label: PUKEBERG SWEDEN. $100-150

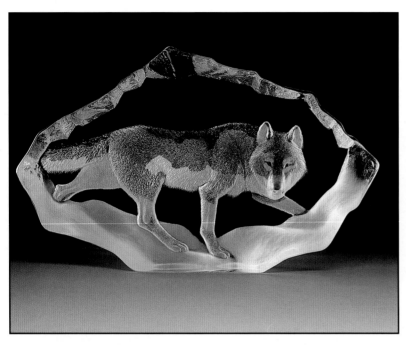

Mats Jonasson Maleras "Wolf" sculpture designed by Mats Jonasson in 2000, in a limited edition.

Ice-like block with irregular edges in clear glass, with a life-like relief of a wolf in movement; l. 12 in. *Sweden.* $600-800

Photo courtesy of Mats Jonasson Maleras

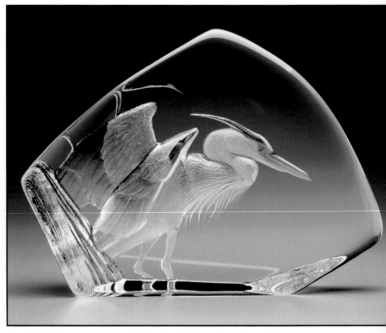

Mats Jonasson Maleras "Heron" sculpture from the "Nordic Birds" designed by Mats Jonasson. l. 6-1/2 in. (16.51 cm). *Sweden.* $125-175

Photo courtesy of Mats Jonasson Maleras

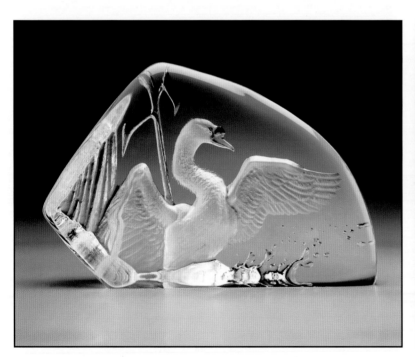

Mats Jonasson Maleras "Swan" sculpture from the "Nordic Birds" series designed by Mats Jonasson; l. 5-1/2 in (13.97 cm). *Sweden.* $75-100

Photo courtesy of Mats Jonasson Maleras

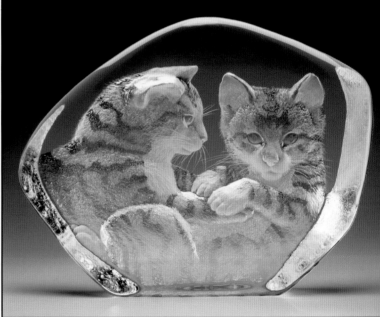

Mats Jonasson Maleras "Playing" cat sculpture form the "Man's Best Friend" series designed by Mats Jonasson; l. 8-3/4 in. (9.53 cm). *Sweden.* $250-350

Photo courtesy of Mats Jonasson Maleras

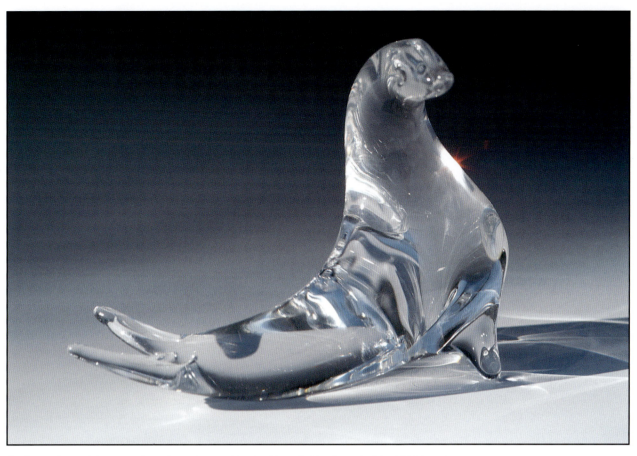

FM Konstglas seal figure in clear glass, designed by the Marcolin Brothers; h. 6 in. (15.24 cm.); signed FM RONNEBY SWEDEN. $150-200

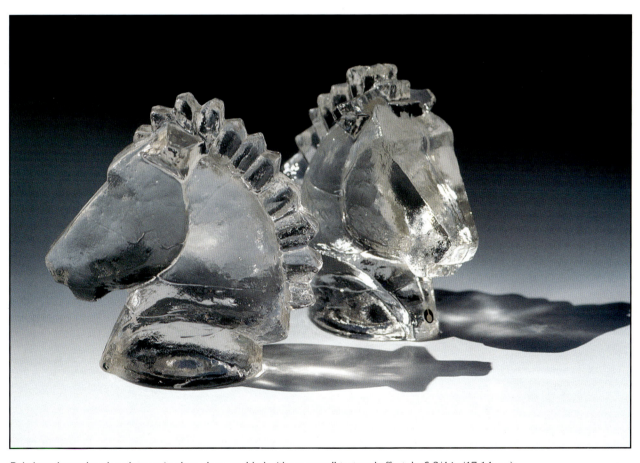

Pukeberg horse head sculptures in clear glass, molded with an overall textured effect; h. 6-3/4 in.(17.14 cm); retains black and white plastic label: PUKEBERG SWEDEN. $75-125 each

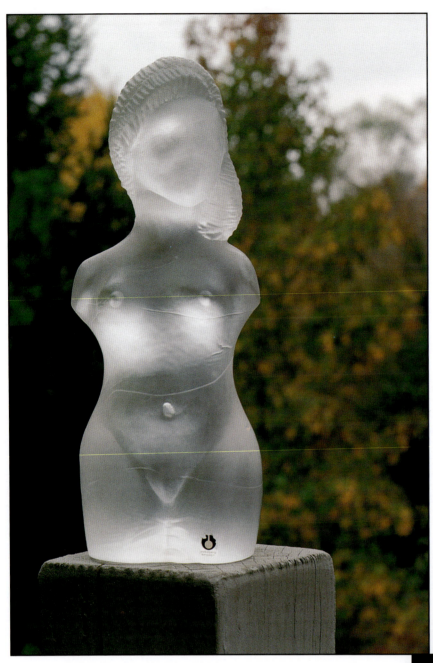

Pukeberg cast female nude sculpture in clear glass with a sandblasted surface designed by Uno Westerberg; h. 7-3/4 in. (19.68 cm); retains black and white cellophane label: PUKEBERG SWEDEN, retains cellophane designer label: DESIGN UNO WESTERBERG. $200-250

Mats Jonasson Maleras "Glinda" sculpture from the "Artemiss" series designed by Erika Hoglund; h. 10 in. (25.40 cm). *Sweden.* $300-450

Photo courtesy of Mats Jonasson Maleras

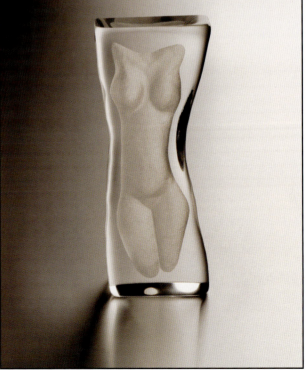

Chapter 10
Tableware

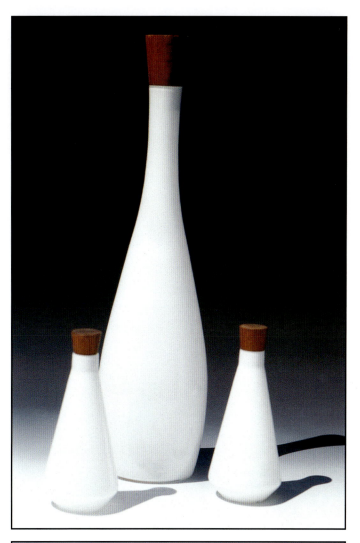

Kastrup decanter and oil and vinegar bottles in milky opaline glass with teak stoppers, designed by Jacob Bang in the early 1960s.
Bottles, h. 7-1/4 in. (18.41 cm); retain paper label: KASTRUP GLAS MADE IN DENMARK. Decanter, h. 19 in. (48.26 cm); retains paper label: RAYMOR 7652 KAS. *Denmark*. Bottles, $100-150 each; decanter, $300-350

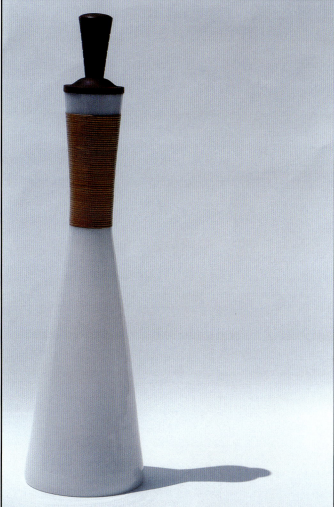

Kastrup decanter in opaline white glass, the neck bound with raffia canes, with teak stopper, designed by Jacob Bang in 1960; h. 19 in. (48.26 cm). *Denmark*. $400-500

131

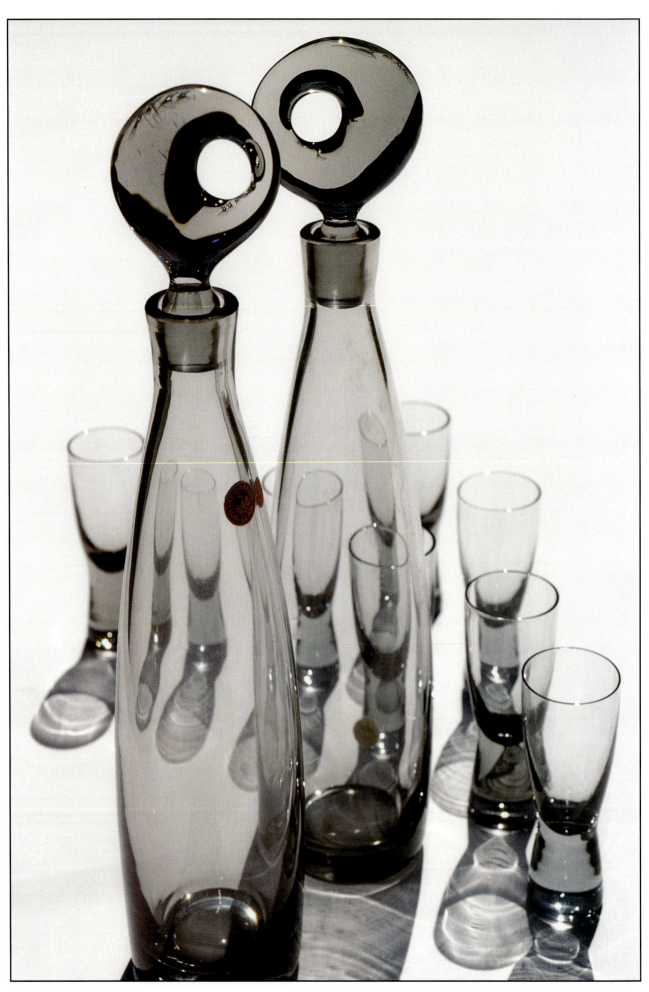

Holmegaard transparent smoke glass "Aristocrat" decanters with cut-out stoppers, designed by Per Lutken in 1956, and "Canada" wine glasses; h. (decanter) 14-3/4 in. (37.47 cm); one decanter retains the original red and white, swan and crown paper label: HOLMEGAARD MADE IN DENMARK BY APPOINTMENT TO HIS MAJESTY THE KING OF DENMARK. Glasses, $25-35 each; decanters, $200-250 each

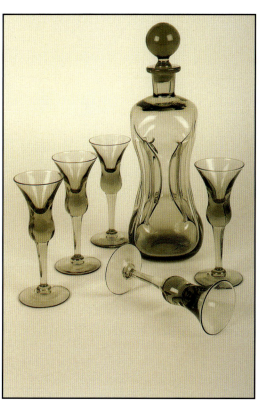 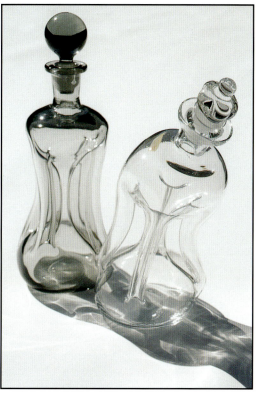 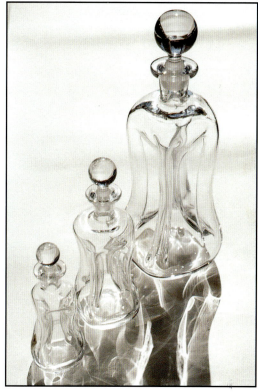

Holmegaard traditional transparent smoke glass "Cluck Cluck" pinched decanter and Dutch cordial glasses, both available in the Holmegaard product catalog of 1950.

Decanter, h. 11-3/4 in. (29.84 cm); glasses, h. 5-3/4 in. (14.61 cm). *Denmark*. Glasses, $15-25 each; decanter, $100-125

Holmegaard "Cluck Cluck" decanters in the normal and bent form variation.

The bent clear glass decanter has a crown shaped stopper; h. 11-3/4 in. (29.84 cm), h. 10-3/4 in. (27.30 cm). *Denmark*. $100-125 each

Holmegaard "Cluck Cluck" clear glass decanters in three different sizes, h. 12-1/2 in. (31.75 cm), h. 8 in. (20.32 cm), h. 6 in. (15.24 cm). *Denmark*. $50-125 depending on size

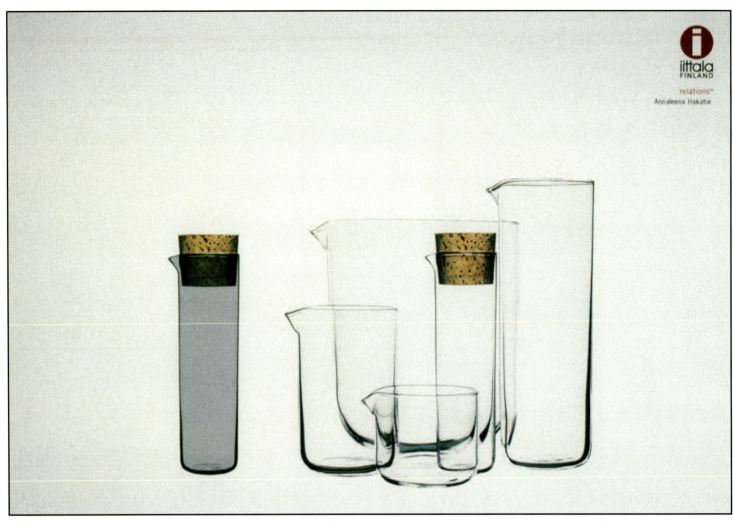

iittala "Hakatie" pitchers, carafes and bowls designed by Annaleena Hakatie in 1998 as part of the "Relations" collection, currently in production. *Finland.* $75-200 depending on form and size

The "Relations" collection was created by iittala in order to give consumers multifunctional glass objects meant to serve the changing needs of contemporary life. In their own words, "This project has set itself the ambitious goal of innovating objects without any specific, strictly limited use. As a modern glass maker, we have always sought products and expressions that represent the age in which we live. They reflect the present age and will influence the future."

Photo courtesy of iittala

Aseda clear glass globular carafes with cork stoppers designed by Bo Borgstrom; h. 9 1/2 in. (24.13 cm), and h. 8 in. (20.32 cm); larger retains original silver and black paper label: SVENSK FORM BO BORGSTROM ASEDA SWEDEN. $75-125

Dansk clear glass conical carafes with teak stoppers designed by Gunnar Cyren; h.13 in. (33.02 cm); the stoppers are stamped on the underside DENMARK. $75-125

Johansfors transparent olive glass decanter with bubble stopper, likely designed by Bengt Orup; h. 10 in. (25.40 cm); retains original gold and yellow paper label: JOHANSFORS SWEDEN. $150-200

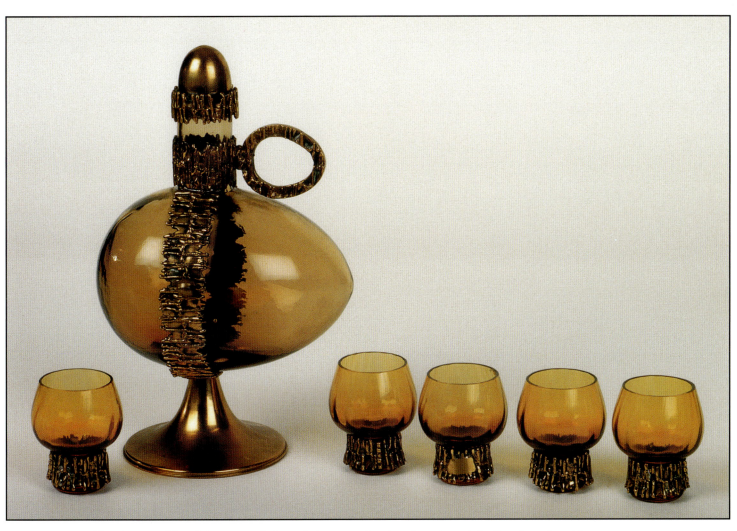

Kumela unusual "egg" decanter and glasses in transparent amber glass, decorated with patterned, cast bronze bands, stopper and base, designed by Pentti Sarpaneva; stamped on the bronze detail P. SARPANEVA BRONZE FINLAND. Decanter, $300-400; glasses, $50-75 each

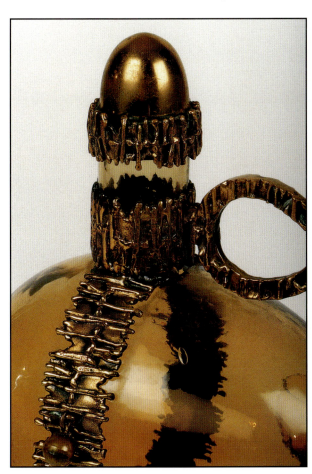

Detail of cast metallic bands, stopper and handle.

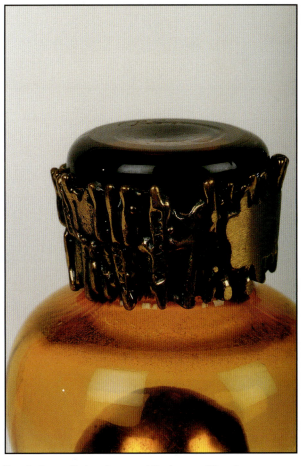

Detail of metallic bands around the bases of the glasses.

Kosta traditional "Pippi" decanter in clear glass with a single trapped air bubble in the stopper as well as the decanter base; h. 12-1/2 in. (31.75 cm); retains original label: KOSTA SWEDEN. $150-200

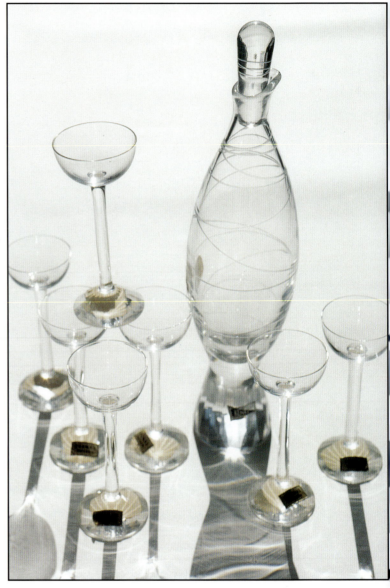

Ekenas clear glass decanter and glasses with multiple, random, etched lines in the body, designed by John Orwar Lake in the 1950s.

The decanter has a heavy base which is cut and faceted; h. 11-3/4 in. (29.84 cm); the decanter retains black and silver paper label: EKENAS SWEDEN DESIGNER LAKE. $500-600 set

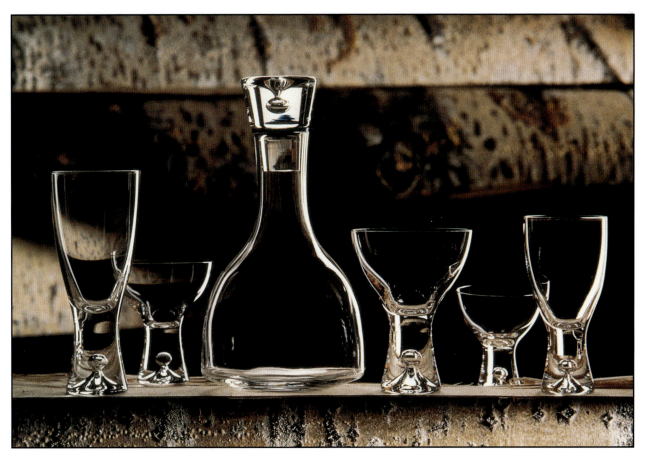

iittala "Tapio" decanter and glasses in clear glass designed by Tapio Wirkkala in 1952.

The open bubble in the bases of the glasses and the decanter stopper is a characteristic detail often used by Wirkkala in his designs. *Finland.* Glasses, $20-35 each; decanter, $125-175

Photo courtesy of iittala

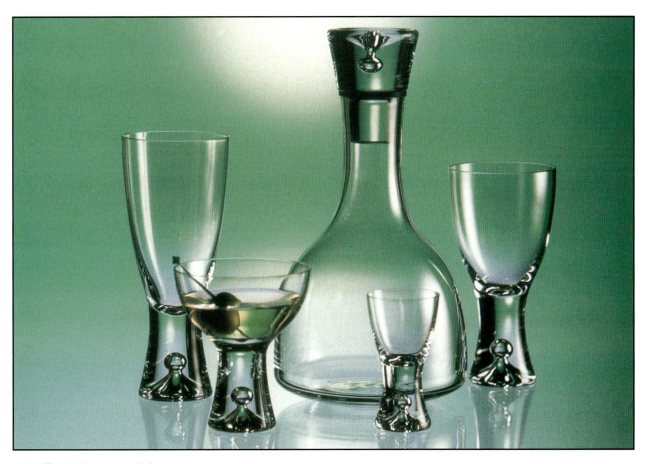

iittala "Tapio" decanter and glasses.

Photo by Markku Alatalo courtesy of iittala

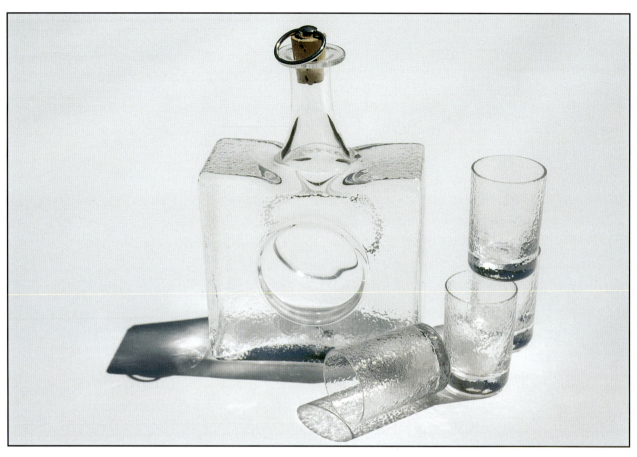

Iittala "Mini" textured square decanter with cork stopper and "Mini" glasses in clear glass, designed by Tapio Wirkkala in the late 1950s or early 1960s; h. (decanter) 6-1/2 in. (16.51 cm); the decanter is signed TW. *Finland.* $200-250 set

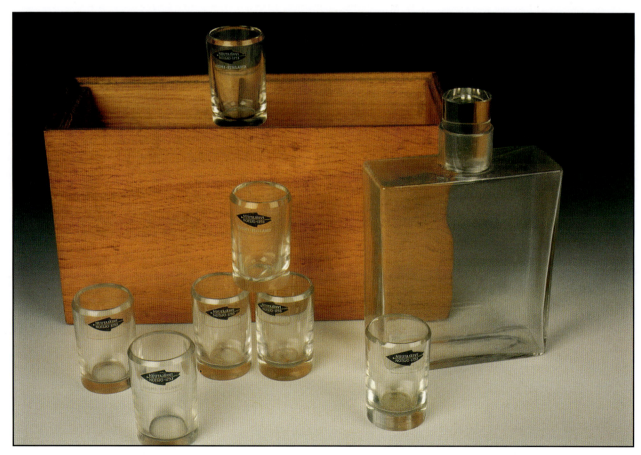

Nuutajarvi Notsjo square pocket flask and glasses in clear glass, with wooden storage case, designed by Kaj Frank and produced from 1960 to 1970; h. (flask) 6-1/2 in. (16.51 cm); the glasses retain the black and white plastic label: NUUTAJARVI NOTSJO-1973 SUOMI FINLAND. $300-400 set

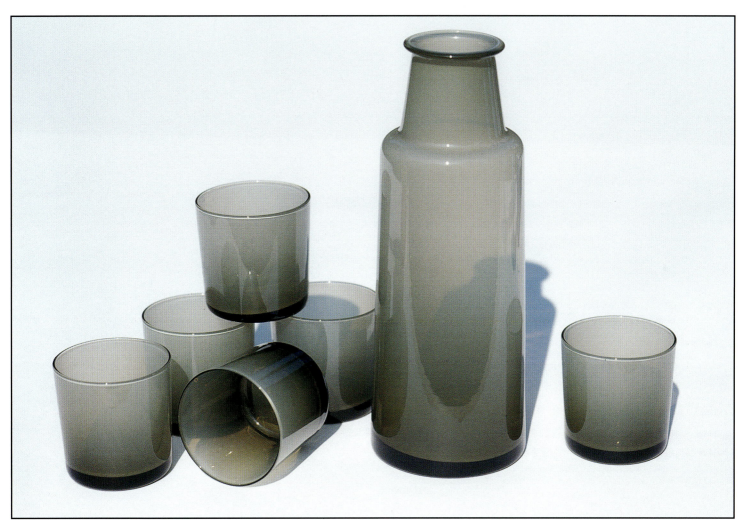

Hadeland cased smoke glass decanter and glasses designed by Willy Johansson; h. (decanter) 9 in. (22.86 cm); signed HADELAND 2095 WJ. *Norway.* $250-325 set

Plus Glasshytte carafe in smoke glass, with applied medallion with bird figures; h. 6-3/4 in. (17.14 cm); acid etched stamp- PLUS NORWAY. $125-175

139

Sea Glasbruk objects in satin glass with random clear glass lines from the "Crazy" series, designed by Renate Stock in 2000. *Sweden.* $75-125 each

Photo courtesy of Sea Glasbruk

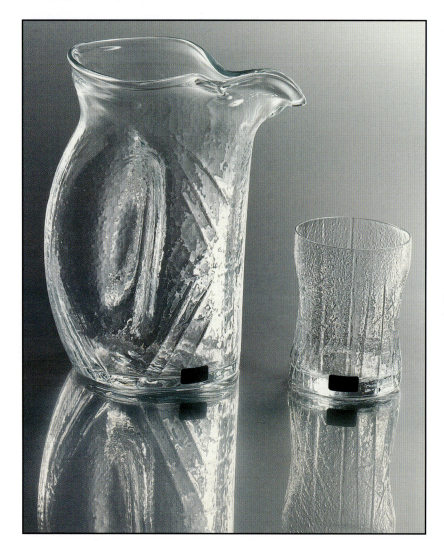

Lindshammar "Pingvin" (penguin) textured jug and glass. designed by Christer Sjogren in the 1970s. *Sweden.* $125-150 set

Photo courtesy of Lindshammar

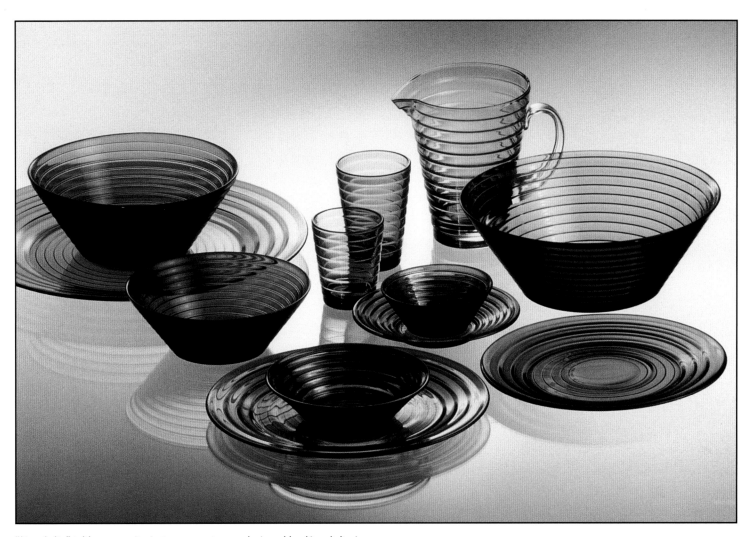

"Aino Aalto" tableware series in transparent gray, designed by Aino Aalto in 1932. *Finland.* $15-100 each

Photo by Timo Kauppila courtesy of iittala

iittala "Aino Aalto" pressed clear glass pitcher and glasses designed by Aino Aalto. *Finland.* Pitcher, $70-100; glasses, $15-25

This series of pressed glass tableware with plain, concentric horizontal ribs was designed by Aino Aalto for Karhula in 1932 and was named "Bolgeblick." It won second prize in the pressed glass entries at the Karhula-iittala glass design competition of 1932. In 1936, the series won the gold medal in the Milan Triennale. Since 1934, it has been produced off and on by Karhula and later by iittala, and it is currently in production today. After a reintroduction by iittala in 1985, the series was renamed "Aino Aalto" in honor of its designer.

Photo by Timo Kauppila courtesy of iittala

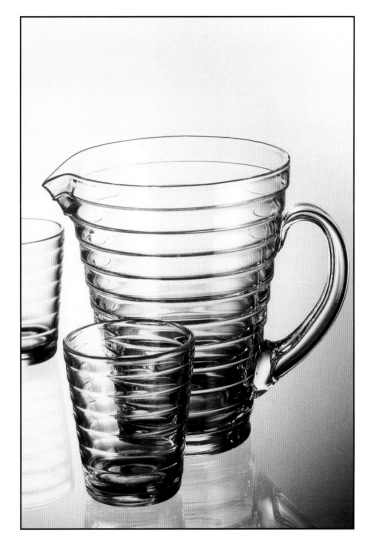

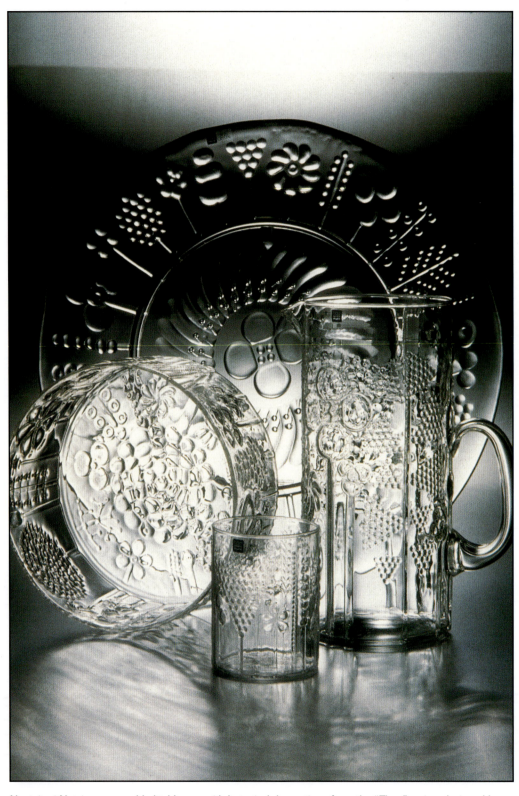

Nuutajarvi Notsjo press molded tableware with botanical decorations from the "Flora" series, designed by Oiva Toikka in 1966. *Finland.* $20-125 each

Photo by Gero Mylius courtesy of iittala

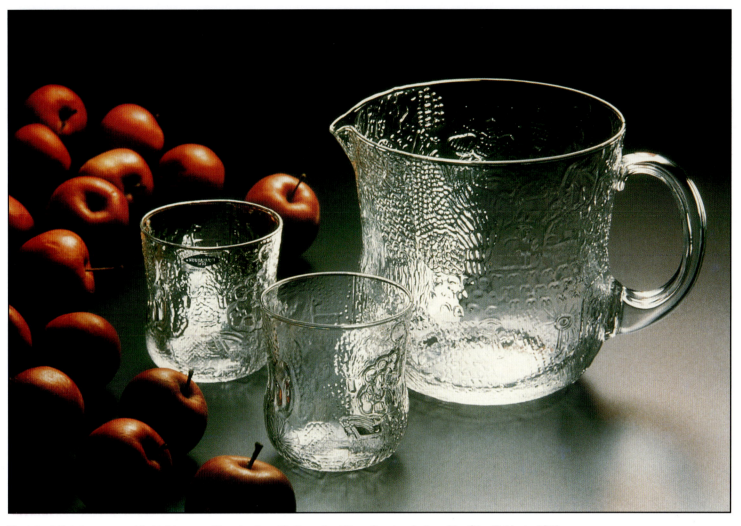

Nuutajarvi Notsjo press-molded tableware with animal motifs from the "Fauna" series designed by Oiva Toikka in 1970. *Finland.* $20-125 each

Photo by Gero Mylius courtesy of iittala

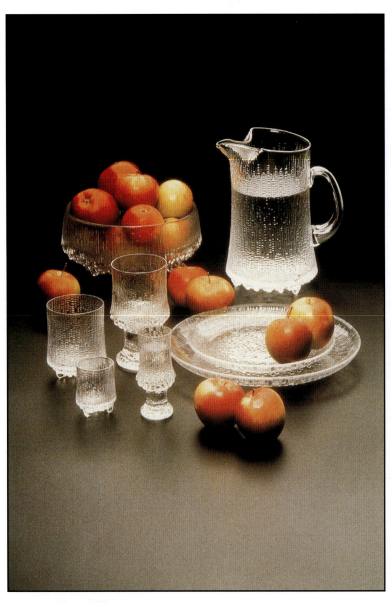

iittala intricately textured tableware with dew-drop like surfaces from the "Ultima Thule" series, designed by Tapio Wirkkala in 1968. *Finland.* $15-100 each

Photo courtesy of iittala

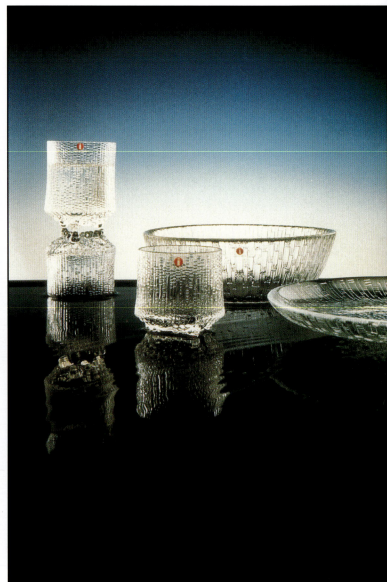

iittala tableware from the "Ultima Thule" series. *Finland.* $15-100 each

Photo courtesy of iittala

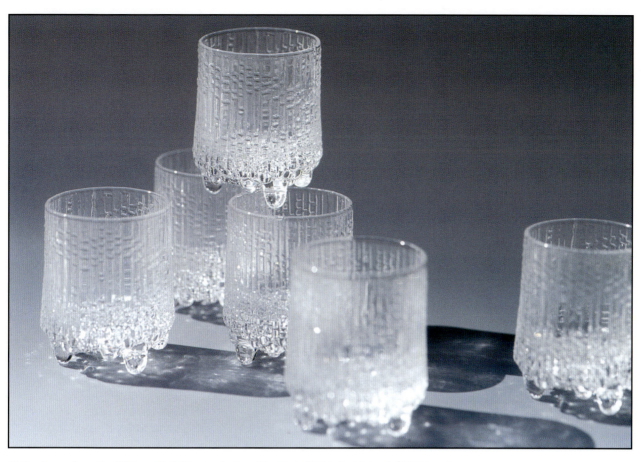
iittala glasses from the "Ultima Thule" series designed by Tapio Wirkkala. *Finland.* $15-25 each

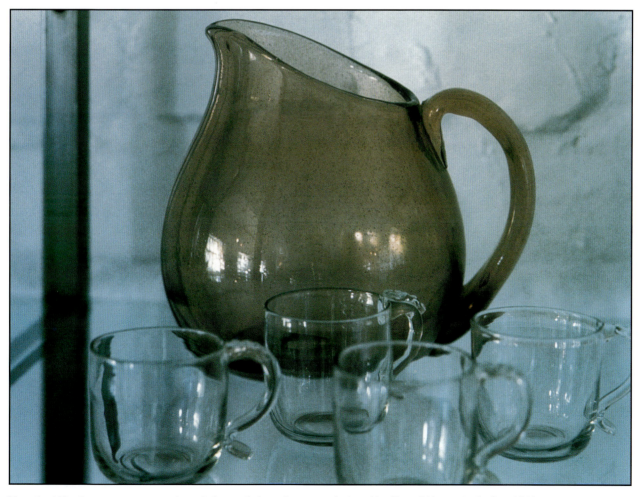
Nuutajarvi Notsjo transparent rust glass pitcher and clear glass cups designed by Gunnel Nyman in the late 1940s. *Finland.* Pitcher, $200-300; glasses, $35-55 each

Photo courtesy of iittala

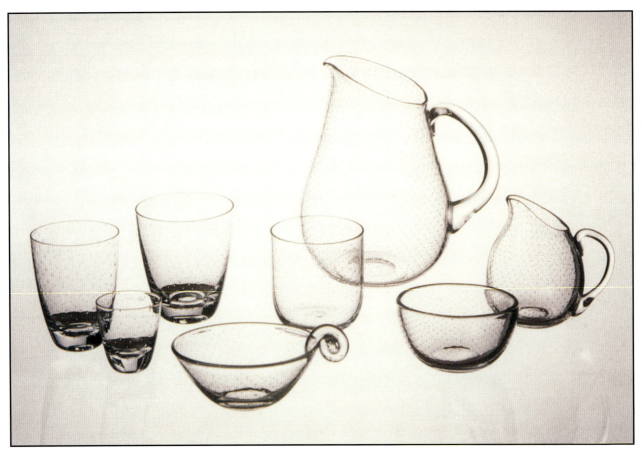

Nuutajarvi Notsjo tableware in clear glass with controlled bubbles, designed by Gunnel Nyman in 1947-48. *Finland.* $50-300 each

Photo by Timo Kauppila courtesy of iittala

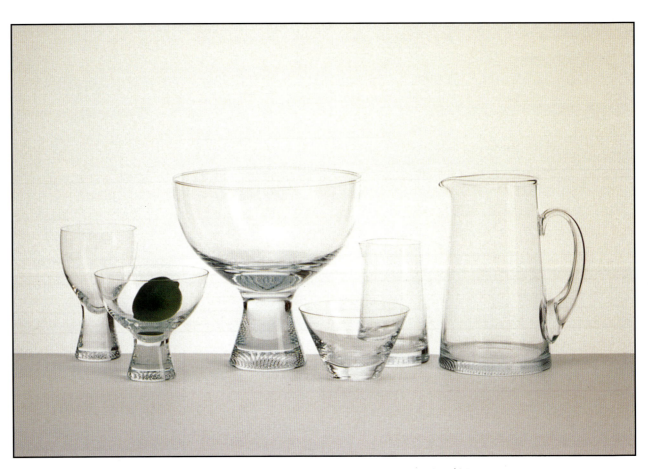

Kosta Boda tableware from the "Limelight" series, designed by Goran Warff in 1985. *Sweden.* $25-75 each

Photo courtesy of Kosta Boda

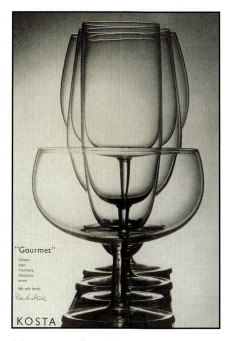

Advertisement from *Form* magazine in 1958, featuring Kosta "Gourmet" stemware, designed by Vicke Lindstrand.

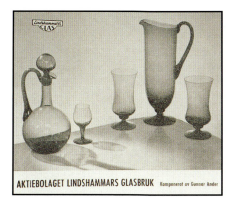

Advertisement from *Form* magazine in 1953, featuring Lindshammar tableware designed by Gunnar Ander.

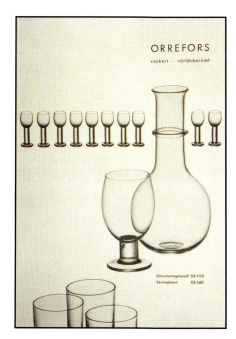

Advertisement from *Form* magazine in 1957, featuring Orrefors pitcher and glasses.

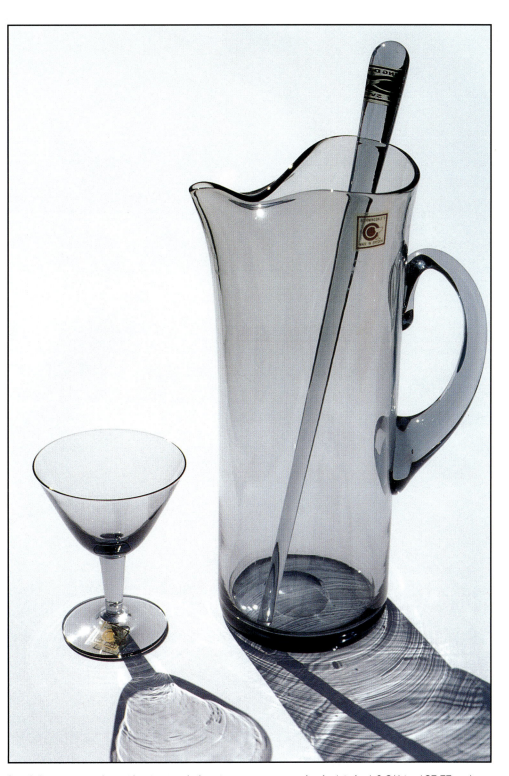

Swedish martini pitcher with stirrer and glass in transparent smoke; h. (pitcher) 9-3/4 in. (27.77 cm) retains paper label: MADE IN SWEDEN as well as Bloomingdale's retail tag. $35-55 set

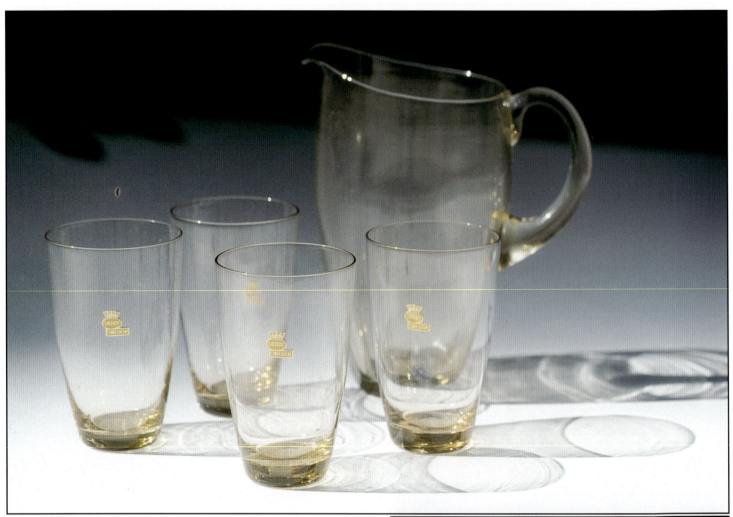

Skruf glasses and Alsterfors pitcher in transparent topaz; h. (pitcher) 8 in. (20.32 cm); glasses retain yellow and gold paper label: SKRUF SWEDEN; pitcher retains blue and white paper label: ALSTERFORS SWEDEN. Pitcher, $50-75; glasses $15-25 each

Kosta "Kontur" cocktail pitcher in clear glass with a suspended dark amethyst glass spiral and clear glass stirrer, designed by Vicke Lindstrand around 1958; h. 10 in. (25.40 cm); signed KOSTA LH 1292. *Sweden.* $150-200

iittala "Stella" tableware in clear glass, designed by Elina Joensuu in 1995, currently in production. *Finland*. $15-100 each

Photo by Markku Alatalo courtesy of iittala

iittala "Aarne" tableware in clear glass, designed by Goran Hongell in 1948. This streamlined design won a gold medal at the Milan Triennale of 1954. The line is in production at iittala currently. *Finland*. $15-100 each

Photo courtesy of iittala

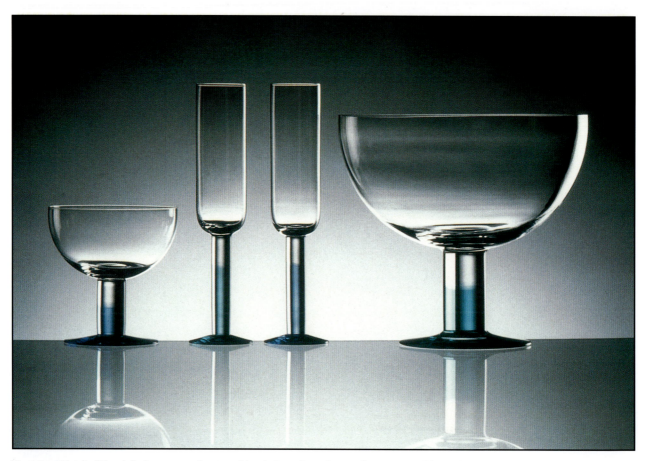

Nuutajarvi Notsjo "Mondo" champagne flutes and bowls in a clear glass and transparent blue color combination, designed by Kerttu Nurminen in 1988. The "Mondo" series is still produced at iittala today. *Finland.* $35-150 each

Photo by Gero Mylius courtesy of iittala

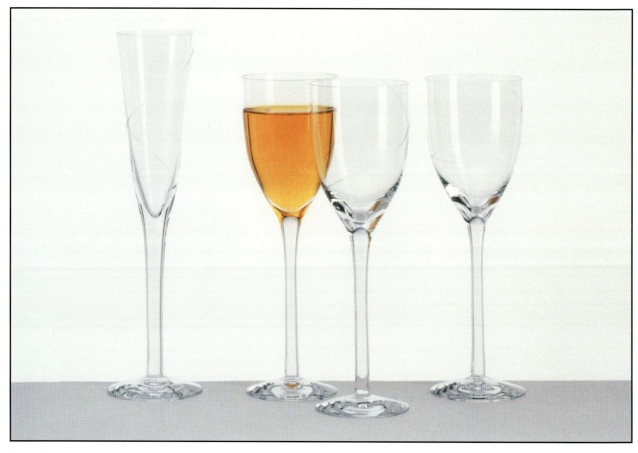

Kosta Boda "Line" champagne and wine glasses in crystal, designed by Anna Ehrner in 1981. *Sweden.* $35-55 each

Photo courtesy of Kosta Boda

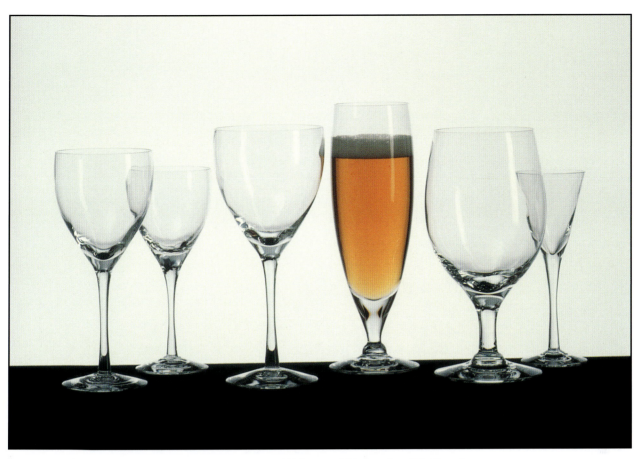

Kosta Boda "Chateau" glasses in crystal, designed by Bertil Vallien in 1981. *Sweden.* $25-45 each

Photo courtesy of Kosta Boda

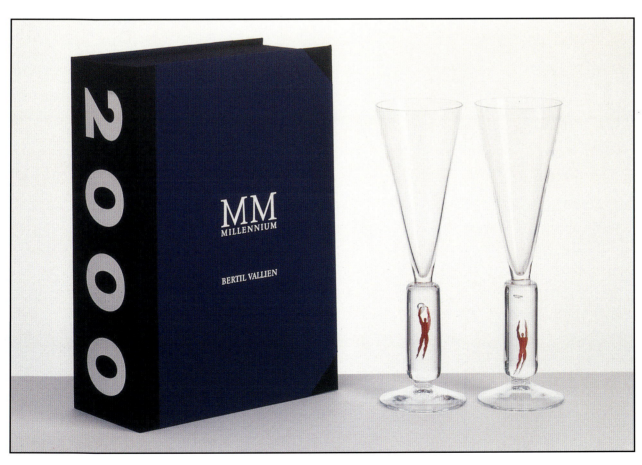

Kosta Boda "Millennium" champagne flutes in clear glass, the necks with encased human figures in ruby glass, designed by Bertil Vallien in 1999. As their name suggests, these glasses were commemorative of a century about to end and a century that was to come. *Sweden.* $175-250 for the pair

Photo courtesy of Kosta Boda

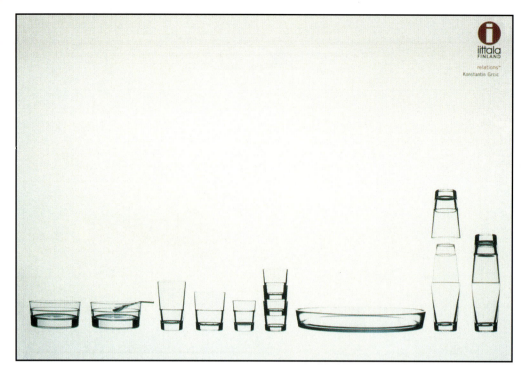

iittala "Grcic" stackable tableware in clear glass, designed by Konstantin Grcic around 1998 as part of the "Relations" collection and still in production. This line received the Design Plus award in Frankfurt, February 2000. *Finland*. $15-75 each

Photo courtesy of iittala

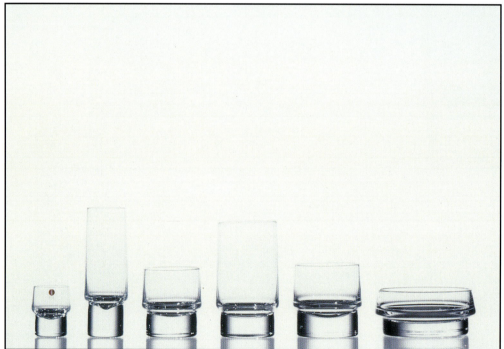

iittala "Klubi" tableware in clear glass, designed by Harri Koskinen in 1998 as part of the "Relations" collection and still in production. *Finland*. $15-45 each

Photo courtesy of iittala

iittala "Newson" clear glasses, designed by Marc Newson in 1998 for the "Relations" collection and still in production. *Finland*. $25-35 each

Photo courtesy of iittala

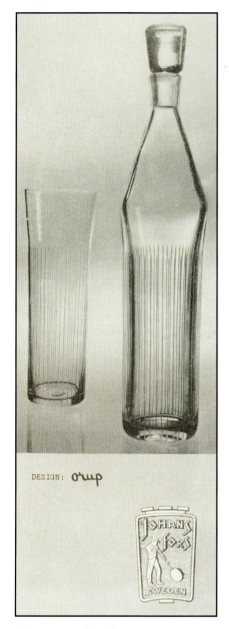

Advertisement from *Form* magazine in 1953, featuring Johansfors decanter and glass designed by Bengt Orup.

iittala clear "Aarne" glasses designed by Goran Hongell in 1948. This line is still in production. *Finland.* $15-30 each

Photo courtesy of iittala

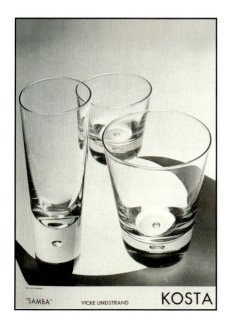

Advertisement from *Kontur* magazine in 1964, featuring Kosta "Samba" glasses designed by Vicke Lindstrand.

Holmegaard "Princess" clear wine glasses with a suspended teardrop bubble in the conical bases, designed by Bent Severin, originally at Kastrup in 1957. This design was part of Corning Glass Museum Special Exhibition of International Contemporary Glass in 1959. *Denmark.* $45-65 each

Holmegaard "Princess" clear glass flutes designed by Bent Severin, originally at Kastrup in 1957. *Denmark.* $45-65 each

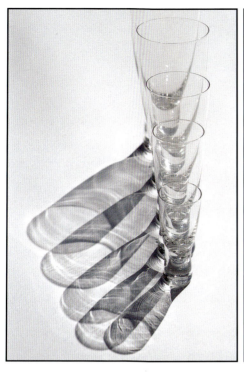
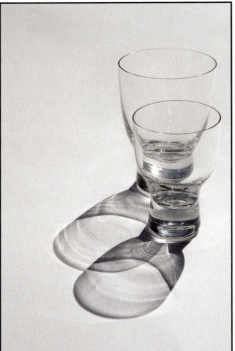
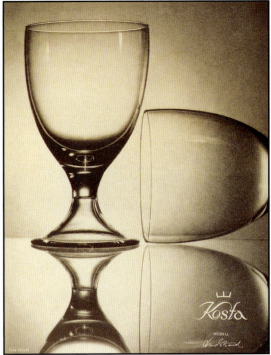

Holmegaard clear glasses from the "Canada" line, available in the product catalog of 1963. *Denmark*. $25-35 each

Courtesy of Michael Ellison

Holmegaard clear tumbler and cocktail glass from the "Canada" line. *Denmark*. $25-35 each

Courtesy of Michael Ellison

Advertisement from *Form* magazine in 1957, featuring Kosta glasses designed by Vicke Lindstrand.

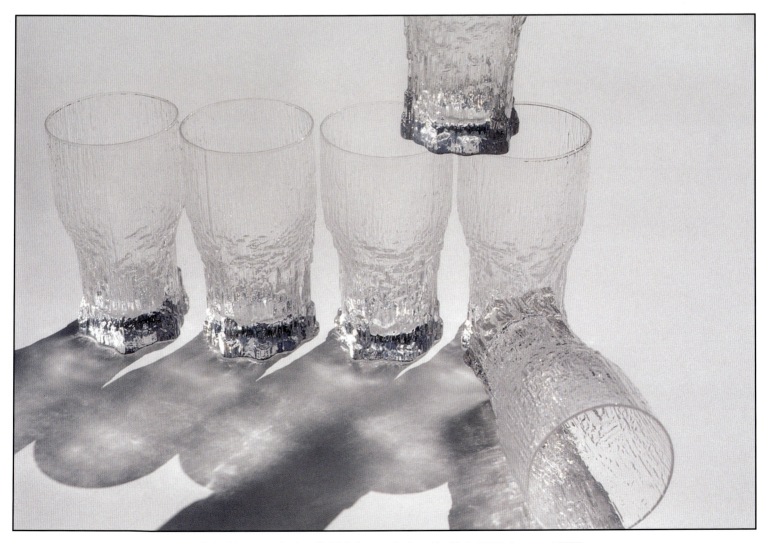

iittala highly textured, clear "Aslak" glasses, designed by Tapio Wirkkala around 1965, and available in the 1973 iittala product catalog. *Finland*. $25-25 each

Courtesy of Michael Ellison

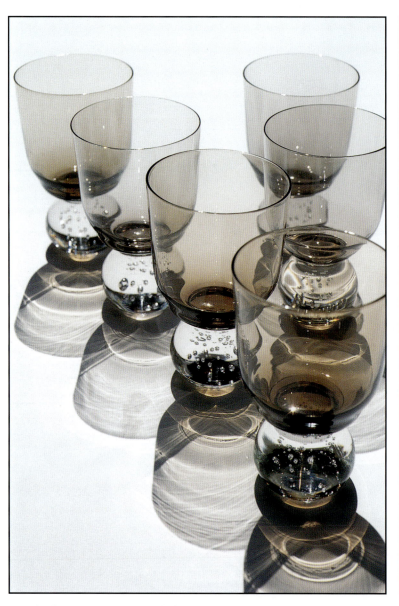

Aseda transparent smoke old-fashioned glasses with trapped air bubbles in clear glass feet, designed by Bo Borgstrom, likely in the 1960s. *Sweden*. $10-25 each

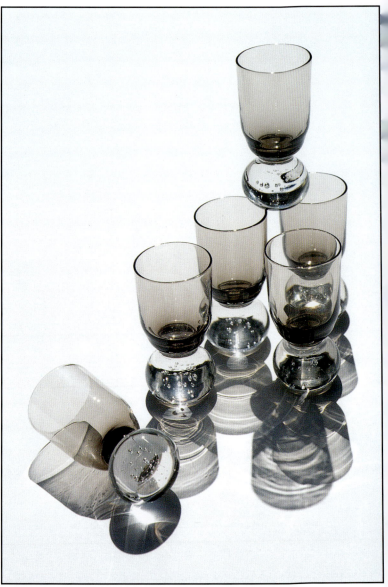

Aseda transparent smoke wine glasses with trapped air bubbles in clear glass feet, designed by Bo Borgstrom, likely in the 1960s. *Sweden*. $10-25 each

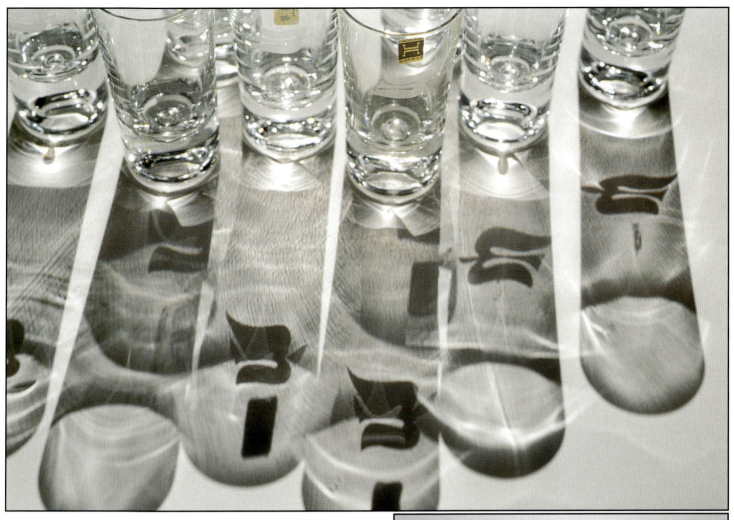

Hadeland glass set with engraved stylized bird decorations. *Norway*. $25-45 each

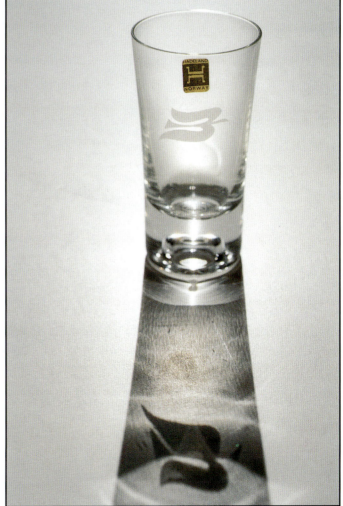

Hadeland clear old-fashioned glass with an engraved decoration of a stylized bird in flight. *Norway*. $25-45

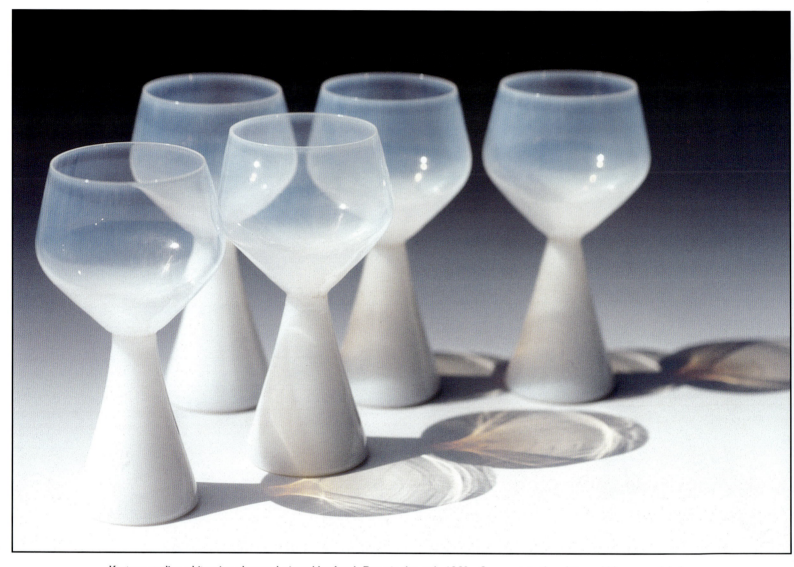

Kastrup opaline white wine glasses designed by Jacob Bang in the early 1960s. Some retain the white and blue paper label: KASTRUP GLAS MADE IN DENMARK. $35-55 each

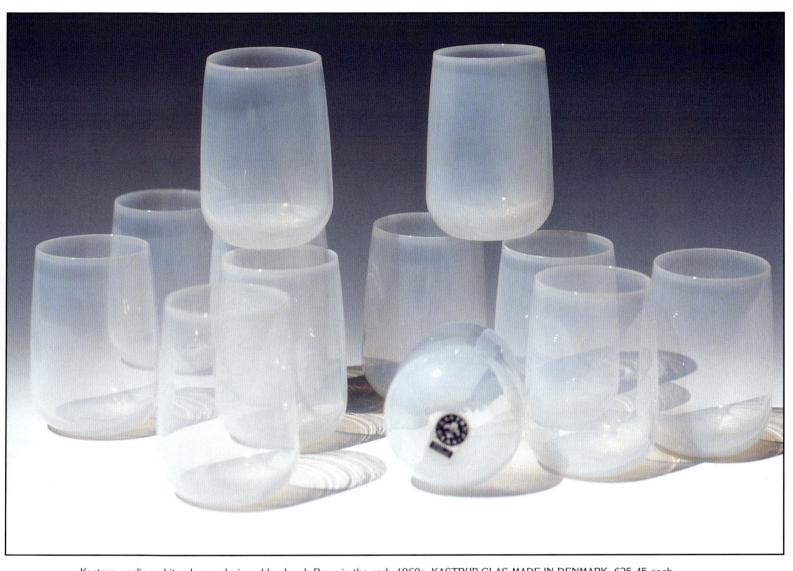

Kastrup opaline white glasses designed by Jacob Bang in the early 1960s. KASTRUP GLAS MADE IN DENMARK. $25-45 each

Aseda clear cylindrical pitcher and glasses with heavy, thick bases, designed by Bo Borgstrom. A glass retains the original silver and black paper label: SVENSK FORM BO BORGSTROM ASEDA SWEDEN. $50-75 set

Holmegaard "Neck" glass designed by Christer Holmgren in the late 1960s or very early 1970s. As the name of the design implies, this glass was meant to be strapped around the neck of the serious partygoer, since it does not have a flat bottom surface to rest on. *Denmark.* $50-75

iittala "Tsaikka" clear glass tea cups with metal filigree holders designed by Timo Sarpaneva in 1957 and still produced. *Finland.* $20-35 each

iittala "Seth-Anderson" bowls in gray and clear glass, designed by Carina Seth-Anderson in 1998 as part of the "Relations" collection, still in production today. *Finland.* $125-250 each

Photo courtesy of iittala

Nuutajarvi Notsjo "Kastelhelmi" plates in clear glass with concentric circular dot compositions, designed by Oiva Toikka in 1964; d. 6-1/2 in. (16.51 cm) *FINLAND*. $50-75 each

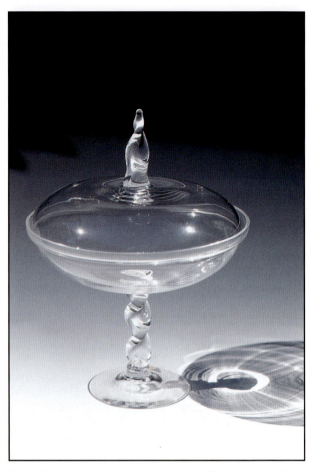

Johansfors clear glass covered compote with a twisted neck and finial; h. 10 in. (25.40 cm); retains gold and yellow paper label: JOHANSFORS SWEDEN. $45-75

Nuutajarvi Notsjo "Rengaslautanen" or ring plate designed by Kaj Frank. Examples with this concentric circular design are found in Kaj Frank's wares as early as the 1960s and thorough the 1980s. *Finland*. $300-400

Photo by Timo Kauppila courtesy of iittala

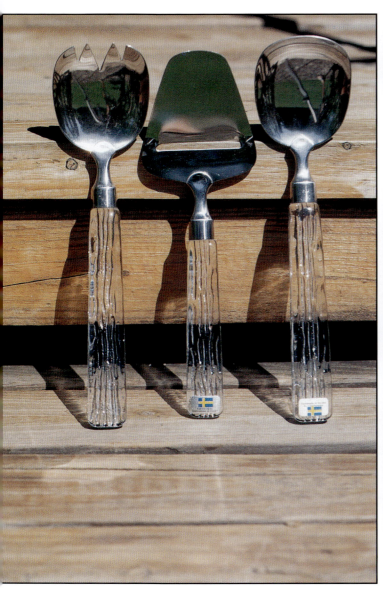
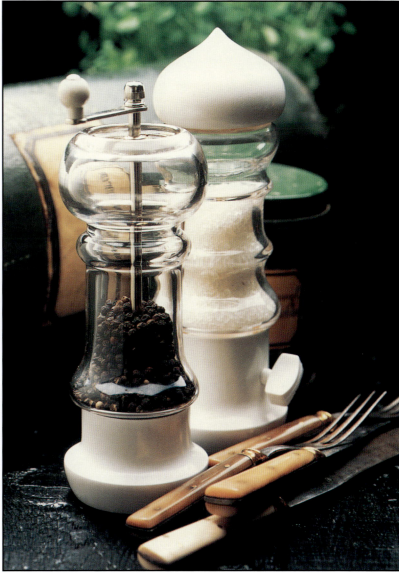

Lindshammar serving utensils with textured clear glass handles; l. 9-1/2 in. (24.13 cm); retain the paper "flag" label: FULL CRYSTAL BY LINDSHAMMAR OF SWEDEN. $35-55 each

Sea Glasbruk salt and pepper mills with clear glass bodies designed by Rune Strand in 1960-70. *Sweden*. $35-65 each

Photo courtesy of Sea Glasbruk

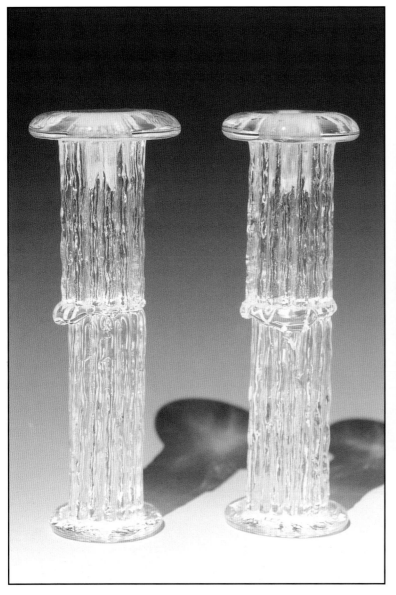
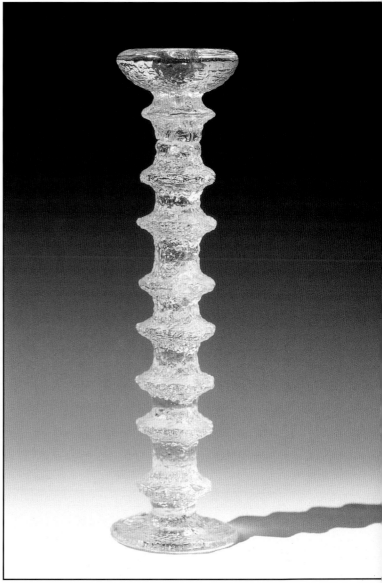

Kosta cast cylindrical candlesticks with a horizontal textured surface effect, designed by Ann and Goran Warff in the early 1970s; h. 9-3/4 in. (24.77 cm); retains crown plastic label: KOSTA SWEDEN. $175-250 pair

iittala "Festivo" ringed and highly textured clear glass candlestick designed by Timo Sarpaneva in 1966 and still in production; h. 12-1/2 in. (31.75 cm). *Finland.* $50-85

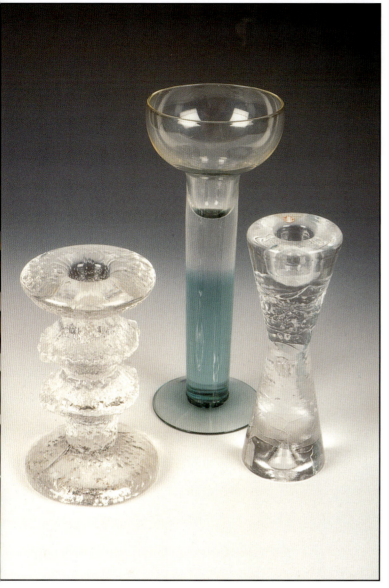

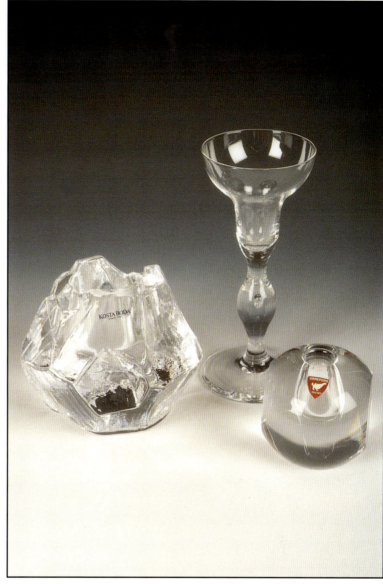

Top left:
Candlesticks. *(Finland)*

iittala "Festivo" candlestick designed by Timo Sarpaneva in 1966. H. 4-1/2 in. (11.43 cm); signed TS. $20-30

Nuutajarvi Notsjo "Mondo" candlestick in the green and clear glass color combination, designed by Kerttu Nurminen in 1988 and still produced by iittala today. H. 7-3/4 in. (19.68 cm). $45-65

iittala "Arkipelago" cast candlestick in the double cone variation, with a textured surface and bubbles throughout, designed by Timo Sarpaneva in 1978. H. 5-1/2 in. (13.97 cm); retains the plastic red dot label i MADE IN FINLAND. $75-125 pair

Top right:
Candleholder and candlesticks. *(Sweden)*

Kosta Boda "Rock" cast glass votive candleholder with a highly textured surface, designed by Anna Ehrner in 1991. H. 3-3/4 in. (9.53 cm); retains plastic label: KOSTA BODA SINCE 1742. $35-60

Kosta clear glass candlestick with swollen neck and suspended bubble designed by Vicke Lindstrand. H. 6 in. (15.24 cm). $45-60

Orrefors spherical clear glass candlestick, with cut flat and polished circular areas on two sides. H. 2-1/2 in. (6.35 cm); signed ORREFORS, retains brown paper label: ORREFORS SWEDEN. $35-60

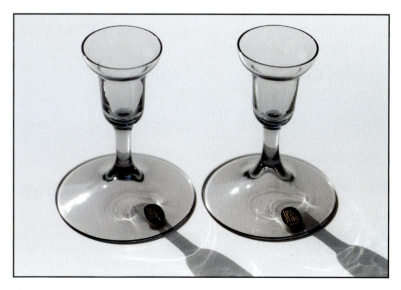

Hovmantorp traditional smoke glass candlesticks. H. 4 in. (10.16 cm). *Sweden*. $35-55 pair

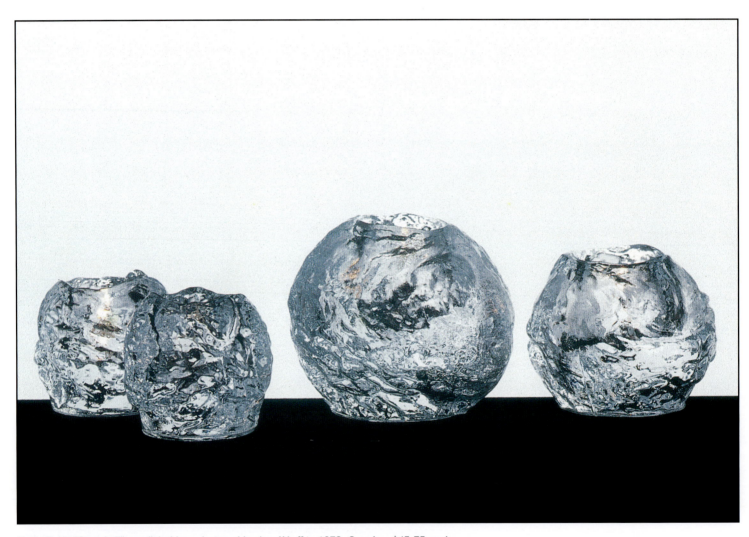

Kosta Boda "Snowball" candleholders, designed by Ann Warff in 1973. *Sweden.* $45-75 each

Photo courtesy of Kosta Boda

iittala flared clear glass candlesticks, designed by Tapio Wirkkala around 1954 and available in the iitala catalog of the same year. H. 5-3/4 in. (14.61 cm); signed TAPIO WIRKKALA 3412. *Finland.* $350-425 pair

Kosta Boda cast clear glass cylindrical candlesticks with textured surface and trapped air bubbles. H. 12 in. (30.48 cm); retains cellophane label: KOSTA BODA SINCE 1742. $150-200 pair

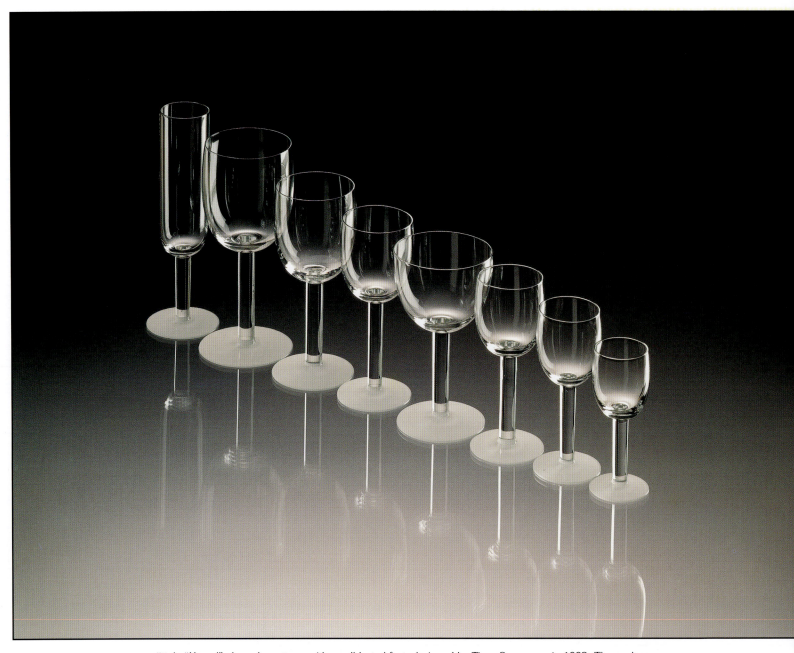

iittala "Marcel" clear glass stems with sandblasted feet, designed by Timo Sarpaneva in 1992. These glasses were originally designed for Mantyniemi, the residence of the President of Finland. $40-65 each

Photo by Markku Luhtala courtesy of iittala

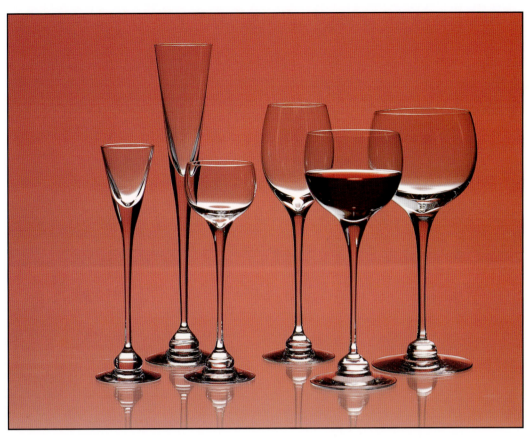

iittala "Aurora" glasses in crystal designed by Heikki Orvola in 1972 and still in production. Of all of Mr. Orvola's glassware designs, this line has been the longest in production. *Finland.* $25-50 each

Photo by Markku Alatalo courtesy of iittala

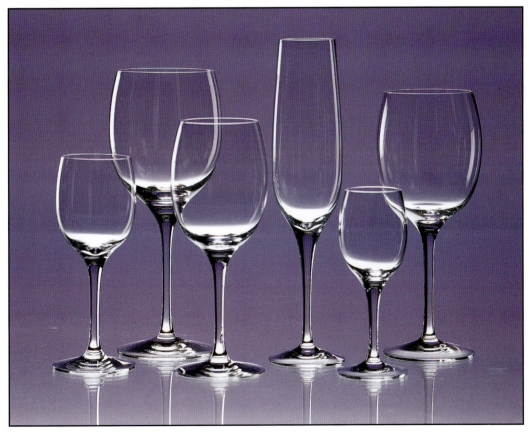

iittala "Kolibri" clear glass stems designed by Timo Sarpaneva in 1983. *Finland.* $20-35 each

Photo by Markku Alatalo courtesy of iittala

Kosta vintage advertisement of 21 glassware services.

Chapter 11
Companies

Afors

Afors was founded in 1876 by four master glassblowers, C. F. Fagerlund, Oscar Fagerlund, Alfred Fagerlund and Carl C. Carlsson, in the Smaland district of Sweden. In 1916, the company was purchased by Ernst Johansson, a wholesale merchant, and Oscar Johansson, proprietor of Hjartsjo glassworks. In 1917 Ernst Johansson became the sole owner. The glassworks soon passed to Ernst's son, Eric, who changed his last name to Afors. Eric Afors retained control of the company until 1975. In 1964 Afors began a cooperative alliance with 2 other glass factories, Kosta and Boda, and together they were named the Afors group in 1971. In 1972, the Afors group also purchased Johansfors. In 1975, the group was sold to Upsala-Ekeby, the Swedish ceramics concern and in 1976 the Afors group was renamed Kosta Boda AB. In 1982 Kosta Boda's entire stock of shares was acquired by AB Proventus. In 1990 Kosta Boda merged with Orrefors, becoming Orrefors Kosta Boda. In 1997, Orrefors Kosta Boda became part of The Royal Scandinavia Group, which currently owns a number of companies including Holmegaard, Orrefors, Kosta Boda, Boda Nova, Georg Jensen, Hoganas Keramik, Royal Copenhagen and Venini.

Early production included mainly household and domestic wares, but in 1910, it expanded to include cut, painted, and etched glass. Bohemian artists such as Karl Zenkert and Karl Diessner helped make Afors renowned in the glass painting technique, which was discontinued in the 1940s. For a short period of time during the 1930s, Astrid Rietz and Edvin Ollers worked for the company. In 1953, designer Ernest Gordon joined the company. In 1963, he was succeeded by Bertil Vallien who experimented with hot-glass ornamentation, sand-blasting techniques and sand-casting. In the 1970s, Afors started its "Artist Collection" to introduce art glass manufactured in small quantities, falling somewhere in between unique design and the standard line of glassware. In 1972 Bertil Vallien was joined by his wife, Ulrica Hydman-Vallien, a ceramist. She began designing glass for Afors, primarily limited edition studio pieces, but later expanded into designing full lines. She is credited with reviving the practice and tradition of painted glass at Afors, which she currently continues to use at Kosta Boda. Other designers at Afors during the 1980s included Australian Ken Done and Jerker Persson. In 1986, Gunnel Sahlin joined the company as a glass designer, and, like the Valliens, she has a studio close to the glassworks. Olle Brozen joined the design team at Kosta Boda in 2000, and he has his studio at Afors.

Because of the long history of mergers and alliances in the Afors group, signatures and markings can sometimes be confusing. Although the literature reports that, since the creation of Kosta Boda AB in 1976, all wares were marketed under the "Kosta Boda" name, in actuality, this is not so. After 1976, some products were still marketed under the "Boda" name only, with signatures and labels to match, and without a reference to "Kosta Boda." Some wares designed as late as 1982-1983, such as the "Rainbow" line by Bertil Vallien, are often found with the "Boda" label and signature. As far as we can discern, sometime between 1984 and 1986, the signatures became uniform, regardless of the factory in which they were produced (Afors, Boda or Kosta) and had both the artist name and the "Kosta Boda" name. Web site: www.kostaboda.se

Alsterfors

Originally an iron foundry, Alsterfors started producing glass in 1885. Around that same time, it was purchased by J.A. Gottwald Fogelberg, the manager at Kosta. In 1903, the company became part of the Association of Swedish Crystal Manufacturers and changed hands many times after that. In 1980, it was leased to Orrefors. Production was discontinued in 1980.

Early production included mostly domestic wares and small items, although production expanded to include tableware, restaurant ware and art glass. After 1958, Alsterfors began to produce glass in a variety of colors. Designers associated with the company include Edvin Ollers (1930-1934), Ingrid Atterberg (1958-1964), Fabian Lundkvist (starting in 1960) and P. O. Strom (1968-1972).

Aseda

Aseda glass of Sweden produced a wide variety of unusual shapes, often with a heavy paperweight type base. Sometimes the base is a contrasting color from the body of the vase. Colors ranged from subdued earthy tones to vibrant reds, oranges, and yellows, which were also made in a semi-opaque, opalescent type glass. The primary designer of these playful sixties forms was ceramist and glass designer, Bo Borgstrom. Before joining Aseda in 1955, Borgstrom studied in Stockholm as well as other European and American cities. A silver foil on paper label has black lettering that is often mistaken as "Seda." In 1974, Aseda became part of the Royal Krona Group (Krona-Bruken AB), which consisted of other four companies: Bjorkshult, Gullaskruf, Maleras, and Skruf. The Royal Krona group went bankrupt in 1977.

Bergdala

Founded in 1889, in Sweden's Smaland region. Bergdala is currently associated with Skruf and Alghult, and together create the Svenska Glasbruk Group. Bergdala is best know for its designs in clear glass with applied cobalt blue glass edges. Current designers for the company include, Thommy Bremberg, Sven Lidberg, Christoffer Ramsey, Lena Linderholm, Eva-Lena Martinsson, and Mats Theselius.

Boda

Boda was founded in 1864 in the Smaland region of Sweden by R. Wiktor Scheutz and Erik Widlund, two glass blowers from Kosta. In 1947, Boda was acquired by Eric Afors, owner of the Afors glass factory, but was independently run and managed by Erik Rosen. In 1964, Boda began a cooperative alliance with Kosta and Afors, and in 1971, all three formally merged into the Afors group. The Afors family sold the company to Upsala Ekeby in 1975, and a year later the company group was reformed into Kosta Boda AB, In 1990 Kosta Boda merged with Orrefors to create Orrefors Kosta Boda. In 1997, Orrefors Kosta Boda became part of The Royal Scandinavia Group.

Boda's early production was blown and pressed glassware and bottles. Around 1920, crystal was brought into production. Gabriel Burmeister designed art glass for a short period during the 1920s. Fritz Kallenberg designed mass-produced domestic glassware and some individual objects from 1925 to 1968. Boda produced canning jars during World War II but by the end of the 1940s, the standard production line went back into operation. In an effort to bring art glass and sophisticated objects into Boda's production, Erik Hoglund was hired by Erik Rosen as a designer in 1953. Hoglund's distinctive engraved crystal and colored seedy glass with imaginative applications brought a new trend to Swedish glass. Hoglund remained at Boda until 1973. Other artists who were associated with Boda were, Lena Larsson (1960s), Monica Backstrom (1965-present), Signe Persson-Melin (1967-1973), Rolf Sinnemark (1971-1985), and Kjell Engman (1978-present). Web site: www.kostaboda.se

Dansk

Dansk was the creation of New York entrepreneur/engineer Ted Nierenberg in collaboration with designer Jens Quistgaard. In 1950, Mr. Nierenberg and his wife Martha traveled to Denmark, and at Copenhagen's Kundstanvaark Museum, saw a hand-forged fork, spoon, and knife with teakwood handles that had won a design competition for 35-year-old Jens Quistgaard. Quistgaard believed that his designs were too difficult to manufacture, and no one wanted to tackle them. But Nierenberg's search led him to manufacturing sources he knew could execute such pieces. He convinced Quistgaard that they had to try. The pattern was Fjord, now considered a classic of modern Scandinavian flatware design. Dansk has specialized in the design of "table top" items, always with the idea that every object needed for the top of the table can be beautiful as well as useful. Dansk continues to produce numerous items in glass, wood, silver, and pottery. Designs created by Jens Quistgaard can be identified by the letters "IHQ" on the labels or marks. Gunnar Cyren also designed for Dansk. His pieces can be identified by the letters "GC" on labels or marks.

Ekenas

Founded in Sweden in 1917 by former Orrefors workers, Ekenas was purchased by Sven Westberg in 1922. For forty years, until he died in 1962, Westberg hired talented designers, including the sculptor John Orwar Lake, who served as chief designer and art director from 1953 to 1976. Danish designer Michael Bang worked briefly for Ekenas in the 1960s. The factory closed in 1976.

Flygsfors

The factory was founded in 1888 in the Smaland region of Sweden, by Ernst Wiktor Lundqvist and August Zeitz, mainly to produce window glass. After changing hands several times, hand-made window glass production was discontinued in 1920. In 1930, the company was renamed Flygsfors Glasbruk AB and began producing tableware, preserve jars and lighting fixtures. Main production in the 1940s consisted of glass prisms, and domestic and ornamental wares. In 1959, Flygsfors acquired the Gadderas Glassworks and the Maleras Glassworks in 1965. Together they became known as the Flygsfors group. Gadderas soon closed and Maleras became part of the Krona-Bruken AB in 1974. Flygsfors was then acquired by Orrefors and production ceased in 1979.

Paul Kedelv joined Flygsfors in 1949, mainly to design light fixtures, but he is best known today for his sculptural art glass, which included the "Coquille" series. After he left the company in 1956, Marie Bergqvist had a brief tenure. Wiktor Berndt designed lighting fixtures and art glass from 1955 until the takeover by Orrefors. Other designers associated with the company were Hans-Agne Jakobsson (from 1957), Ulla Nordenfeldt (around 1960), Sigvard Bernadotte, and the Finnish glass designer Helena Tynell (in 1968).

Most Flygsfors pieces were signed with company name, designer and year of production, or the company name only. However, some were only signed on the bottom with a small mark, which resembles "Sa" and can be difficult to find. Regardless, most Flygsfors pieces are not difficult to identify by their style, especially if they are part of the "Coquille" range.

FM Konstglas

The company was founded in 1961 in Ronneby, Sweden by two Italian brothers, Josef (Guiseppe) and Benito Marcolin. After training as glass blowers in Murano, the Marcolin brothers ventured to the Smaland region of Sweden in the early 1950s. They worked as glass blowers for a period of time, but then decided to start their own venture, and created FM Konstglas, a company which specialized on hand blown figural pieces which, although Swedish, had a decisively Italian touch to them. In order to increase production at they factory, they were also later joined by another brother, Giovanni Luigi, and a sister, Annamaria, who was married to another master glass blower, Aure Toso. The FM initials on the name of the company stand for "Fare Marcolin" or "Made by Marcolin." Their pieces are technically precise, and use many of the techniques that the Marcolin brothers mastered at Murano. They were also wisely and widely marketed worldwide. Forty years after the creation of the company, Josef Marcolin retired and moved back to Italy.

Some of the early FM Konstglas pieces from the 1960s were unsigned and only labeled. However, most of their wares were signed in different ways through the years.

Gullaskruf

Originally a bottle-making company in Sweden's Smaland district from 1893-1921, it reopened in 1927. The new owner, William Stenberg, hired artist Hugo Gehlin in 1930, who became one of Sweden's first designers to work with organic design. He is credited with designing pressed and blown household wares, as well as enameled and free-blown art glass, which gave Gullaskruf a recognizable identity. Arthur Percy joined Gullaskruf in 1951,

and stayed until 1965. Kjell Blomberg began designing geometric forms in 1955, and he remained until 1977. Catharina Aselius-Lidbeck also worked at the company form 1968 to 1970. In 1974, the factory became part of Royal Krona Group (Krona-Bruken AB) and in 1977 was leased to Orrefors after Royal Krona Group went bankrupt. Gullaskruf shut down in 1983, reopened in 1990 under new management, and closed again in 1995.

Most of Gullaskruf wares were labeled and unsigned, however, a few signed examples can be found, particularly in wares produced in the 1960s and 1970s, including some designed by Arthur Percy and Kjell Blomberg.

Hadeland

Hadeland Glassworks is both the oldest existing industrial company in Norway and the longest existing glassworks. In was founded in 1762 at Mo in Jevnaker, a site owned the Danish-Norwegian state, and production started in 1765. Its early production was comprised mainly of bottles, glass for the pharmaceutical industry, and household glass. Hadeland became part of a share-holding company in 1898 called A/S Christiania Glasmagasin with two other glass companies, mainly making lighting and window glass. Sverre Petterson was appointed the first full-time art designer in 1928 and introduced a modern style to the tableware and art glass. Stale Kyllingstad joined Hadeland in 1937 and introduced sandblasted design techniques. After working as an apprentice for many years, Willy Johansson started as a designer for Hadeland in 1946, later became head designer, and remained there until 1988. Hadeland has a long list of illustrious designers which include Hermann Bongard (1947-1955), Gerd Slang (1948-1952 and 1963-1972), Arne Jon Jotrem (1950-1962 and 1985-present), Severin Broby (since 1956), Benny Motzfeldt (1955-1967), Gro Bergslien (married name, Sommerfelt, employed since 1964), and Edla Freij (1970s). Designers during the 1990s include Inger Magnus, Kjell Johannessen, Gro Eriksson Stoll, Kari Ulleberg, Suzanne Schurch and Marketa Burianova. The current chief designer and art director at the company is Maud Gjerulsen, accompanied by Lena Hansson, who is full time designer.

In 1982, share turnover was released and Christiania Glasmagasin turned public. Within a few years, the entire company was acquired by Atle Brynestad and divided into a number of smaller companies. Today, Hadeland Glassworks is a separate and independent company.

Hadeland wares are mostly signed and include the designer signature or initials, production numbers and sometimes year of production.

Holmegaard and Kastrup

The Holmegaard glass factory was founded in 1825 by Countess Henriette Danneskiold-Samsoe near the village of Fensmark, in order to take advantage of the Holmegaard Moors and use peat as a fuel source. For the first ten years, the factory produced bottles for beer and schnapps. In 1835, Holmegaard brought glass blowers from Bohemia and Germany, in order to expand production and to include more domestic items, which they achieved during the latter part of the 19th century.

The Kastrup glass factory was founded by Holmegaard in 1847, in order to produce bottles for the Copenhagen market, which was only a few kilometers from the factory. In 1873, Kastrup was sold and the new owners started producing several types of tableware and other household items. Around that time, the first pressed glass was made in Denmark at the factory. By the turn of the century, Kastrup was manufacturing popular glassware with etched decorations. In 1907, Kastrup bought the Fyens factory (established in 1874) in the town of Odense, in order to specialize in production of opaline glass, which was used mainly for lamp shades.

Until 1965, Holmegaard and Kastrup operated as independent and competing glass factories, but in that year the factories merged to create a single company, Kastrup and Holmegaard. By 1968 the Kastrup glass factory had ceased production of hand blown glass, which was made now only at Holmegaard factory and the Odense factory.

Architect Jacob Bang came to Holmegaard as staff designer in 1927 and brought much attention to the company by designing large collections of art glass. Bang left Holmegaard in 1941 to pursue other interests, but returned in 1957, now as a designer for Kastrup, where he remained until his death in 1965. Per Lutken was hired in 1942, and stayed at Holmegaard as designer and artistic director until his death in 1998. Other designers employed by Kastrup and Holmegaard from the late 1950s to mid-1970s were Christer Holmgren (Holmegaard, 1957-1972), who was also joined by his wife Christel Holmgren in later years, Arne Jon Jutrem (Holmegaard, freelance), Grethe Meyer (Kastrup), Ibi Trier Morch (Kastrup), and Bent Severin (Kastrup). In 1968, Michael Bang, the son of Jacob Bang was hired as a designer for Holmegaard and in the beginning mainly worked at Odense, where he created the "Pallet" series. During the 1970s, many freelance designers were associated with Holmegaard, including Kylle Svanlund, Britta Strombeck, Sidse Werner, the American designer, Joel Philip Myers and the English artist, Annette Meech. In 1979, the Kastrup factory closed. It was around this time that Kastrup and Holmegaard was renamed simply Holmegaard. In 1985, Holmegaard joined the Royal Copenhagen group. The Odense Factory was closed in 1990. In 1997, the Royal Copenhagen group became part of Royal Scandinavia. Holmegaard is still producing glass today.

Most of the glass produced at the Kastrup factory was only labeled and unmarked. The wares produced at Holmegaard were mostly signed, many times indicating the designer and year of production.

iittala

The iittala Glassworks was established in Finland in 1881 by Petter Magnus Abrahamsson, a Swedish master glass blower. After a difficult start, the factory established its status as a manufacturer of quality products, until the long period of growth was interrupted by the First World War. The first glassblowers came to iittala from Sweden. In the beginning, the majority of its production consisted of simple household glass, with little cut or engraved glass. In 1917, because of the great difficulties incurred due to the First World war, the share holders were compelled to sell the company to Ahlstrom Oy, a group which also owned the glass factory Karhula. During the 1920s, although Ahlstrom made numerous improvements at iittala, Karhula still played a more important role. During the 1930s, Karhula concentrated on production of bottles

and pressed glass while iittala concentrated on blown glass. At that time, the companies arranged glass design competitions to attempt to raise the profile of both utility and art glass. Aino Aalto won second prize at the competition in 1932 and Alvar Aalto took first prize in 1936. The "Aalto" vase, though a Karhula-owned design, was transferred to iittala for manufacture. Another competition was held in 1946 to access new engraved glass designs. The outcome of this competition brought Tapio Wirkkala and Kaj Franck to iittala, where both were appointed chief designers. After Franck moved to Nuutajarvi in 1950, Timo Sarpaneva arrived to take his place. In 1956, iittala launched its first modern utility glass collection, designed by Timo Sarpaneva. The "i-collection" or "i-series" arose from a critical demand for modern, functional and beautiful, everyday items. The "i-collection" also carried the "i" label for the first time, which was to become iittala's trademark. In the 1950s and 1960s, Wirkkala and Sarpaneva won prizes at several competitions, including the Milan Triennales. Through their innovative work, Finnish glass gained an international reputation. iittala's factory underwent major renovation in the 1960s, and utility glassware began to be marketed under the "i" trademark. Production methods were created, including the use of burned wooden molds and engraved graphite molds. A breakthrough came in 1964, with Sarpaneva's popular "Finlandia" collection. In 1971, iittala opened a glass museum and built a factory for producing lamps and lighting. Valto Kokko, who since 1963 had designed lamp glass, began also to create utility glass. At the end of the 1980s the ownership of the iittala ownership was changed. In 1987, A. Ahlstrom Oy and Wartsila, two large Finnish industrial groups, merged their glass industries into iittala-Nuutajarvi, in order to fight the heavy competition of the ever growing glass imports. In 1990, the Hackman Group bought iittala-Nuutajarvi, and the new company continued by the name of "Hackman iittala". Today, Hackman has combined its various tableware factories (glass, porcelain and stainless steel) into one unit called Hackman Designor Oy Ab. Hackman Designor Oy currently has four brands which include Arabia, Hackman, iittala, and Rorstrand.

iittala's Staff and Freelance designers:

Aino Aalto	1930s	Jorma Vennola	1975-1986
Alvar Aalto	1930s	Mikko Karpannen	1983-1988
Goran Hongell	1932-1957	Tiina Nordstrom	1988-1997
Erkki Vesanto	1936-1980	Erkkitapio Siiroinen	1992-1996
Greta-Lisa		Kati Tuomen-Niittyla	1993-
Jaderholm-Snellman	1945-1962	Elina Joensuu	1995
Gunnel Nyman	1946-1947	Konstantin Grcic	1998
Tapio Wirkkala	1946-1985	Stefan Lindfors	1998-
Kaj Franck	1946-1950	Harri Koskinen	1998-
Liisa Johansson-Pape	1948-1960s	Marc Newson	1998-
Timo Sarpaneva	1950-	Carina Seth-Anderson	1998-
Valto Kokko	1963-1993		

Other designers associated with iittala are Helja Liukko-Sundstrom, Brita Flanders, Marcus Eerola, and Nathalie Lahdenmaki.

Johanfors

The factory was founded in 1891 in Sweden. One of the founders was F. O. Israelsson, a church warden. From 1904 to 1911, the factory was leased to AB De Svenska Kristallglas-bruken (Association of Crystal Manufacturers), after which it was run by Israelsson. From 1950 to 1972, Sixten Wennerstrand rebuilt and modernized the company. In 1972, Johansfors was sold to the Afors Group (later known as Kosta Boda AB). In 1990, Kosta Boda merged with Orrefors. In 1992 Johansfors was taken over by a group of former employees. The company is still in production and currently owned by the Norwegian glass firm, Magnor.

During the early years of production, Johansfors mainly made pressed glassware and hand painted decorative glass, which later became one of its specialties. During the 1920s, cut glass also became a specialty and several cutters from Kosta and Bohemia came to the company. In the mid-1920s, four engravers were hired, one of whom, Folke Walwing, later became art director at Maleras. Johansfors cut and engraved wares were very successful internationally. Several commendations were given for its products at the World Exhibition in Barcelona in 1929. In the 1930s, new products were designed by artist Gunnar Hakansson and Johanfors concentrated and thrived on producing designs by their artists. From 1938 to 1947, many of the designs were made by Gustaff Hallberg, the chief gaffer. In 1952, artist and designer Bengt Orup, started working for the company and was employed until 1973. Orup was rather prolific and designed wares from simple tableware to art glass. Other artists employed at the company were Margareta and Rik Hennix(65-67) and Ingegerd Raman(68-71).

The majority of Johansfors wares were signed, however, some examples can be found without a signature or only labeled.

Karhula

Karhula Glassworks was founded in 1889 by Captain William Ruth. They produced bottles and household glass with designs copied from Nuutajarvi, Reijmyre, and Swedish and German designs. Molded and blown glass production was overseen by a certified master blower, M.A. Kolehmainen, who worked at Karhula from 1899 to 1910. A. Ahlstrom Oy bought Karhula in 1915 and then bought iittala in 1917. Eric O.W. Ehrstrom was a designer and artistic director starting in 1925, and his designs favored lighter, engraved glass. At the Antwerp world exhibition in 1930, Karhula won awards for its designs. Seeking modern design, Karhula-iittala organized design competitions during the 1930s. Successful designers during these competitions included Aino Aalto, Goran Hongell, Arttu Brummer, Antti Salmenlinna, Elmar Granlund, Yrjo Rosola, Aarre Putro, and Lisa Johansson-Pape. At the Milan Triennale in 1933, Karhula entered all but the pressed glass designs, and the factory won the highest award. After the competition, Goran Hongell was appointed artist designer and held that post until he retired in 1957. One of Hongell's most notable designs, the "Aarne" glass series won a gold medal at the Milan Triennale in 1954. In 1937, another design competition was organized and designers who participated included Gunnel Nyman, Gunilla Jung, Richard Jungell, Yrjo Rosola, Aino and Aalvar Aalto, Goran Hongell, Gunnar Forstrom, Erik Bryggman, and Aulis Blomstedt. Alvar Aalto's "Eskimo Woman's Leather Breeches" was the winner and later acquired the name the "Savoy" vase, because of the association of the piece with Helsinki's Savoy restaurant.

Karhula began producing glass containers in 1945 and utilizing a bottle-making machines in 1948. Molded glass production and art glass was moved to iittala in 1954, leaving Karhula with fully automated glass container production. Karhula produced glass

tiles from the 1930s until 1968. A. Ahlstrom Oy bought Riihimaki glass in 1985 and combined the companies. Riihimaki glass closed in 1990 and in 1995, Karhula was purchased by an American company, Owens-Illinois.

Karhula Glassworks' Staff and Freelance Designers:

Eric O.W. Ehrstrom	1925 (Artistic Advisor)
Richard Jungell	1920s-1930s (Master Cutter)
Goran Hongell	1932-1957
Aino Marsio-Aalto	1930s
Alvar Aalto	1930s
Gunnel Nyman	1935-1937
Arttu Brummer	1930s
Gunilla Jung	1930s
Yrjo Rosola	1930s
Tapio Wirkkala	1960s

Kosta and Kosta Boda

In 1742, two generals in Sweden's army, Anders Koskull and Bogislaus Stael Von Holstein, founded a glass company which they named with letters borrowed from their names "Ko" and "Sta." In 1746, Johan Wickenberg acquired Kosta and it stayed in the family until 1893. The Wickenbergs were excellent managers who expanded sales by opening offices in Stockholm and as far away as Russia. Early production at Kosta was mainly window glass, including the window glass for the royal palace in Stockholm. Kosta also made chandeliers, bottles for beer and schnapps, and household wares. In 1752, engraved glass began production, in 1828 cut glass was introduced, and in 1889 a glass pressing machine was installed. One of Kosta's specialties in the 1880s was stemware. Much of Kosta's production was exported and it was Sweden's second largest glass producer. Production was modernized to include cut glass, and, in 1833, the first printed price list was published by manager Uno Angerstein. Axel Hummel, a former forestry engineer, became manager in 1887. Hummel put company finances in order, modernized production and helped bring the railway to Kosta in 1890. Kosta hired artist Gunnar Wennerberg to design a series of cut and overlay designs for the Paris Exposition of 1900. Another celebrated artist, Alf Wallander, worked at Kosta during the 1900s. Kosta realized much acclaim from the work of Wennerberg and Wallander and they recognized the value of collaboration between artists. Artists who worked for Kosta during the 1920s and 1930s included Karl Hulstrom, Sten Branzell, Ewald Dahlskog, Sven Erixson, Erik Skawonius, Tyra Lundgren, and Edvin Ollers. Elis Bergh was art director at Kosta from 1929 to 1950. He began designing light fixtures, but soon started producing bowls, vases, and stemware.

In 1950, Vicke Lindstrand took over for Bergh. Lindstrand had a gift for bold experimentation and for the creation of art glass techniques. In addition to art glass with new shapes and colors, he is noted for his stemware and even designed glass for public spaces. In the 1960s, Mona Morales-Schildt designed the elegant "Ventana" pieces using a cut overlay technique and several new and young artists found a place at Kosta. These included Sigurd Persson, Lisa Bauer, Rolf Sinnemark, and Ann and Goran Warff. Since the artists who came in the 1960s did such notable and impressive work, Kosta followed suit in the 1970s, hiring Paul Hoff, Bengt Edenfalk, Anna Ehrner, and Klas-Goran Tinback. Since the 1980s, Kosta has produced many series of bowls, vases, and tableware alongside art glass that has brought acclaim both in Sweden and abroad.

In 1964 Kosta began a cooperative alliance with two other glass factories, Afors and Boda, and together they were named the Afors group in 1971. In 1972, the Afors group also purchased Johansfors. In 1975, the group was sold to Upsala-Ekeby, the Swedish ceramics concern, and in 1976 the Afors group was renamed Kosta Boda AB. In 1982 the Kosta Boda's entire stock of shares was acquired by AB Proventus. In 1990 Kosta Boda merged with Orrefors, becoming Orrefors Kosta Boda. In 1997, Orrefors Kosta Boda became part of The Royal Scandinavia Group.

During the early 1950s and 1960s, most pieces were marked "Kosta," with a designer code, followed by a secondary code, which indicated the type of glass, and a four digit production number. These codes were used to resemble those used by Orrefors. The known designer codes during this time are included in the list of designers. The codes for designs by Vicke Lindstrand during the 1950s and 1960s were as follows:

LH	Hand-shaped glass
LU	"Unica" design
LC	Hand-shaped glass in the "Colora" technique
LF	Hand-shaped bird sculptures
LG	Engraved glass
LS	Cut glass

During the early 1970s, the signatures and markings at Kosta changed to include the designers' signatures, as well as a 5 digit production number. This seems to coincide with the creation of the Afors group. The change to 5 digits is significant because, around 1974, the year of design could be identified with the second and third digit of the production number. The first digit indicates the type of ware, for example, vase codes would always start with a 4, bowl codes would start with a 5, candleholders with a 6, plates with a 7, and decanters with an 8. The identification of year of design holds true for most wares except for stemware, but regardless, stemware was rarely signed. This numbering system appears to have been used by all members of the Afors group, therefore a piece signed "Boda" would have the 5 digit numbering system, as would one signed "Boda-Afors" or "Kosta Boda." Sometime between 1984 and 1986, the signatures became uniform regardless of the factory in which they were produced (Afors, Boda, or Kosta) and had both the artist name and the "Kosta Boda" name.

By 2002, Kosta Boda changed the numbering system again to include a 7 digit system, rather than a 5 digit system. Now the first 3 digits indicate the type of ware, while the fourth and fifth digit indicate the year of design. Web site: www.kostaboda.se

Artists at Kosta (with known designer codes):

Axel Enoch Borman	1895-1903	Sven Philstrom	1926-1969
Gunnar Wennerberg	1989-1902; 1908	Einar Nerman	ca. 1926
		Elis Bergh (BH)	1929-1950
Kai Neilsen	1903-1904	Sven-Erik Skawonius	1933-1935; 1944-1950
Ferdinand Boberg	1905		
Karl Lindeberg	1907-1931	Tyra Lundgren	1925
Alf Wallander	1908-1909	R.A. Hickman	1937
Edvin Ollers (O,F)	1917-1918; 1931-1932	Oskar Dahl	1939-1940; 1942-1944
Karl Hulstrom	1917-1919; 1927-1928	John Kandall	1946
		Vicke Lindstrand (L)	1950-1973
Lennart Nyblom	1919	Ernest Gordon	1953-1955
Sten Branzell	1922-1930	Mona Morales-Schildt (SS)	1958-1970
Sven Erixson and Arnold Karlstrom	1923	Ann Warff	1964-1978
Sven Erixson	1929-1931	Goran Warff	1964-
Ewald Dahlskog	1926-1929	Stig Lindberg	1965

175

Rolf Sinnemark	1967-1986	Max Walter Svanberg	1980
Sigurd Persson	1968-1982	Harald Wiberg	1980
Lisa Bauer	1969-1991	Bengt Lindstrom	1982
Paul Hoff	1972-1982	Gun Lindblad	1982-1987
Hertha Hollfon	1974	Christian von Sydow	1984-1989
Anna Ehrner	1974-	Gunnel Sahlin	1986-
Bengt Edenfalk	1978-1989	Ann Wahlstrom	1986-
Klas-Goran Tinback	1976-1981	Anne Nilsson	2001-

Kumela

Kumela Glassworks was founded in Riihimaki in 1933 by Finnish glass painter Toivo Kumen, who later changed his surname to Kumela. In the beginning, Kumela was just a small studio with four workers, three Kumela brothers and one hired worker. They specialized in enamel glass painting, engraving, and cutting. The founder's idea was just to streamline operations for other Finnish factories such as Riihimaen Lasi. However, the business idea was successful and after three years of activity, the Kumela brothers decided to build a factory. At the end on 1936, corporate form changed from sole trader to family-owned company with the name Osakeyhtio Kumela (Oy Kumela). Construction for the new factory started in the summer of 1937 and production started in the autumn of the same year. The new factory produced mainly household glass and art glass. In 1937, Oy Kumela employed 40 workers and the number of workers increased to over 150 workers by 1948. During the Finnish Winter War (1939-1940), production at the Kumela Glassworks was interrupted for a few months. During the late 1940s and early 1950s, Oy Kumela mainly produced bottles for the pharmaceutical and food industry, but the company also produced glass lamp shades, utility glass for restaurants and mass-catering use, household glass, and art glass. In the mid-1950s, in order to increase production, machine made glass needed to be made and more capital was needed. Because of continuous competition in both foreign and domestic markets, the company was forced to reduce its range of products. In 1960 the machine made bottle production became unprofitable and the production ended, and the factory concentrated in hand blown objects again. At that time, Kumela had returned to its beginning: glass painting, cutting and engraving, but now those styles had fallen out of favor and wares did not sell well. In the beginning of 1970s Kumela had to close its glass cutting and engraving departments and the energy crisis forced the owners to sell the company to Humppila Glassworks in 1976. At that time, the name was changed to Kumelan Lasitehdas Oy. After 1977, the new owner started to modernize the production process at the factory, and bought new machinery and equipment to manufacture high quality tableware and art glass gift wares. Production resumed in 1979, and part of it was based on traditional middle-European crystal designs, and another part based modern Finnish design. The idea was to develop and design specialty glass for export, however this was not fruitful, and, in 1980, Kumelan Lasitehdas Oy closed.

In the beginning, the brothers Toivo Kumela and Ilmari Kumela were the main designers in glass enameling and engraving. The first hired designers at Oy Kumela were Ulla Kraemer, Maija Karlsson, jewelry designer Jan Salakari, and interior architect Olavi Ruottinen. Some glass blowers also had input into design. Probably the most important and best known Kumela designer is the Italian master glassblower, Armando Jacobino, who came to the company after his employment at Nuutajarvi Notsjo in the 1950s.

Other designers were Veikko Pekkola, Toivo Karjalainen, Martti Helenius, and Sulo Tommila, all of whom created mostly cut glass objects. During the 1970s, an important designer in the company was Kaj Blomqvist, who created some colorful, ice-like vases which resemble the work of Sarpaneva and Wirkkala for iittala.

Lindshammar

The company was founded in Sweden in 1905 by Robert Rentsch, a German glass blower who previously worked for Kosta and Pukeberg. In 1916, the company was acquired by Anton Petersson, who modernized the factory and included a new blowing room. In 1949 Petersson's son, Erik Hovhammar assumed control and completely rebuilt the factory. Bankruptcy was declared in 1981 and the company was sold in 1984 to Ulf Rosen. Lindshammar continues to produce glass today under the direction of Mr. Rosen.

Primary production in the early years was cut glass tableware and colored ornamental wares, mainly for export. During the Second World War, production also included preserving jars and bottles. In 1949, the company began producing art glass and employed artist Gunnar Ander. Other artists were hired after him, including Christer Sjogren (1963-present), Tom Moller (67-89), Sigvard Bernadotte (1970s), Catharina Aselius-Lidbeck (70-89), and Matz Borgstrom (90-92). Production on blown glass declined during the 1970s and molded and centrifuge glass became the main production. In 1984, Ulf Rosen began reintroducing blown glass, both as art glass and everyday, functional items. The current designers at the factory include Lillemor Bokstrom, Bosse Falk (since 2000), Maud Gjeruldsen Bugge, Lena Hansson, James Hamilton (since 1994), Britten Paag (since 1998), Jonas Torstensson (since 1986), Jan Wiberg, Lars Sestervik (since 1987), Brigitta Watz and Sofia Wiberg. Web site: www.lindshammarglasbruk.se

Magnor

The glassworks was founded in Norway as early as 1896 in the deep forests near the Swedish border, just three kilometers from the border and 120 kilometers from Oslo. Today Magnor continues to produce hand blown glass. The factory currently the factory employs 120 people, and also includes the Swedish company Johansfors, which was purchased by Magnor.

Maleras

Maleras Glassworks was founded in 1924, in the Smaland region of Sweden, and specialized in tableware and art glass. During the 1930s, Maleras became a major supplier to the Swedish Cooperative Union and Wholesale Society. Architects from the union worked on designs for glass. Folke Walwing began at Maleras as an engraver in 1924 and was art director until 1970. Walwing designed cut, engraved, and pressed glass, and led a movement towards textured glass during the 1960s. Mats Jonasson started working at Maleras in 1959 and left from 1969 until 1975 to work at Kosta. During the 1960s, Hannelore Oreutler, Ake Rojgard, and Anette Sviberg-Krahner designed for Maleras for short periods. Sviberg-Krahner returned to Maleras in the 1970s, joining Lisa Larsson and Marianne Westman. When Mats Jonasson returned, he began designing his own models and was made art director in 1981. From 1989 to 1991, Ingeborg Lundin, after winning ac-

claim for her designs at Orrefors, designed for Maleras. Maleras was incorporated into the Flygsfors group in 1965, and then joined the Royal Krona group in 1974. Kosta Boda took over the company in 1977. In 1981, Maleras Glassworks was purchased by its own employees and they ran the company after 1981. In 1988, in order to fight off a take-over by Orrefors, Mats Jonasson bought enough shares to take control of the company. Since then, he has been the managing director, art director and chief designer. Currently he is joined by Erika Hoglund, since 1997, and Klas-Goran Tinback, since 2000, and together they make up the designing team at the company. All current art glass at the company is marketed under the name "Mats Jonasson Maleras".

Web site: www.matsjonasson.com

Nuutajarvi

Nuutajarvi is the oldest glass factory in Finland. The founders, Jacob Wilhelm de Pont and Harald Furuhjelm, began production in 1793 making primarily window glass, bottles, and household glass. The factory was modernized in 1851 and began producing pressed glass and filigree glass under the guidance of Charles Bredgem, a French glassblower. This led to Nuutajarvi becoming a company of note among Nordic glassworks. In an effort to obtain designs of their own, Nuutajarvi held glass competitions in 1905 and 1906. After World War II, under the direction of Gunnel Nyman, Nuutajarvi became a force in the realm of the manufacture of art glass. The Stockholm Exhibition of 1946 was a breakthrough for Nyman's designs and she is credited for the creation of the Nuutajarvi's tradition of artists and glass makers working as teams in small glasshouses or cottages.

The factory burned down in 1950, but was rebuilt quickly and then sold to the Wartsila Group, which had also acquired Arabia. This union brought Kaj Franck to Nuutajarvi where he redesigned the company's utility glassware. Saara Hopea was appointed Kaj Franck's assistant in 1952 and she took on the task of redesigning Nuutajarvi's crystal. Franck had begun to use filigree glass techniques once again and together with Hopea, they forged a solid reputation for Nuutajarvi's utility glass, bringing simplified forms and a wealth of color to glass exhibitions, including the Milan Triennales of that period. Kaj Franck's work brought international acclaim in 1955 when he won the Lunning Prize. The 1960s at Nuutajarvi brought renewed interest in high-quality pressed glass. Oiva Toikka was appointed designer in 1963 and Heikki Orvola came to Nuutajarvi in 1968. Toikka's bold use of color and sculptural techniques brought him attention and he received the Lunning Prize in 1970. Orvola used a mix of techniques in creating glassware, designing notable and unique pieces. Kerttu Nurminen came to Nuutajarvi in 1972. The popular Mondo glassware of 1988 was only one of the lines Nurminen designed. Markku Salo, another innovator of unique glass techniques, has been designing for Nuutajarvi since 1982. 1993 marked the bicentennial anniversary of Nuutajarvi. Art glass from the company has been marketed under the name "Pro Arte" since 1981 and the release of the first "Pro Arte" collection coincided with the bicentennial in 1993. The Hackman Group has owned Nuutajarvi since 1990 and most production moved to iittala, also owned by Hackman Group, leaving Nuutajarvi to make only art glass. All of Nuutajarvi's glass is currently marked under the iittala name. However, the "Pro Arte" collection, which has been continued by iittala, still makes a distinction between the art glass created at Nuutajarvi and the art glass created at iittala.

Nuutajarvi's Staff and Freelance Designers and Artists:

	
Gunnel Nyman	1946-1948
Kaj Franck	1950-1976, freelance 1977-1989
Saara Hopea-Untracht	1952-1959
Hilkka-Liisa Ahola	1950s
Vuokko Eskolin-Nurmesniemi	1956-1957
Harry Moilanen	1960-1962
Oiva Toikka	1963-1993 artistic advisor
Heikki Orvola	1968-1983, freelance 1984-
Inkeri Toikka	1970-1992, freelance 1992-
Kerttu Nurminen	1972-
Markku Salo	1983-1997, freelance 1997-
Taru Syrjanen	1988-1991
Tiina Nordstrom	1988-1990
Annaleena Hakatie	1993-
Sami Lahtinen	1995-
Harri Koskinen	1996-1998

Orrefors

In 1898 Johnan August Samuelson established the Orrefors glassworks on a property that also held a sawmill and iron foundry. In 1913, the glassworks and sawmill were acquired by Johan Eckman. Although his main interest was the lumber business, Eckman hired Albert Ahlin to manage the glassworks. A year before his death in 1819, Eckman acquired Sandvik glassworks and after his passing, his children ran both glassworks. In 1946, Henning Beyer purchased Orrefors and his family remained in charge until 1971 when an investment trust company called Incentive bought a majority of the company stock. The relationship between Incentive and Orrefors continued until 1994. During the seventies Orrefors acquired Alsterfors, Flygsfors, Strombergshyttan, and Gullaskruf and all were closed in a few years. In 1990 Orrefors also acquired Kosta Boda. Currently Orrefors comprises the following companies: Orrefors, Sandvik, Kosta, Boda, Afors, and SEA. The earliest products from Orrefors were simple tableglass, hollow ware, some cut and etched tableware, and sheet glass. Eckman and Ahlin were very interested in the future of art glass and hired Knut Bergqvist, a master glassblower, and Oscar Landas as chief gaffer, Heinrich Wollman, a glass painter, and Fritz Blomqvist to prepare designs. Simon Gate and Edward Hald were hired as designers in 1916 and 1917. To supplement the engraved glass production, Gustaf Abels joined the company in 1915. In 1922, Orrefors opened the first school for glass engraving in Sweden. Sven Palmqvist and Nils Landberg attended the school and then designed for Orrefors and Sandvik for many years. John Selbing was also a designer but most remembered for his photographs of glass. In 1928 Orrefors hired Vicke Lindstrand. Lindstrand's engraved optic bowls garnered much acclaim at the 1930 Stockholm Exhibition. Edvin Ohrstrom, who came to Orrefors in 1936, specialized in heavy monumental pieces. Ingeborg Lundin was hired in 1947 and Gunnar Cyren in 1959. The 1970s brought the retirement of many prominent designers, which paved the way for new designers such as Olle Alberius, Lars Hellsten, Eva Englund, Berit Johansson, and Jan Johansson. The new artists continued to develop new techniques and some also designed sculptural pieces for public spaces. In 1987, Orrefors discontinued producing pieces from artists who were no longer active and allowed broader production of contemporary designs. Contemporary designers included Lena Bergstrom, Helen Krantz, Erika Lagerbielke, Anne Nilsson, Martti Rythonen, and Per B. Sundberg. In 1990 Orrefors bought and merged with Kosta Boda, becoming Orrefors Kosta Boda. In 1997, Orrefors Kosta Boda became part of The Royal Scandinavia Group.

Most of Orrefors pieces are signed and the signature and markings can include much information. The signatures are sometimes complex and at times confusing, because the company has changed the ways they signed their wares throughout the years. Here is some basic information about signatures that can be helpful for the collector in order to identify the designer and approximate year of production.

- The company name was signed first as "Orrefors" or "Of".
- The designer code follows, and it can be found in the following list of designers. Keep in mind that the designer code changed around 1970, and this can help identify if the piece is of earlier or later production than that year.
- The supplemental code follows. These supplemental codes were added in the 1930s, and some of the signatures around that decade or earlier might not include them. If lacking a supplemental code, the piece is likely engraved. Some of these codes are:

 A Cut glass
 E Satin glass
 F Cut overlay
 I Painted glass
 P Pressed glass
 U Blown glass worked in the blowing room

- The production number follows. There are mainly 3 to 5 digits, and sometimes the last digit is separated slash (/).
- After the production number, some pieces were marked with a code designating the date but these can be difficult to understand as they are not simply a date, and are often difficult to read.

Artist	Years Employed	Designer Code (Pre-1970)	Designer Code (Post-1970)
Heinrich Wollmann	1914-1923	HW	
Knut Bergqvist	1914-1928	KB	
Fritz Blomqvist	1915-1917	FB	
Gustaf Abels	1915-1959		
Simon Gate	1916-1945	G	SG
Eva Jancke Bjork	1915-1917		
Edward Hald	1917-1978	H	EH
Nils Landberg	1927-1972	N	NL
John Selbing	1927-1973	C/S	
Vicke Lindstrand	1928-1940	L	VL
Sven Palmqvist	1928-1971	P	SP
Flory Gate	1930		
Edvin Ohrstrom	1936-1957	F	EO
Fritz Kurz	1940-1946	KD	
Carl Fagerlund	1946-1980	R	
Ingeborg Lundin	1947-1971	D	IL
Gunnar Cyren	1959-1970, 1976-	B	GC
Jan Johansson	1969-	J	JJ
Styrbjorn Engstrom	1970		E
Henning Koppel	1971-1981	K	HK
Rolf Nilsson	1971-1972		
Olle Alberius	1971-1993	A	OA
Lars Hellsten	1972-	T	LH
Eva Englund	1974-1990	V	EE
Wiktor Berndt	1975-1979		
Owe Elven	1975-1978		W
Petr Mandl	1970s		
Borge Lindau	1970s		LL
Bo Lindekrantz	1970s		LL
Berit Johansson	1979-1983		BJ
Anette Krahner	1980-1981		AK
Arne Branzell	1980-1982		AB
Klas-Goran Tinback	1982-1983		KGT
Erika Lagerbielke	1982-		EL
Anne Nilsson	1982-2000		AN
Matz Borgstrom	1984-1990		MB
Helen Krantz	1988-		HZ
Vivianne Karlsson	1989-1993		VK
Lena Bergstrom	1994-		LB
Martti Rytkonen	1994-		MR
Per B. Sundberg	1994-		PS

Plus Glasshytte

Founded in 1958 in Fredrikstad, Norway by Per Tannum as part of a workshop cooperative. The cooperative workshops involve not only glass, but ceramics and other types of art wares. Plus Glasshytte is the glass division. The glass workshop has been managed by Benny Motzfeldt since 1970. Most of Plus pieces are signed with and acid etched mark, but do not always identify the designer.

Pukeberg

Founded in 1871 in Pukeberg, Sweden, its early production was mostly pressed domestic glassware. The company was purchased by a lamp manufacturer and began producing lamps, lampshades, and items for oil lamps in 1894. The 1920s brought the production of fittings for electric lights. Pukeberg specialized for a time in large glass globes for advertising signs for gas stations and garages. Decorative glass production started in the 1930s. Uno Westerberg began designing light fixtures for the company and then turned to decorative glass wares in the 1950s. Goran Warff and Ann Wolff joined the company in 1959, met, married and stayed until 1964. Eva Englund came in 1964. Together, the Warffs and Englund revitalized Pukeberg with new designs for art glass. However, Pukeberg had serious financial difficulties during the 1980s and early 1990s and was sold several times. Erik Hoglund worked at Pukeberg from 1978 to 1981. Other artists that worked freelance for Pukeberg include Gunilla Lindahl, Ragnhild Alexandersson, Karin Johansson, and Lars Sestervik. Other Pukeberg designers include Margreta Hennix, Liselotte Hendriksen, Borge Lindau, Rolf Sinnemark, and Birgitta Watz.

Most of the glass produced at Pukeberg was labeled and unsigned, although some of the more complex and sculptural pieces were signed.

Riihimaen Lasi (Riihimaki)

The Riihimaki Joint Stock Company was founded in Riihimaki, Finland, by M.A. Kolehmainen and H.G. Paloheimo in 1910 and renamed Riihimaen Lasi in 1937. Riihimaki manufactured household glass, container glass, crystal, window glass, and eyeglass lenses and was Finland's largest glass factory from the 1920s to the 1960s. The company underwent modernization from 1927 to 1948, under the direction of Roope Kolihmainen. Work was commissioned from designers like Tyra Lundgren and Eva Gylden from the 1920s on. In 1928 Henry Ericsson, who had won a glass design competition open to the public, was hired. Orrefors was dominating the glass export trade at that time and Riihimaki took aim at that market. Ericsson asked Gunnel Nyman to design for Riihimaki in the early 1930s and she made both glassware and art glass. Reaching out with glass competitions in 1933 and 1936, Riihimaki began design associations with Arttu Brummer and Aino and Alvar Aalto. The company engaged a host of designers including Elis Muona, Antii Salmenlinna, Gunnar Finne, Yrjo Rosola, Greta-Lisa Jaderholm-Snellman, and Elmar Grunland. The designer Helena Tynell was hired in 1946. At a Nordic glass competition in 1949, Arttu Brummer took first place, Timo Sarpaneva won second place, and Helena Tynell took third. Nanny Still was hired in 1949. From 1968 to 1985, E.T. (Erkkitapio) Siiroinen was employed at the company. Riihimaki began a cooperative agreement with A. Ahlstrom in 1961 and manual production of glass ended in 1976 when the company turned to mass production.

Household glass was also produced in 1977 by the newly founded Kotilasi unit. A. Ahlstrom bought Riihimaen Lasi in 1985 and in 1988 was it merged with Karhula to form Ahlstrom Riihimaen Lasi Oy. Riihimaen Lasi closed in 1990 and in 1995 Owens-Illinois, an American company, bought Karhula.

Riihimaki Glass Staff and Freelance Designers and Artists:

Tyra Lundgren	1920s	Jaderholm-Snellman	1937-1949
Eva Gylden	1920s	Helena Tynell	1946-1976
Theodor Kappi	1925-1939	Nanny Still	1949-1976
Henry Ericsson	1928-1933	Sakari Pykala	1954-1955
Arttu Brummer	1933-1951	Tamara Aladin	1959-1976
Gunnel Nyman	1932-1947	E. T. Siiroinen	1968-1976,
Aimo Okkolin	1937-1976		1976-1985,
Greta-Lisa			freelance

Artists and designers who had contact with Riihimaki: Toini Muona, Antti Salmenlinna, Gunnar Finne, Yrjo Rosola, Elmar Granlund, Kaj Franck, and Timo Sarpaneva.

Sea Glasbruk

Founded in 1956, Sea Glasbruk is located in the village of Kosta, in the region of Smaland, Sweden. From its inception, production has focused on decorative glassware and gift-ware, characterized by a clean and functional design. Current designers include Goran Anneborg, Lena Engman, Bjorn Ramel, Renate Stock and Rune Strand (until 2000). Still in production, Sea Glasbruk is now associated with Orrefors Kosta Boda Company. Web site: www.seaglasbruk.se

Skruf

The factory was founded in 1897 in the region of Smaland, Sweden by Robert Celander, who was previously the manager at Johansfors. In 1908 the company underwent bankruptcy and was reformed in 1910. In 1946, the facility was completely destroyed by a fire, but production resumed a year later. The 1960s brought modernization to the facility including equipment for the automated cutting and polishing of tableware. In 1974 Skruf joined the Royal Krona group, an enterprise which went bankrupt in 1977. The company was later purchased by Kosta Boda. In 1980, the company closed, but an independent group of glass blowers have continued to produce glass there from 1981 to the present. Skruf is now part of the Svenska Glasbruk Group in association with two other glass factories, Bergdala and Alghult.

Original production during the turn of the 19th century consisted mainly of simple drinking glasses and jam jars. Crystal glass was introduced after 1910. During the 1930s and 1940s, Skruf produced an extensive line of table and domestic glassware including some for export. Most of the pieces of this period were designed by Magni Magnusson, the chief gaffer. In 1953, Bengt Edenfalk joined the company as chief designer. During his time at the company, he designed numerous pieces of tableware, plain and cut, as well decorative art glass, both colored and transparent. Edenfalk left Skruf and moved to Kosta in 1978. Other designers associated with Skruf include Lars Hellsten(1964-1972), Ingegerd Raman(1981-1998), and Anneter Krahner(1982-1994).

Strombergshyttan

Founded in 1876 in Sweden as the Lindfors glassworks, production consisted of plain, cut, engraved, painted, and pressed glassware for homes and restaurants. The company was purchased by the former head of Orrefors, Edward Stromberg, in 1933. He changed the company name. Working with his son, Eric, Edward Stromberg experimented until they produced glass with a bluish silver hue, a color which became the factory's specialty. Using this new glass, Gerda Stromberg designed glass which was executed by glassblower Knut Bergqvist from 1933 to 1955. Asta Stromberg also worked as a designer for the company from the late 1930s until 1976. Eric Stromberg purchased the company after his father's death in 1945. After Eric died in 1960, his wife Asta Stromberg ran the company and modernized operations in 1962.

Gunnar Nylund joined the design staff in 1952, staying until 1975. Rune Strand also designed for Strombergshyttan during the 1960s. There was a serious factory fire in 1973 which caused economic difficulties and the company was sold to Orrefors in 1976. Strombergshyttan closed in 1979.

Most of Strombergshyttan's wares were signed, although exceptions do apply; some pieces were only labeled. The signatures used were "Strombergshyttan" and "Stromberg" with a production code, but they were not designer specific. However, the production codes can provide information to help approximate the time the when pieces were designed. For plain vases, the production code consisted of the letter "B" followed by a series of numbers. For plain bowls, the production code consisted of the letter "T" followed by a series of numbers. In the following list, the year of design is indicated in the upper horizontal column. For example, a vase with a code of B936 was designed between 1954 and 1959/60. This becomes more complex when the pieces were engraved, because the engraving also has a design code, consisting of a letter and a series of numbers. It is important to remember that in engraved pieces the first code corresponds to the type and design of the ware and the second code corresponds to the engraving. It is also important to understand that Strombergshyttan produced more than just vases and bowls. Letters for other wares include "A" for plates, "E" for carafes and brandy glasses, and "O" for Liqueur bottles with glasses, to name a few.

Year of design		1935/36	1941	1944	1947	1954	1959/60	1962
Vases	B	111	318	388	401	642	972	974
Bowls	T	73	164	180	197	264	376	377

Chapter 12
Designers

Aalto, Aino Marsio (Finland, 1894-1949)

Aino trained and graduated as an architect from the Helsinki University of Technology in 1920. In 1924, Aino Marsio got a job at Alvar Aalto's architecture office. They fell in love, got married, and soon started a lifelong partnership. In 1932 Alvar Aalto, who would soon rocket to international fame, lost a the Karhula-iittala design competition to his wife. Her winning entry, the "Bolgeblick" tableware, also went on to win the gold medal at the Milan Triennale in 1936. Besides designing glass for Karhula, in 1932, Aino Aalto was one of the founding members of Artek in 1935, together with Alvar Alto and others. Artek is a Finnish furniture company which still is in operation.

Aalto, Alvar (Kuortane, Finland, 1898-1976)

Hugo Alvar Henrik Aalto trained as an architect in the Helsinki University of Technology from 1916 to 1921. In 1933, he worked on a freelance basis with Riihimaen Lasi and designed the "Riihimaki flower," which won second price in the Riihimaki design competition for domestic glassware of 1933. From 1932 to 1939, he did freelance work for Karhula, where he designed the "Savoy" vase (1936) and, in collaboration with Aino Aalto, the "Aalto Flower" (1939), which was first shown in the New York's World's Fair of 1939. In 1935, in collaboration with Aino Aalto and others, Alvar Aalto founded Artek, a Finnish furniture company, which featured many of Aalto's furniture designs.

Besides Alvar Aalto's significant design contributions in glass, furniture, and other areas, such as textiles, lighting and interior design, he will also be remembered as one of the most important architects of the 20th century. He was a practicing architect from 1923 until his death in 1976. Some of his most important architectural projects include the Viipuri Library (1927) and the Paimo Sanatorium (1929).

Aladin, Tamara (Finland, b. 1932)

Tamara Aladin worked as designer for Riihimaen Lasi from 1959 to 1976. Her designs consist mostly of complex molded forms, many with colored underlays and textured surfaces, intended for mass production. Some of her designs for Riihimaen Lasi include the "Taalari" series (late 1960s), the "Kehra" series (early 1970s), and the "Safari" vases (early 1970s). Most of Aladin's designs for Riihimaen Lasi were labeled, especially those produced in the 1960s and 1970s, however, some were also signed in this manner: "Riihimaen Lasi O.Y. Tamara Aladin."

Anneborg, Goran (Sweden, b. 1935)

Goran Anneborg studied at the Department of Design and Crafts at the Gothenburg University. Trained as an industrial designer, he has worked on varied products, from trucks to refrigerators. He has been employed as a glass designer for Sea Glasbruk since 1990. Some of his designs for Sea Glasbruk include the "Olympia" series (1995), the "Amanda" series (1995), and the "Bolero" series (1997).

Bang, Jacob (Denmark, 1899-1965)

Jacob Bang received his education in the Royal Danish Academy of Fine Arts in Copenhagen from 1916 to 1921, and was trained as an architect. He worked for Holmegaard from 1927 until 1941, and was one of the few Danish artists working in glass during this period. He was appointed artistic director for the company in 1928. Together with Swedish engraver Elving Runemalm, Bang designed copper wheel engraved wares, some of the first to be designed in Denmark. In 1941, he resigned from Holmegaard to concentrate in other artistic activities, including ceramics design. From 1943 to 1957, he was employed as artistic director for Nymolle Faience, a Danish ceramics company. In 1957, he returned to glass design, this time for Kastrup. He remained with the company until his death in 1965 and, just before the merger of Kastrup and Holmegaard. Jacob Bang created a large number of wares for Kastrup, including the "Opaline" series in 1960 and the "Capri" series in 1962.

Bang, Michael (Denmark, b. 1944)

The son of Jacob Bang, Michael trained as a ceramist at the Royal Porcelain factory (Royal Copenhagen) from 1964 to 1966, where he also designed. He was employed as a glass designer from 1966 to 1968 at Ekenas and was employed as a glass designer for Holmegaard since 1968 to the present. In the beginning of his employment at Holmegaard, he was given specific commissions for the factory in Odense, which specialized in opaque glass. One of the results of this assignment was the "Pallet" series (1968), glassware in opaque white glass with strongly colored overlays.

Bauer, Lisa (Gothenburg, Sweden, b. 1920)

Lisa Bauer received her education in the School of Arts and Crafts in Gothenburg from 1937 to 1938 and in the National College of Art, Craft and Design in Stockholm from 1938 to 1942. She was trained as an illustrator. She began her work as a glass designer for Kosta Boda in 1969 until 1991. In the beginning of her work at the company, she designed many of the botanical engravings for the forms created by Sigurd Persson. In the Kosta Boda catalogs, she is referred to as "The queen of flowers," because of her extensive knowledge of botany.

Bergh, Elis (Sweden, 1881-1954)

Elis Bergh studied at the "Tekniska Skolan" and "Hogre Konstindustriella Skolan" (the schools of industrial art) in Stockholm. Bergh was employed from 1903 to 1904 in the office of Architect Agi Lindegren (architect of the Royal castle). In 1905, he received a scholarship to study in Munich. From 1906 to 1915,

he designed at the Bohlmarks lamp factory, designing many wares for Pukeberg. From 1916 to 1921, he worked at Herman Bergman's metal casting factory and from 1921 to 1928, he worked at Hallbergs Gudsmeds AB in Stockholm. He was invited by Kosta to be their design director in 1929 and continued there until his retirement in 1950. Bergh's early design contributions to Kosta were mainly light fixtures, but he soon expanded his designs to include art glass and tableware. Many of his designs for Kosta involved cutting and engraving as well as the use of optics.

Berndt, Wiktor (Sweden, b. 1919)

Wiktor Berndt studied at Kallstroms and then in Murano. He was a designer for Flygsfors from 1955 to 1974 and chief designer from 1956 to 1974. He designed light fixtures, but was also very involved in the production of art glass. During the late 1950s, Berndt designed some hand blown pieces with biomorphic forms and cut-out sections, with transparent colored glass combinations. During the 1960s, he created some memorable mold-blown pieces with colored underlays and modernistic surface reliefs, often representing animals, people or scenes. These surface reliefs were then ground, giving each piece unique hand-made characteristic. Berndt pieces for Flygsfors are often signed with his last name, the company name and the production year.

Blomberg, Kjell (Sweden, b. 1931)

Kjell Blomberg studied at Konstfack, the School of Arts, Crafts and Design. He was employed for Gullaskruf from 1954 to 1977. At least two of his designs, a decanter and beaker glasses in transparent gray glass, were selected for Corning Glass Museum Special Exhibition of International Contemporary Glass in 1959. Blomberg designs were often simple and geometric utility wares, but they struck the perfect balance between form and function, and resulted in beautifully designed and modern forms. Although most of his wares for Gullaskruf were labeled, some pieces have been found with his signature.

Bongard, Hermann (Norway, 1921-1998)

Bongard studied lithography and commercial design at the National College of Applied Art in Oslo, Norway, from 1938 to 1941. He worked as a glass designer for Hadeland from 1947 to 1955. From 1960 to 1964, he was the art director for the Plus Workshops, which included Plus Glasshytte. He won gold and silver medals at the Milan Triennale of 1954 and was awarded the Lunning Prize for excellence in design in 1957. Hermann Bongard is best described as a versatile designer who has worked in many media, including glass, ceramics, silver, wood and textiles. He is noted for the use of broad flat forms in his designs. Many of his designs for Hadeland are signed.

Borgstrom, Bo (Sweden, b. 1929)

Bo Borgstrom was the main glass designer with Aseda glassworks after 1955. He studied in Europe and America after training at Stockholm. During the 1960s, Borgstrom designed numerous wares for Aseda. His forms were often geometric and complex, and he widely explored the use of color in his designs. Many of his wares had underlays of colored glass, cased in clear as well as colored glass. During the 1960s he often used bright and distinctive opaque colors in his designs. His designs for Aseda are mostly labeled and rarely signed.

Borgstrom, Matz (b. 1954)

Matz Borgstrom trained in sculpture. He was a glass designer and artistic director for Lindshammar from 1990 to 1992.

Brauer, Otto

A Master Glass blower for Kastrup, Brauer is credited with designing Kastrup's famous "Gulvase," based on a Per Lutken design for Holmegaard. His gulvases were blown in colored transparent glass.

Brummer, Arttu (Finland, 1891-1951)

Brummer designed glass for Riihimaen Lasi in from 1936 to 1951 on a freelance basis. Some of his designs for the company included some very detailed engraved pieces, as well as vases with a bubbly and textured surfaces. Brummer was also the curator of the Museum of Craft and Design in Helsinki and the chairman of the Association of Designers in Ornamo.

Cyren, Gunnar (Sweden, b. 1931)

Cyren studied to become a goldsmith and silversmith at Konstfack, the School of Arts, Crafts and Design, from 1951 to 1956. He was employed at Orrefors as glass designer from 1959 to 1970 and later, from 1976 to the present, on a freelance basis. He was the artistic director at Orrefors form 1968 to 1970. In 1966, He was awarded with the prestigious Lunning Prize for his designing career. From 1970 to the present, he has been an industrial designer for Dansk, where he creates wares in different media including wood, metals and glass. His glass designs for Dansk are rarely signed, but include his initials (GC) in the labels.

Edenfalk, Bengt (Karlskrona, Sweden, b. 1924)

Bengt Edenfalk studied art at Konstfack, the School of Arts, Crafts and Design in Stockholm, from 1947 to 1952. He worked at Skruf from 1953 to 1978 as chief designer and art director. Upon his arrival at Skruf, most of the designs at the company consisted of utility ware. He began to design a whole new range of tableware that was suitable for cutting and engraving. He also designed art glass, unconventional and strikingly unique. During the mid-1950s he began exploring the use of trapped air bubbles created by manipulating the glass while still hot, and designed wares that had internal "air" decorations with primitive and unconventional anthropomorphic shapes. These experiments resulted in the "Thalatta" technique, which he often used at Skruf and throughout his designing career. He also created a series of vases and bowls with colored underlays and a thick layer of applied threading. Both the "Thalatta", vases, threaded vase, and other of his designs for Skruf were submitted to the Corning Glass Museum Special Exhibition of International Contemporary Glass in 1959. Of 4800 pieces submitted for this important exhibition, 15 were voted as "best in the world." Two of these were designed by Bengt Edenfalk. In 1978, Edenfalk resigned as artistic director for Skruf and began to design for Kosta Boda, where he stayed until 1988. At Kosta Boda, he continued to design molded, blown, cut, and engraved pieces, and experimented widely with opaline glass and colored underlays in patchwork designs. Some examples of his designs for Kosta include the "Akvarellblock" (1986), a sculpture internally decorated with colored patches of opaline and transparent colored glass, and the "Claire de Lune" vase, an ovoid form in opaline white glass internally decorated blue opaline glass

in different shades. Since 1989, Edenfalk has worked mostly on a freelance basis. He still continues to use the "Thalatta" technique extensively, now using multiple combinations of colored underlays. Most of Bengt Edenfalk's designs for Skruf and Kosta Boda were signed, but exceptions do exist. Some pieces for Skruf that were only labeled might not identify him as the designer.

Ehrner, Anna (Stockholm, Sweden, b. 1948)

Anna Ehrner studied at the National College or Art, Craft and Design in Stockholm from 1968 to 1973. Since 1974, she has been employed as designer for Kosta and Kosta Boda. Her designs include "Line" (1981), one of Kosta Boda's most commercially successful designs, "Rock" (1991), "Woodlands" (2000), and "Wind" (2002).

Franck, Kaj (Viipuri, Finland, 1911-1989)

Kaj Franck studied furniture design at the Institute of Industrial Art in Helsinki from 1929 to 1932. Franck is considered by many as "the conscience of Finnish design." Functionality and compatibility were the underlying concepts of his streamlined utility articles, which he often chose to decorate only with color. He designed articles that were beautiful, functional, and affordable to the public. His involvement in the design industry was extensive. He was a glass designer for Riihimaen Lasi in 1934. From 1943 to 1973, he was the head of design of ceramic utility wares for Arabia and also design director from 1968 to 1973. He designed glass for iittala from 1946 to 1950. From 1950 to 1976, he was the art director for Nuutajarvi glass. Besides working in glass and ceramics, he also designed textiles, furniture, lighting and plastics.

In addition to glass utility wares, Franck also designed art glass which was often decorated with color, and also made in simple colorless glass many with internal bubbles. Some of his most notable designs include the "Teema" tableware (ceramics for Arabia designed in the 1950s and still produced), "Kartio" series (designed for Nuutajarvi Notsjo in the 1950s, now produced by iittala), "Soap Bubble" vases (Nuutajarvi, 1951-1961), "Prisma" vases (Nuutajarvi, 1954-68), and "Kremlin Bell" decanters (Nuutajarvi, 1955-1960).

His awards at the Milan Triennales include a gold medal (1951), the diplome d'honneur (1954), the grand prix, and the Compasso d'Oro (1957). He also received the Lunning Prize (1955). His works are included in the following collections: the Victoria and Albert Museum, the Stedelijk Museum, Musée des Arts Decoratifs, the Museum of Modern Art, the Corning Glass Museum, the Cooper-Hewitt Museum, the Finnish Glass Museum, the Arabia Museum, the iittala Museum, and the Nuutajarvi Museum.

Gate, Simon (Sweden, 1883-1945)

Simon Gate received his education at the Konstfack School of Arts, Crafts and Design in Stockholm from 1902 to 1909, and then at the Royal Swedish Academy Art School in Stockholm, around 1909. He worked as a glass designer from 1916 to 1945 and, together with glass blower Knut Bergkvist, is credited with the creation of the "Graal" technique (developed in 1916). Besides his extensive use of the "Graal" technique, Gate also designed traditional engravings, in particular those of nude female forms, as well as cuttings.

Gordon, Ernest (England, b. 1926)

Ernest Gordon graduated from the Royal College of Arts. In 1953, he joined Afors as a glass designer, and stayed until 1963. His designs where mainly simple organic forms with free-flowing lines, but he also explored designs with more sculptural lines. Most of his designs for Afors were signed with his complete name or last name and also included his designer code, which was a "G," for Gordon.

Grcic, Konstantin (Germany, b. 1965)

Konstantin Grcic studied at the RCA in London, and after his return to Germany established an office in Munich. Grcic is an exponent of simplicity, and is regarded as one of the major reformers of design. He has worked with companies such as Authentic, SCP, Driade, and Flos. In 1998, he designed the "Grcic" tableware for the iittala "Relations" collection, comprised of stackable and highly functional pieces. In 2000, the "Grcic" glassware was bestowed the Design Plus Award in Frankfurt.

Hakatie, Annaleena (Finland, b. 1965)

Annaleena Hakatie has designed for iittala since 1993, including the "Ballo" votive candle holder (1995), the "Kupla" series (1996) for the "Pro Arte" collection, and the "Hakatie" series (1998) for the "Relations" collection. She is also a visual artist whose artworks have been exhibited abroad and in Finland. She took part at the International Glass Biennial in Venice, 1998-1999. Hakatie lectures at the University of Arts and Design in Helsinki, from where she graduated as an industrial designer in 1995.

Hald, Edward (Sweden, 1883-1980)

Edward Hald received his artistic education at the Technical Academy of Dresden from 1904 to 1906, trained as an painter and architect, and, from 1908 to 1912, studied abroad, including Paris as a student of Henry Matisse. His career at Orrefors lasted from 1917 to 1944, and was the managing director of the company from 1933 to 1944. He continued to work on a freelance basis until as late as 1978. Some of his important early engraved pieces include the "Fireworks" bowl (1921) and the "Cactus exhibition" bowl and plate (1926). Hald also worked extensively with the "Graal" technique and in 1936 developed the "Fishgraal" series, which featured underwater scenes of fish swimming though seaweed. The "Fishgraal" vases were first produced in 1938.

Hoglund, Erika (Sweden, b. 1971)

Erika Hoglund was raised in a family of artists in Smaland, Sweden. Both her father, Erik Hoglund, and her mother, Monica Backstrom, are well known and important glass artists. Erika studied at Parsons Institute, the art school in New York City. After her studies, Hoglund went to Mexico and Guatemala, where she decided to settle down for a while as a local. Her experience there was a fruitful one. It enabled her to eventually bring back to Sweden a broader understanding in culture, the arts, and life in general. Despite the rich knowledge she gained through her travels, the impressions she received during her stay abroad were not the inspiration behind her first collection, "Artemiss." Instead, her source was old Swedish mythology, "Huldran." The forms found in the "Artemiss" series, resemble sensual females figures encapsulated in clear glass, many hand-painted with complex patterns and designs. Since 1997 she has been a designer for Mats Jonasson Maleras.

Holmgren, Christer (Sweden)

Christer Holmgren was employed as glass designer for Holmegaard frrom 1957 to 1972. His tableware designs include "Icepole" and "Iceflame," both with heavily textured surfaces. In the latter years at Holmegaard, he also worked in conjunction with his wife, Christel Holmgren, and they designed the "Blue Hour" line collaboratively. Christer Holmgren designs are usually signed with a "C" in conjunction with the Holmegaard name and the design number.

Hongell, Goran (Finland, 1902-1973)

Goran Hongell studied decorative art at Central School of Industrial Design and taught decorative painting in later years. He was employed at Karhula form 1932 until his retirement in 1957. Many of his early designs were simple pieces in clear, blue, and green transparent glass, which were engraved and cut with scenes of Finnish provincial everyday life. He is considered one was one of the pioneers of the Finnish glass tradition. As far back as the 1930s, he presented the first version of what would become his most famous creation, the "Aarne" glassware set (1948). It was this very glassware that won the gold medal at the 1954 Milan Triennale. His "Aarne" glassware was selected as the symbol of the iittala glassworks for its centennial in 1981.

Jacobino, Armando (Italy)

Armando Jacobino traveled to Finland and was employed as master glassblower for Nuutajarvi Notsjo in the 1950s. During his employment there, he also designed some pieces offered in the catalogs, which where mainly figurals. During the 1960s, Armando Jacobino was employed at Kumela as a glass blower and glass designer, where he continued to create figurals as well as art glass pieces. Many of his designs were cased with underlays, sometimes in opaque glass as well as colored transparent glass. Many of his pieces were signed "Oy Kumela Jacobino."

Joensuu, Elina (Finland, b. 1974)

Elina Joensuu studied at the Hame Polytechnic, majoring in glass in the Wetterhoff design program. She eventually dropped out, but not before her studies had given her a glimpse of a new field. This young student's proposal won iittala's product design competition. The competition's challenge was to design a glassware collection. When the "Stella" glassware (1995) reached its present form and was ready to be marketed, Elina Joensuu set course for a new field: sea captain's studies.

Johansson, Willy (Norway, b. 1921)

Willy Johansson was working for Hadeland in 1936 at the age of 15, in the glass making workshop. From 1939 to 1942, he trained at the State School of Applied Art and Crafts in Oslo. He then returned to Hadeland where he was employed from 1946 as a full designer. He was awarded a gold medal in the Milan Triennale of 1957. His work is represented in many Scandinavian museums and in America at the Corning Museum of Glass.

Jonasson, Mats (Sweden, b. 1945)

Mats Jonasson started at Maleras in 1959 on leaving school at the age of fourteen. The glass works needed an engraver and, since Mats was known to be good at drawing, his father, who was employed there, was asked if his son could start as an apprentice. After some ten years at Maleras, Jonasson moved to Kosta in 1969, working as a designer, but returned to Maleras in 1975, also as a designer. Since 1988 he has been the managing director for the company.

Jonasson is a master engraver as well as a designer. His designs include a series of molded and engraved crystal relief sculptures, with series such as "Wildlife," which includes numerous life-like depictions of animals in the wild, and "Nordic Birds," which depicts the wild birds of the Scandinavian region. He also created a series of sculptures such as "Man's Best Friend," in which he depicts domestic animals. Recently has also introduced the "Totem" series and "Masq," a group of figural sculptures, some resembling primitive and tribal masks.

Koskinen, Harri (Karstula, Finland, b. 1970)

Harri Koskinen was trained at the Lahti Design Institute from 1989 to 1993 and at the University of Art and Design UIAH, in Helsinki, Finland. In 1996, he worked as a designer for Nuutajarvi, and since 1998 has been employed at iittala. In 2002, has ventured into ceramic design with the "Air" containers with airtight plastic lids for Arabia. In his designs, Koskinen strives to arrive at new solutions that will be considered innovative by both the manufacturer and user. Koskinen's designs for iittala include the "Atlas" candle holder (1996), which was selected for the *International Design Year Book*, "Koskinen" candle lanterns (1999) from the Relations collection, "Klubi" barware (1998), and the "Muotka" vase (2000). In 2000 he won the Young Designer of the Year award, launched by Design Forum Finland and Good Design prize, granted by Chicago Atheneum.

Lake, John-Orwar (Sweden, b. 1921)

After training in Stockholm, partly as a sculptor, John-Orwar Lake joined Arabia in Finland to do some ceramic work. He then returned to Ekenas in Sweden in 1953, and was the chief designer also in charge of product development until 1976. Lake was a talented glass designer. His early designs in the 1950s, were mainly intricately engraved and cut pieces in clear glass of exceptional quality. During the 1960s, he continued designing cut and engraved glass, but also experimented and created some organic forms in which he explored color, texture, and internal decoration, not unlike the art glass being created in the USA during the studio glass movement in the 1960s. Most of his designs were signed, although some, especially his earlier ones were labeled and unsigned.

Landberg, Nils (Sweden, 1907-1991)

Landberg worked with Orrefors from 1925 to 1970. He attended the School of Arts and Crafts in Gothenburg, before joining Orrefors in 1925. For the first two years, he was in the Orrefors school of engraving, and in 1929, became the assistant to Edward Hald. In 1936, he was given the title of full resident designer. His designs during the 1930s and the 1940s were mainly engraved pieces, many in transparent glass, but by the 1950s he had found his own sense of design. In 1954 he designed the "Tulip" glass series, a number of stylized forms with colored glass underlays, with elongated stems. He was awarded the gold medal at the Milan Triennale in 1957 for this series. From 1954 to 1956, he also created some memorable designs which included heavily cased glass pieces, in organic forms, some with colored dark colored underlays, such as dark green, charcoal gray, and deep blue.

Lindstrand, Vicke (Gothenburg, Sweden, 1904-1983)

Vicke Lindstrand studied at the School of the Swedish Society of Arts and Crafts in Gothenburg. He started to work for Orrefors 1928, where he worked closely with Simon Gate and Edward Hald. At Orrefors, Lindstrand created some of the most memorable engraved art glass pieces in Scandinavian design. Although both Gate and Hald had often praised and used the nude female form as topic for their engravings, it was Lindstrand who began to use the male nude form as part of the decorations. During the 1930s, he created a series of vases with engraved underwater scenes of muscular male nude divers, which included "Pearl Fishers" (1931) and "Shark Killers" (1937), among others. He also explored the use of the "Graal" technique in the late 1930s, and created a "Graal" variation called "Mykene." It made use of carborudum powder, which when reheated created a design of closely spaced air bubbles that still retained the original design form. While at Orrefors, Lindstrand also explored the use of surface cutting, but many times opted to leave unpolished areas to created a remarkable visual contrast with polished areas. In 1940, he left Orrefors, to design for Upsala-Ekeby ceramics company, and remained there until 1950. After leaving Upsala-Ekeby, he joined Kosta glass in 1950 and remained with them until 1972. While at Kosta, Lindstrand's design, powered by his untamed creativity, reached new heights. He continued to use engraving and cutting techniques, but also utilized color extensively, including internal colored decoration, sandblasting, and optics. His forms became much more organic, in concordance with the post-war tastes an changing times.

Lundin, Ingeborg (Sweden, 1921-1992)

Ingeborg Lundin studied at the National College of Art , Craft and Design in Stockholm from 1941 to 1946. She began working with glass and joined Orrefors in 1947 until 1971. She was awarded the Lunning Prize in 1954. Lundin also designed for Maleras from 1989 to 1991.

Ingeborg Lundin was the first female designer at Orrefors. Her contributions to design at the factory were significant. During the 1950s and 1960s, she began experimenting with untraditional cuttings and engravings, which were in direct opposition to the decorations made by other designers at the firm during that time. Her forms were also unconventional. She achieved a purity of form in her designs that was remarkable. Her respect for form is best exemplified by the "Applet" (Apple) vase, which was designed in 1955, and has been produced since 1957. The "Applet" vase with its simple globular form and narrow neck, is likely one of the most recognized designs in Scandinavian glass. During the 1960s, Lundin also mastered the "Ariel" technique, creating many pieces with colored underlays and airy geometric designs.

Lutken, Per (Denmark, 1916-1998)

Per Lutken trained in the School of Arts and Crafts in Copenhagen in 1937, mainly in painting and technical drawing. He was employed as artistic director for Holmegaard from 1942 until his death in 1998. Never having worked with glass before his employment at Holmegaard, Lutken experimented his way through the early years. His designs for Holmegaard were extensive. Some of the most famous ones include, the "Beak" or "Duckling" vase (1950), "Aristocrat" tableware (1956), "Cascade" vases (1970), and "Snowdrop" tableware (1978). Per Lutken is highly regarded as one of the most influential artists in Danish glass design and Scandinavian glass design as well. The majority of the wares he designed were signed. He used different manners through the years, but often with his initials "PL" in conjunction with the company name and production number, or by themselves. However, some pieces were only labeled and unsigned.

Morales-Schildt, Mona (Sweden, 1908-1999)

Mona Morales-Schildt studied at the School of Industrial Art in Stockholm and won a scholarship to study ceramics in England and Germany. She also went to a painting school in Paris before starting to work for Gustavberg in 1936 as an assistant to Willhelm Kage. In 1939, she worked for a year at Arabia. She then returned to Stockholm and managed the new Gustavsberg shop until 1941. After her marriage to the author Goran Schildt, she worked from 1945 to 1957 for Nordiska Kompaniet, the Stockholm department store, where she was responsible for all art exhibits. In 1958 she joined Kosta and made her name with a very large range of glass designs. She is best known as the designer of the brightly colored and faceted pieces from the "Ventana" series (1961-1963), a range extending into vases and bowls with depth obtained by cutting through a range of warm colors.

Motzfeldt, Benny (Norway, b. 1909)

Benny Motzfeldt studied graphic design at the National College of Arts and Design. From 1955 to 1967, she worked as a designer at Hadeland. In 1967, she worked as a designer at Randsfjordglass. Since 1970, she has worked as a designer for the Plus Workshop and also managed their glass division, Plus Glasshytte.

During he 1970s, Benny Motzfeldt solidified her position as the most important Norwegian studio glass artist. Even when her designs were produced in larger numbers, they retained a certain uniqueness due to her intended treatment of the medium. She often explored the use of glass, metal, and gauze fiber inclusions in her designs, not necessarily or solely as decoration, but rather as an exploration of the reactionary quality of glass. Her designs for Plus Glasshytte were often stamped with an acid etched mark reading "Plus BM Norway," while most of her unique pieces were simply engraved "BM" with the production year, for example "77."

Newson, Marc (Sydney, Australia, b. 1963)

Marc Newson studied to be a silversmith and moved to Japan, where he designed furniture and worked as an interior decorator. His work has been commissioned by European companies such as Cappellini, Flos, and Swatch. In 1998, he designed the "Newson" glasses for iittala's "Relations" collection.

Nurminen, Kerttu (Lahti, Finland, b. 1943)

Kerttu Nurminen studied at the Central School of Industrial design in Helsinki. Since 1972, she has been employed as a glass designer for Nuutajarvi. Her career continues to this day with the same passion and unwillingness to compromise. Nurminen's talent first found international favor in 1988, when the "the great flame and fluid colors" of her "Mondo" glasses captured the limelight. Its method of manufacture and its unstinting originality exemplify Kerttu Nurminen's creative solutions. Her designs for Nuutajarvi and iittala include "Verna" tableware (1998), "Palazzo"

filigree" tableware (1998) for "Pro Arte," and "Lago" vases and bowls (2000) for "Pro Arte." She also continues to design unique pieces at Nuutajarvi, which often explore themes of nature and the beauty of the countryside. In 1999, at an exhibition of her unique glass pieces, the artist pointed out that her works are mood pieces about nature, but not still lifes. Some of the names of the works shown in this exhibition were evocative of nature and its ever changing and inspirational pallet: Paratiisi, Joki, Aiti maa, Karhutalvi (Paradise, River, Mother Earth, The Winter of the Bear).

Nurminen, Olavi

Olavi Nurminen was a master glass blower for Nuutajarvi Notsjo. During the 1950s some of his designs were included in their production catalogs. His designs are distinguished by technical precision and internal, gauze-like decorations that were very difficult to achieve. Olavi Nurminen's wife, Kerttu Nurminen is a glass designer for Nuutajarvi.

Nylund, Gunnar (Sweden, b. 1904)

Gunnar Nylund studied architecture and worked as a ceramist at Saxbo, and at Bing and Grondahl in Copenhagen. He began his work at Strombergshyttan in 1953 and continued until 1967, both as glass designer and art director. From 1953 until 1957, he worked concurrently for Strombergshyttan and for Rorstrand, where he was the art director and ceramicist from 1931 to 1958. Also while working at Strombergshyttan, he was appointed art director at Nymolle Keramiske Fabriker in Denmark, serving from 1959 to 1974. Gunnar Nylund's designs for Strombergshyttan are organic and sometimes sculptural, and easily distinguishable form those designed by Gerda and Asta Stromberg, which are mostly geometric, with very thick walls and polished rims. Nylund's designs were sometimes asymmetrical and organic forms with soft edges, which often included vibrant colored underlays cased in clear glass.

Nyman, Gunnel (Finland, 1909-1948)

Gunnel Nyman was a pupil of Arttu Brummer and studied at the Central School of Industrial Design in Helsinki, graduating in 1932. She was employed at Riihimaen Lasi from 1932 to 1947. One of her notable designs at Riihimaen Lasi was the "Calla" vase (1946), with its form resembling the flower. She also worked for Karhula from 1935 to 1937, for iittala from 1946-1947, and for Nuutajarvi Notsjo from 1946 to 1948.

Nyman was one of the most influential designers in Scandinavian glass. Her ability to strike the perfect balance between form and function was remarkable. She often used minimal decoration such as controlled bubbles in simple organic forms, as well as in utility wares. From 1946 to 1948, while working at Nuutajarvi Notsjo, she reach the peak of her career, which was unfortunately cut short by illness and her subsequent death. Her designs for Nuutajarvi included the "Huntu" (Veil) vase, with an internal layer of controlled bubbles, the "Parlband" (String of Pearls) vase, with a single elliptical string of bubbles, and the "Serperntiini" (Serpentine) vase.

Ohrstrom, Edvin (Sweden, b. 1906)

Edvin Ohrstrom studied at the Stockholm Institute of Technology and the Stockholm Academy of Fine Arts, where he trained as a sculptor and graphic artist. From 1936 to 1958, he worked as a glass designer at Orrefors. During the mid-1930s, together with master glass blower, Gustaf Berqkvist, and Vicke Linsdtrand, he is credited with the creation of the "Ariel" technique, which has been explored by many of the Orrefors artists since then. Besides his many creations using the "Ariel" technique, Ohrstrom Also designed engraved and cut glass, especially one of Orrefors most commercially successful designs, "Wish to the Moon" (early 1940s).

Orup, Bengt (Sweden, b. 1916)

Bengt Orup trained as a painter in Paris from 1937 to 1938. From 1951 to 1973 he was a glass designer and then director at Johansfors. In 1963, he also worked on a freelance basis for Hyllinge Glasbruk. Some of his designs, including a decanter and beaker glasses decorated with black enameled stripes, were selected for Corning Glass Museum Special Exhibition of International Contemporary Glass in 1959.

Orup is a master of design and form. During his tenure at Johansfors he explored the glass medium in every imaginable way. His work ranged from simple geometric forms to highly organic and asymmetrical forms. His designs ranged from simple tableware to sculptural pieces of art glass. As decoration he utilized engravings, cuttings, inclusions in glass, as well as external applications. His use of color was also exceptional, sometimes simple and subdued, to colorful and vibrant.

Orvola, Heikki (Helsinki, Finland, b. 1943)

Heikki Orvola trained in ceramics at the Central School of Industrial design in Helsinki from 1963 to 1968. He works with glass (Nuutajarvi and iittala, 1968-present), ceramics (Arabia, 1987-1993, and Rorstrand), cast iron, enamel and textiles (Marimekko, 1985-1995). Since 1994 he has been a freelance designer, and continues to work in any medium that sparks his attention. For most of his career, Orvola has worked for industry, but for him artworks made of glass, ceramics, and textiles are a necessary outlet for his creative energies. A 15-year grant from the State, which he has received since the beginning of 1994, has increased his freedom to decide where to apply his energies. The Victoria and Albert Museum, the Museum of Modern Art, the Stedelijk Museum, the Finnish Glass Museum and the Arabia Museum are only some of the museums that have included Orvola's works in their collections. During his career as an industrial designer, Orvola has received the Kaj Franck prize (1998), which is Finland's most important design award, and the Pro Finlandia medal (1984), among other awards. His designs for iittala and Nuutajarvi include the "Aurora" tableware (1972), "Vulcano" vases and bowls (1974-1977), "Filigraani" vessels (since 1980) for "Pro Arte," "Evergreen" vases (1996) and the "Kivi" candleholders (1998).

Palmqvist, Sven (Sweden, 1906-1984)

From 1928 to 1930, Sven Palmqvist trained at the Orrefors Engraving School, as an apprentice under Edward Hald and Simon Gate. From 1931 to 1933 he studied at the Konstfack School of Arts, Crafts and Design in Stockholm, and then in the Royal Swedish Academy Art School from 1934 to 1936, training in sculpture. He also studied in Germany and Paris during the mid- and late 1930s. From 1936 to 1972, he was employed as a glass designer at Orrefors, but still did freelance work with the company after 1972 until his death in 1984. During the 1930s, 1940s and 1950s, Palmqvist worked with traditional techniques such as cutting and engraving, and created some magnificent and memorable pieces.

Palmqvist is credited with developing the "Graal" technique into the styles known as "Kraka" (developed in 1944) and "Ravenna"(developed between 1948-1951). During the early 1950s, Palmqvist achieved great success with a line of domestic and functional wares in transparent glass known as "Fuga," which were ingeniously fashioned by centrifugal force. He used the same technique to create the "Colora" series, but these were made of opaque colored glass. For the "Fuga" series, Palmqvist was awarded the grand Prix at the Milan Triennale of 1957.

Percy, Arthur (Sweden, 1886-1976)

Arthur Percy studied in Stockholm from 1905 to 1908, and in Paris in 1908. Besides being a glass designer, he was also a painter and ceramics and textile designer. In 1951, he joined Gullaskruf where he remained until 1965. His designs were mainly simple functional pieces, many mold blown, but with exceptional attention to form. Some of his designs for Gullaskruf include the bottle vases (1952) and "Randi" bowls and vases (mid-1950s). Due to their excellence in design, some of Percy's wares for Gullaskruf, including his bottle vases, were selected for the Corning Glass Museum Special Exhibition of International Contemporary Glass in 1959.

Persson, Sigurd (b. 1914)

Sigurd Persson studied as a silversmith in Germany and obtained his Master certificate at the Konstfack, the School of Arts, Crafts and Design in 1943. Besides having his own silversmith shop, he started designing glass for Alghult (Sweden) in 1966. From 1968 to 1982 he was a designer at Kosta Boda and worked closely with Lisa Bauer, who would create engravings for many of his forms.

Salo, Markku (Nokia, Finland, b. 1954)

Markku Salo studied at the Helsinki University of Technology from 1974 to 1979. He is a bold and experimental glass artist. Salo began to work for Nuutajarvi in 1983 and continues to work for iittala after Nuutajarvi joined the Hackman group in the early 1990s. His designs for iittala are characterized by disciplined functionality and simple beauty. His designs for iittala include the "Marius" glassware (1985), "Aava" vases (1998), "Nappi" candleholders (1998), and "Gabriel" candlesticks (1999). In 2001, Salo created some unusual glass bottles with wire legs resembling dogs for Nuutajarvi "Pro Arte." These dogs evolved from traditional predecessors: traditional wine dogs made by master glassblowers to show theirs skills, and also from Markku Salo's unique dog sculptures. Salo's work also includes graphic design, ceramics design at Arabia, and electronics design. He has his own studio at Nuutajarvi, where he has created glass sculptures and installations for the Malmi House in Helsinki and the Strand-Intercontinental Hotel. Salo's works are featured in the collections of the Corning Museum of Glass, the Cooper-Hewitt Museum, the Victoria and Albert Museum, Glasmuseum Ebeltoft, the Finnish Glass Museum, and the Arabia Museum, among others. His work has been recognized with the Georg Jensen Award (1990) and the State's Industrial Arts Award (1989).

Sarpaneva, Timo (Helsinki, Finland, b. 1926)

Timo Sarpaneva studied graphic design at the Central School of Industrial Design in Helsinki from 1941 to 1948. Has worked in many media including glass, ceramics, plastics, metals, textiles, wood, and lighting among others. He has been designing for iittala from 1950 to the present and also for Rosenthal (Germany) on a freelance basis since 1970. Since 1988, he has worked for Venini glass (Italy) on a freelance basis. For a long time Sarpaneva has been one of Finnish design's most prominent figures worldwide. In addition to his timeless, stylistically subdued utility glass, he is known for his impressive and ambitious glass sculptures. Sarpaneva is a master of many fields and knows his materials thoroughly. His output extends from utility and art glass to textiles and graphic art. Timo Sarpaneva has won numerous international awards, including many Grand Prix, and gold and silver medals at the Milan Triennale He was also awarded the Lunning Prize in 1956, as well as the Suomi Award in 1993, for a lifetime of excellence in design.

Seth-Andersson, Carina (Stockholm, Sweden, b. 1965)

Carina Seth-Andersson designs in many media including glass, ceramics, metal and wood. Her designs at iittala include the "Seth-Anderson" bowls (1998) for the "Relations" collection and the "Seth-Anderson" metal bowls and wooden salad spoons (1998) for Hackman Tools. Her glass and ceramic designs have been shown around Scandinavia and at several international exhibitions, for example, at the Milan Triennale in 1994. Her glass designs are a part of the permanent collection at the Victoria and Albert museum in London.

Severin, Bent (Denmark, b. 1925)

Bent Severin studied architecture at the Royal Academy of Fine Arts and graduated in 1952. As glass designer for Kastrup in the late 1950s, his most recognizable design is the "Princess" tableware designed in 1957, first produced at Kastrup and produced at Holmegaard since 1968. The "Princess" Line was selected for its good design in the Corning Glass Museum Special Exhibition of International Contemporary Glass in 1959.

Sjogren, Christer (Sweden, b. 1926)

Christer Sjogren studied at Konstfack, the School of Arts, Crafts and Design from 1947 to 1951, and worked mostly as a sculptor thereafter. He has been employed as a glass designer for Lindshammar since 1963, and continues to work there. Christer Sjogren's work can be seen at the Swedish National Museum in Stockholm, the Musee du Verre in Liege, Belgium, the Haaretz Museum in Tel Aviv, and a number of other museums both in Sweden and abroad.

Still, Nanny (Finland, b. 1926)

Nanny Still trained at the Institute of Industrial Arts from1945 to 1949, and joined Riihimaen Lasi in 1949, where she remained until 1976. She has worked in different media such as glass, metal, pottery, ceramics, jewelry, plastics, and light fittings. In 1966 and 1968, she worked for Val St. Lambert (Belgium) in glass and ceramics production. From 1978 to the present, she has worked for Rosenthal (Germany) in glass and ceramic design. Since 1987 she has worked for Hackman designing cookware.

Nanny Still can be described as one of the most versatile and creative personalities in Finnish design. While at Riihimaen Lasi, she created a wide range of wares, including the "Harlekiini" tableware (1958), the "Koristepullo" bottle pitchers (1959), "Saturnus"

vases (1961), the "Flindari" series (1963), the "Pompadour" vases (1968), and the "Grapponia" series (1968).

Stock, Renate (Krems, Austria, b. 1950)
Renate Stock was educated at the Austrian Fashion and Textile School of Arts and Crafts. She moved to Sweden and settled in Kosta in 1984. After completing her glass education, she has been employed at Sea Glasbruk in Kosta since 1989, where she works as a designer and product developer.

Strand, Rune (Sweden, 1924-2000)
Rune Strand belonged to a glassblower family and learned early the genuine glass handicraft from his father. His family moved between several glass factories which gave him experience and impulses from Swedish as well as Danish glass making tradition. During the 1960s, Strand worked for Strombergshyttan. Many of his designs for the company were engraved. Some of his designs were signed with his last name, company name and production number. He also worked at Kosta for ten years with Vicke Lindstrand. After 1978, Strand was employed at Sea Glasbruk as a glass designer until his death in 2000. Some of his designs for Sea Glasbruk include the "Pauline" series (designed in 1983, pieces added in 1994) and the "Blomknyte" series (designed in 1978, pieces added in 1991 and 1992).

Stromberg, Asta
The wife of Eric Stromberg, Asta was manager and owner of Strombergshyttan after the death of Eric Stromberg in 1960. She designed for the company starting in the late 1930s, and was heavily involved with design in the 1960s and 1970s. Her designs were very similar in style to those of Gerda Stromberg's, thick walled and geometric, many in the silvery-blue pale glass, distinctive of Strombergshyttan.

Stromberg, Gerda (Sweden, 1879-1960)
Gerda Stromberg was the wife of Edward Stromberg, who was a managing director at both Kosta and Orrefors. Gerda Stromberg was self taught in glass design. From 1927 to 1333, she designed for Eda Glassworks. After the Strombergs' departure from Eda to start their company, Strombergshyttan, at the old Linderfors factory, Gerda Stromberg continued designing glass for their new company until 1946. Gerda's designs are often characterized by geometric forms with thick walls often in a light silvery-gray color. Other colors include clear, transparent gray and light green, but she rarely used vibrant colors. She often used engraving and cutting for decoration in her designs. Due to their excellence in design, some of Gerda Stromberg's wares for Strombergshyttan were selected for the Corning Glass Museum Special Exhibition of International Contemporary Glass in 1959.

Tinback, Klas-Goran (Sweden, b. 1951)
From 1976 to 1981, Klas-Goran Tinback collaborated as glass designer for Kosta Boda Glassworks. In 1982 he spent a year as designer for Orrefors Glassworks and later, established his own studio on the beautiful castle of Sturehov. Since 2000 Tinback has joined the designer team at Mat Jonasson Maleras where he, together with the two master glassblowers Jon Beyer and Ronny Fagerstrom, have created some magnificent and complex studio glass series, many with colored underlays. These include the "Two-in-one" series, the "Caribbean Blue" series, the "Navarra" series, and the "Fragancia" series.

Toikka, Oiva (Viipuri, Finland, b. 1931)
Toikka studied at the Institute of Industrial Art in Helsinki (Department of Ceramics, 1953 to 1956, and Department of Art Education, 1956 to 1960). He was employed from 1956 to 1959 as a ceramist for Arabia. and also for Marimekko, the Finnish textile company in 1959. In 1963 he became a glass designer for Nuutajarvi. He was awarded the Lunning Prize in 1970. Toikka designs both household glass as well as art glass, many unique. Examples of his production are "Kastelhelmi" (Dewdrop), Flora, and "Fauna." To decorate glass he often uses gold or platinum particles fused in glass. In 1973, he was appointed art director of Nuutajarvi glass. Oiva Toikka has received numerous distinguished awards for his work, both in Finland and abroad.

Tynell, Helena (Aanekoski, Finland, b. 1918)
Helena Tynell studied design at the College of Design in Helsinki from 1938 to 1942. She was employed from 1943 to 1946 as a ceramics designer at Arabia. From 1946 to 1976, she was one of the main glass designers at Riihimaen Lasi. She was also a freelance glass designer for other companies such as Flygsfors from 1967 to 1970, and Fostoria glass in West Virginia , USA, from 1970 to 1976.

Throughout her career as a glass designer, Helena Tynell has explored most of the techniques associated with the art. Her early designs for Riihimaen Lasi included simple and sculptural blown glass forms, some undecorated and some decorated with glass engravings and glass cuttings. In 1946, she designed the "Kaulus-Sarja" vases, cylindrical forms with flared and exaggerated rims decorated with a cut linear design, very similar to Wirkkala's "Kantarelli" vase. In 1947 she designed the "Merivouko" vase, an eccentric vase with a series of octopus-like tentacles around the rim, resembling a sea anemone. During the 1950s, Tynell created some spectacular engravings in clear glass, such as "Sirkus" (Circus, 1956) and "Kissa" (Cat, 1957). In 1959 and the early 1960s, Tynell explored cut glass with colored underlays and created sculptural forms such as the "Revontulet" vase (1956) and the "Castello" series (1961). During the late 1960s and 1970s, when the demand for lower costs and mass production grew stronger, Tynell designed a series of molded wares, without compromising her artistic vision and integrity. Some of these designs include the "Kaapikello" vases (1967), "Aurinko" bottle vases (1968), and the "Piironki" vases (1974).

Vallien, Bertil (Stockholm, Sweden, b. 1938)
Bertil Vallien studied art at Konstfack, the School of Arts, Crafts,and Design graduated top of his class in 1961, and was awarded a Royal foundation scholarship. The grant enabled him to travel extensively in the USA and Mexico between 1961 and 1963 and, in California, to achieve his first success as a ceramics artist. On his return to Sweden, now married to his wife Ulrica, a fellow graduate of the School of Arts, Crafts and Design, Bertil moved to the glass-making region of Smaland and established himself at Afors in 1963. Vallien immediately began to work in glass and wrought iron, and soon began to experiment with sand casting. These experiments resulted in boat-like sculptures such as "Destination X" (1986) and "Precious Cargo" (1985-1986).

During the 1970s Afors introduced the "Artists Collection" for which many of Vallien's designs were selected, in limited editions. These designs were often marketed under the Boda and Kosta Boda name, which were also part of the Afors group of glass factories. Counted among some of his most popular works is tableware such as the "Chateau" series (1981), the best-selling handmade series of all time, with, to date, over 12 million glasses sold worldwide. Other modern classics include "Satellite" (1992), "Domino" (1993), "Viewpoints" (1995), "Tower"(1995), "Chicko" (1996) and "Brains" (1998).

Vesanto, Erkki (Finland, 1915-1990)

Vesanto was a resident designer for iittala from 1936 to 1980. Besides creating functional tableware, he created art glass pieces such as the "Lappi" series (1958). He also designed vases some in clear glass and in transparent yellow glass with modernistic and stylized engraved decorations. One of his design characteristics is a heavy indentation in the bottom of his wares, creating a conical form and an unusual optical effect. His designs for iittala were usually signed "Erkki Vesanto" with the design number.

Walwing, Falke (Maleras, Sweden, b. 1907)

Falke Walwing joined the engraving school at Orrefors and studied under Simon Gate and Edward Hald. In 1924 he rejoined Maleras, serving as their art director until 1970. His designs consisted of many exceptional engravings, sometimes traditional and sometimes quite abstract, as well as most of their designs for pressed glass. During the 1960s, Walwing also explored the use of texture, creating a number of hand blown wares for the "Nebula" series (1965), which combined colored and colorless glass with irregular trapped air bubbles.

Warff (Wolff), Ann (Germany, b. 1937)

Ann worked at Pukeberg from 1959 to 1964, where she met her husband Goran Warff. From 1964 to 1978, she worked at Kosta and Kosta Boda. Until around their divorce in 1972, most of her work at Kosta and Kosta Boda was a collaboration with her husband. While Goran designed many of the forms, Ann created most of the decoration, including engraving. Collaborative designs at Kosta and Kosta Boda where usually signed "Warff," without any first names of initials. During the mid-1960s, the Warffs created a series of pieces in the "Brava" technique, where glass was poured into a mold with fragments of glass, and it would set and create a form with a heavily textured surface. Her designs at Kosta Boda include the "Snowball" candleholders (1973), one of the most commercially successful designs in the company, still produced today. In 1968, the Warffs were awarded the Lunning Prize in recognition of their work.

Warff, Goran (The Island of Gotland, Sweden, b. 1933)

From 1959 to 1964, Goran Warff worked for Pukeberg, where he met his wife and designer partner Ann. Since 1964 he has worked for Kosta Boda, except for some years in 1974 to 1978 when he lived in Australia and from 1982 to 1985 when he moved to England to teach at the Sunderland Polytechnic. In 1968 the Warffs where awarded the Lunning Prize for their excellence in design.

During his employment as designer at Kosta and Kosta Boda, Goran and Ann Warff experimented greatly with the properties of glass. After their divorce in 1972, the form of his designs became quite sculptural, many with cut surfaces. Some examples of his work at Kosta include, "Caesar" vases (1985), the "Contra" series (1988), and the "Sails" series (1989). Most of Goran Warff's designs for Kosta Boda are signed "G. Warff", distinguishing them from collaborative efforts with Ann Warff, which were often signed "Warff".

Wirkkala, Tapio (Hanko, Finland, 1915-1985)

Tapio Wirkkala studied sculpture and graphic design at the Institute of Industrial Arts in Helsinki from 1933 to 1935. From 1951 to 1954, he was the Institute's Artistic Director. Wirkkala is widely recognized as one of the most influential and multi-talented personalities of Finnish design. His works cover many areas and media, including glass, ceramics, wood, cutlery, lighting, exhibition design, graphic design, and banknote design. From 1946 to 1985, he was employed as designer for iittala and Karhula. From 1956 to 1985 he was also employed as a ceramist and glass designer for Rosenthal (Germany). From 1959 to 1985 he also designed glass for Venini (Italy).

Wirkkala was a great observer of nature, where he found much of the inspiration for his designs. Many times he would capture images with his camera and later explore them as themes in his designs. Some of his memorable designs for Karhula and iittala include the "Kantarelli" vase (1946), the "Tapio" tableware (1952) with his signature open and suspended bubble in the bases, the "Tokyo" vase (1954), with the inserted bubble design, and the "Ultima Thule" tableware (1968).

Alsterfors

Chapter 13

Labels

Alsterfors Sweden (blue and white paper label with a star)

Alsterfors Sweden (silver and clear cellophane label with a glassblower)

Aseda

Aseda Sweden (gray and white paper label)

Aseda Sweden (gray and white paper label)

Svensk Form Bo Borgstrom Sweden Aseda (black and silver foil paper label with a glassblower figure, in the shape of the "A")

Bergdala

Boda

Aseda Sweden (blue and gold foil paper label with a crown and cross symbol).

This is the same symbol used by Skruf in the 1960s and 1970s. This label was likely used after the amalgamation of 5 Smalands glassworks in 1975, (Aseda, Bjorkshult, Gullaskruf, Maleras, and Skruf), to create Royal Krona (Krona-Bruken AB). Royal Krona went bankrupt in 1977, but some of the independent glassworks survived.

Bergdala Sweden (dark blue and white paper label)

Boda Sweden Erik Hoglund (black and white paper label)

Boda Handmade Sweden (black and white paper label)

Dansk

Dansk Designs Ltd. Made in Sweden GC (green and gold foil paper label, Gunnar Cyren design (GC))

Dansk International Design (black and clear cellophane label)

Ekenas

Ekenas Sweden Designer Lake (black and silver foil paper label, 1950s)

Ekenas Sweden (blue and gray round paper label with trees)

Flygsfors

Flygsfors Sweden (shell-shaped, red and gold foil paper label)

Gullaskruf

Flygsfors Crystal Sweden (shell-shaped, red and gold foil paper label)

Gullaskruf Sweden (yellow and gold foil paper label)

Raymor, Modern in the Tradition of Good Taste 5419 RUV (RUV is the code Raymor importers used for pieces manufactured by Gullaskruf)

Hadeland

Hadeland Norsk Krystall (yellow and gold round foil paper label)

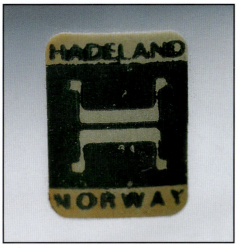

Hadeland Norway (black and silver foil paper label with a stylized "H")

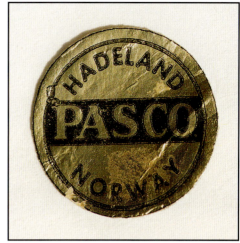

Hadeland Pasco Norway (round black and gold foil paper label)

Hoganas Glasbruk

Hoganas Glasbruk Sweden Kristall (black and silver foil paper label)

Holmegaard and Kastrup

Holmegaards Glas. Made in Denmark. (Danish, red and white round paper label with a swan, and round export label)

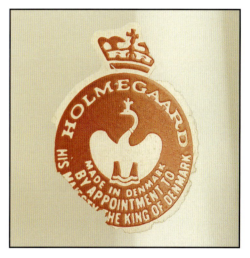

Holmegaard Glass Made in Denmark by Appointment to his Majesty the King of Denmark (red and white round paper with a swan and a crown)

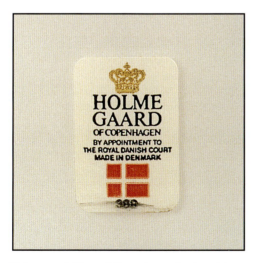

Holmegaard Glass of Copenhagen by Appointment to the Royal Danish Court Made in Denmark 369 (white, black, gold and red square label with a crown and a Danish flag)

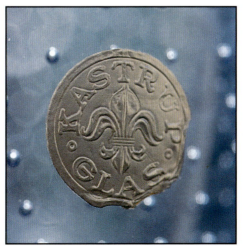

Kastrup Glas (round silver foil paper label with a Fleur de Lis)

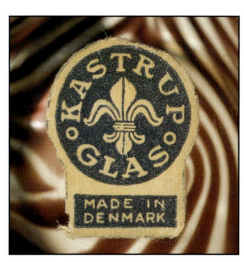

Kastrup Glas Made in Denmark (blue and white paper label with a Fleur de Lis)

Hovmantorp

Kastrup-Holmegaard by Appointment to HM the King of Denmark Made in Denmark (blue and white paper label with white swan and crown)

Hovmantorp Sweden (green and white paper label)

Mantorp Sweden (dark brown and white paper label)

iittala and Karhula

Karhula (silver foil paper label with a bear, pre-1957)

i Made in Finland (red and white cellophane label, first utilized in the i-collection by Timo Sarpaneva in 1956 and later adopted as standard label)

Johansfors

Johansfors Sweden (yellow and gold foil paper label with a glassblower)

Kosta and Kosta Boda

Kosta Sweden 1742 (round yellow and gold foil paper label)

Kosta Sweden (crown shaped, blue and silver foil paper label)

Kosta Sweden (black and gold cellophane label with a crown)

Kosta Boda Sweden Limited Edition by Bertil Vallien (black and silver foil paper label)

Kosta Boda c. Kosta Boda AB, Sweden Handmade (black and silver foil paper label)

Kosta Boda since 1742 (black and clear cellophane label)

Kumela

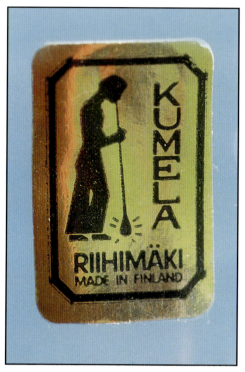

Kumela Riihimaki Made in Finland (black and gold foil paper label with a glassblower)

Lindshammar

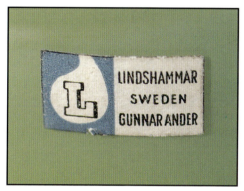

Lindshammar Sweden Gunnar Ander (black, blue and white paper label with an "L", specific to Gunnar Ander designs. The same label can be found for other designers.)

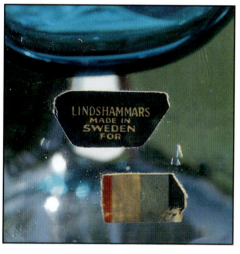

Lindshammars Made in Sweden for Partial Fostoria Label. (During the 1970s, the American company, Fostoria, commissioned pieces from Lindshammar which were sold as part of the Fostoria line.)

Made in Sweden labels

Handmade in Sweden by Lindshammar (paper label with Swedish flag)

Hand Made in Sweden (black and white paper label)

Made in Sweden (round gold foil paper label)

Magnor

Made in Sweden (blue and white paper label)

Swedish glass (green and silver foil paper label with 3 stars)

Magnor Glass Norway (black and white oval paper label)

Maleras

Maleras Glas Made in Sweden (black and silver foil paper label)

Nuutajarvi Notsjo

Nuutajarvi Notsjo 1793 Suomi Finland (black and white cellophane label with a stylized fish)

Nuutajarvi 1793 Made in Finland (blue and silver cellophane label with stylized fish)

Orrefors

Arabia Wartsila Finland (black and white paper label with a crown. Arabia labels are sometimes found in Nuutajarvi's glass items. Arabia is the counterpart pottery company to Nuutajarvi Notsjo glass.)

Orrefors Sweden (brown and white, shield label with rooster)

Pukeberg

Pukeberg Sweden (yellow and gold foil paper label)

Randsfjordglass

Pukeberg Sweden (black and white cellophane label)

Randsfjordglass Made in Norway Design T. Torgersen (blue and white paper label specific to T. Torgersen's designs)

Randsfjordglass Made in Norway Design Benny Motzfeldt (black and silver foil paper label specific to Benny Motzfeldt's designs)

Riihimaen Lasi

Randsfjordglass Made in Norway Handblown (red and gold foil paper label)

Riihimaki Suomi Finland (red and black triangular cellophane label)

Riihimaen Lasi Made in Finland (gold and Black round cellophane label with stylized lion)

Finncristall Made in Finland (gold and Black cellophane label used only by Riihimaen Lasi mainly in the late 1960s and 1970s, for pieces intended for the tourist and export market.)

Riihimaen Lasi Made in Finland (white and clear cellophane label with a stylized lion's paw mark)

Riihimaki Finland (blue and clear cellophane label with a heart design and a small lion)

RYD

RYD Sweden (red, black and silver foil paper label. The indistinguishable upper part is simply a silver "R" letter with a red background.)

Sea Glasbruk

Sea Glasbruk Kosta Sweden (red and gold foil paper label, in the shape of a shield)

Skruf

Sea Glasbruk AB Kosta Sweden (black and clear cellophane label)

Skruf Sweden Full Crystal (yellow black and gold foil paper label with a crown)

Skruf Sweden (gold, black and clear cellophane label, with a cross and a crown)

Smalandshyttan

Smalandshyttan Sweden (blue and gold foil paper label)

Strombergshyttan

Strombergshyttan Sweden (silver and black cellophane label)

Chapter 14

Signatures

As a rule, Scandinavian glass was signed or marked in some fashion. Having said that, the old adage, "rules are meant to be broken," often applies. Some companies, such as Gullaskruf and Aseda, rarely signed their wares. The ones that did, such as Kosta and Orrefors, often changed their identification systems many times over the years.

The following pictures and descriptions of signatures and markings are meant to serve the collector as a guide to identifying the different ways in which Scandinavian companies cataloged their wares. Although it is by no means a complete list, we hope that it helps collectors in the correct identification of companies and artists. This list should be used in conjunction with the rest of the information provided in the book, especially the captions for the wares. We have included in the captions all the signatures and labels associated with the pieces. The company histories and designer biographies should also provide helpful information with identification, especially in approximating periods of production.

Afors

Afors G.H. 554 E. Gordon (Afors company signature, Ernest Gordon code and production code, and Ernest Gordon signature)

Boda

H 669/100 (Erik Hoglund initial and production number)

Most Boda pieces designed by Hoglund have only an "H," without a reference to "Boda" in the marking.

Ekenas Sweden L1456-17 J. O. Lake (Ekenas company signature, production number, and John Orwar Lake signature)

Flygsfors

Flygsfors-56 (Flygsfors company signature and production year)

Berndt (Wiktor Berndt signature)

Coquille (Coquille range)

Gullaskruf

Blomberg Gullaskruf 1963 (Kjell Blomberg signature, Gullaskruf company signature, year of production)

Holmegaard and Kastrup

Holmegaard 1955 (Holmegaard company signature and production date)

Holmegaard 19PL55 (Holmegaard company signature and production date with Per Lutken initials)

Holmegaard 19PL60 KH (Holmegaard company signature, production date with Per Lutken initials, and Kastrup Holmegaard engraved initials)

Hovmantorp

Hovmantorp Sweden 1007 (Hovmantorp company signature and production number)

iittala and Karhula

G Hongell- Karhula (Goran Hongell signature and Karhula company signature)

Timo Sarpaneva- iittala (Timo Sarpaneva Signature and iittala company signature)

Tapio Wirkkala (Tapio Wirkkala signature and illegible production number)

Johansfors

Johansfors Orup (Johansfors company signature and Bengt Orup signature)

J.fors Orup (Johansfors company signature and Bengt Orup signature)

Kjellander

Kjellander 489-1466 (Kjellander company signature and production number)

Kosta and Kosta Boda

Kosta 41842 V. Lindstrand (Kosta company signature, 5 digit production number (1970s and after), and Vicke Lindstrand signature)

Kosta 48254 Tinback (Kosta company signature, 5 digit production number (1970s), Klas-Goran Tinback signature)

Kosta LH 1717 (Kosta company signature, Vicke Lindstrand initial (L), type of glass (H for "blown"), and 4 digit production number (pre-1970s))

Kosta 56129 Warff (Kosta company signature, 5 digit production number, Ann and Goran Warff signature)

Kosta Boda M. Backstrom Atelje (Kosta Boda signature, Monica Backstrom signature and Atelje marking, which was used in limited edition pieces)

Kosta Boda 48860 G. Warff (Kosta Boda company signature, 5 digit production number, Goran Warff signature)

Kosta Boda G. Warff 49808 (Kosta Boda company signature, Goran Warff signature and 5 digit production number)

Kumela

Kumela c Finland (Kumela company signature)

Kaj Blomqvist (Kaj Blomqvist signature)

Nuutajarvi Notsjo

K.F. Nuutajarvi Notsjo-61 (Kaj Frank initials, Nuutajarvi Notsjo company signature, and production year)

201

I. Toikka Nuutajarvi (Inkeri Toikka signature and Nuutajarvi company signature)

Orrefors

Orrefors NU 3538/1 (Orrefors company signature, "N", Nils Landberg designer code and "U" for "blown glass worked in the blowing room," and production number)

Orrefors Sweden (Molded Orrefors company signature found in Colora bowls designed by Sven Palmqvist)

Orrefors Graal Nr. 234 S Edward Hald (Orrefors company signature, Graal technique, production number, and Edward Hald signature)

Plus Glasshytte

Orrefors Ariel Nr. 1711 E Edvin Ohrstrom (Orrefors company signature, Ariel technique, production number, and Edvin Ohrstrom signature)

Plus Norway (Plus Glasshytte company acid etched mark. Note that a plus sign is created between the "[]" marking)

Riihimaen Lasi

Riihimaen Lasi O.Y. Tamara Aladin (Riihimaen Lasi company signature and Tamara Aladin signature)

Riihimaen Lasi O.Y. Nanny Still (Riihimaen Lasi company signature and Nanny Still signature)

Sea Glasbruk

Sea 70062 R Ramel (Sea Glasbruk signature, production number (1970), and Bjorn Ramel signature)

Riihimaen Lasi O.Y. Finland Helena Tynell (Riihimaen Lasi company signature and Helena Tynell signature)

Skruf

530 Bengt Edenfalk (production number and Bengt Edenfalk signature)

Skruf Sweden (Skruf company acid etched mark with cross and crown)

Strombergshyttan

Stromberg B845 (Strombergshyttan company signature and production code. This signature is not designer-specific, and only relates to the company)

Strombergshyttan [B426] (Strombergshyttan company signature and production code)

Appendix

Selected images from Orrefors Catalog No. 12, published in 1937. The first letter of Orrefors factory numbers indicate the designer of each piece; G – Simon Gate, H – Edward Hald, L – Vicke Lindstrand, F – Edvin Ohrstrom, P – Sven Palmqvist. Production codes have been included in the captions when they are not visible in the image.

G1847

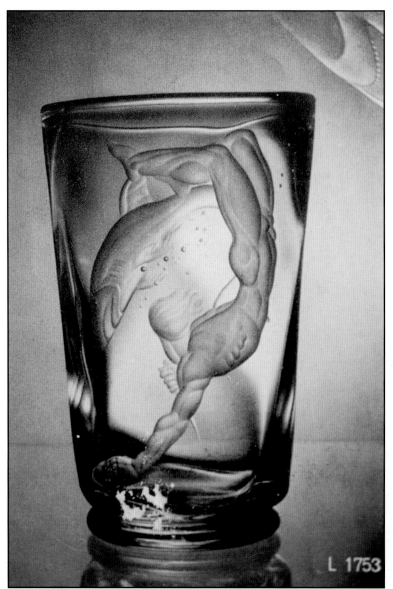

L 1753

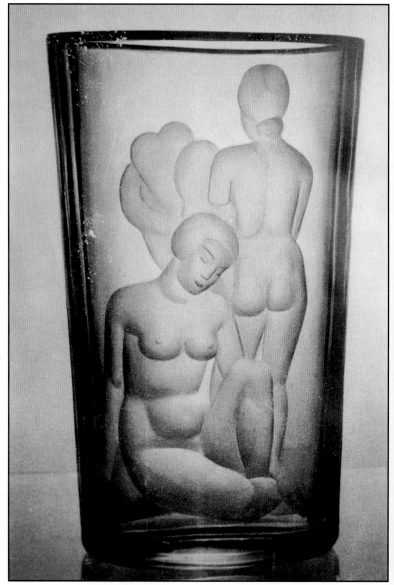

F1767

207

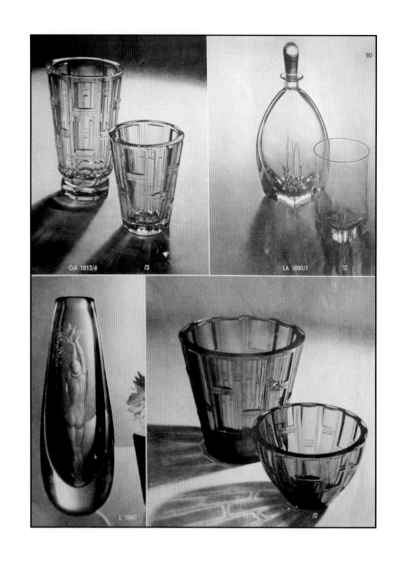

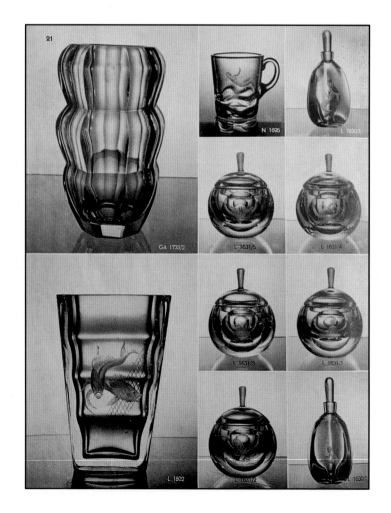

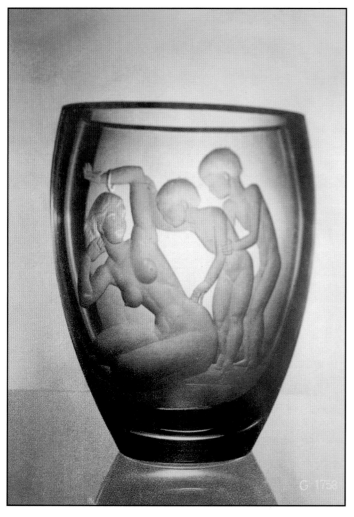

G1758

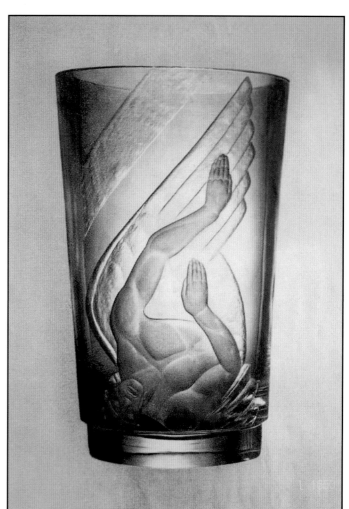

L1650

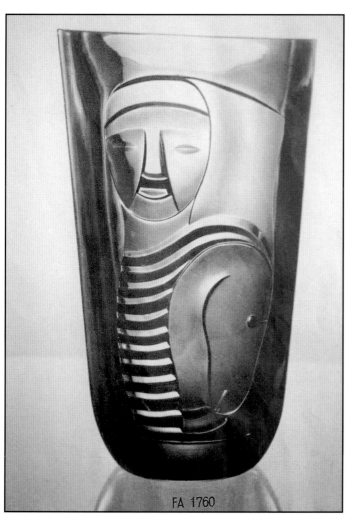

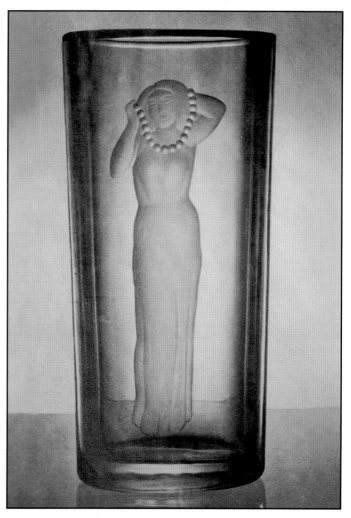

F1703

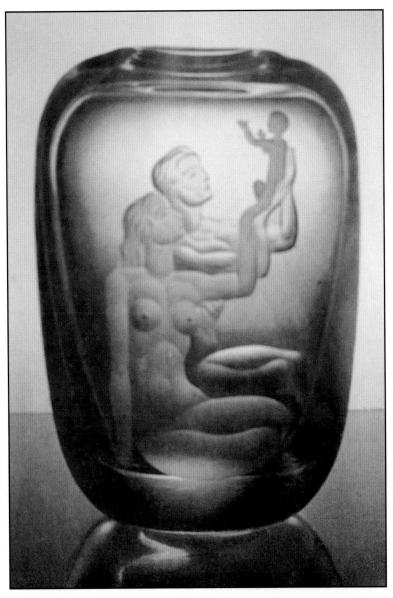

L1724

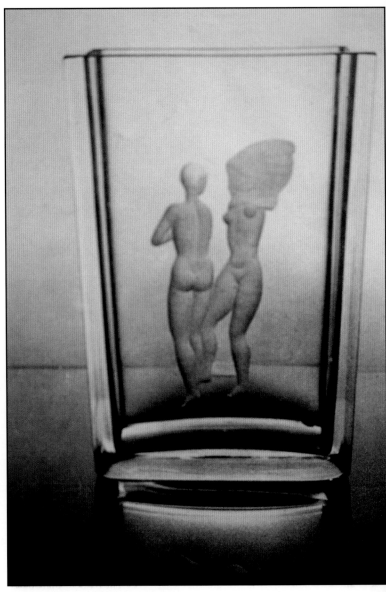

F1761

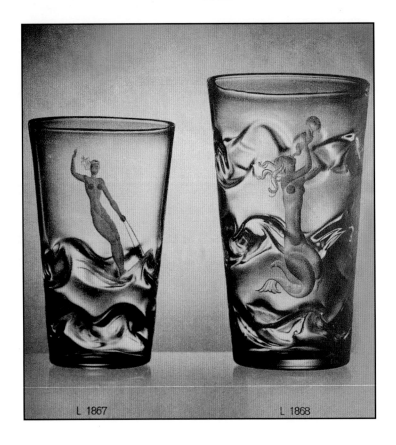

L 1867 L 1868

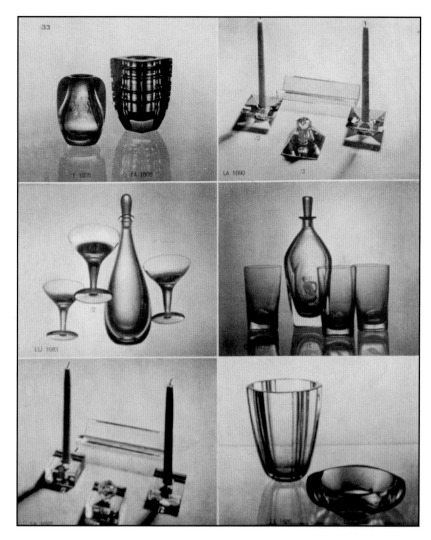

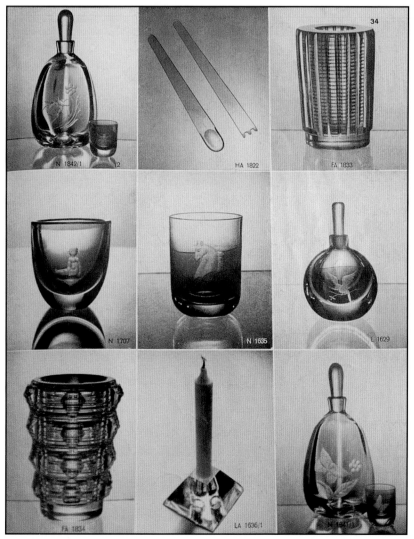

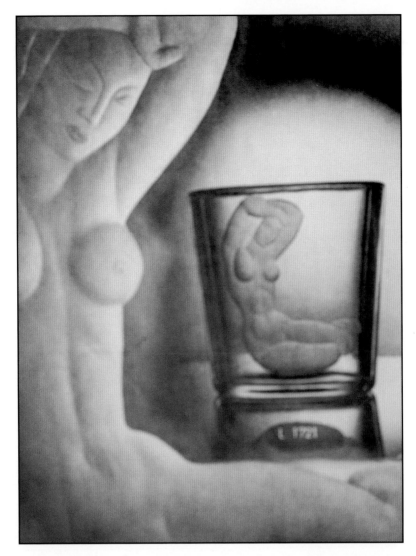
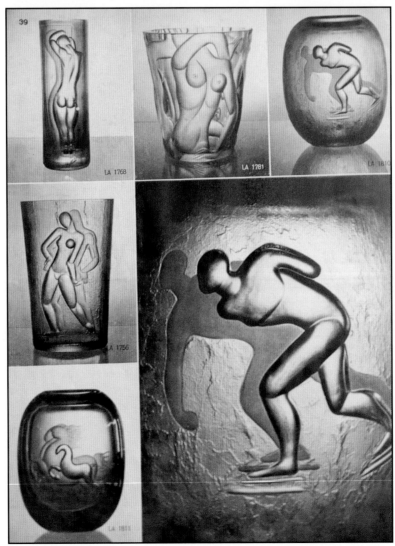

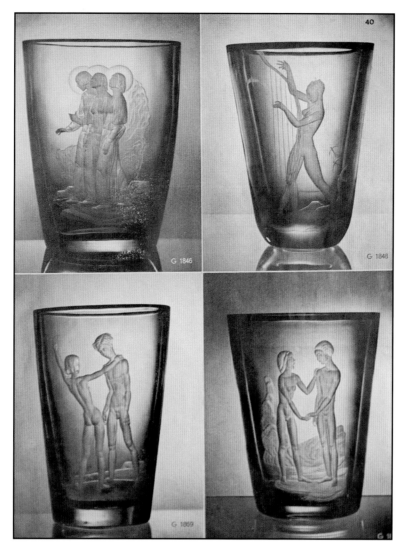

Upper right G1848, Lower right G1844

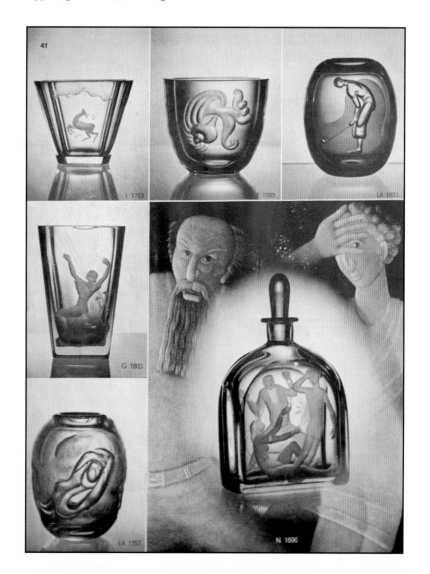

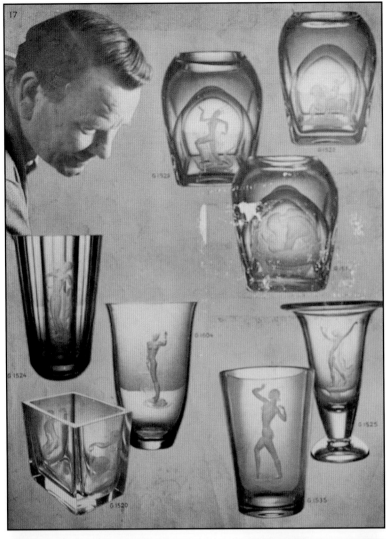

Selected images from Orrefors Catalog No. 12, published in 1937.

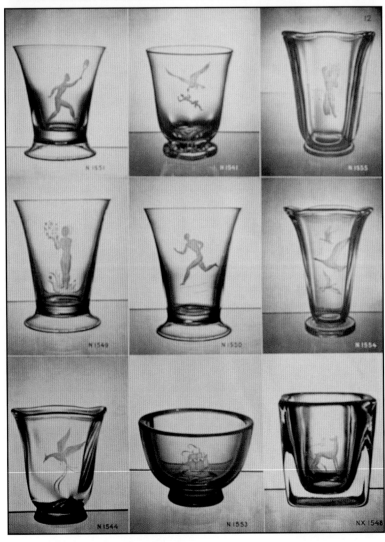

Images from a glass exhibition at the 1939 World's Fair in New York.

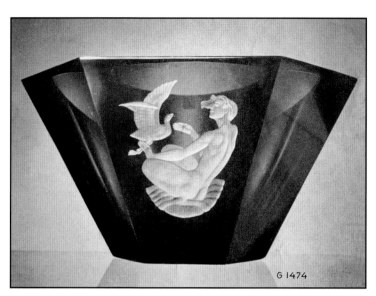

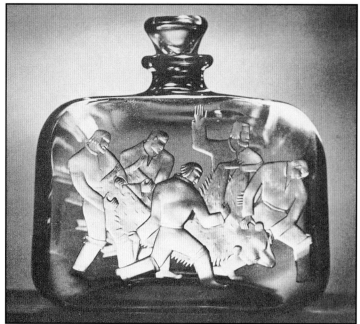

Engraved Riihimaki decanter, designed by Yrjo Rosola.

Selected from Orrefors promotional flyer from the late 1940s highlighting four designers: Simon Gate, Edward Hald, Nils Landberg, and Sven Palmqvist.

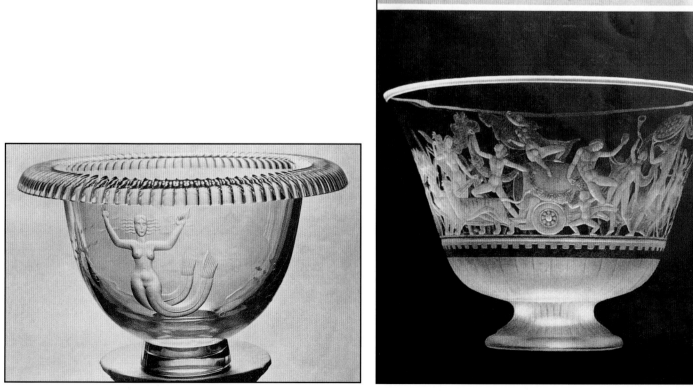

Engraved Riihimaki pedestal bowl, designed by Arttu Brummer.

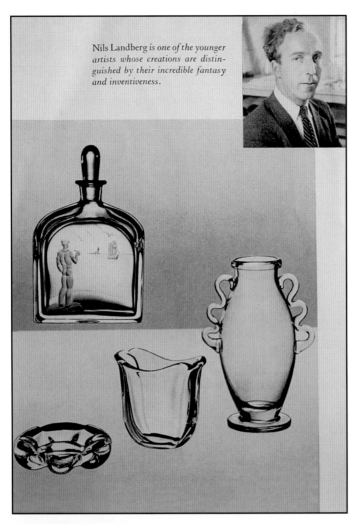
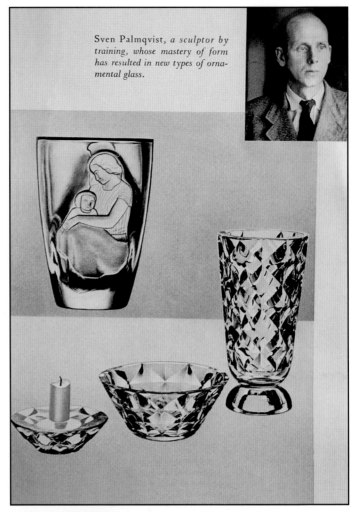
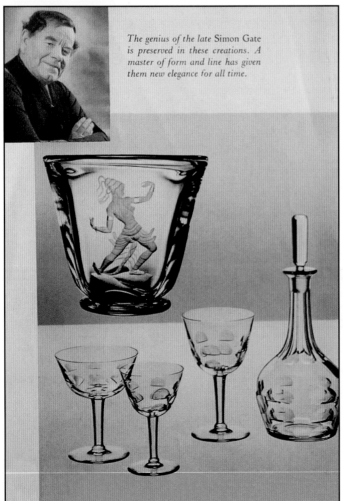
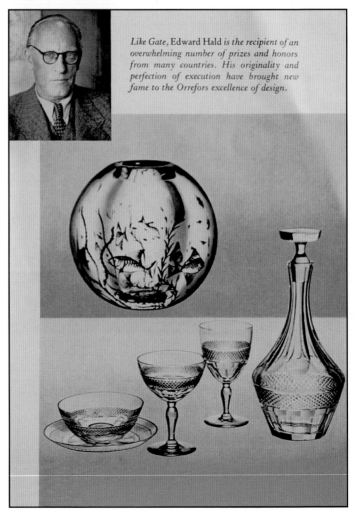

Images from Orrefors promotional catalog from 1951

Selected images from Orrefors Promotional Catalog from 1951.

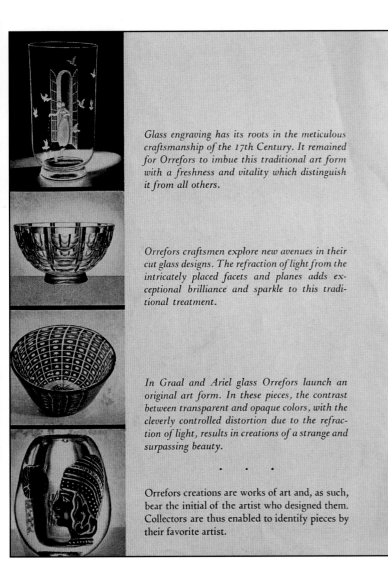

Glass engraving has its roots in the meticulous craftsmanship of the 17th Century. It remained for Orrefors to imbue this traditional art form with a freshness and vitality which distinguish it from all others.

Orrefors craftsmen explore new avenues in their cut glass designs. The refraction of light from the intricately placed facets and planes adds exceptional brilliance and sparkle to this traditional treatment.

In Graal and Ariel glass Orrefors launch an original art form. In these pieces, the contrast between transparent and opaque colors, with the cleverly controlled distortion due to the refraction of light, results in creations of a strange and surpassing beauty.

. . .

Orrefors creations are works of art and, as such, bear the initial of the artist who designed them. Collectors are thus enabled to identify pieces by their favorite artist.

Images from Orrefors promotional flyer from the late 1940's

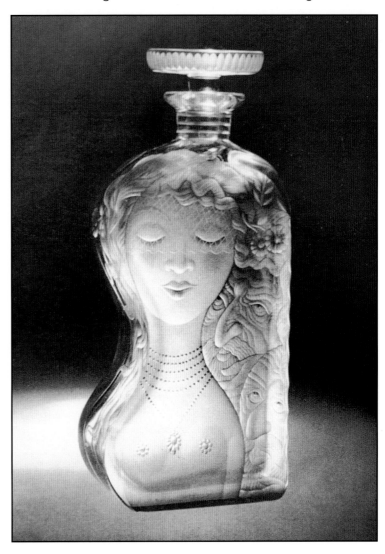

Designer - Nils Landberg

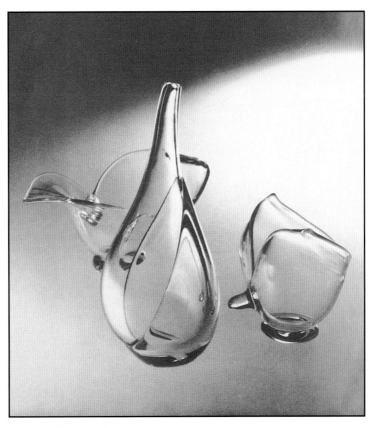

Designer - Ingeborg Lundin

217

Selected images from "Swedish Glass Imports," a catalog from Enright-LaCarboulec, Inc. of New York, New York, from 1953.

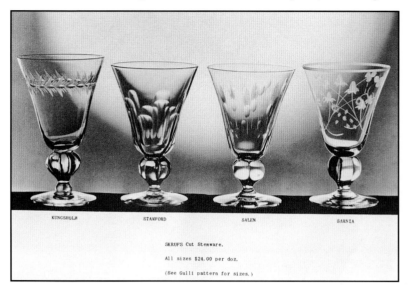

"Gulli" stemware from Skrufs (Skruf). The Gulli line was designed by Magni Magnusson in the 1930's.

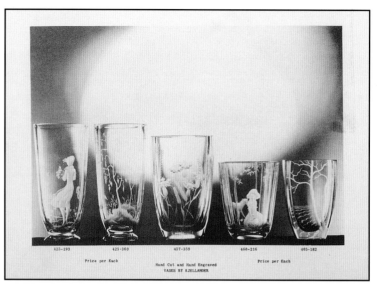

Cut and engraved vases by Kjellander.

Cut and engraved vases by Johansfors.

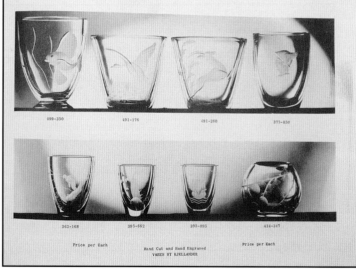

Cut and engraved vases by Kjellander.

Selected Bibliography

Aav, Marianne & Stritzler-Levine, Nina. *Finnish Modern Design: Utopian Ideals and Everyday Realities, 1930-1997*. Yale University Press: London, 1998.

Arrhenius, Lilly. *Svensk Heminredning – Swedish Design*. Vepe Forlag Bokindustri AB: Stockholm, 1957.

Arts Council of Finland and Finnish Ministry of Education. *Design 2005 – Government Decision-In-Principle on Finnish Design Policy 15.06.2000*. Arts Council of Finland and Finnish Ministry of Education: Helsinki, 2000.

____. *Auktion for Svenskt Konstglas*. Auktionsverket auction catalog, Stockholm, August 4, 1985.

____. *Auktion for Svenskt Konstglas*. Auktionsverket auction catalog, Stockholm, August 8, 1987.

Axelsson, Rune B. *Swedish Glass-Awarded Design*. National Swedish Industrial Board: Stockholm, 1984.

Beard, Geoffrey. *International Modern Glass*. Charles Scribner's Sons: New York, 1976.

Beard, Geoffrey. *Modern Glass*. Studio Vista Limited: Great Britain, 1968.

Brown, Conrad. "Coming: Revolution in Scandinavian Design". *Craft Horizons*, March-April 1958.

The Corning Museum of Glass. *Glass 1959-A Special Exhibition of International Contemporary Glass*. The Corning Museum of Glass: New York, 1959.

Dahlback, Helena & Uggla, Marianne. *The Lunning Prize*. Risbergs Tryckeri AB: Stockholm, 1986.

Dawson, Jack. *Finnish Post-War Glass: 1945 – 1996*. University of Sunderland: United Kingdom, 1988.

Fiell, Charlotte & Fiell, Peter. *50's Decorative Art*. Benedikt Taschen Verlag GmbH: Koln, 2000.

Fiell, Charlotte & Fiell, Peter. *60's Decorative Art*. Benedikt Taschen Verlag GmbH: Koln, 2000.

Fiell, Charlotte & Fiell, Peter. *70's Decorative Art*. Benedikt Taschen Verlag GmbH: Koln, 2000.

The Finnish Glass Museum. *Finnish Glass – Glass Manufacturers' Broschures from the 1950's*. Raihimaki, 2000

The Finnish Society of Crafts and Design. *Tapio Wirkkala*. The Finnish Society of Crafts and Design: Helsinki, 1985.

Form, Function, Finland. Issue. 79-80, Volume 3-4/2000

Gerstenberg, Susanne & Amott, John. Bengt Edenfalk. Glass 1990-91, Studioglas, Strombergshytten.

Hawkins Opie, Jennifer. *Scandinavia – Ceramics & Glass in the Twentieth Century*. Rizzoli International Publications: New York, 1990.

____. *Helena Tynell Design 1943 – 1993*. The Finnish Glass Museum: Finland, 1998.

The Helsinki City Art Museum. *Timo Sarpaneva – A Retrospective*. The Helsinki City Art Museum: Finland.

Holmer, Gunnel. *The Brilliance of Swedish Glass – 1918-1939*. The Bard Graduate Center for Studies in the Decorative Arts: New York, 1996.

_____. *Important 20th Century Glass – The Hal Metzler Collection*. Christie's auction catalog, Chicago, May 16, 1998.

Iittala Glass Museum. *Alvar and Aino Aalto as Glass Designers*. Exhibition catalog, 1988.

_____. *Italian Design*. Christie's auction catalog, South Kensington, June 3. 1998.

Jackson, Lesley. *20th Century Factory Glass*. Rizzoli Publications: New York, 2000.

Jantunen, Paivi, Martin, Kaj, & Rasanen, Liisa. *Oiva Toikka – Glass from Nuutajarvi*. Exhibition Catalog: Amos Anderson Art Museum.

Kahma, Marketta. *The Modern Spirit – Glass from Finland*. Vientipaino Oy: Helsinki, 1985.

Kastrup & Holmegaard Glassworks. *150 Years of Danish Glass*. Exhibition catalog. Caulfield Institute of Technology, Melbourne.

Katonah Gallery. *Art by Design: Reflections of Finland*. New York: Katonah Gallery, 1988.

Koivisto, Kaisa. *Suomen Lasi Elaa – Finnish Glass Lives*. The Finnish Glass Museum: Finland, 1986.

_____. *Kosta Boda – 8 Individuals*. Rahms I Lund tryckeri AB: Lind, 1991.

The Kosta Boda Book of Glass. Current Collection as of June 1, 1986. Strokirks: Sweden.

Lassen, Erik & Schluter, Mogens. *Dansk Glass 1925 – 1985*. Nyt Nordisk Forlag Arnold Busck: Copenhagen, 1987.

Lutken, Per. *Glass is Life*. Holmegaard Glassworks, Royal Copenhagen A/S, and Nyt Nordisk Forlag Arnold Busck: Copenhagen, 1986.

Lutzeier, Sabine. *Modernes Glas – Von 1920-1990*. Battenberg Verlag Augsburg: Austria, 1993.

_____. *Modernes Design*. Quittenbaum auction catalog, Munchen, March 20, 2000.

_____. *Modernes Design – Kunsthandwerk Nach 1945*. Quittenbaum auction catalog, Munchen, November 18, 2000.

_____. *Modern Design*. Phillip's auction catalog, New York, March 20, 1999.

_____. *Modern Design*. Christie's auction catalog, South Kensington, October 7, 1998.

Museum of Art and Design. *Tapio Wirkkala – Eye, Hand, Thought*. Museum of Art and Design: Helsinki 2000.

_____. *Nanny Still*. Suomen Lasimuseo: Finland, 1996.

_____. *New Scandinavian Glass*. Exhibition catalog. Ten Arrow Gallery, Massachusetts, March 20 to April 15, 1978.

_____. *New Scandinavian Glass*. Exhibition catalog. Ten Arrow Gallery, Massachusetts, May 12 to June 7, 1980.

Orvola, Mirja. *Craft Design – Heikki Orvola*. Kustannus Pohjoinen: Finland, 2000.

_____. *A Private Collection of Finnish Design*. Christie's auction catalog, March 7, 2001.

Palkonen, Ann. Transalation from the book, Suomen Lasiteollisuus 1681-1981, by Reijo Ahtokari, published in 1981. E-mails in August, 2001.

Piña, Leslie. *Fifties Glass, Second Edition*. Atglen, PA: Schiffer Publishing, Ltd., 2000

_____. *circa Fifties Glass*. Atglen, PA: Schiffer Publishing, Ltd., 1997

Remlov, Arne. *Design in Scandinavia*. Kirstes Boktrykkeri: Norway, 1950's.

Ricke, Helmut & Thor, Lars. *Swedish Glass Factories – Production Catalogues – 1915-1960*. Prestel-Verlag: Munchen, 1987.

Ricke, Helmut & Gronert, Ulrich. *Glas in Schweden, 1915-1960*. Prestel-Verlag Munchen und Kunstmuseaum: Dusseldorf, 1986.

Robert, Guy. *Kostaglas*. Kosta Glasbruk: Sweden, 1963.

_____. *Scandinavian Design*. Christie's auction catalog, South Kensington, September 15, 1999.

Soderstrom Osayeyhtio, Werner. *Kaj Frank – Designer*. WSOY: Porvoo, 1993.

Sparke, Penny. *A Century of Design – Design Pioneers of the 20th Century*. Barron's: New York, 1988.

Stennett-Willson, R. *The Beauty of Modern Glass*. The Studios Limited: London, 1958.

Stockholms Auktionsverk. Auction catalog. *Specialauktion-Svenskt Konstglas*. August 5, 2001.

Sunderland Arts Centre. *Suomen Lasi – Finnish Glass*. Smith Print Group: Newcastle Upon Tyne, 1979.

_____. *Svenskt Konstglas*. Auktionsverket auction catalog, Stockholm, August 12, 1990.

_____. *Svenskt Konstglas*. Auktionsverket auction catalog, Stockholm, August 9, 1992.

Veneti nel Mondo. Vetrai di Murano Nella Diaspora di Angelo Tajani. May 2002.
http://www.regione.veneto.it/videoinf/periodic/precedenti/numero25/dallasvezia.ht

Webb, Aileen O., Slivka, Rose, and Merwin Patch, Margaret. *The Crafts of the Modern World*. New York: Bramhall House, 1968.

Wickman, Kerstin. *Orrefors – A Century of Swedish Glassmaking*. Byggforlaget-Kultur: Stockhom, 1998.

Willman, Tiina. E-mail correspondence from 2001 to 2002.

Zahle, Erik. *A Treasury of Scandinavian Design*. Golden Press: New York, 1961.

Company catalogs for most companies listed in the book, spanning from 1950 to 2002.

Index

A. Ahlstrom Oy, 174
Aalto, Aino (Aino Marsio-Aalto), 141, 174, 175, 180
Aalto, Alvar, 34-37, 174, 175, 180
Abels, Gustaf, 178
Abrahamsson, Magnus, 173
Afors, 22, 40, 46, 171, 175, 182, 187, 197
Afors, Eric, 171
Ahola, Hilkka-Liisa, 177
Aladin, Tamara, 28, 67, 68, 79, 178-180, 203
Alberius, Olle, 177, 178
Alexandersson, Ragnhild, 178
Alghult, 171
Alsterfors, 148, 171, 189
Ander, Gunnar, 77, 147, 176, 193
Anneborg, Goran, 78, 179, 180
Arabia, 183-187, 194
Artek, 180
Aseda, 54, 134, 156, 160, 171, 181, 189
Aselius-Lidbeck, Catharina, 173, 176
Atterberg, Ingrid, 171

Backstrom, Monica, 172, 182, 201
Bang, Jacob, 131, 158, 159, 173, 180
Bang, Michael, 24, 29, 172, 173, 180
Bauer, Lisa, 176, 180
Bergdala, 64, 171, 189
Bergh, Elis, 96, 107, 175, 180
Bergkvist, Gustaf, 185
Bergqvist, Knut, 177-179
Bergqvist, Marie, 172
Bergslien, Gro (Gro Sommerfelt), 173
Bergstrom, Lena, 177, 178
Bernadotte, Sigvard, 172, 176
Berndt, Viktor, 68, 120, 172, 178, 181, 197
Bjork, Eva Jancke, 178
Blomberg, Kjell, 21, 173, 181, 198
Blomqvist, Fritz, 177, 178
Blomqvist, Kaj, 176, 201
Boberg, Ferdinand, 175
Boda (see also Kosta Boda), 64, 104, 106, 172, 189, 190, 197
Boda-Afors, 55
Bokstrom, Lillemor, 176
Bongard, Hermann, 57, 181
Borman, Axel Enoch, 175
Borgstrom, Bo, 54, 134, 156, 160, 171, 181, 189
Borgstrom, Matz, 19, 21, 176, 178, 181
Branzell, Arne, 178
Branzell, Sten, 175
Brauer, Otto, 24, 181
Bremberg, Thommy, 171
Broby, Severin, 173
Brozen, Olle, 171
Brummer, Arttu, 174, 175, 178, 179, 181
Bugge, Maud Gjeruldsen, 176
Burianova, Marketa, 173
Burmeister, Gabriel, 172

Carlsson, Carl, C., 171
Celander, Robert, 179
Coquille, 198
Cyren, Gunnar, 134, 172, 178, 181, 190

Dahl, Oskar, 175
Dahlskog, Ewald, 175

Danneskiold-Samsoe, Countess Henriette, 173
Dansk, 134, 172, 181, 190
Diessner, Karl, 171
Done, Ken, 171

Eda Glassworks, 187
Edenfalk, Bengt, 45, 73, 80, 90-92, 96, 176, 179, 181, 203
Eerola, Marcus, 174
Ehrner, Anna, 39, 150, 165, 176, 182
Ehrstrom, Eric O.W., 175
Ekenas, 85, 136, 172, 183, 190, 197
Elven, Owe, 178
Englund, Eva, 17, 178
Engman, Kjell, 172
Engman, Lena, 179
Engstrom, Styrbjorn, 178
Ericsson, Henry, 178, 179
Erixson, Sven, 175
Eskolin-Nurmesniemi, Vuokko, 177

Fagerlund, Alfred, 171
Fagerlund, Carl, 82, 178
Fagerlund, D.R., 171
Fagerlund, Oscar, 171
Falk, Bosse, 176
Flanders, Brita, 174
Flygsfors, 68, 113, 120, 172, 181, 187, 190, 197, 198
FM Konstglas, 125, 126, 129, 172
Fogelberg, J.A. Gottwald, 171
Fostoria, 193
Franck, Kaj, 17, 50, 51, 56, 125, 138, 162, 174, 177, 182, 201
Freij, Edla, 173

Gadderas Glassworks, 172
Gate, Flory, 178
Gate, Simon, 97, 177, 178, 182, 184
Gehlin, Hugo, 172
Gjerulsen, Maud, 173
Gordon, Ernest, 22, 46, 171, 175, 182, 197
Grcic, Konstantin, 152, 174, 182
Gullaskruf, 9, 10, 21, 81, 172, 173, 181, 186, 190, 198
Gustavsberg, 184
Gylden, Eva, 178, 179

Hackman group, 177, 186
Hackman iittala, 174
Hadeland, 17, 55, 57, 61, 69, 70, 89, 114, 139, 157, 173, 181, 183, 191
Hakansson, Gunnar, 174
Hakatie, Annaleena, 134, 177, 182
Hald, Edward, 82, 177, 178, 182-184, 202
Hallberg, Gustaff, 174
Hamilton, James, 176
Hansson, Lena, 173, 176
Helenius, Martti, 176
Hellsten, Lars, 177-179
Hendriksen, Liselotte, 178
Hennix, Margareta, 174, 178
Hennix, Rik, 174
Hickman, R.A., 175
Hjartsjo, 171
Hoff, Paul, 176
Hoganas, 74, 75, 191
Hoglund, Erik, 172, 178, 182, 189, 197
Hoglund, Erika, 38, 130, 177, 182

Hollfon, Hertha, 176
Holmegaard (see also Kastrup, Holmegaard and Kastrup-Holmegaard), 13, 16-18, 20, 22, 24, 29, 34, 46, 47, 64, 132, 133, 154, 155, 160, 173, 183, 184, 186, 191, 198
Holmgren, Christel, 173
Holmgren, Christer, 17, 160, 173, 183
Hongell, Goran, 149, 153, 174, 175, 183, 199
Hopea, Saara (Saara Hopea-Untracht), 177
Hovhammar, Erik, 176
Hovmantorp, 20, 111, 192, 199
Hulstrom, Karl, 175
Humppila, 176
Hydman-Vallien, Ulrica, 5, 119, 171

Israelsson, F.O., 174
iittala, 10, 16, 18, 19, 23, 27, 30-38, 40, 42-44, 53, 70-72, 79, 122-124, 134, 137, 138, 141, 144, 145, 149, 152, 155, 160, 161, 164, 165, 167-169, 173, 174, 182, 183, 185-188, 192, 199
iittala-Nuutajarvi, 174

Jacobino, Armado, 125, 176, 183
Jaderholm-Snellman, Greta-Lisa, 174, 178, 179
Jakobsson, Hans-Agne, 172
Joensuu, Elina, 149, 174, 183
Johannessen, Kjell, 173
Johansfors, 7, 8, 11-14, 16, 41, 42, 44, 52, 61, 79, 110, 134, 153, 162, 174, 185, 192, 199
Johansson, Berit, 177, 178
Johansson, Ernst, 171
Johansson, Jan, 177, 178
Johansson, Karin, 178
Johansson, Oscar, 171
Johansson-Pape, Liisa, 174
Johansson, Willy, 17, 55, 61, 69, 70, 139, 173, 183
Jonasson, Mats, 111, 117, 128, 176, 177, 183
Jung, Gunilla, 175
Jungell, Richard, 174, 175
Jutrem, Arne Jon, 173

Kallenberg, Fritz, 172
Kandall, John, 175
Kappi Theodor, 178, 179
Karhula, 114, 174, 175, 180, 188, 199
Karhula-iittala, 34
Karjalainen, Toivo, 176
Karlsson, Maija, 176
Karlsson, Vivianne, 178
Karlstrom, Arnold, 175
Karpannen, Mikko, 174
Kastrup (see also Holmegaard, and Holmegaard and Kastrup), 24, 47, 131, 158, 159, 173, 180, 181, 186, 191
Kastrup-Holmegaard, 192
Kedelv, Paul, 172
Kjellander, 102, 106, 200
Kokko, Valto, 174
Kolemainen, M.A., 178
Koskinen, Harri, 23, 38, 152, 174, 177, 183
Konst Glashyttan Urshult, 53
Koppel, Henning, 178
Kosta, Kosta Boda (see also Boda and Afors), 5, 14, 20-22, 26, 29, 39-41, 45, 52, 61, 65, 77, 85, 88, 93, 94, 96-99, 107, 110, 111, 115, 116, 119, 121, 126, 127, 136, 146-148, 150, 151, 153, 155, 164-167, 170, 175, 181-184, 187, 192, 193, 200, 201
Kosta Glasbruk, 78
Kraemer, Ulla, 176
Krahner, Anette, 178, 179
Krantz, Helen, 177, 178
Kumela (also Oy Kumela), 63, 78, 125, 135, 176, 183, 193, 201
Kumela, Ilmari, 176
Kumela, Toivo, 176
Kumen, Toivo, 176
Kurz, Fritz, 178
Kyllingstad, Stale, 173

Lagerbielke, Erika, 177, 178
Lahdenmaki, Nathalie, 174

Lahtinen, Sami, 177
Lake, John Orwar, 85, 136, 172, 183, 190, 197
Landas, Oscar, 177
Landberg, Nils, 14, 49, 113, 178, 183, 202
Larsson, Lena, 172
Larsson, Lisa, 176
Lidberg, Sven, 171
Lindahl, Gunilla, 178
Lindau, Borge, 178
Lindberg, Stig, 175
Lindblad, Gun, 176
Lindeberg, Karl, 175
Lindekrantz, Bo, 178
Linderholm, Lena, 171
Lindfors, Stefan, 174
Lindshammar, 19, 21, 68, 77, 140, 147, 163, 176, 181, 186, 193
Lindstrand, Vicke, 14, 20, 22, 26, 40, 41, 44, 61, 85, 94, 96-100, 110, 126, 147, 148, 153, 155, 165, 175, 178, 184, 185, 200
Lindstrom, Bengt, 176
Liukko-Sundstrom, Helja, 174
Lundgren, Tyra, 175, 178, 179
Lundin, Ingeborg, 42, 83, 84, 103, 179, 184
Lundkvist, Fabian, 171
Lundqvist, Wiktor, 172
Lutken, Per, 13, 16, 18, 20, 22, 34, 46, 47, 132, 173, 184, 198

Magnor, 81, 174, 176, 194
Magnus, Inger, 173
Magnusson, Magni, 179
Maleras, 20, 21, 103, 111, 172, 176, 183, 194
Mandl, Petr, 178
Manthorp, 192
Marcolin, Benito, 172
Marcolin brothers (Benito and Josef), 125, 126, 129, 172
Marcolin, Giovanni Luigi, 172
Marcolin, Josef (Guiseppe), 172
Marikekko, 187
Martinsson, Eva-Lena, 171
Mats Jonasson Maleras, 38, 40, 117, 128, 130, 177, 182, 187
Meech, Annette, 173
Meyer, Grethe, 173
Moilanen, Harry, 177
Moller, Tom, 176
Morales-Schildt, Mona, 5, 88, 93, 175, 184
Morch, Ibi Trier, 173
Motzfeldt, Benny, 57, 173, 178, 184, 195
Myers, Joel Philip, 173

Neilsen, Kai, 175
Nerman, Einar, 175
Newson, Marc, 152, 174, 184
Nierenberg, Ted, 172
Nilsson, Anne, 176-178
Nilsson, Rolf, 178
Nordenfeldt, Ulla, 172
Nordstrom, Tiina, 174, 177
Nurminen, Olavi, 56, 185
Nurminen, Kerttu, 58-60, 150, 165, 177, 184, 185
Nuutajarvi Notsjo (Nuutajarvi), 6, 17, 50, 51, 53, 56, 58-60, 62, 68, 125, 126, 138, 142, 143, 145, 146, 150, 162, 165, 177, 182, 183-187, 194, 201, 202
Nyblom, Lennart, 175
Nylund, Gunnar, 12, 13, 48, 179, 185
Nyman, Gunnel, 40, 62, 145, 146, 174, 175, 177-179, 185

Ohrstrom, Edvin, 115, 178, 185, 202
Okkolin, Aimo, 178, 179
Ollers, Edvin, 171, 175
Oreutler, Hannelore, 176
Orrefors, 14, 18, 29, 34, 42, 44, 45, 49, 76, 82-84, 86, 87, 95, 97, 99-101, 103, 110, 112, 113, 115, 147, 164, 172, 177, 178, 181-187, 194, 202
Orrefors Kosta Boda, 172, 177, 179
Orup, Bengt, 7, 8, 11-14, 16, 41, 42, 44, 52, 61, 79, 110, 134, 153, 174, 185, 199
Orvola, Heikki, 6, 169, 177, 185
Owens-Illinois, 175

Paag, Britten, 176
Paloheimo, H.G., 178
Palmqvist, Sven, 18, 34, 45, 86, 95, 99, 101, 110, 112, 178, 185, 186, 202
Pekkola, Veikko, 176
Percy, Arthur, 9, 10, 173, 186
Persson, Jerker, 171
Persson, Sigurd, 110, 176, 180, 186
Persson-Melin, Signe, 172
Petersson, Anton, 176
Petterson, Sverre, 173
Philstrom, Sven, 175
Plus Glasshytte, 57, 139, 178, 181, 184, 202
Pukeberg, 76, 77, 127, 129, 130, 178, 180, 187, 194, 195
Pykala, Sakari, 124, 178, 179

Quistgaard, Jens, 172

Raman, Ingegerd, 174, 179
Ramel, Bjorn, 179
Ramsey, Christoffer, 171
Randsfjordglass, 55, 195
Raymor, 190
Rentsch, Robert, 176
Rietz, Astrid, 171
Riihimaen Lasi (Riihimaki), 9, 27, 28, 66-68, 79, 82, 124, 174, 175, 178-182, 185-187, 195, 203
Rojgard, Ake, 176
Rosen, Erik, 172
Rosen, Ulf, 176
Rosenthal, 186
Rosola, Yrjo, 174, 175
Royal Copenhagen, 180
Royal Scandinavia Group, 172
Runemalm, Elving, 180
Ruottinen, Olavi, 176
RYD, 34, 196
Rytkonen, Martti, 177, 178

Sahlin, Gunnel, 176
Salakari, Jan, 176
Salo, Markku, 32, 33, 177, 186
Samuelsson, Inge, 15
Sandeberg, Ove, 121
Sarpaneva, Pentti, 135
Sarpaneva, Timo, 10, 19, 30, 31, 44, 53, 70, 160, 164, 165, 168, 169, 174, 186, 192, 199
Scheutz, Wiktor, 172
Schurch, Suzanne, 173
Sea Glasbruk, 15, 28, 39, 45, 56, 118, 140, 163, 179, 180, 187, 196, 203
Selbing, John, 178
Sestervik, Lars, 176, 178
Seth-Anderson, Carina, 161, 174, 186
Severin, Bent, 154, 173, 186
Siiroinen, E.T. (Erkkitapio), 79, 174, 178, 179
Sinnemark, Rolf, 172, 176, 178
Sjogren, Christer, 68, 140, 176, 186
Skawonius, Sven-Erik, 175
Skruf, 73, 80, 90-92, 96, 148, 171, 179, 181, 196, 203
Smalandshyttan, 111, 196

Still, Nanny, 9, 27, 28, 82, 178, 179, 186, 203
Stock, Renate, 118, 140, 179, 187
Stoll, Gro Eriksson, 173
Strand, Rune, 39, 45, 56, 163, 179, 187
Strom, P.O., 171
Strombeck, Britta, 173
Stromberg, Asta, 25, 26, 109, 179
Stromberg, Edward, 179
Stromberg, Gerda, 25, 179, 187
Stromberg, Eric, 179, 187
Strombergshyttan, 12, 13, 25, 26, 48, 93, 109, 110, 179, 187, 196, 204
Sundberg, Per B., 177, 178
Svanberg, Max Walter, 176
Svanlund, Kylle, 173
Sviberg-Krahner, Anette, 176
Syrjanen, Taru, 177

Theselius, Mats, 171
Tinback, Klas-Goran, 40, 65, 176-178, 187, 200
Toikka, Inkeri, 177, 202
Toikka, Oiva, 68, 122-124, 126, 142, 143, 162, 177, 187
Tommila, Sulo, 176
Torgersen, T., 195
Torstensson, Jonas, 176
Toso, Annamaria, 172
Toso, Aure, 172
Tuomen-Niityla, Kati, 174
Tynell, Helena, 66, 172, 178, 179, 187, 203

Ulleberg, Kari, 173
Upsala-Ekeby, 184

Vallien, Bertil, 55, 64, 119, 151, 171, 187, 188
Venini, 188
Vennola, Jorma, 174
Vesanto, Erkki, 16, 18, 174, 188
von Sydow, Christian, 176

Wahlstrom, Ann, 176
Wallander, Alf, 175
Walwing, Folke, 20, 21, 103, 174, 176, 188
Warff, Ann, 77, 115, 116, 164, 166, 175, 178, 188, 200
Warff, Goran, 29, 52, 77, 115, 116, 146, 164, 175, 178, 188, 200, 201
Watz, Brigitta, 176, 178
Wennerberg, Gunnar, 175
Werner, Sidse, 173
Westberg, Sven, 172
Westerberg, Uno, 130, 178
Westman, Marianne, 176
Wiberg, Harald, 176
Wiberg, Jan, 176
Wiberg, Sofia, 176
Wickenberg, Johan, 175
Widlund, Erik, 172
Wirkkala, Tapio, 27, 42, 43, 71, 72, 79, 137, 138, 144, 145, 155, 167, 174, 175, 188, 199
Wollman, Heinrich, 177, 178

Zeitz, August, 172
Zenkert, Karl, 171